1-16-75

1-16-75

Influence
in Art and
Literature

Influence in Art and Literature

GÖRAN HERMERÉN

Princeton University Press PRINCETON, NEW JERSEY

Copyright © 1975 by Princeton University Press
Published by Princeton University Press
Princeton and London

All Rights Reserved

LCC: 73-2466
ISBN: 0-691-07194-2

Library of Congress Cataloging in Publication data
will be found on the last printed page of this book

Publication of this book has been aided by
the Whitney Darrow Publication Reserve Fund of
Princeton University Press

Composed in Linotype Baskerville and printed
in the United States of America by Princeton
University Press, Princeton, New Jersey

Le jeu des influences reçues ou exercées est un élément essentiel de l'histoire littéraire. PAUL VAN TIEGHEM

For a variety of reasons, a re-examination of the concept of influence is a primary need for Comparative Literature today. HASKELL M. BLOCK

The most essential task which faces the comparative scholar at the present time is to renovate and broaden his methods and to acquire a fresh conception of the essential notion of influence in literature. HENRI PEYRE

Contents

List of Illustrations ix

Preface xiii

Abbreviations xvii

1. Problems and Distinctions

 1.1 Introduction 3

 1.2 Ontological principles 10

 1.3 Different kinds of influence 28

 1.4 Further distinctions 50

 1.5 Causal explanations and hypotheses about
 influence 104

 1.6 Normative implications 127

 1.7 Concluding remarks 154

2. Conditions for Influence

 2.1 Introduction 156

 2.2 The temporal requirement A 157

 2.3 The requirement of contact 164

 2.4 The temporal requirement B 172

 2.5 The requirement of similarity 177

 2.6 The requirement of change 239

 2.7 Concluding remarks 257

3. Measurement of Influence

3.1 Introduction 263
3.2 Some examples 265
3.3 Measures I–III: the size of the similarities 272
3.4 Measure IV: the size of the change 277
3.5 Measures V–VI: the probability of the change 284
3.6 Measures VII–IX: the extensiveness of
the change 288
3.7 Measures X–XI: the importance of the change 295
3.8 Measures XII–XIII: the duration of the influence 297
3.9 Concluding remarks 300

4. Consequences and Conclusions

4.1 Introduction 303
4.2 Influence, tradition, and development 305
4.3 Influence and interpretation 308
4.4 Influences, value judgments, and normative
implications 312
4.5 Influence, originality, and normative
implications 317
4.6 Practical conclusions 319

Bibliography 323
Index 337

Illustrations

Unless otherwise indicated, all photographs of the works of art reproduced in this book have been supplied by the owners.

1. Marcel Duchamp, *The Bottle Dryer*, 1914, photo of a reconstruction, Nationalmuseum, Stockholm. (p. 24)
2. Andy Warhol, *Campell's Soup*, 1965, Museum of Modern Art, New York. Philip Johnson Fund. (p. 25)
3. Arne Jones, *Cathedral*, Nationalmuseum, Stockholm. (p. 26)
4. Eugène Delacroix, *Les Femmes d'Alger*, 1834, Louvre, Paris. Photo: Giraudon, Paris. (p. 29)
5. Francisco Goya, *May 3, 1808 in Madrid*, Prado, Madrid. Photo: Alinari, Florence. (p. 47)
6. Edouard Manet, *The Death of Maximilian*, Museum of Fine Arts, Boston; by courtesy. Gift of Mr. and Mrs. Frank Bait Macomber. (p. 47)
7. Olle Baertling, *Iru*, 1958, Moderna museet, Stockholm. (p. 48)
8. Michelangelo, *Wax Model for a Sculpture*, c. 1519, Victoria and Albert Museum, London; by courtesy. (p. 52)
9. Michelangelo, *The Dying Slave*, Louvre, Paris. Photo: Alinari, Florence. (p. 52)

10. Titian, *Polyptych* (detail: lower right part showing St. Sebastian), SS. Nazzaro e Celso, Brescia. Photo: Alinari, Florence. (p. 53)
11. Jan van Scorel, *St. Sebastian*, 1542, Museum Boysmans-van Beuningen, Rotterdam. (p. 53)
12. Claes Oldenburg, *Sketch of a Monument in Stockholm*, 1966, Arkivmuséet, Lund. (p. 56)
13. John Constable, *Sketch for Valley Farm, c.* 1835, Victoria and Albert Museum, London; by courtesy. (p. 57)
14. John Constable, *Sketch for Valley Farm, c.* 1835, Victoria and Albert Museum, London; by courtesy. (p. 58)
15. John Constable, *Valley Farm*, 1835, Tate Gallery, London. (p. 59)
16. Theodore Géricault, *The Raft of Medusa*, 1818–1819, Louvre, Paris. Photo: Alinari, Florence. (p. 60)
17. Theodore Géricault, *Sketch for the Raft of Medusa*, 1818, Louvre, Paris. Photo: Giraudon, Paris. (p. 60)
18. Titian, *Bachanal with the Sleeping Ariadne*, *c.* 1518–1519, Prado, Madrid. Photo: Alinari, Florence. (p. 64)
19. Peter Paul Rubens, *Copy of Titian's Bachanal with the Sleeping Ariadne*, Nationalmuseum, Stockholm. (p. 65)
20. Nicolas Poussin, *Copy of Bellini's Feast of the Gods*, National Gallery of Scotland, Edinburgh. (p. 66)
21. Giovanni Bellini, *The Feast of the Gods*, National Gallery, Washington, D.C., Widener Collection. (p. 67)
22. Pablo Picasso, *Paraphrase of Las Meninas*, 1957, belongs to the artist's estate. Photo: Giraudon, Paris. (p. 69)
23. Diego Velazquez, *Las Meninas, c.* 1658, Prado, Madrid. Photo: Alinari, Florence. (p. 70)
24. Francis Bacon, *Nr VII from Eight Studies for a Portrait*, 1953, Museum of Modern Art, New York. Gift of Mr. and Mrs. William A. M. Burden. (p. 71)
25. Diego Velazquez, *Pope Innocentius X, c.* 1648–1650, Palazzo Doria, Rome. (p. 72)

26. Raphael, *Portrait of Pope Julius II*, drawing, Corsini Gallery, Florence. Photo: Alinari, Florence. (p. 73)
27. Joan Miró, *Dutch Interior I*, 1928, Peggy Guggenheim Foundation, Venice. (p. 74)
28. Jan Steen, *Tanzstunde des Kätzchens*, Rijksmuseum, Amsterdam. (p. 75)
29. Pablo Picasso, *The Studio*, 1927–1928, Museum of Modern Art, New York. Gift of Walter P. Chrysler, Jr. (p. 76)
30. Marcantonio Raimondi, *The Judgment of Paris*, *c.* 1515, engraving. Prints division, New York Public Library. Astor, Lenox and Tilden Foundations. (p. 79)
31. Edouard Manet, *Le Déjeuner sur l'herbe*, 1863, Louvre, Paris. Photo: Giraudon, Paris. (p. 80)
32. Rembrandt, *The Storm on the Sea of Galilee, c.* 1633, Isabella Stewart Gardner Museum, Boston; by courtesy. (p. 81)
33. Martin de Vos, *The Storm on the Sea of Genezareth*, Etching, *c.* 1580, Bibliothèque Nationale, Paris. (p. 82)
34. Cesare Ripa, *Truth*, Iconologia, 1603. (p. 83)
35. Lorenzo Bernini, *Truth Unveiled, c.* 1646–1652, Galleria Borghese, Rome. Photo: Alinari, Florence. (p. 84)
36. Paul Gauguin, *The Green Christ*, Musées Royeaux des Beaux-Arts de Belgique, Bruxelles. (p. 85)
37. Jacques Stella, *Playing Children*, Etching, 1657. (After K. E. Maison, *Bild und Abbild*, München & Zürich: Droemersche Verlagsanstalt, 1960.) (p. 86)
38. Jean-Baptist Huet (?), *Playing Children*, Painting, *c.* 1770, formerly Blackwood Collection, London. (After K. E. Maison, *Bild und Abbild*, München & Zürich: Droemersche Verlagsanstalt, 1960.) (p. 87)
39. Pablo Picasso, *Accordionist*, 1911, Solomon R. Guggenheim Museum, New York. (p. 90)
40. Georges Braque, *Man With a Guitar*, 1911, Museum of Modern Art, New York, acquired through the Lillie P. Bliss Bequest. (p. 91)

xi

Preface

Critics and scholars every now and then claim that one artist or work of art was influenced by another, and these claims may start long and occasionally heated debates which in some cases have lasted for decades. These debates raise a number of intriguing theoretical and methodological problems. What, for example, is meant by "influence" in this context? What methods can be used to settle disagreements about influence? What kind of disagreement is involved? What reasons could be used to support or reject statements about artistic and literary influence?

In the present investigation I shall try to answer some of these questions. In the first chapter I propose to make a number of distinctions between different kinds of influence. In the next chapter I shall discuss a series of necessary conditions for artistic influence to have taken place; these conditions are used by scholars and critics as reasons in discussions for and against the statement that one particular work of art was influenced by another. In the final chapter I shall state and analyze some methods which are used or could be used to measure the extent of the artistic influence. The distinctions, conditions, reasons, and measures are illustrated by quotations from writings in the history of art and literature.

The purpose of my investigation is to provide a systematic survey of the conceptual framework used by critics and scholars when they discuss problems of influence. This survey is based on descriptive analyses in which I have tried to make explicit what is said or implied in a number of quotations taken from writings on the history of art and literature. In this respect the present investigation resembles my previous book *Representation and Meaning in the Arts* (Lund, 1969). In both cases the investigations are based on empirical material and descriptive analyses, but to a certain extent they also contain constructive elements and proposals.

Thus the purpose of this book is both descriptive and explicative. It is descriptive insofar as it describes the reasons, methods, concepts, and assumptions used by critics and scholars; and it is explicative insofar as it calls attention to vagueness and ambiguity, tries to clarify concepts and distinctions, or to draw new distinctions and replace vague concepts with concepts that are less vague. I also hope to be able to call attention to a number of more or less controversial assumptions that are made when certain arguments are used to support or reject claims about influence, or when certain methods are used to grade the size or strength of the influence.

This book deals with a number of problems in a borderline area where several disciplines (aesthetics, psychology, philosophy, history of art and literature) meet. Of course, nobody can pretend to be an expert in all these fields, and I have concentrated on conceptual, theoretical, and methodological issues. I have also had the opportunity to present the basic ideas of this book in lectures and seminars to both historians of art and literature and to philosophers.

I have been working on the problems to be discussed in this book over a number of years, but my work has several times been interrupted by other research projects. A crude version of the basic ideas was mimeographed in 1965, and a second typewritten version was completed in 1969. I

would like to thank Sören Halldén for many helpful comments on these earlier versions and for stimulating encouragement over the years.

The main part of the present book is based on a mimeographed version I wrote in Philadelphia during the spring of 1972, while I enjoyed the benefits of a fellowship from the National Endowment for the Humanities, administered by Temple University and Monroe Beardsley. I am very grateful to Monroe Beardsley and John Fisher for this fellowship and for the invitation to spend a term at Temple University, which made it possible for me to write without having to think about any administrative duties.

Parts of earlier versions of this book have been presented in seminars and lectures at various Swedish universities, several times at the University of Lund before 1970 and later at the universities of Umeå, Uppsala, and Stockholm. Some of the basic ideas of the book were also presented in a seminar at Temple University and in a lecture at the University of Virginia during the spring of 1972. I want to thank the participants of these discussions for stimulating comments.

Some friends have been kind enough to read the 1972 version of the book and to call my attention to some unclear points. I want to thank George Dickie, who suggested some improvements of chapter one; Peter Kivy, who made comments on the whole 1972 version; and Louise Vinge, who likewise made helpful comments on the whole manuscript. Moreover, I want to thank Manfred Moritz, Staffan Björck, Carl Fehrman, Oscar Reutersvärd, and Sven Sandström, with whom I have discussed earlier versions of this book. I would also like to thank Margaret H. Case for her skillful work in preparing the manuscript for the press, and Sanford G. Thatcher, editor of Princeton University Press, for his assistance with the proofs and the technical details of the production.

I am indebted to my father, Harry Hermerén, who helped me with the proofreading, and to Karin Knecht, who

typed most of the manuscript, including the bibliography, and gave valuable assistance with the index. A special thanks is due to the staff at the Marquand Library, Princeton University; to the staff at the University Library at Lund; to the staff at the Library of Temple University, Philadelphia; and to the staff at the University Library at Umeå.

For permission to reproduce photographs of works of art to which they owned the copyright my thanks are due to Fratelli Alinari, Florence; Arkivmuséet, Lund; Bibliothèque National, Paris; Peggy Guggenheim Foundation, Venice; Museum Boysmans-van Beuningen, Rotterdam; Isabella Stewart Gardner Museum, Boston; Photographie Giraudon, Paris; Solomon R. Guggenheim Museum, New York; Museum of Fine Arts, Boston; Museum of Modern Art, New York; Musées Royaux des Beaux-Arts de Belgique, Bruxelles; National Gallery of Art, Washington, D.C.; National Gallery of Scotland, Edinburgh; Nationalmuseum, Stockholm; New York Public Library, New York; Öffentliche Kunstsammlung, Kunstmuseum Basel, Basel; Rijksmuseum, Amsterdam; Tate Gallery, London; and Victoria and Albert Museum, London. Detailed credits are given in the caption lines below the illustrations.

My work was supported by a grant from Statens Humanistiska Forskningsråd, Stockholm, which is gratefully acknowledged.

Umeå, June 1973

GÖRAN HERMERÉN

Abbreviations

AB Art Bulletin
BM Burlington Magazine
CL Comparative Literature
GBA Gazette des Beaux-Arts
JAAC Journal of Aesthetics and Art Criticism
PMLA Publications of the Modern Language Association
YCGL Yearbook of Comparative and General Literature

Quotations from works written in less well-known lan-
guages, such as the Scandinavian ones, have been translated
into English by the author, but the original text is quoted
in the footnotes. Works written in fairly well-known lan-
guages are quoted from the original text. However, quota-
tions from Spanish and German texts are translated into
English in the footnotes.

Influence
in Art and
Literature

1.

Problems and Distinctions

Methodology seeks but to make explicit
in logical terms what is de facto *going on*
in living research. KARL MANNHEIM

1.1 INTRODUCTION

WORKS of art are not produced in a vacuum; every work of art is surrounded by what might be called its artistic field, and this field includes buyers, sellers, critics, artistic traditions, literary movements, current philosophical ideas, political and social structures, and many other things. All these factors may influence the creation of works of art. It is sometimes argued against much of the research done in art history and in the study of literature that when scholars discuss problems of influence, they consider only a very small sector of what I have called the artistic field.

This is no doubt frequently true, and the importance of widening the perspective and looking for alternative explanations will be stressed many times in this book. Nevertheless, certain factors in the artistic field may be singled out, and the relations between them concentrated on, provided one is aware of the existence of other factors as well. The fact that some scholars have failed to take the whole artistic field into consideration can hardly be held against the use of comparative methods as such. Nor does this fact prove that there is something wrong in the concept of artistic influence or in being interested in artistic influences. However, this interest can be misdirected, and attempts to solve

3

problems of influence can fail for a variety of reasons, some of which will be discussed in detail in this book.

Many other charges have been made against the use of comparative methods in the study of art and literature. For example, it is sometimes said that these methods have dictated the scholars' choice of what artists to study. It is tempting to concentrate on artists and writers who are, so to speak, rewarding and easy to investigate with comparative methods, and these artists tend to be the minor ones. This may sometimes be true, but not always, as the examples in the rest of this book will show. And even if it were true, it should not mislead us; the same charge can be made against any method. The fault lies here not in the method itself but rather in those who use the method. Besides, it would be a mistake to think that great artists are never influenced by other artists. On the contrary, these influences are only harder to detect; they require a subtle mind and methodological imagination on the part of the scholar.

Any method can be misused. It is possible to find investigations where comparative methods have been used *in absurdum* to construe influences between artists and writers. There are also investigations totally dominated by the search for influences and almost nothing is said about the qualities, structure, expression, and symbolic content of works of art. But these facts should not be used as support of a general rejection of this kind of research and of comparative methods in the study of art and literature. A method has no value in itself; the value of a method depends on how and for what purpose it is used.

The most enthusiastic comparatists sometimes seem to have had a strictly deterministic conception of artistic creation. Let us call this psychological view the billiard ball model of artistic creation. Adherents of this view seem to have thought that every feature of a work of art can be derived from external influences, and that accordingly a study of these influences would give a complete explanation of the work of art. This conception obviously leaves little room for

creative artistic imagination and inventiveness. However, neither the concept of artistic influence nor the comparative method stands and falls with this rather naive view. Research into influences can be carried out with more modest claims.

It is possible that older research of this kind was founded to a considerable extent on mistaken or implausible theories about the process of artistic creation and about the ways in which the artistic imagination works. Perhaps it was thought that artists were like billiard balls or like some kind of complicated automata, and that accordingly laws and approaches which had proved to be useful in mechanics and biology could be applied without change to the study of art and literature. Influence was defined as a cause of a process rather than as a cause of an action; and the concept of action introduces, as we shall see, a number of interesting complications in this context.

Clearly, it makes sense to talk about causal connections in experimental research, where we have a well-defined set of factors which can be manipulated at will. By such manipulations it is possible to find out whether a given factor is, for example, a necessary or a sufficient condition for the occurrence of another factor. But can the conceptual framework used in describing and analyzing such situations be applied to essentially nonexperimental problems like investigations of what artists influenced and were influenced by Titian?

I do not wish to go into a detailed discussion of the distinction between experimental and nonexperimental research and the possibly related distinctions between various kinds of causality. All this has been the subject of a long and at times heated controversy over several hundreds of years; a thorough discussion of these distinctions could fill several volumes. I only want to call attention to a problem and to the central role of the concept of action in analyzing statements about artistic influence.

Roughly speaking the situation seems to be as follows.

Suppose an artist or an author *A* has rendered a motif in a particular way in the work *X*. After some time, another author or artist *B* comes into contact with this work; he reads or contemplates *X*. But it is by no means certain that *B*'s subsequent artistic production will be influenced by *X*. If he is to be influenced by this contact, several conditions have to be satisfied. For example, *B* should be open to new ideas, be in a formative state of his development, or in other words have a disposition to become influenced.

If comparative methods are to be used in a fruitful way, it is necessary not only to ask in what respect a particular artist was influenced by another. It is also important—and this is probably more difficult—to ask and try to answer a number of other questions, such as the following ones: in what respect was he *not* influenced by this other artist? In what respect has he transformed the first artist's ideas into something new? Has the influence from this other artist helped him to find a style or an expression of his own? (Perhaps the contact with this other artist made it possible for him to develop an original style.) Only in this way can comparative methods throw light on the ways in which the artistic imagination works.

So far, I have suggested that research into artistic and literary influences may be based on more or less plausible theories about the process of artistic creation. I have also suggested that research of this kind may be carried out independently of obviously naive conceptions like the billiard ball model of the artistic imagination. It would be interesting to go further into a discussion of these psychological questions, but they require a separate investigation.[1] In what follows I shall instead concentrate on some semantical and logical problems raised by arguments pro and con hypotheses about influence.

[1] See John Livingstone Lowes, *The Road to Xanadu. A Study in the Ways of the Imagination*, New York: Vintage Books, 1959; and Ragnar Josephson, *Konstverkets födelse*, Stockholm: Natur och Kultur, 1955.

Are there, it may be asked, any good reasons to study discussions about artistic and literary influence from a semantical and a logical point of view? I suppose that nobody would want to deny that such discussions may suffer from lack of clarity, but that is not the only reason for this investigation. It is a fact that discussions of this kind play an important role in many art history and literary investigations. The result of research into the complex network of influences is one (among several) important types of analyses and explanations of works of art. This alone is sufficient to show that an investigation of arguments pro and con statements about influence should be worthwhile.

An investigation of artistic and literary influence from a semantical and logical point of view should be of interest not only to specialists in semantics and in the philosophy of the humanities. Art historians frequently have occasion to discuss critically hypotheses about influence suggested by themselves or by their colleagues. In such situations they will make intuitive logical and semantical considerations of the kind to be discussed in some detail in the subsequent chapters of this book.

Distinctions between different concepts of influence may then help to avoid pseudoagreement or pseudodisagreement, and a systematic study of the relevant arguments for and against hypotheses about influence will make it easier to weigh and sift the evidence in particular cases. Methodological research is not, as Sven Linnér points out in his book *Litteraturhistoriska argument*, "a divertisement between serious work. It either goes straight down to the empirical issues or examines the instruments by which these empirical issues are discussed."[2]

Moreover, hypotheses about influence are also quite common in studies of the history of ideas. According to the programmatic writings of some scholars in this field, the concept of influence is the basic concept in their research. This

2 Sven Linnér, *Litteraturhistoriska argument*, Stockholm: Svenska Bokförlaget/Bonniers, 1964, preface: p. v. My translation.

is so when, for example, the history of ideas is defined as the study of the way in which physics, biology, and other disciplines have influenced, and been influenced by, philosophical systems and world views.

Discussions about influence occurs in every historical discipline. Political history is no exception. A fairly recent example is the analysis of Wegener's influence on Raeder in Carl Axel Gemzell's dissertation *Raeder, Hitler und Skandinavien* (Lund, 1965) and the controversy about this analysis.[3] However, material of this kind will not be discussed here; in this book I shall concentrate exclusively on analyzing quotations from studies in art history and comparative literature.

To be sure, it is true that investigations of influences used to be more common than they are today. The exaggerations and the lack of subtlety in many literary investigations of this kind during the first decades of this century and the later vigorous criticism of the new critics—who emphasized the importance of close reading of the literary texts and despised external biographical and historical studies—have given the term "influence research" a bad connotation. The same is true also in art history.

However, it would be a serious mistake to think that no research of this kind is going on. If, for a moment, I may concentrate on monographs (and thus disregard the great number of articles in which influence relations are more or less clearly discussed), it is evident that new contributions to this kind of research are published almost every year,

3 See Sven Tägil, "Wegener, Raeder, and the German Naval Strategy. Some Viewpoints on the Conditions for Influence of Ideas," *Cooperation and Conflict*, II, 1967, pp. 101–12, and the discussion between Tägil and Gemzell in *Historisk Tidskrift*, 1966–67. For other examples from the history of ideas, see John Blackmore, *Ernst Mach. His Work, Life and Influence*, Berkeley & Los Angeles: University of California Press, 1972, and any recent volume of *Journal of the History of Ideas*. See also the articles by Driscoll, Echeverria, Huntley, and Werner mentioned in the bibliography.

and there do not seem to be any signs indicating that this flow of publications concerned with problems of influence will decrease or disappear.

Some recent examples include Philippe van Tieghem, *Les Influences étrangères sur la litterature française (1550–1850)*, Paris: Presses Universitaires de France, 1961; Rafique Ali Jairazbhoy *Foreign Influence in Ancient India* (New York: Asia Publishing House, 1963) and *Oriental Influences in Western Art* (London: Asia Publishing House, 1965); Norman J. Fedder, *The Influence of D. H. Lawrence on Tennessee Williams* (The Hague: Mouton, 1966); K. L. Goodwin, *The Influence of Ezra Pound* (London: Oxford University Press, 1966); Alfred Moir's extensive investigation, *The Italian Followers of Caravaggio* (Cambridge, Mass.: Harvard University Press, 1967); and Jean Weisgerber, *Faulkner et Dostoievsky: confluences et influences,* Bruxelles, Presses Universitaires de France & Presses Universitaires de Bruxelles, 1968. Among Swedish art historians Aron Andersson has perhaps more than any other discussed problems of influence. In particular I might mention his book *English Influence in Norwegian and Swedish Figure Sculpture in Wood, 1220–1270* (Stockholm, 1949).[4]

Finally, I would like to stress that this book is not intended to be a contribution to the historical discussion as to whether a particular artist or author was (or was not) influenced by some of his colleagues. The purpose of this investigation is to analyze and make precise the tools which

[4] In this context it might be mentioned that when a previous version of this book was written (in 1969) a number of students at the Institute of Art History at Lund University were studying if and to what extent Swedish artists like Hill and Josephson had been influenced by Goya and Velázquez.

For studies of literary influence, see Fernand Baldensperger and Werner P. Friedrich, *Bibliography of Comparative Literature*, Chapel Hill: University of North Carolina Press, 1950. For more recent studies see the yearly supplements in *YCGL* from 1952 on, especially the survey articles by Gillispie and Avni mentioned in the bibliography.

art historians and students of literary history use, when they try to solve problems of this kind. The fact that I have chosen to discuss the views of a particular art historian, for example, does not mean that I like his views. Nor does it mean that I dislike them. It means only that in my opinion his views are interesting from a semantical or logical point of view; they illustrate a distinction or a way of arguing.

1.2 ONTOLOGICAL PRINCIPLES

The point of departure for the present analysis is provided by statements like the following ones, collected from writings on the history of art and literature by such scholars as Haskell Block, Albert Friedman, John Golding, Roland Penrose, Robert Rosenblum, and Philippe van Tieghem:

> The influence of Wagner on Mallarmé is of capital importance in the development of the poet's mature dramatic theory.[5]

> However, a study of the work of his 'Negroid' period shows that Picasso was influenced as much by the general characteristics of Negro sculpture as by the peculiarities of the individual pieces he owned or saw.[6]

> No sooner had Cubism made its appearance than its influence began to spread to other arts.[7]

> L'influence de l'Italie littéraire sur nos écrivains de la période romantique se réduit à peu de chose, surtout si l'on considère les écrivains modernes de ce pays.[8]

[5] Haskell M. Block, *Mallarmé and the Symbolist Drama*, Detroit: Wayne State University Press, 1963, p. 54.

[6] John Golding, *Cubism: A History and an Analysis 1907–1914*, London: Faber & Faber, 1959, p. 59.

[7] Roland Penrose, *Picasso. His Life and Work*, Harmondsworth: Penguin, 1971, p. 164.

[8] Philippe van Tieghem, *Les Influences étrangères sur la littérature française (1550–1880)*, Paris: Presses Universitaires de France, 1961, p. 213.

Ironically, the ballades which Percy most altered are those which spread the influence of the collection furthest.[9]

Again, as in *Les Demoiselles,* the influence of African Negro art is evident.[10]

In all these examples, two entities are related to each other, and one of them is said to have influenced the other. To facilitate generalizations and to save space, I shall use *X* and *Y* as variables for these entities. Thus, the examples above can be compressed into the following brief formula "*X* influenced *Y*."

However, an artist is not influenced by the works of another artist in general but in a particular respect, such as technique, style, expression, symbolism, and so forth. I shall therefore regard influence as a three-place relation; "*X* influenced *Y*" is an abbreviation of "*X* influenced *Y* with respect to *a*." In this section I propose to discuss the values of the variables *X*, *Y*, and *a* in this sentence. A close examination of what is said to influence what by students of art and literature suggests a number of interesting distinctions between different kinds of influence.

1.2.1 *The Value of the Variable* a

As to the variable *a* in literary contexts, the following quotation from a book by K. L. Goodwin may serve as illustration:

What Pound passed on to his friends, acquaintances, and imitators was sometimes style, sometimes a tone, sometimes subject-matter, sometimes a form of construction. The more superficial tricks of style—the startling new image in the last line of an Imagist poem, the omission of articles, the insertion of letters into narrative—could be

[9] Albert Friedman, *The Ballad Revival*, Chicago & London: University of Chicago Press, 1961, p. 209.
[10] Robert Rosenblum, *Cubism and 20th Century Art*, New York: Abrams, 1961, p. 26.

11

learnt by quite unintelligent and minor poets, or by major poets as a passing phase. The less superficial aspects of style, such as the handling of colloquial rhythms and the use of brief anecdote to illustrate a point, were less teachable, and few poets made the intense study of Pound's work necessary to learn them. . . . Subject-matter and the writer's attitude to it are again rather personal matters, and Pound's interests have been almost as esoteric as Yeats's; he has, however, maintained and passed on the typical Romantic interest in the sea, and in travel. The invention or promotion of a form of construction is a much rarer kind of influence, yet Pound has promoted both the Imagist poem and the ideogrammic method. As both these forms are capable of indefinite modification, it could be expected that Pound's influence with them is likely to continue.[11]

This quotation contains a number of terms which could be substituted for *a* in the sentence "*X* influenced *Y* with respect to *a*." These terms refer to various aspects of the style, expression, subject-matter, and form of construction of Pound's poetry.

This list is not intended to be exhaustive, but it gives a rough idea of what kinds of qualities are relevant in this context. Words like "style" and "expression" could, as is well known, be understood in several ways; they are category terms which can be replaced by a number of more specific expressions. In the quotation above, Goodwin in fact gives some hints in this direction by distinguishing between—and exemplifying—what he calls more and less superficial aspects of style.

In addition to the qualities referred to by Goodwin, I would like to mention the symbolic contents of works of art; obviously, the symbolism in a particular painting or poem can influence the choice of symbols in other works of

[11] K. L. Goodwin, *The Influence of Ezra Pound*, London: Oxford University Press, 1966, pp. 218–19.

art. Again, "symbolism" covers a broad category of features, and this term could be replaced by a number of more specific expressions, but it is not necessary to go into detail here and repeat the distinctions I have outlined elsewhere.[12]

These remarks about the range of significance of the variable a can be generalized and hold for art history as well. Here the relevant categories are subject matter, technique, style, structure, expression, and symbolic contents of various kinds.

However, there are also examples indicating that the value of the variable a in "X influenced Y with respect to a" is not restricted to names or descriptions of aesthetic qualities in any narrow sense. For instance, in his book on the history of cubism, John Golding writes as follows:

> However, if Metzinger was able to appreciate intellectually the importance of Picasso's art, in his own painting he was influenced only by its most superficial aspects. In the *Two Nudes* Metzinger has learned from Picasso how to reconcile three-dimensional form with the picture plane, by placing the subject in shallow depth and fusing it with its surroundings, but there is no real interest in analysing solid forms.[13]

Thus the respects in which Metzinger was influenced by Picasso are not aesthetic qualities in the usual sense (qualities such as harmony, dynamism, balance, power, and so forth).[14] But it can be argued that what he learnt from Pi-

[12] Göran Hermerén, *Representation and Meaning in the Visual Arts*, Lund: Läromedelsförlagen, 1969.

[13] Golding, *Cubism*, p. 147.

[14] On aesthetic qualities, see Frank Sibley, "Aesthetic Concepts," reprinted in W. E. Kennick, ed., *Art and Philosophy*, New York, 1964, pp. 351–73. I have discussed aesthetic qualities in my "The Existence of Aesthetic Qualities," in Bengt Hansson, *et al.*, eds., *Modality and Morality and Other Problems of Sense and Nonsense*, Lund: Gleerups, 1973, pp. 64–76; and in my "Aesthetic Qualities, Value, and Emotive Meaning," *Theoria*, XXXIX, 1973, pp. 71–100.

casso is relevant to the aesthetic appreciation of his pictures.

There is no need to attempt anything like an exhaustive classification of the possible values of the variable a. X can be influenced by Y in form as well as in content, that is in style, composition, technique, imagery, and themes as well as in the ideas or general world view expressed. In all these cases I shall say that the influence concerns features which are relevant to the appreciation and understanding of the works involved. I admit that this is vague, but I shall place the following restriction on the concept or rather family of concepts of influence that will be examined here:

(R 1) *Ontological Requirement 1.* If X influenced Y with respect to a, then the value of the variable a is limited to names or descriptions of features relevant to the understanding and appreciation of X and Y.

Of course, I do not deny that X can influence Y in many other respects, and some people might want to extend the range of significance of the variable a to terms referring to, say, the size of the pages in a novel, the weight of a painting, the color of the cover of a book, and so forth. But I shall, perhaps somewhat arbitrarily, confine myself to study influence relations satisfying among others the requirement (R 1).

This still leaves room for some uncertainty as to the exact range of significance of the variable a, but I hope that what I have said will be sufficiently precise for my present purpose.

1.2.2 *The Values of the Variables* X *and* Y

As to the other variables X and Y in the sentence "X influenced Y with respect to a," the situation is rather complex. It is possible to distinguish between a number of different kinds of influence by indicating and classifying the values of these variables in a systematic way, and that is what I propose to do in the rest of this section.

To begin with, it might be mentioned that the kind of influence I am interested in should be distinguished from several other relations, which are also sometimes called influence. For example, when Stanley T. Williams discusses Spanish influence on American literature, he sometimes pays a great deal of attention to the use of Spanish words, of stories from Spain, and to indications of the American authors' interest and familiarity with Spanish geography, language, literature, and customs.[15] Studies of this kind are valuable, as is a study of the reception of a Spanish writer's work in America, but they are not studies of influence in the sense to be discussed in this book.

It is possible to talk about influence as a relation between artists and as a relation between works of art, and it is that usage I am interested in here. In both cases we may distinguish between the following four possibilities:

(a) individual influences individual
(b) individual influences group
(c) group influences individual
(d) group influences group

We have an instance of case (a) when it is said that D. H. Lawrence influenced Tennessee Williams, or that Wagner influenced Mallarmé; an example of (b) when it is said that Percy has influenced the ballads of a number of other poets; an example of (c) when it is said that Picasso was influenced by Negro art or that Monet was influenced by Japanese woodcuts; and an example of (d) when it is said that Italian writers during a certain period have influenced French writers.

The problem of verification may very well be slightly dif-

[15] Stanley T. Williams, *The Spanish Background of American Literature*, New Haven: Yale University Press, 1955; see vol. I, pp. 126, 129–30 for examples; see also his "Spanish Influences on the Fiction of William Gilmore Simms," *Hispanic Review*, XXI, 1953, pp. 221–28. Incidentally, it is instructive to compare this article with the paper by Thomas J. Wesley mentioned in the bibliography.

ferent in these four cases, and for this reason it may be wise to distinguish between them. The fact that there are similarities between works of art is often used to support the claim that one of these works influenced the other. But it is obviously much easier to check whether there are similarities between two individual works of art than it is to check whether there are similarities between two groups of works of art.

In the latter case we could proceed in two ways. One would be to match every work of art belonging to one group with every work of art belonging to the other group and then somehow summarize the findings in one short formula. We could also select one work to represent one of these groups and another work to represent the other and then compare these two works with each other. But in the latter case—which seems to be the standard method in art historical writings—we must ask: According to what principles were these works of art selected? How do we know that they are representative of their respective groups?

But more distinctions remain to be made. The situation in case (a) above can be illustrated by the following diagram, where "*A*" and "*B*" are variables ranging over names or descriptions of artists (writers), and "*X*" and "*Y*" are variables ranging over names or descriptions of works of art (poems, etc.):

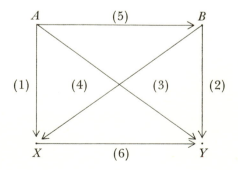

The arrows (1) and (2) stand for relations of production: *A* created *X* and *B* created *Y*. Arrow (3) indicates that *B* came into contact with (saw or read) *X*. The other arrows indicate relations between the entities which are sometimes said to have influenced each other, namely:

(4) An artist *A* influences a work of art *Y*
(5) An artist *A* influences another artist *B*
(6) A work of art *X* influences another work of art *Y*.

The relations between these three statements are not quite clear and may be worth examining in some detail. I shall here make a few comments on these three statements, and I shall begin with the last one.

Strictly speaking, it is just as absurd to say that a work of art in itself influenced another as to say that a chair in itself influenced another. But statements like (6) can be defined in terms of the relations (3) and (2): the artist *B* saw or read or heard about the work of art *X*, and this contact caused—in a sense to be discussed further in section 1.5—that the work of art *Y* was created in the way it was and with the properties it has in fact.

Statements like (5)—that one artist or writer has influenced another—can sometimes be a convenient way of saying that the works of one of these artists influenced the works of the other. But the statement that one artist has influenced another sometimes means something quite different; for example, that one artist has influenced the other by talking about technical or poetical principles, or simply by criticizing the work of the other artist.

The following quotation from a book by Richard Ellman may be used to illustrate this kind of influence:

> It was Pound who, hearing that Yeats had spent six or seven years trying to write *The Player Queen* as a tragedy, suggested that it might be made into a comedy, with such effect that Yeats completely transformed the play at once.[16]

[16] Richard Ellman, *Yeats: The Man and the Masks*, London: MacMillan, 1949, p. 215.

In this case Pound obviously influenced Yeats, but he influenced Yeats by his words rather than by his works. Obviously statements like (5) and (6) raise quite different problems of verification, and that is the reason why it is important to distinguish between them.

Finally, statements like (4)—that one artist has influenced the work of another artist—can be understood in several ways. For example, they might be taken to mean that one person influenced another by discussions and criticisms in the way suggested by the quotation above. In extreme cases one might conceive of influence by hypnosis or extrasensory perception. But such statements might also be interpreted as saying that the works of one artist were influenced by contacts with the works of another artist in the way suggested in the comment on (6) above.

All these relations of influence are important and deserve close examination. But it is also important to distinguish between them, since it is far from clear that they can be analyzed in the same way.

The concept of influence to be studied in this book can now be characterized in a crude and preliminary fashion by means of the distinctions introduced above: I propose to study relations of type (6) in the diagram, that is, (a) statements in which it is said that an individual artistic or literary work influenced another, (b) statements which are equivalent to or imply such statements, and finally (c) the reasons that are or could be given for or against statements of these two kinds.

Thus the following requirement may be added to the one already introduced:

(R 2) *Ontological Requirement 2.* If X influenced Y with respect to a, then the values of the variables X and Y are limited to names or descriptions of literary or visual works of art.

However, this requirement raises several problems, and I shall now comment on some of them.

To begin with I shall only discuss influence between works belonging to the same medium; if X in "X influences Y with respect to a" is replaced by a name or a description of a literary work, then Y in this sentence will also be replaced by a name or a description of a literary work. Later on I shall consider the complications which arise when, for example, X is a painting and Y is a poem.

There is, as is well known, a rather extensive literature on the open texture of the concept of art and the emotive overtones of terms like "art" and its synonyms. But there is no need to go into these problems here. In the present context it is quite sufficient to say that objects created by human beings and discussed in art historic journals and books are to be counted as works of art. The class of literary works of art can be delimited in an analogous way. This strategy might not eliminate all unclear borderline cases, but it does give what is needed here: a long and impressive list of clear examples of what is to be counted as literary and artistic works.

Moreover, it is possible to distinguish between different kinds of works of art (or poems), and some of these distinctions may prove to be important. As a point of departure for a discussion of such a distinction, I shall use a quotation from a book by Octavio Paz.

> Perhaps the two painters who have had the greatest influence on our century are Pablo Picasso and Marcel Duchamp. The former by his works; the latter by a single work which is nothing less than the negation of work in the modern sense of the word.[17]

I shall now try to explicate the difference between two kinds of works of art which the author is hinting at in the quotation above.

Consider one of Duchamp's famous ready-mades. What was the point of exhibiting these objects as works of art?

[17] Octavio Paz, *Marcel Duchamp or the Castle of Purity*, London: Cape Goliard Press, 1970, p. 1.

The point was, I suggest, to challenge our traditional conception of art and to open up new ways of seeing. The action, then, is more important than the physical object exhibited. Indeed, the structure and the color of the ready-mades are of little significance to those who study the art of Marcel Duchamp; one would miss the point of his art if one devoted a great deal of attention to the structure and colors of the ready-mades. When it is said that Marcel Duchamp had a great influence on contemporary artists, this is no doubt true. But it should be observed that Duchamp did not influence these other artists by his works but rather by his actions.

Compare, by way of contrast, the art of Duchamp with that of Titian or Rembrandt. Neither of these latter artists wanted to change or challenge our traditional conception of art in the way Duchamp did. The works of both these artists fall squarely within the traditional conception; they painted with oil on canvas, and their paintings represented persons and events, as did those of their predecessors. (In other respects their paintings differed, of course, from those of earlier painters.) The structure and color of the canvases they produced are by no means irrelevant to those who want to study their art; and one would not miss the point of their contributions to Western civilization, if one devoted a great deal of attention to these aspects of their works.

For want of better names I shall refer to these two kinds of art as the action-dominated and as the object-dominated conceptions of art. It is, I think, important to see that the distinction between these conceptions does not coincide exactly with the distinction between *objet trouvé* and painting. In the first place, it is possible to challenge current conceptions of art by paintings in the way Yves Klein, for example, did: by painting and exhibiting a series of blue monochrome paintings. Moreover, the distinction suggested above applies also to literature, but here it is not at all clear what the equivalent to an *objet trouvé* would be.

Nor does the distinction suggested above coincide exactly

with the distinction between representative and nonrepresentative art. This distinction can, to be sure, be drawn in a variety of ways, and one might wonder about the exact relation between concepts such as concrete art, abstract art, and nonrepresentative art. However, there is no need to discuss these problems here. For in whatever way the distinction between representative and nonrepresentative art is drawn, it must be acknowledged that impressionist art was representative and at the same time a challenge to the conception of art which was current at that time.

It can also be argued that many of the painters now regarded as classical—such as Patinir, Bruegel, Courbet—were in their own time revolutionaries, who tried to change or at least challenge the current conception of art by depicting new kinds of motifs, such as landscapes, peasants, or still lifes, which previously had not been considered dignified enough to be the subject matter of a work of art. Thus in making this distinction between what I above called the action-dominated and the object-dominated conception of art I do not have to rely on avant-garde painters like Marcel Duchamp and Yves Klein.

The basic idea behind this distinction is as follows: it is no doubt possible to distinguish between (a) the work of art, which is created by an artist at a particular moment, and (b) what the artist intended to achieve by creating, exhibiting, and perhaps also destroying this work of art. Now (a) and (b) are distinguishable features of every situation in which a work of art is created. Both of them are, so to speak, always present. But sometimes art historians, critics, and beholders focus on the object, sometimes on the intentions or action. Why?

The answer is very simple. Sometimes the action is more interesting than the object, sometimes the object is more interesting than the action. When critics and art historians focus on, say, the action rather than the object in a particular case, this is because the action is more interesting than the object, given a certain knowledge of art history and of

the situation in which the work was created in combination with more or less systematic and articulate views on artistic value and what makes it worthwhile to study art. The reasons that could be given to support such claims deserve further study.

For example, it may be argued that the action in a particular case is more interesting than the object, since the action is more original than the object. Reasons of this kind bring out the importance of art and literary history; to be able to decide whether a certain style, technique, choice of motifs, and so forth, is original or not, it is necessary to be familiar with the history of style and the history of artistic traditions. Moreover, this kind of reason is relevant only if certain views on art and artistic value are accepted, as will be made clear later on in this chapter.

It is important to clarify the distinction between these two conceptions of art. But it is also important to have appropriate labels on them; and it could perhaps be argued that the word "dominated" is misleading or unfortunate in this context. Since the attention of critics and art historians can shift from the object to the action and vice versa, it might be better to use the expressions "the object-focussed conception of art" and "the action-focussed conception of art." Whatever label is preferred, I hope that what I have said so far is sufficient to make the distinction clear enough for my purposes. The point of the distinction will be obvious in the course of discussion, and I shall now consider some objections that could be raised against it.

In the first place, it may be suggested that the distinction between what I above called the action-dominated and the object-dominated conception of art is not a sharp one, and what we have here is rather a continuum of cases. I would be inclined to agree with this; obviously, it is possible to pay attention both to the work of art and to the intentions of the artist, and to pay more attention to the object than to the intentions, and vice versa. But at the same time I would like

to stress that this fact in no way shows that the distinction is untenable. (The distinction between night and day is not a sharp one—the day turns successively into night—but this does not show that there is no distinction between night and day.)

Moreover, it may be suggested that the action-dominated conception of art can somehow be reduced to the object-dominated conception, for example by analyzing the similarities between the colors, structures, and shapes of the objects created or exhibited by the artist. This is possible, only if the following statements are true: (a) if two works of art are similar, then the intentions of those who created these works of art are similar; and (b) if the intentions of those who created two works of art are similar, then the works they created are also similar. It is a priori very unlikely that either of these statements are true; and a few counterexamples will be sufficient to refute them.

Consider first a Gothic chapel from, say, the thirteenth century and a Neogothic chapel, which was created several centuries later. The two chapels can be almost indistinguishable from each other visually; only an expert in art history can tell which of them is Gothic and which is Neogothic. Yet it is clear that the intentions of the architects were not at all likely to have been the same; the situation in which the Gothic chapel was created was very different from the situation in which the Neogothic chapel was created. For one thing, there was no Gothic architecture to imitate in the former case.

Let us then compare some of the famous ready-mades by Marcel Duchamp, say *The Fountain* or *The Bottle Dryer*, with works of art by other contemporary artists and painters. In my view, it can well be argued that there is much more similarity between the action of exhibiting *The Bottle Dryer* (figure 1) and the action of making and exhibiting a painting such as Andy Warhol's famous *Campbell's Soup* (figure 2) than there is between the objects exhibited by

23

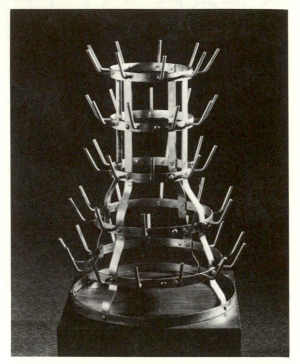

Figure 1.

Duchamp and Warhol; the point Duchamp wanted to make resembles in many important ways the point Warhol wanted to make much later.

In fact, it can also be argued that there is greater similarity between Duchamp's ready-made and, for example, *Cathedral* by Arne Jones (figure 3) than there is between it and the painting by Warhol, and yet the works by Jones and Duchamp represent different conceptions of art. The point of exhibiting Duchamp's ready-mades is quite different from the point of exhibiting the sculpture by Jones, although these works are much more similar to each other than are Warhol's painting of the Campbell soup can and Duchamp's bottle rack. This shows, I think, that the action-dominated conception of art cannot be reduced to the object-dominated conception.

24

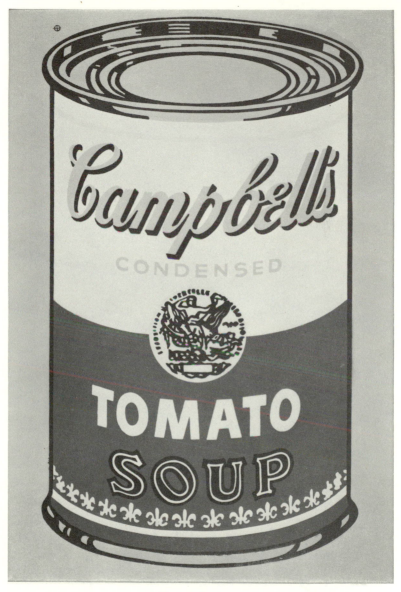

Figure 2.

25

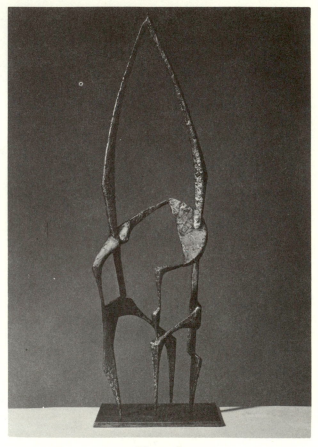

Figure 3.

The importance of the distinction between these two conceptions in the present context is that the values of the variables X and Y in sentences like "X influenced Y with respect to a" are in the one case certain actions, in the other case certain physical objects.

Thus the previously suggested ontological requirement (R 2) should be replaced by

(R 2)' *Ontological Requirement 2'.* If X influenced the creation of Y with respect to a, then the values of the

variables X and Y are limited to names or descriptions of literary or visual works of art, or alternatively to certain kinds of actions.

In the first case the object-focussed conception of art has been presupposed, in the second, the action-focussed conception of art.

Now physical objects have structure and color, but actions do not; or, to be more precise, perhaps actions can be said to have a structure of a sort, but they do not have a structure *and* a color. Thus the problem of verification—and the methods used to corroborate the claim that X did influence Y—will be different in the two cases. Similarity is often used as evidence of influence, and to show that two paintings are similar, art historians use comparative methods of various kinds. But one action cannot be similar to another action in the way one work of art can be similar to another. For these reasons it is necessary to specify exactly between what kinds of works of art the relation of influence is supposed to hold.

1.2.3 *Concluding Remarks*

The conclusions of this book are relative to the material used. This material consists of (a) a number of works of art (paintings, poems, plays, novels), and (b) a number of statements about these works of art, quoted from the writings of contemporary scholars such as Jean Adhémar, Frederick Antal, Haskell Block, Kenneth Clark, Richard Ellman, Norman Fedder, Walter Friedlaender, John Golding, K. L. Goodwin, Millard Meiss, Alfred Moir, Erwin Panofsky, Philippe van Tieghem, and many others. The bibliography at the end indicates exactly what art history and literary writings I have used.

In the discussion to follow I have used works of art of several kinds, though mainly works falling within the traditional object-focussed conception of art. However, I shall also pay some attention to the complications which arise if

these examples are replaced by works of art illustrating the action-focussed conception of art.

1.3 DIFFERENT KINDS OF INFLUENCE

In this section I intend to make a number of distinctions between different kinds of influence which will prove to be important if clarity is desired. However, some of these distinctions raise a number of intriguing issues and cannot be stated clearly until several problems to be discussed later are solved or at least clarified. In particular, this is true of the distinction between positive and negative influence.

1.3.1 *Artistic and Nonartistic Influence*

In his book *David to Delacroix*, Walter Friedlaender writes as follows:

> In 1832, seven years after his trip to England, Delacroix undertook an expedition to Morocco which had much stronger influence on him and on his art [than Bonington had].[18]

This quotation is interesting, since it illustrates two kinds of influence which, for want of better terms, I propose to call artistic and nonartistic influence. Friedlaender argues that the trip to Morocco (nonartistic influence)—which inspired Delacroix to such paintings as *Les Femmes d'Alger* (figure 4)—had a stronger influence on the art of Delacroix than Bonington (artistic influence) had.

The distinction between artistic and nonartistic influence may not be a sharp one—it is sharp only to the extent it is possible to draw a sharp line between art and nonart—but it may nevertheless be worth making. A few examples may illustrate the distinction and perhaps make it more clear. In his book on Florentine painting after the black death, Millard Meiss calls attention to the influence on art of a group

[18] Walter Friedlaender, *David to Delacroix*, Cambridge, Mass.: Harvard University Press, 1964, p. 116.

28

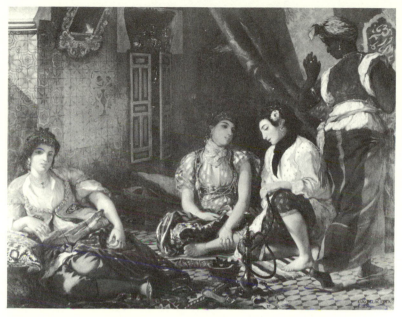

Figure 4.

of religious leaders such as St. Catherine, Giovanni dalle Celle, Colombini, Passavanti and their adherents:

> They communicated their ardor to a people that had already been made fervent by the trials and disasters of the time. We feel their influence in the spiritual intensity of contemporary painting, in its reversion, not without ambivalence and conflict, from the natural and human to the unnatural and divine.[19]

The religious leaders mentioned above had an influence on contemporary art, if Meiss is right; but they exerted this influence by their actions, preaching, and manner of living, and not by works of art of their own.

[19] Millard Meiss, *Painting in Florence and Siena after the Black Death*, Princeton: Princeton University Press, 1951 and Harper Torchbook, New York: Harper & Row, 1964, pp. 89–90 (the page references are to the latter edition).

What I have called "nonartistic influence" is not limited to influence from travels and religious leaders. It also includes influence from the social, political, intellectual, and moral milieu, and influence from childhood experiences, illnesses, love affairs, and so forth. Provided that a clear distinction can be drawn between literary and nonliterary books, influence from nonliterary books should also be counted as nonartistic influence.

Consider, for example, the following discussion of Vermeer's *Allegory of the Catholic Faith* (Metropolitan Museum of Art, New York):

> The invention for the representation of the allegorical figure is not Vermeer's. He followed instructions published by Cesare Ripa in his popular handbook *Iconologia*.[20]

I would be inclined to classify this influence from Ripa on Vermeer as nonartistic rather than artistic.

The following case is perhaps more problematic than the previous one. Charles Biederman is an American artist, who also writes theoretical books on art and on the principles of art. Biederman's *Art as the Evolution of Visual Knowledge*[21] is not a work of art, it is about works of art. Biederman has exerted influence on many other artists both through his structurist reliefs and through his book.[22] However, I shall only regard the former as artistic influence, though I am fully aware of the difficulties to distinguish between these two kinds of influences in practice.

In both cases above—Ripa and Biederman—the crucial questions are these:

(a) Do the books that are supposed to have had influence on a particular work of art contain any illustrations?

[20] J. Rosenberg, S. Slive, and E. H. Ter Kuile, *Dutch Art and Architecture, 1600–1800*, Harmondsworth: Pelican, 1966, p. 123.

[21] Red Wing, Minn.: Art History Publishers, 1948.

[22] Cf. Leif Sjöberg, "Biederman's Structurism: Its Influences," *Art International*, 1966, no. 10, pp. 33–35.

(b) Are these illustrations works of art, or can they be regarded as works of art?

(c) Is it the illustrations and not the text that had an influence on the creation of this particular work of art?

If all these questions are answered in the affirmative, we are dealing with an instance of artistic influence. But if one of them is answered with *no*, we are dealing with an instance of nonartistic influence.

According to the restriction of the values of the variables X and Y in the sentence "X influenced Y with respect to a" which were stated in the previous section, nonartistic influence will not be discussed in this book, and I shall therefore not go into details here. But I have mentioned these three examples in order to illustrate what has already been mentioned in the opening lines of chapter 1: that the creation of a work of art may be influenced by a number of factors, and that familiarity with works of other artists is only one of these factors. Exclusive concentration on artistic influence can therefore give a distorted picture of the process of artistic creation.

It should also be mentioned that it may sometimes be difficult to decide whether artistic or nonartistic influence is involved for other reasons than that the distinction between art and nonart is unclear. In his paper on the relations between Thomas Carlyle and Jean Paul Richter, J.W.S. Smeed at one place makes the following point:

> It is not easy to distinguish here between traits derived from Jean Paul himself and those derived from his characters, since his character drawing is highly subjective. We know that Sterling held Jean Paul himself to be the prototype of Teufelsdröckh and the opinion of one as close to Carlyle as Sterling still was in 1835 cannot be dismissed.[23]

[23] J.W.S. Smeed, "Thomas Carlyle and Jean Paul Richter," *CL*, XVI, 1964, pp. 232–33.

What Smeed writes here is, of course, quite compatible with the statement that there is a sharp distinction between art and nonart.

However, the distinction between artistic and nonartistic influence is not the only one worth making. If we limit our attention to artistic influence, it is clear that terms such as "influence," "inspiration," "impact," "impulse," "impression," and their cognates may be used to refer to a number of different concepts. Further distinctions are therefore necessary. In the rest of this section I propose to distinguish between direct and indirect influence and also between positive and negative influence.

1.3.2 Direct and Indirect Influence

In this book I shall concentrate on direct artistic influence, since many other kinds of artistic influence can be defined by this concept.

In his book *The Italian Followers of Caravaggio*, Alfred Moir writes as follows:

> Perhaps also during this decade, Caroselli began working in a second Caravaggesque style, derived from Honthorst rather than direct from Caravaggio.[24]

The concept of indirect influence which is hinted at in this quotation can be defined in terms of direct artistic influence in one of the following two ways.

First, it may be suggested that to say that a work of art X influenced another work of art Y indirectly means that there is at least one more work of art Z such that X directly influenced Z and that Z directly influenced Y. A slightly different definition would be as follows: to say that a work of art X indirectly influenced another work of art Y means that there is at least one person P such that X influenced P directly and that P influenced Y directly.

These two definitions can be made more precise in

[24] Alfred Moir, *The Italian Followers of Caravaggio*, Cambridge, Mass.: Harvard University Press, 1967, pp. 89–90.

a number of ways, and thus we can get a series of concepts of direct influence and a corresponding series of concepts of indirect influence. But before I go into a discussion of these problems, I would like to comment briefly on the relations between these two definitions. If the person P in the second definition is identical with the creator of the work of art Z in the first definition, these definitions might very well be equivalent and their relations to each other could in that case be illustrated by a diagram of the following kind:

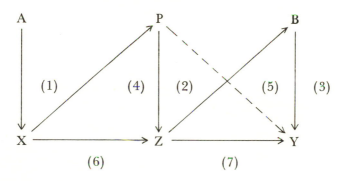

I shall now explain this diagram and then use it to clarify the relations between the two definitions of indirect influence.

The arrows (1), (2), and (3) stand for production-relations: A created X, P created Z, and B created Y. Moreover, P at some time saw or read X and became influenced by X (4), and this influence is discernible in Z. Later on, B saw or read Z and became influenced by it (5), and traces of this influence are discernible in Y. The arrows (6) and (7) stand for relations of influence between works of art, which, as I have suggested in section 1.2, may be defined in terms of the relations (4) and (2), and (5) and (3) respectively. Finally, the dotted arrow from P to Y may be defined in terms of the relations (2), (5), and (3).

Now, if P—as suggested by this diagram—is identical

with the creator of Z, and if P—as is also suggested by this diagram—influenced B by this work of art Z, then the two definitions of indirect influence outlined above are clearly equivalent, and in that case it is merely a matter of taste which definition one prefers. But the definitions need not be equivalent, and it is therefore important to make the relations between them explicit. Suppose, for example, that P is not identical with the creator of Z. In what way does this change the relations between the two definitions?

In that case, the definitions are obviously *not* equivalent; X can very well influence Y indirectly in the sense suggested by the second definition without influencing Y indirectly in the sense suggested by the first definition. The first definition is stronger than the second one in the sense that if X influenced Y indirectly according to the first definition, then it also influenced Y according to the second definition. But the converse does not hold: X may influence Y indirectly according to the second definition without influencing Y indirectly according to the first definition.

It is instructive to compare the diagram above with the following diagram, which illustrates the second definition in the case when P is not identical with the creator of Z:

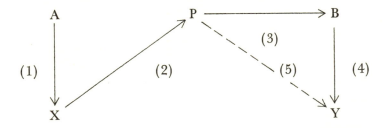

Here the arrows (1) and (4) stand for relations of production: A created X and B created Y. P saw or read X and was influenced by it (2). Later on, P met B and talked to him about art, or wrote a review of works of art created by B, or influenced him in some similar way (3). The dotted arrow (5) from P to Y can be defined in terms of the rela-

tions (3) and (4), for example, by saying that (3) was a necessary condition of (4).

I shall now make a number of comments on the two definitions suggested above. The basic idea in both definitions is that if the relation of indirect influence holds between any two entities, then there is one or more other entities which connect these two entities with each other in a chain of causal relations. This chain can of course contain a great number of links. The more links (artists or works of art) it contains, the weaker it becomes, at least in principle.

It is probably possible to construe such chains from the paintings of Altamira to those of Piet Mondrian, if we permit the chain to have a sufficient number of links. But we would, I suppose, hesitate to talk about indirect influence in such situations. It is, however, difficult to say how many links the chain from X to Y may contain if there is to be a causal connection of any kind between X and Y. The concept of indirect influence does not seem to be so clear that an unequivocal and noncontroversial decision of this kind is possible or desirable.

I would also like to stress the following point. It is taken for granted in the first definition that the influence from X to Z and from Z to Y concerns the same respect (color, expression, technique, and so forth). I did not make this assumption explicitly in my preliminary version of the definition in order to avoid complications and to be able to compare the two definitions more easily. Thus, if X influenced Y indirectly with respect to a, then there is a work of art Z such that X influenced Z directly with respect to a, and Z influenced Y directly with respect to a. I shall refer to this as the *standard version* of the first definition.

At this point, however, it should be acknowledged that it is also possible to define a concept of indirect influence without making this assumption; the requirement that the relevant works of art shall have influenced each other in the same respect is then dropped. In that way we get the following definition of the concept of indirect influence: to say

that X influenced Y indirectly is to say that there is at least one work of art Z such that X influenced Z in some respect a, and Z influenced Y in some respect b, and a and b are not identical. I shall refer to this as the *nonstandard version* of the first definition of indirect influence.

If the last clause in the nonstandard version of the first definition is replaced by "and a and b may or may not be identical," we get what I propose to call the *weak version* of the first definition of the concept of indirect influence. The standard version implies, but is not implied by, the weak version. This holds for the nonstandard version as well. That is why I have chosen to call this third version of the first definition the weak one. In what follows, when I refer to the first definition of the concept of indirect influence I shall always—unless I explicitly state otherwise—refer to the standard version.

The following quotation, taken from the investigation by Alfred Moir mentioned in the beginning of this subsection, illustrates the standard version of the first definition:

> Surely the sharp contrasts of light and dark on their figures, and the formal clarity which Briganti notes in their art, were distantly derivative from Caravaggio through his followers.[25]

In this case it seems quite clear that Moir assumes that the relevant works of art have influenced each other in the same respect: "sharp contrasts . . . and formal clarity."

It also seems reasonable to interpret the following two sentences from K. L. Goodwin's book *The Influence of Ezra Pound* in the same way:

> When Pound is separated from a poet whose work shows signs of influence, one can rarely be sure that the influence is not coming second-hand from one of Pound's followers.
>
> The likelihood of indirect or secondary influence is

[25] *Ibid.*, pp. 151–52.

borne out by the fact that Pound's influence was felt much more by important American poets than by important British ones.[26]

The second sentence is, however, open to other interpretations as well. Perhaps these lines can also be interpreted as illustrating the weak version of the first definition of the concept of indirect influence.

In the preface to his book on foreign influences on French literature, Philippe van Tieghem makes the following comment on the relative frequency of direct and indirect influences:

> D'ailleurs, les influences indirectes sont beaucoup plus fréquentes que les influences directes; on imite des imitateurs; on suit les Pétrarquistes italiens plus que Pétrarque lui-même; on croit connaître Spinoza parce qu'on a lu Bayle; on se nourrit de traductions tronquées et on croit imiter l'oeuvre originale.[27]

Here the use of "imite" and "imitateurs" suggests that van Tieghem has in mind something that comes very close to what I have called the standard version of the first definition.

This version is also suggested by the following quotation from Golding's history of cubism:

> Superficially this painting [*Eiffel Tower*] has something in common with certain Cubist landscapes by Picasso and Braque, . . . and it seems likely that in these paintings Delauny had again been directly influenced by what he saw at Kahnweiler's gallery.[28]

However, it need not be stressed that the direct influence Golding discusses here has nothing to do with the notion of directly visible influence he discusses a few pages ahead in his book: even if the influence from X is directly visible in

[26] Goodwin, *The Influence of Ezra Pound*, pp. 143–44.
[27] van Tieghem, *Influences étrangères*, p. 5.
[28] Golding, *Cubism*, p. 155.

Y, *X* need, of course, not have influenced *Y* directly; and even if *X* influenced *Y* directly, this influence need not be directly visible.

In this context it should be stressed that direct and indirect influence need not, of course, exclude each other. A work of art—or a novel—*X* can influence the creation of another work of art *Y* both directly and indirectly at the same time:

Moreover, *X* can influence *Y* directly and indirectly in the same or in different respects.

The former alternative can be illustrated by the following example. In his book *The Influence of D. H. Lawrence on Tennessee Williams*, Norman J. Fedder makes the following point:

> His characteristic themes and forms established in these early works directly influenced by Lawrence, Williams has continued to write material the bulk of which, as a result of conscious effort or indirect influence, bears a striking resemblance to certain of Lawrence's poems, stories, and novels.[29]

This quotation can be understood in several ways.

The argument in the quotation turns on the distinction between direct and indirect influence. Now it is not quite clear how these key expressions are to be interpreted here. But it could be argued that Fedder uses "indirect influence"

[29] Norman J. Fedder, *The Influence of D. H. Lawrence on Tennessee Williams*, The Hague: Mouton, 1966, p. 12.

in a way that is different from the ones defined above. Perhaps he means to say that X influenced Y indirectly, if and only if X influenced Y, and it was a long time ago since the person who created Y saw or read X. However, this does not seem to be a very fortunate usage; and it might also be argued that it is reasonable to interpret the quotation above as saying that the works by D. H. Lawrence have influenced the works by Tennessee Williams in the same respects both directly and indirectly in some of the senses outlined above.

The latter alternative can be illustrated by the following somewhat more complicated example. In his book *De cultu et amore dei. Studier i Swedenborgs skapelsedrama*,[30] Inge Jonsson has argued against Martin Lamm that Swedenborg's transformation of the Narcissus myth is independent of Milton and only influenced by Ovid's version of this myth. Jonsson's thesis can be illustrated by a diagram of the following kind:

Needless to say, this figure only summarizes the basic idea of Jonsson's thesis; it does not do justice to his learned and complex reasoning.

However, Louise Vinge in her recent book, *The Narcissus Theme in Western European Literature up to the Early 19th Century*,[31] has defended and to some extent modified

[30] Inge Jonsson, *Swedenborgs skapelsedrama De Cultu et Amore Dei*, Stockholm: Natur och Kultur, 1961.

[31] Louise Vinge, *The Narcissus Theme in Western European Literature up to the Early 19th Century*, Lund: Gleerups, 1967, pp. 290–91.

Lamm's thesis that Swedenborg was influenced by Milton. Her main reasons are the following ones. Swedenborg's transformation of the myth is similar to that of Milton's on a number of specific points, and—which is even more important—these similarities are unique in the sense that the specific features of the transformations by Milton and Swedenborg do not appear elsewhere in the history of the myth or in this genre.

For example, both Milton and Swedenborg have inserted their versions of the myth in the biblical story about Genesis, and in both cases it is Eve who before meeting Adam sees her picture reflected in water. On the other hand, Swedenborg's version also has features which are similar to Ovid's version but not to that of Milton. Vinge's conclusion is that Swedenborg got the idea for the episode from Milton but that he was also influenced by Ovid, since there are striking similarities in some respects between the versions of Ovid and Swedenborg.

Her thesis can then be illustrated by the following figure, where the letters a, b, c indicate the respect in which influence took place:

If I understand it correctly, Vinge's thesis presupposes that a is not identical with c, and that b is not identical with c.

Thus, if this is correct, Ovid influenced Swedenborg directly in some respects and indirectly in others. Moreover, Ovid influenced Swedenborg indirectly in the sense indicated by the nonstandard version of the first definition of the concept of indirect influence. Vinge's main argument against Jonsson is, as I pointed out above, that the specific

features of Milton's and Swedenborg's transformations do not appear elsewhere in the history of the myth. In this respect they both differ from Ovid; thus, *b* and *c* cannot be identical. Accordingly, the requirement of the nonstandard version is satisfied.

The pattern illustrated above in the Ovid-Milton-Swedenborg case is far from unusual. It could be illustrated by many other examples, particularly if *X* is a classic literary work.[32] It seems reasonable enough to suppose that writers often become acquainted with classic works first via various secondary sources (other works influenced by it, summaries, adaptions, and paraphrases). Then they might read the original and make discoveries of their own, which are mixed and fused with whatever they have earlier assimilated of the classic work.

In this subsection I have distinguished between two definitions of indirect influence, which are not always equivalent. I have also distinguished between three nonequivalent versions of the first of these definitions. So far, I have assumed that the concept of direct influence—which I have used in defining all these different kinds of indirect influence—was fairly clear and unproblematic. But is this so? Clearly, if there are several different kinds of direct influence, then to each of them corresponds a series of definitions of indirect influence of the kind I have outlined here.

It may, for example, be suggested that when *X* directly influences *Y*, the causal connection can be of different kinds and strengths. Moreover, it may be argued that the influence can be more or less interesting from a normative or aesthetic point of view, and that these differences are important. (The influence from one artist to another may help the other artist to create an original style of his own. But if

[32] See, for instance, J. T. Shaw, "Byron, the Byronic Tradition of the Romantic Verse Tale in Russian, and Lermontov's *Mtsyri*," *Indiana Slavic Studies*, I, 1956, pp. 165–90; *idem*, "Lermontov's *Demon* and the Byronic Verse Tale," *Indiana Slavic Studies*, II, 1958, pp. 163–80; and Göran Bornäs, "Le Cocu battu et content. Étude sur un conte de La Fontaine," *Studia Neophilologica*, XLIV, 1972, pp. 37–61.

the other artist is an epigon, the situation is quite different.) I would be inclined to agree with these suggestions, and I shall discuss to what extent they are true in the remaining sections of this chapter. Thus the distinction between direct and indirect influence outlined here is rather crude.

1.3.3. *Positive and Negative Influence*.

In addition to the distinctions between direct and indirect influence, I would like to distinguish between positive and negative influence. This distinction can be stated in a preliminary way as follows.

If a visual or literary work of art X had a positive influence on the creation of another visual or literary work of art Y, then X has, metaphorically speaking, been an attracting factor; the creator of Y saw or read X and this contact with X caused him—in a sense to be specified shortly—to make a work which in certain respects is similar to X. For example, he may have used the same technique, composition, style, symbols, motifs, and so forth. In many and perhaps most cases when scholars discuss artistic and literary influence, they are concerned with what I here propose to call "positive influence."

But if X had a negative influence on the creation of Y, then X has, metaphorically speaking, been a repelling factor; the creator of Y saw or read X and reacted against it, and this contact with X caused him to make a work which in certain respects is markedly different from X. If X influenced Y negatively, then Y was created as a protest against X. We can therefore expect Y to be the antithesis of X in a number of respects; in this sense X and Y are systematically different.

For example, if the influence concerns ideas, one author can deny what the other asserts. If A and B are artists, and if A represents an event in one way in X, and if B is negatively influenced by this work, then B may represent the same event in a quite different way, which is incompatible with the way A has represented it. If A and B are playwrights, and if B is negatively influenced by, say, the moral

of A's play X, he may write a play Y suggesting a different moral. To make sure that the beholders shall not miss his intention—that is, who and what the target of his polemic is—B may allude to X in the title of his play or in some key dialogues.

This way of drawing the distinction seems to fit in well with the way Anna Balakian used the distinction in her well-known paper on the difference between studies of literary influence and reception:

> It is interesting to note that very often the influences of authors of the same nationality and language upon each other are negative influences, the result of reactions, for generations often tend to be rivals of each other and in the name of individualism reject in the work of their elders what they consider to be the conventions of the past. On the contrary, the education of a writer can be dramatically shaped by foreign authors, first because there is no longer a question of rivalry, and particularly as the reading of foreign literature is done generally at a more mature age when one may be more aware of the needs for models and direction.[33]

It may be doubted, however, that the distinction between positive and negative influence is generally tied to the distinction between domestic and foreign authors, particularly in our international age when authors travel extensively and more translations than ever before are published. Moreover, negative influence can occur also in the visual arts and in music, and there the distinction between domestic and foreign artists seems quite unimportant in this context.

The distinction between positive and negative influence outlined above can be illustrated by the following three quotations. The first one is taken from Örjan Lindberger's article "Pär Lagerkvists bön på Akropolis," where Lindberger compares Renan's *Prière sur l'Acropole* and Lagerkvist's *Västerlandets heliga berg*:

[33] Anna Balakian, "Influence and Literary Fortune: The Equivocal Junction of Two Methods," *YCGL*, 1962, p. 29.

43

There is only one point on which it is possible to assume
a positive influence from Renan. . . . But even on this
point one has to realize that the influence from Renan is
of limited importance. Lagerkvist's confession and al-
legiance to rational thought is in the first place a reaction
to the antiintellectualism of nazism.[34]

In this quotation Lindberger states two theses about influ-
ence: (a) there is a strong and extensive negative influence
from the antiintellectualism of nazism ("in the first place a
reaction against"); and (b) there is a limited positive influ-
ence from Renan's *Prière sur l'Acropole*.

It should be observed that the positive influence Lind-
berger is referring to in the first thesis is an example of what
I have called "nonartistic influence," whereas the negative
influence mentioned in the last thesis is an example of what
I have called "artistic influence." The relations between the
distinctions between positive and negative influence on the
one hand and artistic and nonartistic influence on the other
can be illustrated by the following diagram:

	Artistic influence	Nonartistic influence
Positive influence		
Negative influence		

The example above shows that these pairs of distinctions
are independent of each other. The problems of verifica-
tion will probably be quite different, depending on whether
artistic or nonartistic influence is concerned.

[34] Örjan Lindberger, "Pär Lagerkvists bön på Akropolis," *Samlaren*,
LXXXI, 1960, p. 28. My translation. The original Swedish text reads
as follows: Det finns egentligen bara en punkt i Lagerkvists fram-
ställning där man kan förutsätta ett positivt inflytande från Renan.
. . . Men även på denna punkt måste man räkna med att inflytandet
från Renan är av begränsad betydelse. Lagerkvists bekännelse till
tanken är i främsta rummet en reaktion mot nazismens antiintellek-
tualism.

44

The second example is a quotation from Sten Malmström's dissertation on the style in Stagnelius' poetry.

It should have been Atterbom's example which inspired Stagnelius to evoke sentimentally the picture of his own funeral procession in distich form; . . . Stagnelius' words give the *negated counterpicture* to a few lines in the following quotation from Atterbom ("Jungfrur skynda sig fram . . ."); Stagnelius seems to have seen his own fate in opposition to Atterbom's fantasy in elegiac contrast that is characteristic to him. . . . "Ingen tärna med fladdrande hår i det luftiga fenstret/ Sitter och blickar med gråt . . ." —this can in the present context be taken as a *negated reflex* of Atterbom's image of the sister of the deceased who is sitting in a window and looking at the funeral procession.[35]

Malmström here notes a number of systematic differences between Atterbom's and Stagnelius' poetic descriptions of the funeral; the terms "negated counterpicture" and "negated reflex" indicate that Malmström means to say that Stagnelius was negatively influenced by Atterbom.

Instead of talking about systematic differences between Atterbom and Stagnelius, as I am doing here, some scholars might be inclined to prefer expressions like "antithetical similarities"[36] (which at first sounds like a *contradictio in*

[35] Sten Malmström, *Studier över stilen i Stagnelius lyrik*, Stockholm: Svenska Bokförlaget/Bonniers, 1961, pp. 287–88. My italics and translation. The original Swedish text reads as follows: Det bör ha varit Atterboms exempel som inspirerade Stagnelius att i distikonform sentimentalt framkalla bilden av sin egen likprocession; . . . Stagnelius ord ger den *negerade motbilden* till ett par rader i Atterbomcitatet ("Jungfrur skynda sig fram . . ."); Stagnelius tycks med en för honom karakteristisk elegisk kontrastering ha sett sitt öde i motsättning till Atterboms fantasi. . . . "Ingen tärna med fladdrande hår i det luftiga fenstret/Sitter och blickar med gråt . . ."—det synes likaledes i detta sammanhang kunna vara en *negerad reflex* av Atterboms bild av den dödes syster som i fönstret blickar efter begravningsföljet.

[36] This term was suggested to me by my colleague Magnus von Platen in a discussion at his seminar.

adiecto), since there are similarities between the two au-
thors—they deal with the same topic, they discuss it from
the same aspects, they can be compared to each other on a
number of specific points—and since what one author says
on these points is the antithesis of what the other says
(young maidens hasten to step forward vs. no young maid-
ens hasten to step forward; the sister of the deceased is sit-
ting in the window, looking at the funeral procession with
tears in her eyes vs. no young woman is sitting in the win-
dow, looking at the funeral procession with tears in her
eyes). But whatever terminology is preferred, it is impor-
tant to be clear as to what is involved in talking about nega-
tive influence; and I think that this quotation from Malm-
ström illustrates this kind of influence in an instructive way.

The third and last example to be discussed in this sub-
section is taken from Nils Gösta Sandblad's book, *Manet.
Three Studies in Artistic Conception*. In one place the au-
thor compares Goya's painting of the executions on May 3,
1808, in Madrid (figure 5) with the Boston version of
Manet's *The Death of Maximilian* (figure 6), and he argues
as follows:

> Indeed, it [Goya's painting] played a part in the creative
> process, sometimes as an attracting, sometimes as a repel-
> lent force.[37]

This quotation can be understood as saying or implying
either (a) that Goya's painting has had a positive influence
on some of the five known versions of Manet's painting and
a negative influence on some of the other versions of this
painting, or (b) that Goya's painting had a positive influ-
ence on some versions in some respects and a negative in-
fluence on the same versions in other respects.

The distinction between positive and negative influence
could perhaps be clarified by considering the following ob-
jection to my way of drawing this distinction. Suppose that

[37] Nils Gösta Sandblad, *Manet. Three Studies in Artistic Conception*,
Lund: Gleerups, 1954, p. 122.

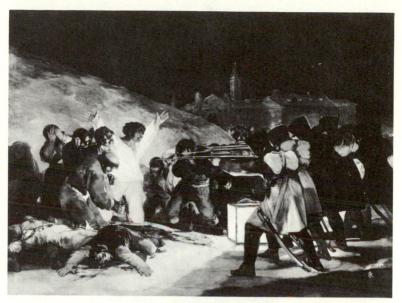

Figure 5.

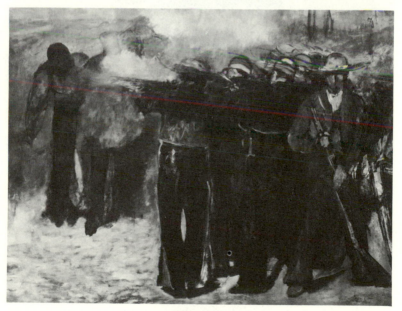

Figure 6.

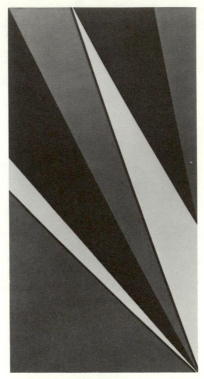

Figure 7.

a contemporary artist like Baertling, who paints in the style exemplified by figure 7, happens to visit an exhibition of paintings by a not very gifted Baertling epigon. Baertling strongly dislikes the paintings he sees; he leaves the exhibition upset and angry, and he walks home and makes some paintings in protest against the paintings of this epigon.

In that case it could probably be said that Baertling was influenced negatively, at least in some respects, by the paintings he saw at the exhibition. Yet the paintings by Baertling and this epigon need not be very different from each other: both would consist of triangles in strong colors and both would probably be classified by most beholders as belonging to the same style. Some people might not even be able to see any difference between these paintings.

Superficially, the paintings would be similar, in spite of the fact that Baertling was influenced negatively by the other artist; but a trained and sophisticated critic would no doubt note a number of important systematic differences or "antithetical similarities" between the paintings. Thus it is important to distinguish between the statements "there are systematic differences between X and Y" and "A notes that there are systematic differences between X and Y." The former statement does not imply the latter, and thus one cannot draw any conclusions from, say, the falsity of the latter to the falsity of the former.

Moreover, this example demonstrates that there is no fixed number or strength of similarities involved in positive influence. Nor is there any corresponding fixed standard for the number and strength of systematic differences involved in negative influence. Perhaps this makes the distinction appear elusive. But it does not show that there is no distinction to be made. At this point it would be dangerous to ask for a greater degree of precision that the subject allows.

1.3.4 *Concluding Remarks*

The distinction between positive and negative influence can be combined with the distinctions between direct and indirect influence in the way indicated by the following diagram:

Influence	Positive	Negative
Direct		
Indirect		

In what follows I shall confine myself to investigate direct positive influence, unless I explicitly state otherwise. When "influence" is used in the rest of this book without a

49

qualifying adjective, I am always referring to direct positive influence.

1.4 FURTHER DISTINCTIONS

In this section I will introduce a number of further distinctions by means of some examples, in order to be able to isolate a concept of artistic influence that in my view is particularly interesting and worthy of close examination.

Consider now the works reproduced in figures 8 through 11. These works of art are fairly similar to each other. If we did not know anything about them, we would have to admit that a great number of relations could hold between them. The important point here is that we cannot tell exactly which of these relations the three works of art have to each other merely by looking at them and considering the similarities between them. Is X a sketch of Y? Or a copy of Y? Or is X influenced by Y? Or is there no causal relation at all between them?

In what follows I shall use words like "sketch," "copy," "borrowing," "source," "paraphrase," and "model" to refer to some of the relations that could hold between these three works of art, and I want to distinguish all these relations from influence in the narrow sense in which I am particularly interested. It should be made clear that all these words are used in slightly different ways by different scholars, and I do not claim to describe the usage of any particular group of writers.

Such descriptions are important and interesting in their own right. But it is more important in the present context to clarify certain distinctions which are made implicitly in writings on art and literature, and to construct a family of related but different concepts which are useful in discussions and analyses of relations between works of art. Most of the distinctions I am going to make in this section are observed by art historians and literary scholars, but what I shall say will probably sharpen these distinctions.

Finally, I would like to add that the present survey makes no claim of completeness. I shall concentrate on distinctions made in art historical writings, but related distinctions are made in literary scholarship as well. Moreover, if X is a translation of Y, then it could be said that there is some kind of causal connection between X and Y. But clearly Y has not influenced X artistically in any interesting sense. There are also paraphrases, parodies, and travesties in literature, but they do not constitute instances of artistic influence of the kind I am interested in here.

1.4.1 *Parallels*

The word "parallel" will in this book be used to refer to the well-known phenomenon that two or more works of art are very similar to each other, though there is no causal connection (direct or indirect influence) between them. Thus, if X is *parallel* to Y in this strict sense, then (a) X and Y are created by different persons, (b) X and Y are fairly similar to each other, (c) X and Y are not causally connected, and (d) X and Y may, but need not, be created at the same time.

Conspicuous examples of such parallels are found in heroic poetry, i.e., narrative epic songs and poems, by different people. As V. M. Zhirmunsky has pointed out, the typological analogies between the heroic epics of different people are not confined to motives and plots:

They are deeper and more general, and they include the whole complex of internal and external features characteristic of epic poetry as of a particular stage of cultural and literary development: the ideological substance of the epic narrative and its structure as a poetic genre; its typical figures and situations; its traditional style (formulas, fixed epithets, epic repetitions of various kinds); the successive forms in the evolution of genre (formation of biographical and genealogical cycles, development from a short song to a long poem, and from oral to written literary forms); and last but not least—the social status of

51

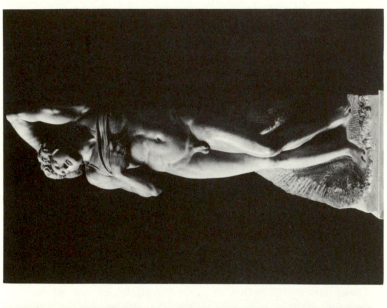

Figure 9.

Figure 8.

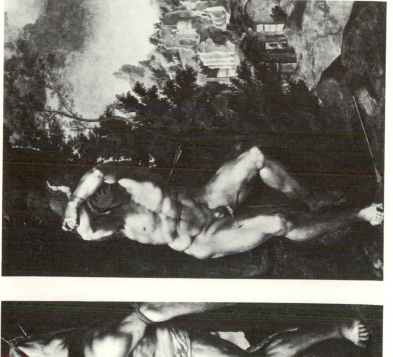

Figure 10.

Figure 11.

epic minstrelsy, the singer and his audience (folk-singers and singers at princely courts), the character of oral song with its interaction of tradition and improvisation with partial re-creation of the text within the bounds of a collective poetic heritage.[38]

In his paper, Zhirmunsky illustrates such parallels with several examples. One of them is a comparison between the Persian poems of the Azerbaidzhan poet Nizami (c. 1140–1203) and the metrical romances of his contemporary, Chrétien de Troyes. He concludes as follows:

A comparison of the metrical romances of Chrétien and Nizami, reveals similar features of a new literary genre, and at the same time of a specific cultural epoch, which are quite independent of any direct "influence" or "borrowing." The widespread popularity of this genre both in the East and in the West testifies to the fact that it had become a poetic incarnation of the new ideology of feudal society at an advanced stage in its development, and an idealized reflexion of similar social conditions which, incidentally, were more advanced at that time in the East than they were in the West.[39]

Zhirmunsky discusses several other instructive examples, but there is no need of going into all of them here. One of the most intriguing methodological problems facing scholars in art and literature is to decide when two similar innovations at different places are parallel in the sense discussed here or are due to some kind of influence; these problems will be dealt with at some length in chapter 2.

1.4.2 Sketches

Unfortunately, the word "sketch" can be used in slightly different senses. If an artist visits a museum, he can make

[38] V. M. Zhirmunsky, "On the Study of Comparative Literature," *Oxford Slavonic Papers*, XIII, 1967, p. 4. On heroic poetry, see the more detailed exposition in C. M. Bowra, *Heroic Poetry*, London: MacMillan, 1952; and H. M. and N. K. Chadwick, *The Growth of Literature*, 3 vols., Cambridge: Cambridge University Press, 1932-1940.

[39] *Ibid.*, p. 5.

sketches of some of the masterpieces on the wall as an exercize or in order to remember them better. Here "sketch" is used in a sense that comes close to "depict," and when I need to talk about "sketch" in this sense only, I will use a subscript and write "sketch$_D$" (where "D" is short for "depict"). Manet's oil sketch of Titian's *Venus from Urbino* (*c.* 1538, Uffizi, Florence) is a sketch of this kind.[40]

But such sketches should be distinguished from figures 8 and 12. Oldenburg's drawing (now at Arkivmuséet, Lund, Sweden) is a sketch of a monument that was never made, and perhaps was never seriously meant to be made. But Michelangelo's wax model is a sketch of one of his marble sculptures. In the previous two sentences, the word "sketch" is used in the sense of "outline," and when I need to talk about "sketch" in this sense only, I will use another subscript and write "sketch$_O$" (where "O" is short for "outline").

Thus, if X is a *sketch$_O$* of Y, then (a) X and Y are created by the same artist, (b) X and Y are fairly similar to each other, (c) X and Y are not causally connected in the sense that Y is a necessary condition of X, and (d) X was created before Y. An artist may several times in his life return to motifs of the same kind, and this does not necessarily turn his earlier paintings of these motifs into sketches of the later ones. This shows that (a) through (d) are necessary but not sufficient conditions, and that they should be supplemented by statements like: (e) X is more unfinished than the original Y, (f) X is smaller than Y, (g) X is made of less expensive material than Y, and (h) statements about the intentions of the artist. This analysis is made with examples like Michelangelo's wax model in mind. Sketches like Oldenburg's drawing (figure 12) will obviously have to be analyzed in a somewhat different way.

In many cases the sketches of works of art have been pre-

[40] The artistic *oeuvres* of Leonardo da Vinci, Paul Peter Rubens, Eugène Delacroix and many others contain numerous examples of this kind of sketch. For an analysis of depiction, see my *Representation and Meaning*, chapter 2.

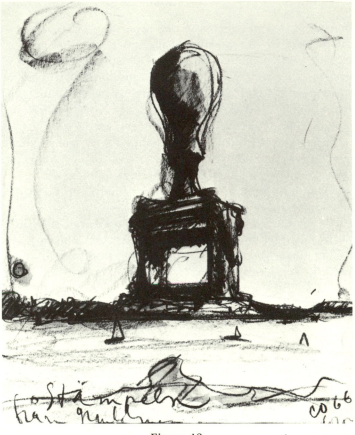

Figure 12.

served, and it is fascinating to follow the transformations of the motifs. I am now thinking of material of the kind collected in books by Ragnar Josephson and Rudolf Arnheim; the genetic approach to the study of art has given many interesting results.[41] It is obvious that the number and extent of the similarities between a sketch and the corresponding original can vary considerably, as an inspection of a few instances chosen at random will show.

[41] Rudolf Arnheim, *Picasso's Guernica. The Genesis of a Painting*, Berkeley & Los Angeles: University of California Press, 1962; and Josephson, *Konstverkets födelse*.

Figure 13.

In the Victoria and Albert Museum, London, there are two sketches (figures 13 and 14) of John Constable's *Valley Farm* (figure 15), now in the Tate Gallery, London. The similarities between these three works are quite obvious and need not be pointed out here, but there are also important differences between them. The sketches are made in a much more impressionistic manner than the final version: the foliage of the trees is just outlined in the sketches, and there are no windows on the house. The clouds are more articulated in the final version than in the sketches, and so are the branches of the trees.

However, the most conspicuous difference between the

Figure 14.

three paintings, apart from the darkness of the original
(which may be due to the reproduction), is the difference
between the number of persons in the boat and their pos-
tures. Constable has combined the persons represented in
the sketches, with changes, in the final version. Moreover,
he has added the foreground to the left in the final version;
it is not in the sketches. He has also added birds in the
background, cows in the river, a chimney to the house, and
numerous other details.

Turning to a brief comparison between two paintings by
Theodore Gericault, I will now comment on his *The Raft
of Medusa* (figure 16) and a sketch of this painting (figure

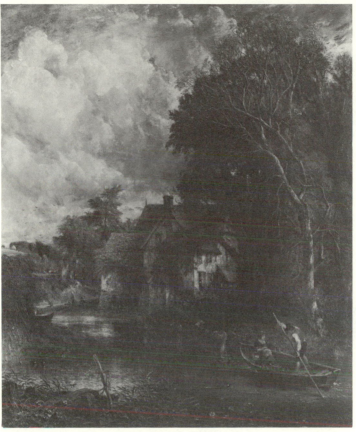

Figure 15.

17). The similarities between the paintings are again obviously enough, but there are also some striking differences. Among other things, in the sketch one misses the body which has been thrown overboard in the right foreground and the dying man on the edge of the raft to the left. The colors and the technique are also different in the two paintings; some critics think that the sketch is better than the original.

A closer look at these two paintings reveals a number of other differences between them. For example, the ship in

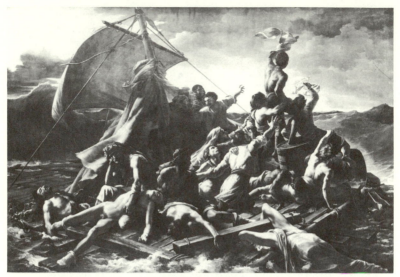

Figure 16.

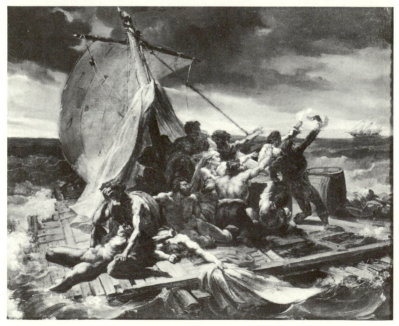

Figure 17.

the right background of the sketch has been transformed into a wave. The darkest part of the sky in the upper left corner of the sketch has been changed into the brightest part of the sky in the final version. The big wave to the left in the original is missing in the sketch, and the water around the raft is different in the two paintings. The bodies and faces of the people on the raft are treated in a much more impressionistic manner in the sketch than in the original. Moreover, beards have been taken away, persons have been added, and postures have been changed.

However, the most conspicuous difference between the sketch and the original is probably that the artist in the latter has added a man with naked back, who sits on the shoulders of his comrades waving at a small ship or lighthouse far away, which incidentally is also missing in the sketch. Besides, the waving persons on the raft are looking at the lighthouse close to the center of the horizon in the original, whereas in the sketch they are looking at the ship to the right on the horizon.

There is no need to go into details here, but it may be interesting to ask why the artist made all these changes. The answer must remain a conjecture, but it can be pointed out that there is a certain consistency or logic in these changes. In the sketch, the dominant line of the mast is counteracted by the edge of the raft in the foreground of the painting, and the tensions between these two lines help to create balance in the composition. In the original, however, the relation of the raft to the frame of the painting is different; and as a result the edge of the raft does not counteract the dominant line of the mast.

In order to balance the composition in the original, the artist has added the figure with the naked back to the right; he has added the left shroud; he has added a piece of timber in the center of the foreground; he has added a dying man to the left; he has made the raft darker and by a skillful use of light and dark he has stressed a diagonal from the man to the left on the raft to the waving man on the right.

61

This diagonal restores the balance of the painting. I do not say that the artist made all these changes consciously with this aim in mind, but the changes all make sense if viewed in this light.

Now let us suppose that we did not know that these two paintings were made by the same artist, or rather that we knew that they were made by different artists. Then it would have been very tempting indeed to suggest that one of them was a sketch$_D$ of the other, or that one of them was influenced by the other. The similarities are so many and so detailed that it is extremely unlikely that the works in that case would be parallels in the sense explained above.

The observations above suggest the following general point: our knowledge and expectations determine what similarities (or differences) we notice and, in particular, what weight we give to them. If we know that X is a copy of Y, or that X is a sketch of Y, then we expect them to be very similar and are likely to notice even rather small differences and to focus our attention on them. If, however, we know that X and Y are made by different artists, then we will not expect them to be very similar and are likely to notice rather faint similarities and to focus our attention on them. If the works in figures 16 and 17 were created by different artists, the similarities would be overwhelming and we would probably tend to disregard the differences.

1.4.3 *Copies*

If X is a copy of Y, then there is a high degree of similarity in all respects between X and Y; in some cases it may even be difficult to distinguish between the copy and the original. This does not, however, prevent copies from having, in many cases, distinctive features of their own by which they differ from the original, especially if the painter who made the copy is a great artist. I am now thinking of, for example, Peter Paul Rubens' and Ernst Josephson's copies of paintings by Titian.

Thus, if X is a *copy* of Y, then (a) X and Y need not be, and usually are not, created by the same artist, (b) X and Y are fairly similar to each other, (c) X and Y are causally connected in the sense that Y is a necessary condition for the creation of X, and (d) X was not created before Y. If Y is a painting, then it is sometimes the case that X is smaller than Y, but it is not the case that X is more unfinished than Y or that X is made of less expensive material than Y.

Copies are more interesting than is commonly thought. Compare, for instance, Titian's *Bachanal with the Sleeping Ariadne* (figure 18), with Peter Paul Rubens' copy of this painting at the National Museum, Stockholm (figure 19). At first glance the paintings appear very similar to each other, but a closer inspection reveals a number of interesting differences between them, quite apart from the fact that Rubens has painted his copy in his own characteristic style.

The foliage to the left in Titian's painting is much denser than in the painting by Rubens. The man in the right background appears to be sleeping in Titian's painting, but not in Rubens', and he is closer to the spectator in the former than in the latter. In the Titian there is one big ship at sea, but in the Rubens there are two small ships. The letter in the center foreground of Titian's painting is missing in the painting by Rubens, and so is the blue mountain in the background of the Titian painting. The clouds in the two paintings are different, as are the cloth on the right leg of the man to the left and the bird in the tree at the center. In the left foreground Rubens has added some flowers.

Rubens has treated the woman in the lower right corner differently from the way she had been treated by Titian. The cloth on her left arm is more distinctly articulated in Titian's painting, and her mouth is different in the two pictures. When one looks at the woman in the lower right corner in Titian's picture, one sees a sleeping woman. The same woman in Rubens' painting gives the impression that she is sleeping because she has drunk too much wine; her

63

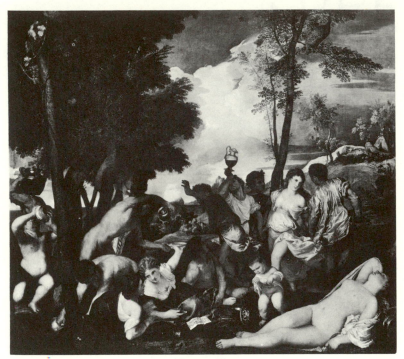

Figure 18.

mouth is open, and one can almost hear her snoring. The most conspicuous difference between the two women is, however, that Rubens in the name of decency has felt himself obliged to place some flowers in the left hand of the sleeping woman in order to cover part of her body. Morals in Titian's Venice apparently permitted more than they did north of the Alps at this time.

It is probably unnecessary to stress that the number and the extent of the similarities between the original and the copy may vary considerably. The copy of Bellini's *The Feast of the Gods* (National Gallery, Washington) attributed to Poussin (National Galleries of Scotland, Edinburgh) has a striking resemblance to the original, as a comparison between figures 20 and 21 shows. But it is not difficult to

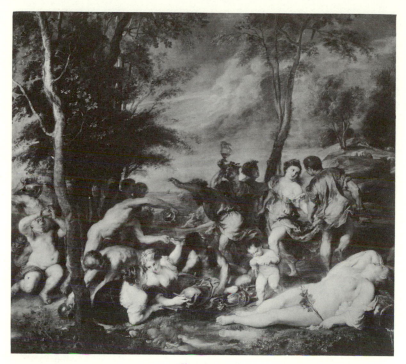

Figure 19.

find examples where the differences between copy and
original are as conspicuous as the similarities.[42]

In his book *Bild und Abbild*, K. E. Maison has repro-
duced a painting by Titian known under various titles,
among others *Painting of a Bride* or *Lavinia in Bride Dress*
(*c.* 1555, Gemäldegallerie, Dresden), along with a copy by
Rubens (*c.* 1604–1605, now in Vienna).[43] He mentions that
according to some art historians Rubens' copy is not made

[42] For interesting examples, see Stephan Poglayen-Neuwall, "Titian's
Pictures of the Toilet of Venus and Their Copies," *AB*, 1934, pp.
358–84, which is a sequel to his earlier article "Eine tizianeske Toilette
der Venus aus dem Cranach-Kreis," *Münchener Jahrbuch der Bilden-
den Kunst*, N.F., VI, 1929, pp. 167–99.

[43] K. E. Maison, *Bild und Abbild*, München & Zürich: Droemersche
Verlagsanstalt, 1960, figures 83–84.

Figure 20.

after the Dresden original, but after a copy of the Dresden
picture.[44] This raises some interesting problems. If X is
parallel to Y, then clearly Y is also parallel to X. It is equally
clear that if X is a copy of Y, then Y is not a copy of X. But
suppose that X is a copy of Y, and Y is a copy of Z. Is X then
a copy of Z?

At first one is probably inclined to answer in the affirma-
tive, but I shall argue that X is not a copy of Z in this case,
although some qualifications have to be made. The reason
for this is as follows: to decide whether or not X is a copy
of Y, we have to find out whether or not X was made after
Y, among other things. If X was made after Y, and the per-
son who made X intended it to be a replica of Y, then it is
a copy of Y; and it does not matter if there is another work

[44] *Ibid.*, p. 216.

66

Figure 21.

Z which X happens to resemble equally or even more than it resembles Y.

However, suppose that X was made after Y (which is a copy of Z) but that the person who made X was familiar with Z and wanted to make a copy of it. Suppose also that Z was inaccessible to him for some reason or other. So he had to make his painting copying Y. Furthermore, the artist knows that the copy Y deviates from the original in some ways, and in painting X he tries to make it look more like the original. Is X in this case a copy of Y or of Z? This might be a more difficult question to answer, but I would still be inclined to say that X is a copy of Y, although the artist deliberately changed it in some respects in order to make X more similar to Z.

But how is this question to be answered, if there are strik-ing differences between Y and Z, and the artist who made X used a photograph of Z in addition to Y? Can X be a copy of both pictures at the same time? Or, in such a case, when should we say that X is a picture of Z but not of Y? There does not seem to me to be any clear answer to these questions.

1.4.4 *Paraphrases*

If X is a paraphrase of Y, then (a) X and Y need not be, and usually are not, created by the same artist, (b) X and Y are fairly similar to each other, though not so similar as a copy to an original, (c) X and Y are causally connected in the sense that Y is a necessary condition of the creation of X, and (d) X was not created before Y.

Thus the notion of paraphrase appears to be closely re-lated to that of copy, and yet these notions are clearly dis-tinct. The chief difference is evident from clause (b) above; a paraphrase is much more an independent work of art than a copy is. If X is a paraphrase of Y, then the artist who cre-ated X used Y as a point of departure for his work. He may have rearranged the motifs of Y, changed the colors and the composition of Y, and so forth. Thus, he has created some-thing reminiscent of Y in his own personal style.

It should be stressed that in this case the artist does not intend to create a work which in any particular respect is strikingly similar to the original. On the contrary, the orig-inal serves in the first place as a stimulus for the imagina-tion of the artist; a paraphrase can be very free in relation to the work of art of which it is a paraphrase, and it can sometimes be difficult to see what a paraphrase is a para-phrase of.

A glance at a few examples will bring this out clearly. Picasso has made a famous series of paraphrases of works of other artists, including *Les Femmes d'Alger* by Delacroix (figure 4). Comparing his paraphrase of *Las Meninas* by Velázquez (figure 22) with the original (figure 23), it is easy

68

Figure 22.

to recognize the structure of the original in Picasso's painting, though all the details are changed and the picture is painted in Picasso's characteristic style. Sometimes Picasso has simplified the forms of the original. This is especially striking in the right part of the painting, for instance, in the dog and the figure, which are merely outlined by contours. But other parts of the picture are more complex than in the original, particularly the canvas and the painter to the left, where Picasso has dissolved the forms in Cubist manner and also made the painter much taller than he is in the original. The final version of Picasso's paraphrase is in this case based on hundreds of drawings and more than eighty sketches in oil.

Another example is Francis Bacon's paraphrase (figure 24) of the portrait of Pope Innocent X (figure 25) by Diego Velázquez. Bacon has changed the picture considerably; his treatment of the clothes and the face of the pope is far less detailed than that of Velazquez. Yet it is sufficiently de-

69

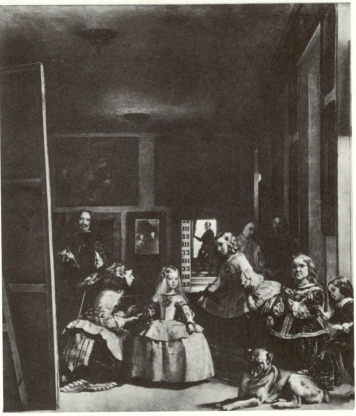

Figure 23.

tailed to make it possible to see that his painting is a para-
phrase of Velázquez's portrait rather than of, say, Raphael's
drawing of Pope Julius II (figure 26), or Raphael's portrait
of Pope Julius II (*c.* 1511–12, Palazzo Pitti, Florence), or
Titian's copy of Raphael's painting (*c.* 1545, Uffizi,
Florence).

The situation is somewhat different, if one compares Joan
Miró's *Dutch Interior* (figure 27) with *Tanzstunde des
Kätzchens* by Jan Steen (figure 28). The former is painted
in Miró's characteristic style, which, needless to say, is very
different from that of Steen. It takes some time before one

70

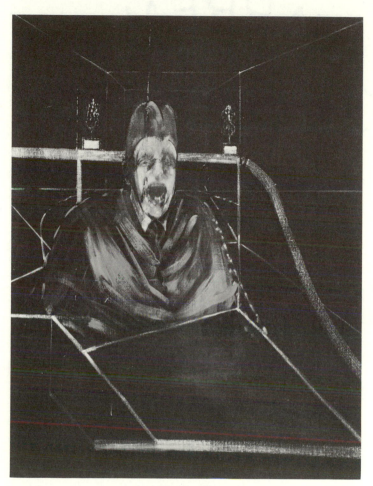

Figure 24.

begins to notice the similarities between the two paintings.
But there are similarities, and on closer inspection one rec-
ognizes in Miró's painting the dog in the foreground, the
musical instrument in the background to the right, the cat
and the face of the girl who is playing flute. The face of the
laughing person to the left in Steen's painting is represented
in roughly the same place in the painting by Miró, although

71

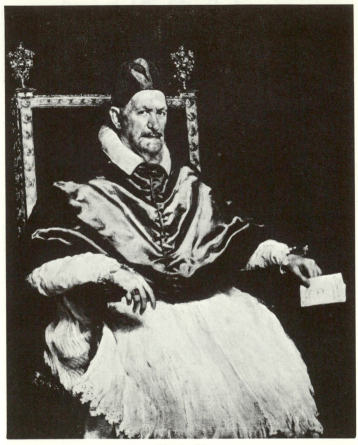

Figure 25.

enlarged and transformed, and so forth. Besides, there is
also external (biographical) evidence connecting the two
paintings with each other.[45]

I admit that it can be very difficult to draw a sharp line

[45] Jacques Dupin, *Joan Miró. Leben und Werke*, Köln: DuMont
Schauberg, 1961, pp. 168–73. According to Dupin, Miró's Dutch in-
teriors were painted from postcards, and Dupin also reproduces a
number of interesting sketches for these paintings illustrating Miró's
transformations of Steen's painting. Cf. also Walter Erben, *Joan
Miró*, London: Lund Humphries, 1959.

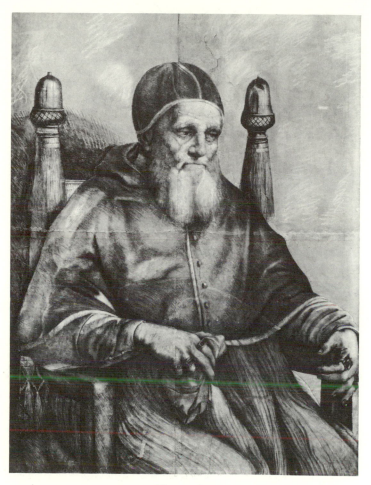

Figure 26.

between, say, a free paraphrase and a poor copy. It is quite possible that two artists could make one painting each after, say, Goya's *La Maja Desnuda* (Prado, Madrid). Their paintings could be very similar to each other, but one could be a paraphrase and the other a rather poor copy; two paintings resembling each other do not have to stand in exactly the same relation to the original which they are painted

73

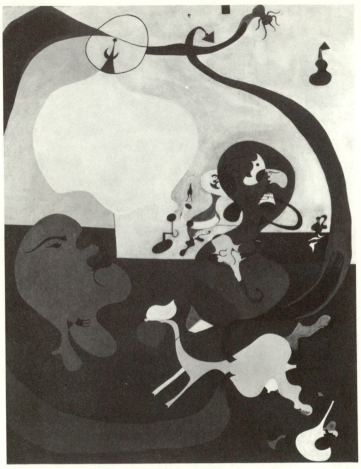

Figure 27.

after. Moreover, if the artist's intentions do not settle the issue, and if it is better to be a free paraphrase than a poor copy, then disagreement as to whether a particular painting is a free paraphrase rather than a poor copy cannot be decided by empirical methods alone. But I would be prepared to argue that if X is a paraphrase of Y, then the artist's intentions are not the same as when X is a copy of Y; in the latter case, but not in the former, X is intended to be a replica of Y.

Figure 28.

1.4.5 *Allusions*

Allusions resemble paraphrases in many ways, but they are
more subtle and difficult to discover than paraphrases. This
can be seen if *The Studio* (figure 29) by Picasso is compared
with *Las Meninas* by Velázquez (figure 23) and with his
paraphrase of this painting (figure 22). The similarities be-
tween the latter two are much more striking than are the
similarities between the former two. Clearly, *The Studio* is
not a paraphrase of *Las Meninas*. But, according to Robert
Rosenblum, it is an allusion to that painting:

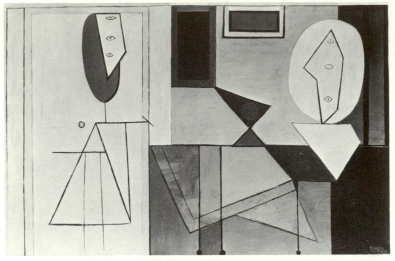

Figure 29.

In the earlier of the two, *The Studio* of 1927–28, Picasso again reasserts his Spanish heritage by alluding, con-sciously or not, to Velázquez's famous masterpiece, *Las Meninas (The Maids of Honor)*. Like the seventeenth-century painting, Picasso's may be interpreted as an al-legory of the relationship between the artist and reality. In both pictures, the painter stands at the left before his easel, his paintbrush delicately poised in his hand. To the right are the realities that he must translate into art—in the Velázquez, the mirror image of King and Queen, whose portrait he is painting, as well as the Infanta and her attendants; in the Picasso, a table with a bowl of green fruit and a white sculptured head. And both works include framed images that evoke varying degrees of reality and illusion—pictures, mirrors, doors, windows.[46]

The author points out that the painter's canvas and easel in Picasso's work closely resemble those in the painting by Velázquez, and he describes how Picasso has interpreted his theme "through the aesthetic of Cubism."

In my earlier treatment of the notion of allusion, I have

[46] Rosenblum, *Cubism*, p. 290.

76

argued that it is possible to obtain a series of more or less strong concepts of allusion by combining the following conditions in different ways: (a) the artist who created X (in this case, *The Studio*) intended to make beholders think of Y (in this case, *Las Meninas*); (b) as a matter of fact, beholders contemplating X make associations with Y; and (c) the beholders recognize that this was what the artist wanted them to do.[47]

Now each of these conditions can be interpreted in many ways. For instance, one can distinguish between more or less informed beholders, and the artist may not always be aware of his intentions. I would argue, however, that some version of the first condition above is necessary; if the artist did not consciously or unconsciously want to make beholders think of the work in question, then he did not allude to it. But for the limited purposes of the present subsection I do not need to go into detail and distinguish between a number of possible concepts of allusion.

1.4.6. *Borrowings, Models, and Sources*

In this section I shall discuss a number of phenomena which are often referred to as instances of influence. To be able to discuss them more clearly, I shall use the terms "borrowing," "model," and "source" in senses that are slightly more precise than usual.

A number of distinctions can be made at this point. If X is a painting, and X was influenced by Y, then X and Y can belong to the same medium or not. If they do, then Y is also a painting. Moreover, the artist who created X may use whatever he borrowed from Y without changing it very much, or he may change it considerably. After these preliminaries, the distinction between borrowings and models can be outlined as follows.

Let X_y represent that in X which resembles Y. If X_y is a *borrowing* from Y, then (a) X_y is a physical part of X, (b)

[47] Hermerén, *Representation and Meaning*, pp. 87–90. An alternative series of concepts is obtained if (a) is replaced by (a'): *A* had *Y* in mind, when he created *X*.

X_y and Y belong to the same medium, and (c) X_y and Y are very similar to each other; the artist has made small or insignificant changes of Y when he borrowed it. However, if Y is a *model* for X_y, then (a) X_y is a physical part of X, but (b) X and Y belong to different media, and (c) X_y and Y are similar to each other, though the artist has made considerable changes in Y, or additions to Y.

Borrowings and models differ from each other also in the following respect. If X_y is a borrowing from Y, then a causal connection is involved in the sense that Y was a necessary condition for the creation of X_y, and that contact with Y was part of a sufficient condition (in a sense to be explained in the next section) for the creation of X_y. If, however, X is a model for Y, then the situation is reversed. In that case X was a necessary condition for the creation of Y, and the contact with X was part of a sufficient condition for the creation of Y.

The term "source" should, according to the usage I am recommending, neither be taken to be synonymous with "borrowing," nor with "model." We need a somewhat vaguer term for more general borrowings. Thus I shall say that if X is the *source* of Y, then (a) the person who created Y got the idea for Y or a part of Y when he saw or read X, (b) X and Y are similar to each other, though the similarities may be more difficult to discover than in the case of borrowings and models, and (c) X and Y may or may not belong to different media.

Turning now to the notion of model,[48] the main problem is to make clear precisely in what respects the artist has made considerable changes of or additions to the work he used as a starting point. It may be wise to begin with a few examples. It has been pointed out that the group of three persons in the lower right corner of Marcantonio's engraving *The Judgment of Paris* (figure 30) has been used as a model by Edouard Manet for the three persons in the fore-

[48] The corresponding German term is "Vorlage," and the corresponding Swedish term is "förlaga."

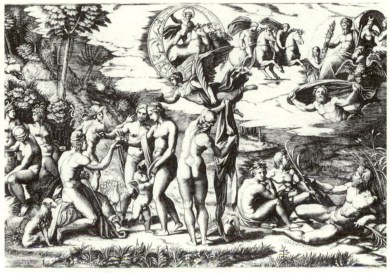

Figure 30.

ground in his *Le Déjeuner sur l'herbe* (figure 31).[49] The differences between the model and Manet's painting are too obvious to mention, as a glance at the reproductions will show. Manet has only used part of the engraving, and he has, of course, added the colors. But the similarity of the design of the two groups of people is very striking.

Frits Lugt has pointed out that when in 1633 Rembrandt painted a subject rarely illustrated in painting before, *The Storm on the Sea of Galilee* (figure 32), he used as a model of the composition an engraving after his Mannerist predecessor Martin de Vos (figure 33):

But what of the design? Could it be entirely his? In this case it is not one of the sovereign painters who provided it but a very able illustrator, Martin de Vos, working at Antwerp in the second half of the sixteenth century, who made innumerable drawings of biblical and mythological

[49] Cf., for instance, Maison, *Bild und Abbild*, p. 138; and Ernst H. Gombrich, *Art and Illusion*, New York: Pantheon, 1960, p. 323.

79

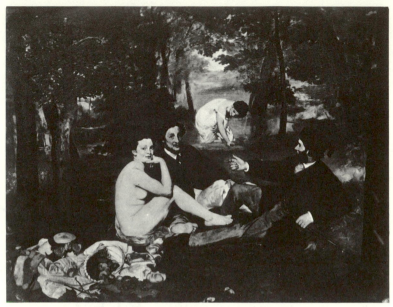

Figure 31.

scenes, widely known through the engravings of the Col-
laerts and Sadelers.[50]

Lugt adds that Rembrandt's painting is far better than any
of the paintings by de Vos. The latter are solid and sober
but lack the dramatic intensity of the former: "Rembrandt
went far beyond what he took from his forerunner—in his
novel grouping of the figures, in the accents of the composi-
tion, in the creation of a haunting space and above all in his
color."[51]

The best known examples of models (in my sense of this
term) are provided, however, by the engravings in the works
of Andrea Alciati, Cesare Ripa, and Piero Valeriano.[52] The

[50] Frits Lugt, "Rembrandt: follower and innovator," *Art News*,
1952, p. 40.

[51] *Ibid.*

[52] Andrea Alciati, *Emblemata*, Augsburg, 1531; Piero Valeriano,
Hieroglyphica, Basel, 1556; Cesare Ripa, *Iconologia*, Rome, 1593.
These books were printed in many editions and had numerous
progeny. Cf. Mario Praz, *Studies in Seventeenth-Century Imagery*,

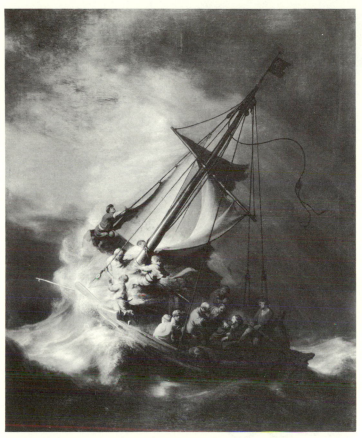

Figure 32.

works by these authors and their followers were used as manuals by many artists during the sixteenth and seventeenth centuries. The similarities between Ripa's *Truth* (figure 34) and Bernini's *Truth Unveiled* (figure 35) are in-

2nd ed., Rome: Edizioni di Storia e Letteratura, 1964; and William S. Heckscher and K.-A. Wirth, "Emblem, Emblembuch," in Ludwig H. Heydenreich and Karl-August Wirth, eds., *Reallexikon zur deutschen Kunstgeschichte*, V, Stuttgart, 1967, columns 85–228. For a general survey of the influence of Ripa on art and for a bibliography of the different editions of *Iconologia*, see E. Mandowsky, *Untersuchungen zur Iconologie des Cesare Ripa*, Hamburg: Proctor, 1934.

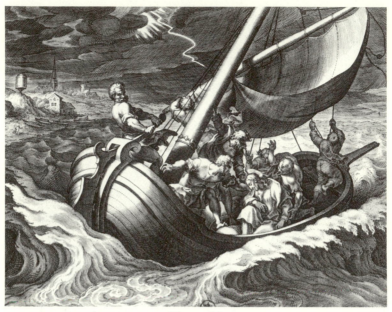

Figure 33.

deed striking, and one can safely assume that the former was used as a model for the latter. It is also instructive to compare, for example, Alciati's emblem *Concordia* with the general compositional formula in Velázquez's *The Surrender at Breda* (*c.* 1634–35, Prado, Madrid).

The model does not, of course, have to be a drawing or an engraving; it can be any kind of work of art. Thus Fernand Dauchot has shown that during his symbolistic period Gauguin used sculptures from churches in Bretagne as models for some of his best known paintings. For instance, Gauguin has used a calvary group in stone from the sixteenth century (which incidentally is partly covered by green moss) as a model for part of his *Green Christ* (figure 36).[53]

[53] The calvary group is reproduced in Maison, *Bild und Abbild*, figure 239. Cf. also, for a discussion of the model for Christ in another painting by Gauguin, Fernand Dauchot, "Le *Christ Jaune* de Gauguin," *GBA*, XLIV, 1954, pp. 65–68.

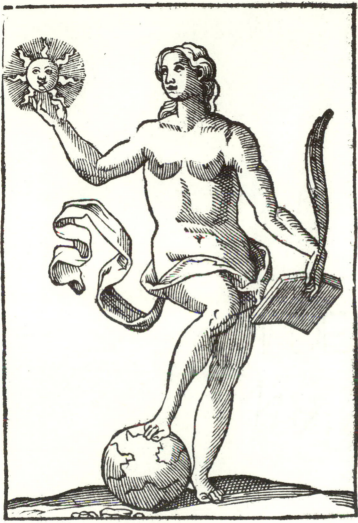

Figure 34.

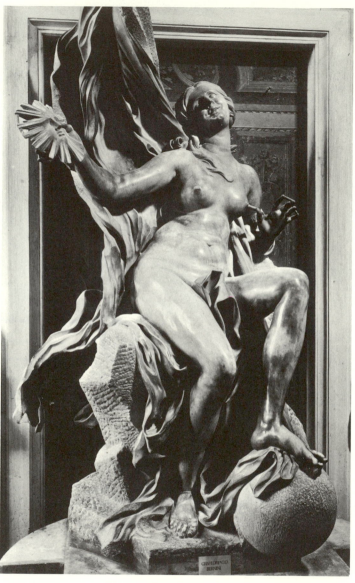

Figure 35.

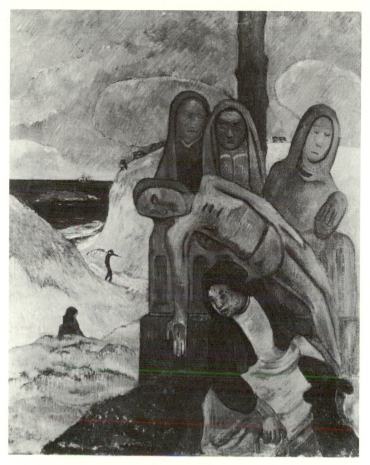

Figure 36.

Bellamy Gardner has called attention to a slightly different and somewhat less well-known example. In the volume *Les Jeux et plaisirs de l'enfance,* by Jacques Stella (Paris, 1657) there is an engraving showing children at play. One of these engravings (*Playing Children*) illustrated a game called "le cheval fondue" (figure 37). This engraving has no doubt served as a model (in my sense of this word) for a

Figure 37.

painting by Jean Baptiste Huet (figure 38). This painting shows, as Gardner points out, "the same infants fully clothed, including four boys and one girl in the same identical postures and positions as Stella's but with a different background."[54]

Thus, models differ from borrowings and copies in the following way. If X is a model for Y, then the artist who created Y used X only to some extent or in some respect, and was in others quite independent of Y. When an artist is to make a mural painting, he may use an engraving or a drawing as a model for part of the composition. When the artist is painting the wall, he is quite independent of the model, since it has no colors at all. In such cases there is not a very high degree of similarity between X and Y in all respects—

[54] Bellamy Gardner, "Children's Games on Chelsea Plates," *Apollo*, XXIX, 1939, p. 60.

86

Figure 38.

as when X is a copy of Y—but only a high degree of similarity in some respects.

The remarks just made suggest another difference between the notions of copy and model. Suppose that X was created before Y. If the relation of model holds between X and Y, then in that case X is a model for Y. But if the relation of copy holds between X and Y, then Y is a copy of X. Thus the order of the variables X and Y is reversed, though a causal relation is involved in both cases. In this respect, the notion of paraphrase is similar to that of copy and different from that of model. For if X was created before Y, and if the relation of paraphrase holds between X and Y, then clearly Y is a paraphrase of X.

To facilitate a comparison between a number of the concepts discussed so far, I will now summarize some of their distinctive features in the following diagram:

If X is a	parallel to Y	sketch$_D$ of Y	sketch$_O$ of Y	copy of Y	paraphrase of Y	borrowing from Y	model of Y
then X and Y are always created by the same person	no	no	yes	no	no	no	no
then X is always closely similar to Y with respect to both design and color	no	no	no	yes	no	yes	no
then Y is a necessary condition for the creation of X	no	yes	no	yes	yes	yes	no
then X is always created before Y is created	no	no	yes	no	no	no	yes
then that in X which resembles Y is always a physical part of X	no	no	no	no	no	yes	no
then X and Y always belong to the same medium	no	no	no	yes	no	yes	no
then the person who created X is always familiar with Y	no	yes	no	yes	yes	yes	no
then X is intended to be a replica of Y (and not an independent work of art	no	no	no	yes	no	no	no
then the relation that holds between X and Y also holds between Y and X	yes	no	no	no	no	no	no
and if the same relation holds between Y and Z, then it also holds between X and Z	yes	no	no	no	no	no	no

The diagram can be made more precise, but also more complicated, by replacing the unqualified "no" with one of these three alternatives: "no, never," "no, usually not," and "no, not always but frequently."

1.4.7 *Genuine Influence*

The relations between the art of Picasso and Braque during the decade after 1908 is a clear example of what I would like to call genuine influence or influence in the narrow sense, as opposed to the relations so far discussed.

Before they met, Braque and Picasso painted in rather different styles. The first traces of influence are visible in the large *Baigneuse* or *Nu* by Braque (*c*. 1908, Collection Mme. Cuttoli, Paris), a milestone in the history of Cubism according to John Golding; here Braque was influenced by Picasso's *Demoiselles d'Avignon*. The mutual influence of the two artists on each other grew stronger, and their paintings became more and more like each other, as is evident from figures 39 and 40. By 1911–12, some paintings of the two artists are so similar that only connoisseurs can distinguish between the works of Picasso and Braque. Some years later the two painters began to develop in different directions, and by 1920 the differences between their works are again quite obvious.

Another example is provided by Jean Paul Richter's influence on Thomas Carlyle, though this example may not be quite so uncontroversial as the previous one. A change in Carlyle's style is clearly recognizable after he had read and translated works by Richter into English. The effects or the influence are strongest and most obvious in Carlyle's novel *Sartor*, but Richter continued to influence Carlyle's style for several years, though to a lesser extent. Metaphors and images which indicate Richter's influence also occur in Carlyle's later works, although not as much as in *Sartor*.

Artistic influence of this kind is clearly different from the other relations discussed so far, though it should be stressed that it does not exclude borrowings and allusions. On the

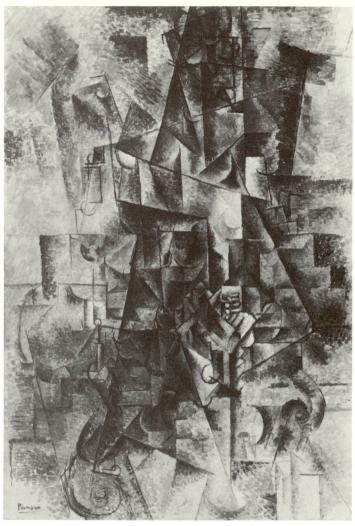

Figure 39.

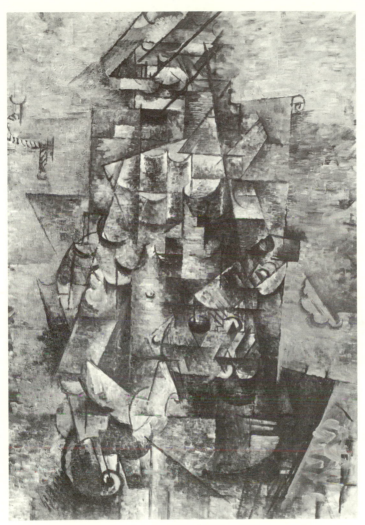

Figure 40.

contrary, the latter may be signs of the former. If one author borrows metaphors and images from another and coins unorthodox compound words in a way that is obviously derived from him, then this may be used as evidence supporting the hypothesis that the former was influenced by the latter.

However, before I try to spell out the differences between what I propose to call "genuine influence" and the other relations discussed in this section in some detail, it might be well to summarize the distinctions made in the previous subsections in the following diagram:

Influence		Not influence	
Narrow sense	Extended sense	Necessary condition	Not necessary condition
Genuine influence	Borrowing	Copy	Parallel
	Model	$Sketch_D$	$Sketch_O$
	Source	Paraphrase	
		Allusion	

A few comments on this diagram may not be out of place.

First, it should be stressed that the diagram makes no claim of completeness. Considering the conceptual framework of literary scholarship, one might, for instance, want to add translation, parody, and pastiche to the third column. Second, the items in the second and third column have been arranged according to decreasing similarity with the influencing work of art (the work of art which is copied, etc.). Third, when "influence" is used in such a way that it includes both the narrow and the extended sense, I shall say that "influence" is used in the wide sense.

The diagram above raises the following three fundamental questions, among others:

(a) What do all kinds of influences in the wide sense have in common?
(b) What distinguishes influences in the wide sense from copies, sketches, paraphrases, and so forth?
(c) What distinguishes genuine influence from other kinds of influence?

The rest of this chapter is an attempt to provide an answer to these questions.

Turning first to question (a), all kinds of influences in the wide sense of course satisfy the two ontological requirements already discussed:

(R 1) *Ontological Requirement 1.* If X influenced the creation of Y with respect to a, then a is a feature relevant to the understanding and appreciation of X and Y.
(R 2) *Ontological Requirement 2.* If X influenced the creation of Y with respect to a, then X and Y are visual or literary works of art or, alternatively, certain kinds of actions.

These requirements are here formulated in a somewhat different way than in section 1.2, but the formulations are equivalent.

In addition to (R 1) and (R 2), there are a number of other requirements which all kinds of influences in the wide sense seem to satisfy, among others the following ones:

(R 3) *Causal Requirement.* If X influenced the creation of Y with respect to a, and if B created Y, then B's contact with X was a contributory cause of the creation of Y with respect to a.
(R 4) *Visibility Requirement.* If X influenced the creation of Y in some respect, then traces of the influence from X should be manifest (visible or recognizable) in Y.

93

These requirements raise various problems. The notion of causality, which plays a crucial role in the former, is too complex to be discussed briefly; it will be discussed in a separate section shortly. The importance of something like the visibility requirement has been stressed by several scholars. For instance, in a paper on literary indebtedness J. T. Shaw makes the following point:

> Influences, to be meaningful, must be manifested in an intrinsic form, upon or within the literary works themselves.[55]

This quotation contains the very difficult words "meaningful" and "intrinsic," which certainly can be understood in many ways. But it does not seem far fetched to interpret this statement as an endorsement of what I have called the visibility requirement.

The importance of this requirement has also been stressed by Haskell Block, both in his earlier paper on the concept of influence (from which one of the mottos to this book is taken)[56] and in his recent survey of new tendencies in comparative literature. In the latter he writes:

> Toute l'influence digne de notre attention se transmet d'une oeuvre à une autre et s'exprime dans les rapports internes de créations riches et attachantes.[57]

Both these quotations raise a number of interesting problems concerning what the relevant criteria of visibility are,

[55] J. T. Shaw, "Literary Indebtedness and Comparative Literary Studies," in N. P. Stallknecht & H. Franz, eds., *Comparative Literature. Method and Perspective*, Carbondale: Southern Illinois University Press, 1961, p. 66.

[56] Cf. Haskell M. Block, "The Concept of Influence in Comparative Literature," *YCGL*, VII, 1958, p. 35: "the movement of influence is not simply from writer to writer but from work to work." I interpret this as a methodological recommendation saying that scholars should only study influences that have left visible traces on the works involved.

[57] Haskell M. Block, *Nouvelles tendences en littérature comparée*, Paris: Editions A. G. Nizet, 1970, pp. 47–48.

but it would carry us too far away from the main line of this investigation to discuss these problems.

At this point, however, we must pause to consider the relations between (R 1) and (R 4). They are obviously closely connected, but how are they related to each other? It seems to me that (R 4) is not equivalent to (R 1), and that (R 4) places further restrictions on the values of the variable *a*: artistic influence concerns features relevant to the understanding and appreciation of the works of art in question, but these features should also be visible and not concern, for instance, nonvisible philosophical ideas expressed in the work. Alternatively, (R 4) might be said to impose restrictions on what is to be counted as "appreciation and understanding" in this context.

It might be added that it is important to distinguish between influence and traces of influence. I do not believe, as Jan Brandt Corstius evidently does, that when "two texts are placed side by side, the formal and ideational data they present make it possible to speak about influence and to know exactly what the term implies."[58] In the first place, one may speak about influence without knowing exactly what the term implies. Secondly, two texts may be as similar as you please and yet neither of them need to have influenced the creation of the other.

Thus I would like to stress that the requirement of visibility does not say or imply that the influence should be visible, only that traces of the influence should be manifested in the work. In the last analysis it is necessary to show, as Claudio Guillén has emphasized,[59] that the influencing work has played a role in the creative process; and

[58] Jan Brandt Corstius, *Introduction to the Comparative Study of Literature*, New York: Random House, 1968, p. 183.

[59] This has been stressed by Claudio Guillén in "Literatura Como Sistema," *Filologia Romanza*, IV, 1957, pp. 1–29, and in "The Aesthetics of Influence Studies in Comparative Literature," in Werner P. Friedrich, ed., *Comparative Literature: Proceedings of the Second Congress of the International Comparative Literature Association*, I, Chapel Hill: University of North Carolina Press, 1959, pp. 175–92.

this process is not visible, though it can be partly recon-
structed on the basis of internal and external evidence, that
is, on the basis of sketches, works of art, diaries, letters, and
so forth.

Let us now return to the three questions raised by the
diagram above. The three requirements so far discussed
provide an answer to the first question but not to the sec-
ond one, since they do not distinguish clearly between influ-
ences in the extended sense and copies, paraphrases, and
allusions. To bring out these differences, the following re-
quirements have to be added:

(R 5) *Normative requirement.* If X influenced the crea-
tion of Y in some respect, then the statement that this is
so has normative implications in a sense to be discussed
shortly.
(R 6) *Intentional requirement.* If X influenced the crea-
tion of Y in some respect, then the artist who created Y
may be aware of this influence, but need not be.
(R 7) *Similarity requirement.* If X influenced the crea-
tion of Y with respect to a, then the similarities between
X and Y with respect to a are more subtle and more diffi-
cult to discover than in the case of copies, sketches, para-
phrases, etc.

These requirements, too, raise a number of intriguing prob-
lems, and the notions of similarity and normative implica-
tion will be discussed separately later on in this book. For
the time being I will only make a few brief comments on the
intentional requirement.

According to this requirement, an artist does not have to
be aware of the fact that he was influenced by the work of
art X, when he created his work Y. But if an artist is making
a copy of X, or is using X as a model, then he is always
aware of this fact; he does so deliberately. As a rule, he is
working next to the original or to a reproduction of the
original in those cases. But when he is influenced by a work

96

of art, this work can be miles away and it may be years since he saw it.

This point can also be expressed in the following way. Consider the following four statements:

(a) the artist A's painting Y is a copy of X,
(b) A has used X as a model of (part of) Y,
(c) A's painting Y is a paraphrase of X,
(d) in creating Y, A was influenced by X.

Suppose, moreover, that to each of these statements the following statement is added:

(e) A is not aware of this fact.

Now the conjunction of (d) and (e) is not a contradiction. But the conjunction of (e) and any of the first three statements will result in a contradiction, if certain normal (and very reasonable) requirements are satisfied—for instance that A is not hypnotized while he is working. For if A makes a copy of X under hypnosis, or makes a copy of X and then gets amnesia, it would then be true to say "A's painting Y is a copy of X, but A is not aware of this fact."

After these digressions I shall now return to the questions raised by the diagram at the beginning of this subsection: (a) what do all kinds of influence in the wide sense have in common? (b) what distinguishes influences in the wide sense from copies, sketches, paraphrases, and so forth? and (c) what distinguishes genuine influence from other kinds of influence? Clearly, a precise answer to these questions can be given only to the extent that the requirements discussed in this subsection can be made precise. Requirements (R 1) through (R 7) provide a tentative answer to the first two questions, and I shall now try to answer the third question.

There are some requirements which X and Y need to satisfy if X genuinely influenced Y but not if X influenced Y in the extended sense. The requirements below are all vague,

97

but together they may indicate what kind of concept I have in mind.

(R 8) *Requirement of totality.* If X genuinely influenced the creation of Y with respect to a, then a is not a detail borrowed from X but some more pervasive feature, such as style or expression, which concerns Y as a whole.

However, this requirement does not quite solve my problem of demarcation.

According to (R 8), genuine influence concerns the work of art as a whole; it is not confined to details such as borrowings of subject-matter, plot, figures, persons, or compositional features from other works of art. In the latter case, Y or part of Y closely resembles a part of X. This requirement distinguishes between genuine influence on the one hand and borrowings and models on the other. But it does not distinguish clearly between genuine influence and sources, nor does it distinguish between genuine influence and copies or paraphrases.

Thus the requirement above has to be supplemented with others, and I propose the following:

(R 9) *Requirement of assimilation.* If X genuinely influenced the creation of Y, then the influence of X is pervasive in the sense that the artist who created Y has assimilated X.

The notion of assimilation is far from clear, and I admit that this requirement is rather obscure; it can be made more precise in several ways.

For instance, the following two requirements may be proposed as more precise versions of (R 9):

(R 10) *Requirement of continuity.* If X genuinely influenced the creation of Y, then there is a continuity between Y and other works by the person who created Y; the influence has affected several of his works and Y is not an isolated phenomenon in his production.

(R 11) *Requirement of long lasting effect.* If X genuinely influenced the creation of Y, then the influence of Y is

long lasting in the sense that it has affected the person who made Y during a fairly long period of time.

Again, none of these requirements is particularly clear.

What are the criteria of continuity and long lasting effects? For example, how many works besides Y have to be affected by the influence from X? How long does an effect have to last in order to be long lasting? It would obviously be possible to obtain a series of more precise versions of (R 10) and (R 11) by interpreting the key expressions in them in different ways, but I shall not try to do that; art history is not a branch of mathematics, and it would be foolish to ask for more precision than the subject allows.

However, I would like to make one comment on the last two requirements. They are obviously closely related to each other. It might even be argued that (R 11) is superfluous in the sense that it is just another way of saying what is already said in (R 10). But is this so? Suppose it is suggested that an artist A has influenced the works of artists B and C, and suppose, moreover, that artist B works slowly and carefully, like Baertling, and produces roughly one painting a year, whereas C works quickly, like Picasso, and produces ten paintings a month or more. Considering the relations between A and B, then (R 11) but not (R 10) may be satisfied. Considering the relations between A and C, however, it is possible that (R 10) but not (R 11) may be satisfied.

In addition to all this, it might be said that there is a difference in degree between borrowings and models on the one hand and genuine influence on the other. If X has served as a model of Y, or if the artist who created Y has borrowed something from X, then there are striking similarities between X and Y in the relevant respects. But this need not be so if Y was genuinely influenced by X. Thus I propose to add:

(R 12) *Requirement of similarity.* If X genuinely influenced the creation of Y with respect to a, then there need not be any obvious and easily discovered similarities between X and Y in this respect.

99

This requirement differs from (R 8) through (R 11) by calling attention to features which borrowings and models have and which genuine influences need not have, rather than by singling out features which genuine influences have and borrowings and models do not have.

1.4.8 *Influence and Forgery*

It may be instructive to compare some of the concepts discussed above with that of forgery. What is, for example, the difference between copies, forgeries, and instances of artistic influence?

If *X* is a forgery of an original work of art *Y*, then *X* is very similar to *Y* and said to be *Y*; skillful forgeries like those by van Meegeren have in many cases successfully been claimed to be originals and deceived critics, scholars, and museum directors. This is, however, only a preliminary explanation of the notion of forgery; every forgery does not have to be a forgery of an original work of art in the way suggested above. Some of the paintings van Meegeren claimed to have made were skillful copies of this kind, but others were made in the style of Vermeer and not after an original by Vermeer.

In discussing the relations between forgeries, copies, and artistic influences, the following three considerations seem relevant: (a) the number of similarities, (b) the strength of the similarities, and (c) the intentions of the artist. The number of respects in which any two works *X* and *Y* are similar can, of course, vary a great deal. The relations between *X* and *Y* in this respect can be indicated by a mark on a sliding scale of the following kind:

(a) ————————————————————————
 none some many all

It may be objected that these marks are bound to be arbitrary, since it is not clear what is to be counted as *one* respect. Clearly, what one author treats as one respect (for instance, composition), another may analyze further and divide into several respects. However, this objection is not fatal, as long as one is consistent in comparing works of art; if composition is counted as one respect in comparing X and Y, it should also be counted as one respect in comparing X and Z.

Moreover, in each respect the similarity may be more or less strong. Again, the relations between X and Y can be represented by marks on a sliding scale:

(b) ————————————————————————————————

weak considerable strong

Now, what is meant by "strong" and "weak" in this context? I shall discuss the notion of similarity later on in some detail, and for the time being I propose that "strong similarities" are interpreted as "striking similarities."

Finally, the artist may be more or less dimly aware of the causal relation between X and Y. In this case, too, we can indicate the relations between X and Y with a mark on a sliding scale:

(c) ————————————————————————————————

unaware dimly aware clearly aware

Now let us see whether it is possible to throw any interesting light on the differences between copies, influences, and forgeries by means of these scales.

If X is a forgery of Y, then we should indicate the relations between X and Y with a mark at the right end of all these three scales. In this respect the concept of forgery is similar to that of copy and different from that of artistic influence. The difference between forgeries and copies lies on a level that is not indicated by these three scales: the intentions with which the relevant work of art is exhibited and presented to the public. If X is claimed—by the artist or by someone else—to be by, say, Vermeer, though it is made by someone else, if it is presented as if it were an original Vermeer, priced as if it were a painting by Vermeer, and so forth, then I shall say that X is a forgery.

It may not always be easy to discover the intentions with which a particular work of art was created, presented, and priced. If this is true, it may sometimes be difficult to decide whether a particular work of art is a forgery or a copy. For example, a skillful artist may very well make a faithful copy of a work of art in order to show that he has mastered the technique just as well as any of the classical artists. Then someone else may buy or steal this copy and try to sell it as if it were an original by, say, Titian. However, this does not mean that the conceptual distinction between copies and forgeries disappears or cannot be maintained.

Similarly, it is theoretically possible that for lack of evidence it may be difficult or impossible in certain particular cases to decide whether X is a copy of Y, Y is a model of X, X is a paraphrase of Y, or we are confronted with an example of obvious positive artistic influence. This situation certainly has occurred several times in the history of art. But again this fact does not eliminate the distinctions outlined here between the concepts of copy, model, paraphrase, and artistic influence.

In addition to the differences between these concepts to which I have called attention above, there are also interesting differences as to the normative implications of the three statements:

(a) X is a copy of Y,
(b) X is a forgery of Y,
(c) X is influenced by Y.

I shall discuss these normative implications in some detail in section 1.6 below.

1.4.9 Concluding Remarks

In concluding this section, I would like to make one more distinction. Suppose X and Y are works of art, and that X was created by A and Y by B. May A in such cases be identical with B? Do we have different influence relations depending on whether A is identical with B or not?

Suppose an art historian compares two works of art with each other. One of them is signed by Goya, the other is not signed or dated. The two works are strikingly similar in some respects, though there are also interesting differences between them. All the evidence available supports the hypothesis that one of these works influenced, or was influenced by, the other. But then a document is discovered, which shows that the two paintings were created by the same person, Goya. Would we then be inclined to say that one of these works influenced the other? I would hesitate to say this, unless the similarities between the two works are of a very special kind and unless this hypothesis about influence is supported by other (external) evidence as well.

Of course, I would not want to deny that it is possible that an artist can be influenced by his own works, particularly if he reaches an old age, like Titian or Picasso. There are also, I have been told, historical examples of this phenomenon. But by the remarks above I merely want to distinguish between two cases in which the problems of verification become slightly different. If X and Y are made by different artists, and you want to show that one of these works, X, influenced the other, then you would have to show that the artist who created Y had seen or heard of X

before he created Y. This may often be very difficult to prove. But if X and Y are made by the same artist, the situation is quite different. In that case it is not necessary to waste energy in trying to prove that the artist who created Y was familiar with X.

However, for the sake of simplicity in the rest of this book I shall confine myself—perhaps somewhat arbitrarily —to studying relations of influence which satisfy the following requirement:

> (R 13) *Requirement of different creators.* If X influenced the creation of Y in some particular respect a, then the person who created X is not identical with the person who created Y.

1.5 CAUSAL EXPLANATIONS AND HYPOTHESES
ABOUT INFLUENCE

In light of the distinctions made in the preceding sections, we are now ready to take a closer look at the concept or concepts of direct positive influence. In the following sections I intend to characterize two important features of this concept: (a) the causal relation which is involved in claiming that one artist or work of art was influenced by another, and (b) the normative implications of saying that one artist or work of art was influenced by another.

Before I go into a more detailed discussion of the causal requirement, I would like to make a brief digression at this point to indicate an interesting connection between the issues to be discussed here and certain problems in the modern philosophical theory of action. If the painting of a picture is a human action, then some contemporary philosophers would argue that there cannot be a causal relation between that action and the antecedent circumstances and occurrences.[60] If this is correct, it would be a

[60] Philosophers who hold that the concept of action should not be analyzed in causal terms include A. I. Melden, Stuart Hampshire, and Georg Henrik von Wright.

mistake to try to analyze the notion of influence causally. There is a deep and intriguing philosophical problem here, since many (but not all) philosophers working with problems in action theory seem to want to say that it is inappropriate to talk about a human action being caused.

However, the space available here permits neither a detailed examination of the crucial distinction between reasons and causes, nor a review of the arguments for and against causal analyses of human actions.[61] I shall have to limit myself to making a few brief points: (a) the arguments against the causal analysis of actions are of very different value and strength, (b) there are also good arguments supporting the causal analysis of actions,[62] and (c) the causal and noncausal analyses do not, in my view, exclude each other; they are rather different ways of talking about human actions, each of which can be worked out consistently. If this is so, then none of them can be proved to be wrong, and the distinctions between different kinds of causes should correspond to analogous distinctions in the other kind of analysis.

But for the time being I propose to disregard these complications; I hope to have an opportunity to discuss them in a separate study. Anyway, it seems clear that anyone who says that the way a particular artist A rendered a motif in his work X was influenced by A's previous contact with the work Y—and who uses words like "influence" according to the rules of ordinary English—is saying or implying that there is at least a weak causal connection between X and Y, or rather between the creation of X and A's contact with Y. The problem to be discussed in this section can now be stated as follows: exactly what causal connections are involved or presupposed in such claims? Is the causal connection always of the same kind, or do we have a family of

[61] For a bibliography and a survey of the relevant literature on this and related topics, see my paper "Historiska förklaringar," *Historisk Tidskrift*, 1973, pp. 212–38.

[62] See, for instance, Ruth Macklin, "Explanation and Action: Recent Issues and Controversies," *Synthese*, XX, 1969, pp. 388–415.

causal connections here and thus a family of concepts of direct influence?

I shall now try to answer these questions, using the distinction between necessary and sufficient conditions as a point of departure. However, this distinction is not quite clear, and I shall therefore try to clarify it before I start analyzing examples from writings on the history of art and literature.

1.5.1 *Necessary and Sufficient Conditions*

It is evident from a quick look at the way in which the terms "necessary condition" and "sufficient condition" are used in philosophical and logical writings, (a) that these terms are used to refer to relations between entities of several different kinds, and (b) that these relations are defined in terms of conditional sentences of various kinds.

By combining these two bases of division, it is possible to obtain the following combinations, among others, which will serve as a basis for my attempt to clarify in what way I am going to use the terms "necessary condition" and "sufficient condition."

a is a necessary (sufficient) condition for *b*	(A) *a* and *b* are terms (or predicates)	(B) *a* and *b* are sentences (propositions)	(C) *a* and *b* are events (actions)
(1) defined as a formal implication	X		
(2) defined as a material implication		X	
(3) defined as a counter-factual condition			X

Some of these combinations—like (2A) or (2C)—are excluded or empty for obvious logical reasons, but it is clear from this diagram that we can construe a series of definitions of "necessary condition" and "sufficient condition."

The three Xs in the diagram indicate three standard ways of defining the concepts of necessary and sufficient conditions: as a formal implication between terms or predicates (concepts); as a material implication between sentences or propositions; and as a counterfactual conditional between events or actions. It can be argued that it is possible to obtain a definition of type (2B) from a definition of type (3C), provided that the sentences in combination (2B) are replaced by sentences saying that certain actions were performed by certain agents, or that certain events took place at a specific time and place. However, for reasons given in several textbooks in logic, it is clear that these definitions are not equivalent.

The reasons are as follows: in a counterfactual conditional such as "if Hitler had invaded London in 1941, he would have won the war," the if clause is false. According to the rules of material implication, the statement as a whole is therefore true. But the statement "if Hitler had invaded London in 1941, he would not have won the war" denies what is asserted by the other statement, and yet the latter statement is also true according to the rules of material implication. Now there may be other ways of going from definitions of type (3C) to definitions of the other two types, but for the time being it seems wise to distinguish between them.

This does not preclude, however, that the modal relation supposed to hold between Hitler's action of not invading London and the outcome of the war can easily be extended to terms and sentences as well. For if an event occurred at a particular time and place, or if an agent performed a particular action in a certain situation, it is always possible to describe the occurrence of this event and the performance of this action in a sentence. It may therefore seem arbitrary

107

to combine (3) in the diagram only with (C). I would not want to deny this, but it seems very natural to conceive of causal relations—which is what I am interested in clarifying here—as relations between events or actions. That is why—perhaps somewhat arbitrarily—I have confined my attention to the particular combination (3C), although (3A) and (3B) are equally possible.

Thus when I use terms like "necessary condition" or "sufficient condition" in the rest of this book, I am referring to a relation between events or actions, defined by means of a counterfactual conditional as follows, unless I explicitly state otherwise:

> Definition of Sufficient Condition: a is a sufficient condition for b, if and only if (1) a and b are individual actions or events, (2) a precedes b in time, or is simultaneous with b, and (3) if a had occurred—or been performed—then b would have occurred or been performed.

> Definition of Necessary Condition: a is a necessary condition for b, if and only if (1) a and b are individual actions or events, (2) a precedes b in time, or is simultaneous with b, and (3) if a had not occurred—or been performed—then b would not have occurred or been performed.

The expression "individual actions or events" is included in these definitions to emphasize that a and b do not stand for classes of events or actions.

The difference between necessary and sufficient conditions in the sense defined above can be illustrated by means of two simple examples. Consider the following statement, which obviously is very reasonable:

> (a) If Einstein—without parachute or any other safety device—had jumped from the top of the Eiffel tower, he would have died.

In that case, Einstein's jump is a sufficient but not necessary condition for his death. If the jump had also been a

necessary condition, there would have been a very simple way for Einstein to secure physical immortality: to avoid the Eiffel tower.

Since it is possible to die even if one does not jump from the top of the Eiffel tower, the following statement is clearly false:

(b) If a person does not jump from the top of the Eiffel tower he will not die.

Accordingly, Einstein's jump from the top of the Eiffel tower cannot possibly be a necessary condition for his death.

Moreover, consider the following statement, which is just as reasonable as (a):

(c) If my uncle does not cross the French border, he will not jump from the top of the Eiffel tower.

In this case, my uncle's crossing of the border is clearly a necessary but not sufficient condition for his jump. If it had also been a sufficient condition, the following statement would have been true:

(d) If my uncle crosses the French border, he will jump from the top of the Eiffel tower.

This statement, however, is obviously and fortunately false.

Many other examples could be given to illustrate this distinction between necessary and sufficient conditions, but I hope the ones discussed here will be enough.

These definitions of the two concepts, necessary and sufficient conditions, can serve as the point of departure for a series of definitions of different though related concepts. I shall now call attention to two important ways—which can be combined with each other—of modifying the definitions above: to make the concepts probabilistic rather than non-probabilistic, and to analyze them as three-place relations rather than as two-place relations.

The first modification consists in inserting "it is probable that" or some equivalent phrase immediately after "then."

This insertion raises two intriguing questions: how is "probable" in this context to be understood, and how great is the probability supposed to be? There is an extensive literature on the interpretation of words like "probability" and it is not possible to discuss this problem in all its ramifications within the scope of present investigation.

As to the second question, it is possible to be slightly more—but not very much more—definite. It seems reasonable to require that the probability should be greater than 0.5. But it is here possible to think of a variety of possibilities—0.5 . . . greater than 0.5 . . . considerably greater than 0.5 . . . close to 1—and there does not seem to be a sharp line between these possibilities. Thus what we have is some kind of sliding scale from fairly low to fairly high probability, and this is true also in the case where the probability cannot be estimated in exact numerical terms.

The two definitions given above imply, respectively, that a is a necessary and a sufficient condition for b, independently of what happens in the rest of the world at the time. In many cases this concept is much too strong; the definitions are then inapplicable to many cases in which one would want to speak of causal connections. In order to make the definitions more useful, it may then be tempting to suggest a modification along the following lines.

The basic idea is to construe the concepts of necessary and sufficient conditions as three-place relations. The point of departure for the new definitions will then be statements like "a is a necessary condition for b in the presence (or absence) of c" or "a is a sufficient condition for b in the presence (or absence) of c." This means that a is a necessary—or sufficient—condition for b, because of the presence or absence of c. Now how is this to be understood? What is meant by "because," and what is the value of the variable c?

As to the first question, the meaning of "because" can be clarified by means of the definitions we have made for the concepts of necessary and sufficient condition. Thus we can

distinguish between the case when the presence (or absence) of c is a necessary condition for a to be a necessary condition for b, and the case when the presence (or absence) of c is a sufficient condition for a to be a necessary condition for b; corresponding distinctions can be made in the case where a is a sufficient condition for b.

It can, of course, be objected that if the definitions of necessary and sufficient condition are modified in the way suggested now, then a is no longer a necessary (or, respectively, sufficient) condition for b. I can understand why this objection is made, but I want to stress that terminology is not important at this point; I would not mind replacing the terms "necessary condition" and "sufficient condition" in these cases with other expressions, but I have not been able to find any better ones. Besides, what is more important than terminology is to become clear as to the difference between a number of more or less weak causal connections.

As to the second question, concerning the range of significance of the variable c, I would like to make the following remarks. This variable can in the first place be replaced with names or descriptions of (a) events which occurred before or simultaneously with a, or (b) actions which were performed before or simultaneously with a. But it may also be replaced with names of descriptions of (c) nontrivial standing conditions like the existence of particular economic, political, or social structures at the time when a occurred or was performed, or (d) trivial standing conditions like the fact that there was oxygen in the air at the time when a occurred or was performed.

To make it easier to refer to some of these concepts I shall now introduce the following terminology. When a—in the senses indicated above—is a sufficient condition for b in the presence (or absence) of c, then I shall say that a is part (moment) of a sufficient condition for b. Here c is causally relevant in the following sense: a is a sufficient condition for b, *because of* the presence or absence of c. Similarly, when a is a necessary condition for b (in the senses

indicated above) in the presence (or absence) of c, then I shall say that a is part of a necessary condition for b. Again c is causally relevant in the sense that a is a necessary condition for b, *because of* the presence or absence of c.

However, if a is part of a necessary condition for b because of the presence or absence of c, then c is—at least indirectly—a necessary condition for b: if c does not take place, then b will not take place. This may seem to be an awkward consequence, and it suggests that the distinctions between the various weak concepts of necessary condition discussed above are not very useful. But I think it should be clarifying to distinguish between the case when a is not at all causally related to b, and the case when a is causally related to b, though only in the presence or absence of c.

The causal relations I have tried to distinguish here can, of course, be combined with each other in many ways. If a is both a necessary and a sufficient condition for b, then there is a strong causal connection between a and b. This connection can be weakened, as I have tried to indicate in this subsection, in various ways. By systematizing the possible combinations and the various logical relations between these more or less strong causal connections, it is possible to get a survey of the rather heterogeneous class of causal relations which are mentioned or presupposed in scholarly writings in humanistic disciplines.

Such a systematization is, however, not necessary in the present context, and it would be the proper subject of an investigation of its own. What is needed is to have a few reasonably clear distinctions between a number of causal relations. By means of such distinctions, it will then be possible to shed some light on a number of examples quoted from writings on the history of art and literature. Before I discuss these examples, I would like to make two general remarks.

First, the various concepts of necessary condition seem to be more interesting than the concept of sufficient condition, in spite of the awkward consequence mentioned

above. The reason for this is that the latter presupposes general laws or at least regularities in nature of the following kind: if a is a sufficient condition for b, then: whenever a occurs, then b will occur. It is difficult to believe that a concept like artistic influence could be analyzed in terms of a concept of this kind.

Second, the various concepts of necessary condition are quite compatible with many other distinctions that are worth making, for example, between the case where the influence stimulates the artistic imagination (and helps the artist to create a style of his own) and the case where the influence results only in inspiration to do something similar (and thus does not help the artist to create a style of his own). I shall return to the latter distinction in the following section.

1.5.2 *Some Examples*

Using the definitions of the various concepts of necessary and sufficient conditions in the previous subsection as a point of departure, I shall now discuss some examples of artistic and literary influence and try to highlight the causal relations involved in these examples.

The first example is taken from a book by Philippe van Tieghem. Discussing the Italian influence on French comedies, van Tieghem writes:

> Pour ne prendre qu'un example, le plus illustre, Molière n'eût pas composé ses comédies exactement comme il l'a fait s'il n'avait pas été formé lui-même et s'il n'avait pas formé sa troupe sous l'influence des Italiens.[63]

Here it seems fairly clear that the author is saying that the contact with the Italians was a necessary condition and also part of a sufficient condition for the composition of Molière's comedies; he would not have composed them in the way he did but for this contact.

[63] Van Tieghem, *Influences étrangères*, p. 28.

In his paper on the influence of Jean Paul Richter on Thomas Carlyle, J.W.S. Smeed at one point writes as follows:

> But, despite this lack of genuine creative impulse, *Sartor* is a remarkable and unique work, which could never have been written in the form in which we know it but for the influence of Jean Paul.[64]

Here the causal part of the hypothesis of influence can be analyzed in the same way as above: Carlyle's contact with the works of Richter is a necessary condition and also part of a sufficient condition for the creation of *Sartor*.

These two examples are, it seems, rather simple and uncontroversial. I will now discuss two somewhat more complicated examples. In his book *Tre fornnordiska gestalter*, Albert Nilsson argues as follows to show that Tegnér's poem *Nattvardsbarnen* was influenced by a poem by Grafström:

> As far as I can see, we must exclude the possibility that Tegnér's poem is independent of that by Grafström. The part of Lessing's treatise to which Grafström refers does not contain the idea that Love and Death are two bewilderingly similar twin brothers. Tegnér is not similar to Lessing but to Grafström, who on the basis of the brief passage about the much debated classic figure creates a new myth. It is quite inconceivable that two Swedish poets independently of each other and almost at the same time would create the same myth, using Lessing's treatise as a point of departure.[65]

[64] Smeed, "Thomas Carlyle and Jean Paul Richter," p. 238.

[65] Albert Nilsson, *Tre fornnordiska gestalter*, Lund: Gleerups, 1928, p. 394. My translation. The original Swedish text reads as follows: Såvitt jag kan se, är det uteslutet, att Tegnér icke är beroende av Grafström. Det av Grafström åsyftade stället i Lessings avhandling innehåller icke idén att Kärleken och Döden är två förvillande lika tvillingbröder. Tegnér överensstämmer icke med Lessing utan med

In this quotation the author discusses two hypotheses, which can be illustrated by means of the following diagram:

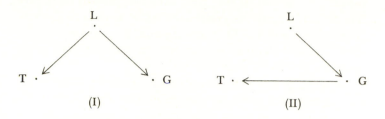

(I) (II)

The available facts about the time of creation of the two poems combined with an analysis of similarities and differences between the works of the three authors mentioned in the quotation makes Nilsson reject hypothesis (I) and accept hypothesis (II).

When Albert Nilsson writes here that it is inconceivable that two Swedish poets "independently of each other and almost at the same time" should have created the same myth with Lessing's treatise as a point of departure, and goes on to conclude that Tegnér was influenced by Grafström, it seems reasonable to interpret this conclusion as saying or implying that Tegnér's contact with the poem by Grafström is a part of a sufficient condition for the way Tegnér rendered his poem *Nattvardsbarnen*; the situation was such that if the contact, in addition to several other circumstances, took place at a certain time, then Tegnér's poem was created in the way it was.

But it also seems quite clear from the last sentence of the quotation that Nilsson would want to argue that Tegnér's contact with the poem by Grafström was also a necessary

Grafström, som på grundvalen av den korta passagen om den omtvistade antika figuren skapar en ny myt. Det är alldeles otänkbart, att tvänne *svenska* skalder oberoende av varandra och nära nog *samtidigt* skulle med uppslaget hämtat ur Lessings avhandling skapa samma myt.

condition for Tegnér's new version of the classic myth: if Tegnér had not been familiar with the poem by Grafström —which he was—then Tegnér's poem would not have been created in the way it was and with the properties it now has. Here the term "necessary condition" is used in the fairly strong sense of the first definition in the previous subsection. This last claim by Albert Nilsson raises an interesting question, to which I shall now turn.

On what grounds can counterfactual conditionals of the kind mentioned above be asserted? What evidence is used —or could be used—to support such statements? In the present case, the answer to the questions above would probably be something along these lines: knowledge about Tegnér's artistic imagination and methods of creation, various historical facts, and general knowledge of the ways in which human beings behave. Knowledge about other influence relations can also be used to support Nilsson's claim. Let us call the statements which express all this knowledge the *basis* of the counterfactual conditional. It is interesting to note that this basis contains statements of several kinds: statements about facts, common sense assumptions, statistic generalizations, and so forth.

I shall now discuss a somewhat different example. In his book *The Influence of Ezra Pound*, K. L. Goodwin compares two different versions—from 1913 and 1922, respectively—of Yeats' poem *The Folly of Being Comforted*. Having quoted the two versions, Goodwin continues as follows:

> It will be readily seen that even these changes are of little importance. They certainly seem to bear no marks of Pound's tuition, *for Yeats was quite capable of making such changes by himself,* and in any case Pound was not present when the changes were made.
>
> As no poem was altered more than "The Folly of Being Comforted," and as alterations made in other poems are of the same type as those in this poem, it can be suggested with some confidence that *Pound had virtually no influ-*

ence on the revision of the poems written by Yeats before he met Pound.[66]

According to Goodwin, the hypothesis that Pound had any influence on these changes is thus unnecessary, since "Yeats was quite capable of making such changes by himself." This means that the contact with Pound was not a necessary condition for the revision of Yeats' poem; consequently, the contact was not a necessary condition *and* a part of a sufficient condition for the revision.

On the basis of examinations of these and other examples I shall now propose the following rule, which is intended to make clear the nature of the causal connection implied in hypotheses about influence: if a visual or literary work of art X influenced the creation of the work of art Y, and if Y was created by the artist or poet B, then B's contact with X was a necessary condition, and a part of a sufficient condition, for the creation of Y. This rule can be applied to artistic as well as literary influence, and there seems to be no reason to doubt that the same type of causal connection is also often implied by hypotheses about nonartistic influence.

However, it is probably wise to be careful at this point. It should be stressed that both art historians and scholars in comparative literature sometimes make very vague, cautious, and noncommitting statements about influences. A hypothesis about influence can be put forth as an interesting possibility, and in such cases the scholar probably does not want to commit himself to asserting or defending a particular or precise hypothesis. For example, Gunnar Tideström writes in *Lyrisk Tidsspegel* that

Heidenstam's Jairi dotter . . . can by the way not have been without importance for the creation of the poem by Lagerkvist.[67]

[66] Goodwin, *The Influence of Ezra Pound*, p. 87, my italics.
[67] Gunnar Tideström, "[Analys av] Lagerkvist *I själens gränder*," *Lyrisk Tidsspegel*, Lund: Gleerups, 1960, pp. 185–86. My translation.

This is a cautiously worded statement about literary influence, which can be stretched in various directions. It can be interpreted as a definite statement about a weaker causal connection than the one I suggested in my rule above. But it can also be interpreted as an indefinite statement about a causal connection of the kind indicated in my rule. As far as I can see, there is no reason showing that the former interpretation is more reasonable in this context than the latter.

Also the following quotation—taken from Sten Malmström's *Studier över stilen i Stagnelius lyrik*—can, it seems, be analyzed in a similar fashion. It illustrates well how a scholar may suggest influence hypotheses without committing himself to any of these particular hypotheses he is suggesting. Malmström writes as follows:

> The meter of these lines [from the introduction to the Phosphoros-prologue] corresponds exactly to the meter in the latter half of Stagnelius' poem. And there are also other formal similarities between the introduction to the Phosphoros-prologue and the poem *Amanda*. . . . Stagnelius' first lines express—like those of the prologue—enchanted feeling of the New Creation, more precisely Stagnelius' feeling of the re-creation of nature in the love to Amanda. Something of the feeling expressed in

The original Swedish text reads as follows: "Heidenstams Jairi dotter . . . väl för övrigt inte kan ha varit utan betydelse för den lagerkvistska diktens konception." Cf. also John Rewald's statement in *The History of Impressionism* (New York: Museum of Modern Art, 1961, p. 171: "At the last minute Manet had painted for his exhibition a large canvas representing the execution of Emperor Maximilian, a work inspired by the tragic events of June 1867 (and not unrelated to the treatment of a similar subject by Goya)." Since, strictly speaking, everything is related to everything else, at least by being different from it, I interpret Rewald's parenthetical remark as suggesting that Manet's *The Death of Maximilian* (figure 6) was influenced by Goya's *May 3, 1808 in Madrid* (figure 5). As will be seen later on in this book, this cautious suggestion has been developed more fully by other writers, in particular by Nils Gösta Sandblad.

the Phosphoros-prologue may have been present in Stagnelius' mind, when he created Amanda in a related meter. But he can also have been inspired (as far as the meter is concerned) from other directions, from poems of a more elegiac sort.[68]

The main point of the quotation may be rephrased in the following somewhat abstract way.

Here (and on the following page in his book) Malmström compares a work *Y* with two other works *X* and *Z*, both of which were written before *Y*. He points out similarities between *X* and *Y* and between *Z* and *Y*. He suggests that there may have been influence with phrases such as "the feeling expressed in the Phosphoros-prologue *may* have been present," and "he *can* also have been inspired." The author does not want to take a stand and choose between these hypotheses "*X* influenced *Y*" and "*Z* influenced *Y*" respectively. Nor does he want to commit himself in any definite way as to grading the causal relevance of the factors *X* and *Y*.

1.5.3. *Influence Statements as Explanations*

Influence statements can be analyzed as a particular kind of causal explanation. As is well known, explanations of various sorts have been the subject of long and intensive discussions in the philosophy of science over the last decades. It should therefore be rewarding to try to relate the analysis of the concept (or concepts) of influence—and of

[68] Malmström, *Stagnelius lyrik*, p. 415. My translation. The original Swedish text reads as follows: Versschemat i dessa rader [från Phosphoros-prologens inledning] motsvarar exakt schemat i den senare hälften av Stagnelius' strof. Och det finns andra formella likheter mella Phosphoros-prologens inledning och dikten Amanda. . . . Stagnelius' inledningsstrof uttrycker liksom Prologens en hänförd känsla av Den nya skapelsen, närmare bestämt Stagnelius' känsla av naturens pånyttfödelse i kärleken till Amanda. Något av Phosphoros-prologens stämning kan ha varit närvarande i Stagnelius' medvetande, när han diktade Amanda i ett besläktat versmått. Men han kan ha hämtat metrisk impuls också från ett annat håll, från diktverk av mer elegisk hållning.

discussions as to whether X in a particular case did influence Y or not—to the general problems of explanation. In this subsection I intend to make an attempt in that direction.

Consider a sentence of the following kind:

X influenced Y with respect to a (choice of motifs, style, expression, technique, symbolism, meter, rhythm, rhymes, and so forth).

Such sentences can be used to answer questions like: "Why has Y this or that particular property?" and "How is it possible that—or how could it happen that—Y was created with this or that particular property?" These questions are clearly requests for explanations.

The fact that art historians have also observed a connection between hypotheses about influence and explanations is suggested by the following quotation from Aron Andersson's book *English Influence in Norwegian and Swedish Figure Sculpture in Wood*:

> This is not meant as a denial of the obvious relationship between the Austrât Madonna and the Wells sculpture; but it deserves to be pointed out that one cannot altogether *explain* the Austrât figure on the basis of the Wells sculpture; her features are younger and—partly—differing from those of the latter.[69]

What Andersson seems to be saying in the quotation above is this: the Austrât Madonna was influenced by the Wells sculpture, and this fact helps to explain some features of the Austrât Madonna; but it does not explain all her features. Perhaps the author thinks that these other features could be explained by other influences, or perhaps he thinks they could be explained in some other way; he does not take a stand on this issue in the lines quoted above.

[69] Aron Andersson, *English Influence in Norwegian and Swedish Figure Sculpture in Wood, 1220–1270*, Stockholm, 1949, p. 117, my italics.

It is not difficult to find other examples. In his book *Jan van Eyck*, Ludwig Baldass writes as follows:

> In the more advanced wing-panels with the standing figures of the Virgin and St. Veronica, in the same museum, many details (treatment of the flesh, clothing materials, such as veil, cloth, fur, leather, brocade, backgrounds and grassy terrain with minutely rendered flowers) reveal a material characterization of their texture. We must here assume an influence exercised by Jan van Eyck's art, probably derived from the panels of the Ghent altarpiece, which at that time had just been completed.[70]

The expression "we must here assume" could, I suggest, be interpreted as implying that the hypothesis about influence put forward in the quotation according to Baldass is the only reasonable or possible explanation of the many similarities between the works of art referred to.

Another example is the following quotation from Alfred Moir's *The Italian Followers of Caravaggio*. There Moir discusses two paintings by the Italian artist Artemisia, both of which represent Judith with the head of Holofernes. One of these paintings is now in Detroit, the other in Florence (Pitti). Moir concludes the comparison between the two pictures with these words:

> The glossy illusionism and the light system of the Detroit painting are notably inconsistent with the handling and the light of the other painting, but this contradiction can perhaps be *explained* as a manifestation of Artemisia's contact in Rome before she went to Florence, with such members of her father's circle as Cavarozzi, and with such northern painters as Cecco and Honthorst.[71]

The problem of explanation can here be reconstructed as follows. Artemisia Gentileschi has created two paintings representing the same motif. According to Moir, the paint-

[70] Ludwig Baldass, *Jan van Eyck*, London: Phaidon, 1952, p. 88.
[71] Moir, *The Italian Followers of Caravaggio*, p. 101, my italics.

ings are created at about the same time (the second decade of the seventeenth century). It would then perhaps be reasonable to expect the two paintings to be similar to each other. But as a matter of fact the Detroit version and the Pitti version are "notably inconsistent" in some respects, particularly concerning "the glossy illusionism" and "the light system." Why?

These differences can surely be explained in many ways. Moir chooses to explain them by making a conjecture about influences. If we assume that the creation of one of Artemisia's paintings was influenced by one or more of the three painters Cavarozzi, Cecco, or Honthorst, then this will—according to Moir—explain why the pictures are different from each other. He presupposes, it seems, that one of Artemisia's paintings is more similar to some particular paintings by the three artists referred to than it is similar to Artemisia's other painting with respect to "glossy illusionism" and "light system."

If this presupposition is true—and that is, of course, something that has to be demonstrated by empirical research—then the hypothesis about influence seems to satisfy a rather elementary and fundamental requirement of an explanation: the explanatory hypothesis can be a premise of a deductive or an inductive inference, where the conclusion is a statement describing that which is to be explained. But it remains to be shown, of course, that it is true that one or more of the three painters really did have any influence on the creation of one of Artemisia's paintings.

If the relation of explanation is defined as a relation between a statement describing a fact (event, action, process, regularity) and a statement answering the question: "Why is this object like this?" or "Why did this event (etc.) take place at the time and in the way it did?" then it is obvious that influence statements provide us with explanations; they indicate *why* works of art have certain definite properties, and they provide us with causal explanations, since they

indicate the cause or at least a cause of the fact that the works of art in question have these properties.

An example of such an explanation might be stated as follows: "Höckert created his *Brudfärd på Hornavan* the way he did, because he was influenced by Tidemand's *Brudefaerd i Hardanger.*" I suppose then that Höckert's contact with Tidemand's painting was a part of a sufficient condition and also a necessary condition for Höckert's creation of his painting. The last words of the previous sentence could, however, be misunderstood. I do not merely want to say that this contact was part of a sufficient condition and also a necessary condition for the fact that Höckert created his painting—it was part of a sufficient condition and also a necessary condition for the fact that he created his painting in the way he did; and that is something quite different.

Thus, influence hypotheses can be part of explanations. But they also include explanations. This can be illustrated in the following somewhat abstract way. Consider the explanatory schema:

(a) The visual or literary work of art Y has the property P, because the person who created Y was influenced by the work of art X.

Sentences of this type can be interpreted as implying:

(a_1) It is a fact that the work of art (poem, etc.) Y has the particular property P.

(a_2) This fact depends on the fact that the person who created Y has acted in a particular way.

(a_3) The fact that the creator of Y acted in this way depends on the fact that he was influenced by X.

It can readily be seen that two different explanations are involved here.

1.5.4 *Explanations of Influences*

Moreover, a third explanation may be added. For it can be asked why the person who created Y was influenced by

123

X on this occasion, or why he was influenced by X rather than by Z. Thus we may add the following statement to the previous three:

(a_4) The fact that the creator of Y was influenced by X depends on the fact that p,

and here p may be replaced by descriptions of the dispositions of the person who created Y ("he was open to new ideas") and of certain events ("he saw or read X").

This new level of explanation might be illustrated by the following example. In a paper on Flemish influence in Italian art, Guy de Tervarent discusses what might be represented in an engraving by Marcantonio Raimondi and a painting of the school of the brothers Dossi in the Dresden Gallery. The engraving shows "two nude women asleep on the bank of a river, while a fire rages on the opposite bank."[72] The similarity of the subject in the two works are striking, and de Tervarent suggests that a verse attributed to Statius provides the key to Marcantonio's engraving and to the Dresden picture. He also points out that Flemish influence is obvious in both these works of art: "The monsters in the engraving as well as the incendiary in the background of the painting are exactly in the manner of Hieronymus Bosch."[73]

This influence raises a new problem to the author: "How can this influence which has long been recognised be explained?" The explanation suggested by de Tervarent is as follows. First he mentions that in 1521 a now lost picture by Bosch entitled "tella dei sogni"—the canvas of dreams—was to be seen in the collection of Cardinal Grimani at Venice. Then he calls attention to the fact that a work of the Flemish school of the fifteenth century, destroyed in 1943, "represented a dream exactly in the manner of Italian artists of the sixteenth century."[74]

[72] Guy de Tervarent, "Instances of Flemish Influence in Italian Art," *BM*, LXXXIV, p. 290.

[73] *Ibid.*, p. 294. [74] *Ibid.*

Guy de Tervarent describes the subject matter of the latter painting in the following way:

> In the foreground a figure was asleep under a tent. The rest of the composition was devoted to its dreams. Monstrous creatures in the manner of Hieronymus Bosch covered the canvas. These, however, did not flee from Apollo and his light, but from that of the Christ Child, Who blesses with His right hand and in His left holds the globe with the cross, as He is represented in the famous Prague statue.[75]

The author then immediately concludes:

> Marcantonio Raimondi as well as the Dossi school were thus indebted to the Flemish school—represented before their eyes by a work of Bosch or one of his school, like that in the Museo Filangieri—for the arrangement of the scene, the sleeping figure in the foreground, and for certain details such as the fire and the monsters.[76]

But does this conclusion follow from the sentences preceding it?

Of course, it does not, unless a number of extra premises are added. I am quite sure de Tervarent is well aware of this, and I mention it only for the opportunity of indicating what form a more complete explanation might take. The basic idea in de Tervarent's explanation can be schematized as follows: the influence from X to Y has been mediated by Z; the latter provides the link between X and Y. But if this is so, then one must, of course, also show that the person who created Y was familiar with Z and was in a formable state of his development and thus had a disposition to become influenced; if he is not open to new ideas, he might very well see a work without being influenced by it.

Finally, in order to do justice to the artists involved and to de Tervarent, I hasten to add that he carefully delimits the scope of the influence:

[75] *Ibid.* [76] *Ibid.*

What the Italian artists of the sixteenth century bor-
rowed from the Flemish artists of the fifteenth century
only concerns the form and does not go beyond the
technique.[77]

1.5.5 *Concluding Remarks*

I have suggested that the causal statements involved in ex-
planations of this sort should be analyzed as counterfactual
conditionals, and I have also suggested that the basis of
these counterfactuals might be of several different kinds.
In concluding this section, I would like to return to and
amplify this point.

There seem to be interesting differences between various
statements about influence in respect to the basis of the
counterfactuals. For example, when a critic or scholar
argues that van Gogh's mental illness influenced his way of
painting, he is obviously assuming that there is some kind
of causal connection between the painter's illness and the
style (etc.) of his paintings. This assumption can be sup-
ported by referring to empirical laws or regularities. But
it is not clear that one could support the contention that
Tegnér got the idea for his poem *Nattvardsbarnen* from
Grafström in the same way.

In fact, the bases of hypotheses about influence can be of
many different kinds. They can be general assumptions of
varying precision, generalizations of more or less common-
sense knowledge concerning all people at all places and at
all times, or some people at some places and at some times.
These generalizations may be mentioned explicitly, though
usually they are taken for granted implicitly. But the
counterfactuals involved can also be based on more or less
well-established psychological and historical facts. For in-
stance, a literary scholar may talk about certain peculiarities
in the conception of reality of a particular poet at a certain
time and place, and use a statement about this conception

[77] *Ibid.*

as a basis for a counterfactual conditional without wishing to make any general claims about other poets.

All this raises interesting questions about the logic of counterfactual conditionals and the possibilities of defining general truth conditions for these statements. I would be inclined to think that it is extremely difficult, if not impossible, to define any general conditions of this kind, since the bases of various kinds of counterfactuals are so different. It would, however, carry us too far away from the main line of this investigation to go into these problems here.[78]

1.6 NORMATIVE IMPLICATIONS

There is sometimes a very thin line between legitimate influence and plagiarism, and between plagiarism and forgery. Indeed, it would seem appropriate to represent the relations between these concepts by sliding scales of the following type:

LITERATURE

influence	imitation	plagiarism

ART

influence	imitation	plagiarism	forgery

I am using two scales, since one talks about forgeries in the visual arts but not in literature.

[78] For a general introduction to these problems, I shall have to refer interested readers to the by now classical article by Nelson Goodman, "The Problem of Counterfactual Conditionals," *Journal of Philosophy*, XLIV, 1947, pp. 113–28; reprinted with minor changes in Goodman, *Fact, Fiction, and Forecast*, New York: Bobbs-Merrill, 1965.

127

The diagram suggests that there is no sharp distinction between influence, imitation, plagiarism, and so forth; it is a difference in degree rather than in kind. This is not quite correct, granted that the requirements I have laid down in section 1.4 are accepted. Though this figure represents a great deal of oversimplification in other respects, as will soon become apparent, it may be useful as a point of departure for the discussion in the present section, which will focus on the normative (moral, legal, etc.) implications of statements about influence.

Statements like "X is a plagiarism of Y" and "X is a forgery of Y" have fairly obvious normative and legal implications. That this is so is evident from the standard definitions of these terms in works like the *Oxford English Dictionary*. For example, the *OED* defines plagiarism as "the *wrongful* appropriation or purloining, and publication as one's own, of the ideas, or the expression of the ideas, . . . of another." The normative implications of statements to the effect that X is a forgery of Y are still more obvious; there are laws against forgery and these laws are much more severe than those against plagiarism.

Plagiarism is said to be a "wrongful appropriation or purloining." But what is wrong with plagiarism? In what sense has an artist who produces plagiarisms of the works of other artists done anything wrong? Clearly, moral blame is involved here. If he presents the ideas taken from others as his own, he is trying to deceive others; and deceit is morally offensive. But that is not all. Artistic blame is also involved, since the notion of art is currently closely tied to that of originality. If a work of art X is plagiarism of another work of art Y, then X is not very original. But aesthetic blame need not at all be involved. Aesthetically, the plagiarism can be as satisfactory as an original work of art.[79]

[79] These remarks seem to hold for forgery as well. Cf. Alfred Lessing, "What Is Wrong with a Forgery?" *JAAC*, XXIII, 1965, reprinted in Monroe Beardsley and Herbert Schueller, *Aesthetic Inquiry*, Belmont:

Also statements to the effect that a work of art Y was influenced by another work of art X may have normative implications, though the situation is here more complex than in the case of plagiarism and forgery. In the following subsections I shall try to call attention to some of these complications and to clarify the relations between making causal judgments and attributing praise or blame.

1.6.1 *Influence, Originality, and Artistic Value*

Before I try to explore the relationships between the notions of influence, originality, and artistic value, I propose to distinguish between (a) originality as a characteristic of artists, and (b) originality as a characteristic of works of art. In the first case, "originality" is used to describe the behavior of persons; in the second case it refers to an aesthetic quality. In this section I shall concentrate on originality in the first sense, since I am discussing artistic rather than aesthetic value. (If there is such an aesthetic quality as originality, it is relevant to discussions of aesthetic rather than artistic value.)

The connection which many people make between such notions as influence and artistic value can be illustrated by the following quotation from Roland Penrose's book on Picasso:

> the infectious influence of Picasso both as a man and as an artist is immense. . . . Power is inherent in his work, and we are in the habit of judging the greatness of a painter by the strength he has to affect ourselves and others.[80]

Dickensson, 1967, pp. 241–52. See also Nelson Goodman, *Languages of Art*, Indianapolis & New York: Bobbs-Merrill, 1968, chapter 3, and the critical discussion of Goodman's views in Richard Rudner, "On Seeing What We Shall See," in Richard Rudner and Israel Scheffler, eds., *Logic and Art. Essays in Honor of Nelson Goodman*, Indianapolis & New York: Bobbs-Merrill, 1972, pp. 163–94.

[80] Penrose, *Picasso*, p. 417.

129

This can be taken as a psychological generalization or as a semantic statement about what the reasons for certain kinds of value judgments are. But interpreted in either way, it shows an interesting connection between the concepts of artistic value ("the greatness of a painter") and influence ("the capacity he has to affect ourselves and others").

This connection can be spelled out in the following preliminary way. If it is believed that an artist or a writer B has invented new techniques, styles, symbols, or modes of expression, then he is usually praised for this; originality is generally considered to be artistically valuable. If, however, it is later discovered that this particular artist or writer was influenced by some other artist A in the relevant respect, and thus got the idea of the artistic invention from him, then part of the praise earlier given to B now goes to A instead.

In discussing the normative implications of the concept of influence, it is, of course, necessary to distinguish between the work of art as a whole and the particular respect in which it was influenced by another work. If X and Y are poems, and if the poet who created Y got the idea of his poem from X, or has borrowed a few metaphors from X, then he is not original in this respect. But his poem Y can still be far better than the poem X as a whole, and the poet who created Y can be original in the way he has used his sources of inspiration.

Similarly it can be argued that Shakespeare was not a poor playwright just because he sometimes used stories taken from Italian writers, thoughts from French writers, and verses from older compatriots. The point is that what we appreciate in Shakespeare is not that he borrowed extensively (if this is so) but rather something else: that he succeeded in creating unique and coherent works of art of all these borrowings and impulses. The moral of this is that one should have a less moralistic view of influence: it need not be a fault or a sign of weakness to be influenced by others; and this, in turn, would be to challenge the

basically Romantic conception of originality as the supreme value in art.[81]

In summary, the idea that statements about influence have normative implications, should not be construed as:

(a) If X influenced Y with respect to a, then X is a better work of art than Y.

This statement represents a misunderstanding which I am anxious to avoid. Instead (a) should be replaced by

(b) If X influenced Y with respect to a, then the praise (or blame) for the invention of a goes to the creator of X rather than to the creator of Y.

This statement is finally, of course, compatible with:

(c) If X influenced the creation of Y with respect to a, then Y as a whole is an infinitely better work of art than X is.

The distinctions between (a), (b), and (c) seem obvious enough, at least as far as influence in the extended sense is concerned, but some complications will be discussed later in this section.

If (b) is correct, then discussions about artistic and literary influence can to some extent have a normative character and concern the question of who is to praise or blame for an artistic invention. Suppose that three persons disagree as to which of the following three statements is true:

(1) X influenced the creation of Y with respect to a (style, subject matter, expression, and so forth).

(2) It was Z and not X which influenced the creation of Y with respect to a (style, subject matter, etc.).

(3) The creation of Y with respect to a was neither influenced by X nor by Y nor by any other work of art.

[81] This has been argued by Louise Vinge in her review of Lars Gustafsson's anthology, *Forskningsfält och metoder inom litteraturvetenskapen*, in *Samlaren*, 1971, pp. 274-77.

This disagreement can then partly concern normative questions and questions of value. This is also true when persons are grading the relative importance of the influence of different works of art and, for example, discuss whether the influence from X was more important than that from Z.

The implicit normative views of the three persons arguing about (1), (2), and (3) may then be stated roughly as follows:

(1)′ The creator of X ought to be praised for the artistic invention with respect to *a* for which the creator of Y previously was praised.

(2)′ The creator of Z ought to be praised for the artistic invention with respect to *a* for which the creator of Y previously was praised.

(3)′ Neither the creator of X nor the creator of Z nor anyone else but the creator of Y ought to be praised for the artistic invention with respect to *a*.

The strong connection, or indeed the identification, between the concepts of artistic value and originality, also means that lack of originality will be taken as an artistic weakness or fault. It is then not only true that the positive value previously ascribed to Y is transferred to other works like X and Z—or to their creators. It is also true that this previous positive attitude towards Y is replaced by a negative attitude.

If this is the case, it means that causal judgments of the kind considered here—statements to the effect that the creation of one work of art was influenced by another—are tied to attribution of praise or blame according to the following schema:

(N 1) If the creation of Y in a particular respect *a* was influenced by X, then the creator of X ought to get the praise or blame (or at least an essential share of it) for the fact that Y with respect to *a* looks the way it does.

(N 1) is a norm which states the conditions under which someone ought to be praised or blamed. Since praise and blame of the sort relevant here cannot be classified as norms, (N 1) cannot be classified as a supernorm in the sense explained by Manfred Moritz,[82] but (N 1) resembles in several important respects these supernorms. If we accept (N 1), which I think many people in our culture would be willing to do, then it is possible to explain in what way statements like "X influenced Y with respect to a" can have normative implications and be used to express practical (nontheoretical) judgments, or at least judgments that have nontheoretical components.

In that case it is also possible to explain why research into influences has sometimes been strongly resented by artists and writers themselves, and occasionally led them to deny rather obvious influences. Even if the scholar did not intend to make any implications of this sort, statements to the effect that one work of art was influenced by another have frequently been understood as implying accusations of unimaginativeness, lack of originality, plagiarism, theft, and so forth.

Incidentally, the normative implications of statements about influence are also indicated by the very words sometimes used in formulating these hypotheses, in particular "owes," "debt," "indebted," and "debtor." There are numerous examples of the use of these words in the material collected in the bibliography of the present book. These words are also used in stating problems like: What was Shakespeare's debt to Montaigne? How much does Shakespeare owe to Boccaccio? The economic metaphors used in these questions have normative implications; at least, they do when they are used literally. If X owes 20 dollars to Y, then X ought to pay Y back 20 dollars.

[82] See Manfred Moritz, "On Super-Norms," *Ratio*, X, 1968, pp. 101–15.

1.6.2 *Some Distinctions*

However, the precise sense in which statements about influence have or can have normative implications is far from clear, and it will therefore be necessary to introduce a few distinctions.

It is obviously important to distinguish between the norm (N 1) stated above and:

> (N 2) If the creation of *Y* in a particular respect *a* was influenced by *X*, then someone thinks that the creator of *X* ought to get the praise or blame (or at least an essential share of it) for the fact that *Y* with respect to *a* looks the way it does.

This sentence does not state the conditions under which someone ought to be praised or blamed. The then clause in (N 2) is clearly a theoretical statement, and the if clause in this sentence states a sufficient condition for the truth of the then clause. Thus (N 1) and (N 2) are fundamentally different.

However, (N 2) can be understood in several ways. For one thing, it is necessary to make clear who "someone" in the then clause refers to. At this point, several suggestions present themselves: this term might refer to the art historian who has discovered the fact that *Y* was influenced by *X*, or to his readers, or to a combination of the two. Furthermore, it should be stressed that (N 1) and (N 2) need not exclude each other; on the contrary, they can easily be combined with each other. In what follows I shall try to develop and clarify these ideas.

(A) *The normative action and intention of the art historian.* To utter or write a sentence is to perform a special kind of action. These actions can be analyzed and classified in a variety of ways; I am now thinking of the late John Austin's classification of different types of speech acts,[83] and

[83] John Austin, *How to Do Things with Words*, London, Oxford and New York: Oxford University Press, Clarendon Press, 1962.

the vast literature to which his ideas have given rise, including contributions by William Alston and John Searle. The distinctions made by these authors can be applied fruitfully to our present problem.[84]

The fact that the previous positive evaluation of Y in this context is transferred to X can be understood as follows: in saying or writing that X influenced Y with respect to a the author is giving an essential share of the praise (or blame) for the fact that Y with respect to a looks the way it does to X, or perhaps to the creator of X, rather than to the creator of Y. If this is true, then statements about artistic influence have an illocutionary dimension (in the sense of Austin) which it would be worthwhile to investigate in some detail.

It is easy to make variations on the analysis suggested above. For instance, it is possible to replace "is giving" with "intends to give." In that way we obtain a new analysis which should be distinguished clearly from the first one, since it is possible either to perform an action without in-

[84] John Austin distinguishes between what he calls locutionary, illocutionary, and perlocutionary acts. This distinction can be explained roughly as follows. Suppose someone says: "Please close the door." To utter a sentence is to perform a locutionary act. *In* uttering this sentence the speaker is doing something, for instance, asking someone to close the door. This is the illocutionary act. (The speaker may of course also be testing his voice or doing other things.) *By* uttering this sentence the speaker may bring about various results, such as getting someone to close the door. To get someone to do something would be an example of a perlocutionary act. The two main differences between perlocutionary and illocutionary acts seem to be these. First, perlocutionary acts essentially involve the production of an effect (getting someone to do something). This is not true of illocutionary acts. Second, an illocutionary act requires a locutionary act as a base. This is not true of perlocutionary acts. These distinctions have been discussed widely in the philosophy of language in recent years. See Austin, *How to Do Things with Words*, lectures viii and following; William P. Alston, *Philosophy of Language*, Englewood Cliffs: Prentice Hall, 1964, pp. 34–36; John Searle, *Speech Acts*, New York: Cambridge University Press, 1969; and Mats Furberg, *Saying and Meaning*, Oxford: Basil Blackwell, 1971.

tending to do so or to intend to perform an action but fail. However, these two analyses can easily be combined with each other. Moreover, the analysis in terms of the intentions of the scholars can be supplemented with a clause saying that the speaker or writer—that is, for example, the art historian—wants his readers to understand his intention to praise or blame X, or the creator of X, rather than the creator of Y.

So far, I have suggested some possible senses in which statements to the effect that one work of art Y was influenced by another X can be said to have normative implications. I have above dealt exclusively with the case when "someone" in (N 2) above is replaced by a name or description of the person who makes the statement about influence (art historians, literary scholars). Now I shall turn to the other main alternative: when "someone" in (N 2) is replaced by a name or description of those who have heard or read that X influenced Y, or by a name or description of a proper subset of this group.

(B) *The normative effects on the readers.* Several objections may be made against the analysis proposed above. For example, it may be argued that art historians and literary historians consider themselves to state "objective facts" when they discover and state that influence has taken place; they do not make any evaluative or normative judgments, nor do they intend to make any judgments of this kind. They would probably admit that it is possible that some readers may draw normative or evaluative conclusions on the basis of facts discovered by themselves and by other scholars, but they would argue that they did not intend to make the readers draw these conclusions.

However, this objection need not be conclusive. Art historians and other scholars in the humanities may very well have mistaken theories about their own research and the implications of the statements they make. But the objection nevertheless suggests that it might be worthwhile to look

for other analyses such as, for instance, the following one. To say that the previous positive evaluation of Y is transferred to X can also be understood as follows. Let p be a statement to the effect that Y was influenced by X with respect to a. Let F be the fact that Y with respect to a looks the way it does. Now the transference of evaluation means that p will make those who read or hear it give an essential share of the praise for F to X, or perhaps to the creator of X, rather than to the creator of Y, since the former and not the latter was the original artist.

Also in this case it is easy to make variations on the analysis suggested above. For example, it is possible to replace "will make" with "will tend to make," "will probably make," "will have a disposition to make," and so forth. In that way we can get probabilistic analyses and dispositional analyses of what it means to say that statements about artistic influence have normative implications. The analyses suggested here under (B) can be tested by empirical investigations, and they can also be combined with the ones suggested above under (A).

I shall now discuss some examples which indicate that art historians themselves are aware of the normative implications of statements about influence. In that way I hope to be able to illustrate some of the distinctions made above under (A) and (B).

(C) *Some examples.* In a paper on Rembrandt's links with the tradition, Frits Lugt makes the following observation:

> If the revelation of his numerous borrowings shows him as a more humanly comprehensible genius, this question continues to astonish many people; they feel disappointed, almost betrayed.[85]

Here the author is clearly discussing the normative effects on readers of statements about influence; apparently they

[85] Lugt, "Rembrandt," p. 39.

137

feel disappointed, because they consider Rembrandt to be a great artist and think that if he borrowed extensively from other artists, then he cannot be as great as they thought.

The second example is taken from Charles de Tolnay's book on Hieronymus Bosch, where he makes the following comments on the earlier research by Fraenger on Bosch:

> Although Fraenger's writings contain interesting observations on points of detail, on the whole the figure of Bosch appears as a passive transmitter of the ideas of his presumed patron, Jacob van Almangien, and inadequate justice is done to the creative originality of the master.[86]

The phrase "inadequate justice is done" has obvious normative implications; Bosch appears as an uninteresting and unimaginative painter, and too great a share of the praise goes, according to de Tolnay, to Jacob van Almangien.

The criticism of de Tolnay can here be interpreted in several ways along the lines outlined above. He can be understood as saying that Fraenger, in making all these claims about influence, gives too much praise to those who have influenced Bosch. But he may also be understood as saying that although much of what Fraenger says is true, it will make (or tend to make) readers give too much praise to Almangien and too little to Bosch. Though both interpretations are possible and can very well be combined with each other, the latter is perhaps the most interesting one here.

The next example is the following quotation taken from Nils Gösta Sandblad's previously mentioned book on Manet:

> Manet has, one might say, been sufficiently well laden with external influences. Only in the preceding investigation has it been shown how deeply, in spite of everything,

[86] Charles de Tolnay, *Hieronymus Bosch*, London: Methuen, 1966, p. 415.

he was bound to the traditions of Couture's studio, to how great an extent his imagination was fed by the classical works in the museums of Europe, and how closely he followed the dictum of Baudelaire, from *La Musique aux Tuileries* onwards, in taking as materials for his painting the bustling city-life going on about him. What would be left of his self-reliance, his lightheartedness and his instinctive spontaneity if one must also ransack his art for the effects of his short visits to Madame de Soye's shop when, going with Baudelaire from the Tuileries to the Café Tortini, he passed the Rue de Rivoli?[87]

If read benevolently, this quotation might be interpreted in the following way.

If it is true that Manet's paintings were influenced by the works of many artists in many important respects, then Manet will on the whole appear as a rather uninteresting painter. Now Sandblad himself has shown how deeply Manet was influenced by the traditions of Couture's studio, the classical works in the museums of Europe, and so forth. Sandblad acknowledges that if one were also to "ransack his art for the effects of the short visits to Madame de Soye's shop," then not much would remain of the previously praised valuable qualities in Manet's paintings: "his self-reliance, his lightheartedness, and his instinctive spontaneity." The question at the end of the quotation suggests that Sandblad is well aware of the fact that his readers are likely to change their previously positive attitudes to Manet on the basis of these claims about influence.

The following example, taken from Lawrence Gowing's book, *Vermeer,* is perhaps even clearer:

Consideration of the sources of so pure a painter, and it will later be necessary to pursue them in some detail, has none the less an air of incongruity; we are apt to regard

[87] Sandblad, *Manet,* pp. 79–80.

139

each new debt as a new limitation. In Vermeer's case at least the contrary is more true.[88]

Here there can be no doubt that the author is aware of the normative implications of statements about influence. The key passage of the quotation above is "we are apt to regard each new debt as a new limitation." I shall now make four brief comments on this statement.

First, it is not quite clear exactly which persons Gowing refers to as "we"—it may be anyone who reads his book, or only certain of his readers; and he might (or might not) want to include himself in this group. Second, the word "apt" suggests that the author is hinting at normative implications of the kind described above under heading (B); or, to be somewhat more precise, this expression suggests that Gowing is thinking of something like the dispositional version of this kind of normative implication. Third, the word "debt" is value-loaded, as I have already pointed out; if you are in debt to someone, then you owe something to this person. It is surely no accident that the author has chosen a term with these moral overtones. Finally, Gowing does not specify exactly what limitation he has in mind, but I think it is fairly safe to assume that he is thinking of limitations of the artistic achievements of Vermeer (or of the artistic value of his paintings).

In this context I would also like to call attention to a passage in Norman Fedder's *The Influence of D. H. Lawrence on Tennessee Williams*. This book contains analyses and discussions of parallels between texts written by these two authors, and it concludes with what the author calls an attempt "to define the extent of Williams' artistic achievement in comparison with the works which so profoundly inspired it."[89] Here the connection between the concepts of influence, originality, and artistic value seems rather obvious; Williams' artistic achievement is, according to Fedder, a

[88] Lawrence Gowing, *Vermeer*, 2nd ed., London: Faber & Faber, 1970, p. 33.

[89] Fedder, *The Influence of D. H. Lawrence on Tennessee Williams*, p. 6.

function of the extent to which his works are original and hence not influenced by those of D. H. Lawrence.

(D) *Conclusions.* In this subsection I have tried to distinguish between some of the senses in which statements to the effect that one work of art was influenced by another can have normative implications. I have also tried to illustrate some of these senses with quotations from writings on the history of art and literature. So far, I have distinguished between six main senses. Each of them can occur separately, but they can also be combined with each other in a variety of ways. The total number of possible senses is thus considerable. This fact is the first main complication of the claim that statements about artistic influence have normative implications. In the next two sections I shall discuss two other complications.

1.6.3 *Art and Originality: A Historical Digression*

What I have said in the previous section suggests that the normative implications of statments about influence are no doubt due to the high value attached to artistic originality. But originality has not always been as highly praised as it is at the moment; artists and patrons of art have at different times had different attitudes toward imitation and originality in art. It is therefore necessary to discuss the normative implications of influence statements relative to a particular medium (painting, literature, or music) at a particular time and place.

Let us make a brief historical digression. In 1759 the English poet Edward Young wrote a book, which he called *Conjectures on Original Composition.* This book, which is reprinted in his complete works and is also available in a facsimile edition,[90] proved to be historically important. Here Young eloquently recommended original writing, and he argued that poets and writers must stop imitating

[90] Edward Young, *Conjectures on Original Composition,* 1759; facsimile edition, Leeds: The Scholar Press, 1966. All page references to Young's book are to the facsimile edition.

the classical Greek and Roman authors in order to be able to surpass them. In this book he also explicitly connects the notions of originality and artistic value. For example, he writes that "all must allow that some Compositions are more so [original] than others; and the more they are so, I say, the better."[91]

It may be argued that it is not clear from this quotation alone whether Young is saying that originality is *the* feature that makes writing good (i.e., if originality is the sufficient condition for any work of art to be good), or if Young is merely saying that originality is *a* feature that makes writing good, and that there may be others as well. Fortunately it is not necessary for the limited purposes of the present subsection to go deeper into these exegetical problems.

In any case, throughout the book Young contrasts originals and imitators. He praises original writing by striking metaphors and similes, of which the following ones may serve as examples:

The mind of a man of Genius . . . enjoys a perpetual Spring. Of that Spring, *Originals* are the fairest Flowers: *Imitations* are of quicker growth, but fainter bloom.[92]

An Imitator shares his Crown, if he has one, with the chosen Object of his Imitation; an *Original* enjoys an undivided applause.[93]

Originals shine, like comets; have no peer in their path; are rival'd by none, and the gaze of all: All other compositions (if they shine at all) shine in clusters; like the stars in the galaxy; where, like bad neighbours, all suffer from all; each particular being diminished and almost lost in the throng.[94]

Young also argues that the spirit of imitation has many bad effects,[95] and he points out that Homer did not have any-

[91] *Ibid.*, p. 10. [92] *Ibid.*, p. 9. [93] *Ibid.*, p. 11.
[94] *Ibid.*, p. 77. [95] *Ibid.*, pp. 40–44.

one to imitate; he was an original. We should therefore imitate the man Homer (that is, the example set by him), but not his verse.

As Monroe Beardsley points out in his history of aesthetics, Young's *Conjectures* were "enthusiastically read in Germany, where many of Young's ideas fitted in well with, and strengthened, some tendencies in German Aesthetic theory."[96] These tendencies culminated in the Romantic movement with such writers as Schelling, Schlegel, Novalis, and their followers. As a whole, then, the strong connection between the concepts of originality and art is a fairly recent phenomenon. And I would like to add: it is also a typically Western phenomenon. It is no accident that in the comprehensive two-volume work on contemporary aesthetics by K. C. Panday,[97] there is only one discussion of the notion of originality, and it is—significantly enough— to be found in the volume on Western aesthetics. In the volume on Indian aesthetics (comprising a total of 616 pages) there is no reference at all to the notion of originality.

Thus, statements to the effect that *Y* was influenced by *X* or that *Y* is an imitation of *X* did not have the same normative implications in the Western civilization before 1600 as, say, after 1800. After 1800 it can be argued that these statements pragmatically implied that the speaker or the listener or both praised *X* rather than *Y*—in the sense that it would be strange if they accepted these statements and yet at the same time praised *Y* rather than *X*. But the situation might very well have been quite different before 1600. In those days it was considered a merit to be able to imitate the ancients.[98] Incidentally, this illustrates in an instructive way the important and sometimes inadequately

[96] Monroe C. Beardsley, *Aesthetics from Classical Greece to the Present*, New York: Macmillan, 1966, p. 168.

[97] K. C. Panday, *Contemporary Aesthetics*, Varanasi: n.p., 1959.

[98] In a letter Peter Kivy has pointed out that there is an argument supporting my view in the introduction to Leo Schrade, *Monteverdi. Creator of Modern Music*, London: Gollancz, 1951.

stressed normative function of traditional aesthetic theories (such as the imitation, expression, and formalist theories of art).

1.6.4 *A Further Complication: Normative and Nonnormative Concepts*

It is important to observe that critics and scholars sometimes talk about artistic influence without making any normative implications as to who is to be praised or blamed. In these cases the principle

> (N 1) If the creation of Y in a particular respect a was influenced by X, then the creator of X ought to get the praise—or the blame—for the fact that Y with respect to a looks the way it does,

which was discussed at the end of subsection 1.6.1, does not seem to hold, not even in our modern Western culture. This is especially true of discussions about quotations (verbal as well as nonverbal), borrowings, and allusions.

Suppose that a contemporary painter borrows a detail from a painting by Picasso or alludes to, say, a painting by Géricault. The borrowing or the allusion may be quite obvious, but it may also be difficult to see. Anyway, let us suppose that an art historian discovers this fact and writes that the creation of the work Y by the contemporary artist in this particular respect a was influenced by Picasso or by Géricault. Does this mean that a positive evaluation previously made of the painting Y with respect to a by this scholar or by his readers now is transferred to Picasso or to Géricault and replaced by a negative evaluation of Y?

No, that does not have to be the case. The decisive thing here is *how* the contemporary artist has used the detail in question. If he has used the detail in an ingenious way, then he and his work will be positively valued for this; if he has not used the detail in an ingenious way, then he and his work will be criticized. Thus it seems reasonable to say that this kind of influence statement cannot be characterized

as having any general and unambiguous normative implications.

In this situation, it seems that we have to choose between the following two alternatives:

Alternative 1. One has to distinguish clearly between two types of concepts of artistic influence, one of which has normative implications in the sense previously indicated, whereas the other is not normative in this sense.

Alternative 2. The concept of artistic influence always has normative implications of the kind described above, but borrowings, quotations, and so forth, should not be counted as instances of influence.

First I propose to elaborate on alternative 1. Then I shall make some more general comments on these alternatives and relate them to requirement (R 5) in section 1.4.7.

Roughly, the distinction between causal concepts with and without normative implications can be described and illustrated as follows. Suppose X is the work by a recognized master, and that the creator of Y has borrowed a feature of X in a rather unimaginative way. In the standard case, when statement (N 1) above holds, X or its creator will get the praise. The fact that Y was influenced by X does not involve any originality or creative ingenuity on the part of the artist who made Y. He has neither developed the ideas of X in an interesting way, nor did this influence help him to create a style or a mode of expression of his own.

This case should be contrasted with the example of Duchamp's version of *Mona Lisa*. But for the moustache added by Duchamp, his picture is very similar to that of Leonardo. But the moustache changes the character of the picture completely. In a sense, Duchamp's work is just as original as Leonardo's. The example shows that it is important to take into account not only the resemblances between the physical and aesthetic properties of the works, but also the intentions of the artist and the artistic traditions at the time. Indeed, it can be argued that it is necessary to be

familiar with Leonardo's work in order to appreciate fully the work by Duchamp. In this case, statement (N 1) does obviously not hold.

The latter case can be described in the following general and somewhat abstract manner. X influenced the creation of Y, and X is a work by a recognized master. The influence is so obvious that anyone with the barest knowledge of art history will recognize it. In fact, X and Y can be quite similar in many respects except for a few important details. These details, however, make Y—at least to those who are familiar with X—into an original work of art with a quite different character from that of X, and thus the praise does not go to X but to Y. In this case it is important to consider the character of the works as a whole and not merely to look at the physical properties they have in common.

Now the interesting thing about the two alternatives just proposed is that both of them seem to contradict what was said in section 1.4. Thus alternative 1 contradicts the following requirement:

(R 5) If X influenced the creation of Y with respect to a, then the statement that this is so has normative implications.

According to this requirement, a hypothesis of influence without normative implications is obviously a contradiction in terms. Alternative 2 contradicts the suggestion illustrated by the diagram in section 1.4.7 that borrowings and quotations are instances of influence.

However, the difficulty is not serious. Two solutions are possible. The first would be to divide the class of borrowings, quotations, etc., into two mutually exclusive subclasses, and to say that only the elements in one of these classes are considered to be examples of influences. The second solution would be to say that all borrowings and quotations are instances of influence, and to modify and reformulate (R 5).

If the latter alternative is chosen, (R 5) could be made

more precise by distinguishing between influence in the narrow and extended sense; thus we get the following two versions of this requirement:

(R 5.1) If X influenced the creation of Y in the narrow sense with respect to a, then the statement that this is so has normative implications.

(R 5.2) If X influenced the creation of Y in the extended sense with respect to a, then the statement that this is so has normative implications.

Since it would be absurd to claim that Duchamp was genuinely influenced (in my sense) by Leonardo, I shall concentrate on (R 5.2) first and then return to (R 5.1).

To begin with, it is clear that (R 5.2) does not hold generally; I therefore suggest that it is replaced by

(R 5.2)′ If X influenced the creation of Y in the extended sense with respect to a, then the statement that this is so has normative implications, unless p.

Then the problem arises: what should the variable p in this general formulation be replaced with?

Considering the examples discussed above, the following six statements suggest themselves:

(a) a closely resembles a work of art or a physical part of a work of art; it is not a feature of a work of art, such as style, perspective, technique, expression, and so forth.

(b) a is so well known—like the face of Mona Lisa or the first three bars of *Yankee Doodle*—that it is obvious that it was not invented by the person who created Y.

(c) The creator of Y intended the beholders to recognize that a was not invented by him, but rather used by him in a new way; he has never claimed or pretended to be the inventor of a.

(d) By inserting or using a in his work Y, the artist who created Y makes an artistic comment on a or changes its meaning and significance.

147

(e) The presence of *a* in the work *Y* is vital to the point the person who created *Y* wishes to make by creating and exhibiting *Y*.

(f) Statements (d) and (e) make *Y* into an independent work of art, which is original and has an artistic and aesthetic value of its own.

If these six conditions are satisfied, then there is obviously no question of transferring praise of the kind suggested by principle (N 1) above, since it is obvious from the beginning that the person who created *Y* did not invent *a*; in fact, that is part of the point of his work.

Some of these six statements could no doubt be made much more precise. In particular, this is true of statements (b) and (e). The former could be made more precise by specifying for whom it is obvious that *a* was not created by the person who created *Y*. The latter could be made more precise by clarifying what is meant by "vital." However, it does not seem necessary to discuss these problems in the present context. As far as (b) is concerned, it suffices to say that it should be obvious to anyone with an elementary familiarity with the history of art, literature, or music.

These six statements could also be used to distinguish between two subclasses of borrowings: borrowings and quotations that satisfy these six conditions belong to the subclass that does not contain any instances of artistic influence. If this solution to the problem is chosen, then a slight change has to be made in the diagram in section 1.4.7. We have to introduce an index to distinguish between the two kinds of borrowings, say "borrowing$_A$" and "borrowing$_B$," and then one of them should be placed in column two and the other in column three.

Which of the two solutions proposed here should be preferred? As far as I can see, it does not matter very much which strategy is adopted, since they are about equal in terms of economy or parsimony. One of them complicates (R 5), the other the notion of borrowing. Moreover, it is

not clear to me what strategy involves the least deviation from the usage of art historians; in this respect also the two solutions seem to be about equal.

Let us now for a moment return to (R 5.1). This requirement raises the following problem: is it possible to distinguish clearly between the feature *a* and the work *Y*, when *X* genuinely influences *Y* with respect to *a*? According to requirement (R 8), genuine influence is total and pervasive and not limited to details like a borrowed figure, a quoted passage, or a tune inserted in a composition. The answer is: if *X* influences *Y*, then *X* has an influence on the creative process whose result is *Y*. The influence on this process may be more or less total and pervasive. And even when it is pervasive, and when we discuss clear instances of genuine influence, such as the Braque-Picasso relationship, then we can, comparing their works, specify in what respects one of them was influenced by the other.

1.6.5 *The Assumption of Inferiority*

In this subsection I shall try to indicate and illustrate in what way evaluations and normative considerations may play an important role in the reasoning for and against hypotheses about influence.

To begin with, it may be useful to make a rough distinction between (a) evaluations which, together with evidence of other kinds, are used to justify statements about influence, and (b) the evaluations which are sometimes implied by statements about influence. The latter—which concerns the normative conclusions which are sometimes drawn when it has been shown that *X* influenced the creation of *Y*—have already been discussed at some length, and I shall now turn to the former case, and try to clarify and illustrate (a).

In the previous subsection I made an attempt to distinguish between normative (evaluative) and nonnormative (neutral) concepts of influence, or uses of the term "influence." The normative concept—or use—differs from the

149

neutral one in the following respect: X shall influence Y in a respect that is aesthetically relevant, and, above all, the result of the influence shall be aesthetically significant. Then aesthetic appreciation and evaluation will, together with other evidence, play a decisive role in the attempt to find out whether X did influence the creation of Y or not. This means that a painting which lacks every trace of aesthetic significance cannot exert or be the result of *artistic* influence, though it may of course influence and be influenced by works of art in other ways.

For the sake of convenience, I shall now introduce the term "the assumption of inferiority" for the following statement:

If X has less artistic value than Y, then it is improbable that X had any influence on the creation of Y.

I shall not discuss here how statements about artistic value are to be understood, or how disagreement about the artistic value of a work of art is to be settled, but I propose to illustrate the role of this assumption in discussions about influence; I am assuming that the persons involved in the discussion agree on the if clause of the statement above; that is, they all agree that X has less artistic value than Y.

The assumption of inferiority is seldom stated explicitly, but it is sometimes taken for granted implicitly in discussions about whether a particular work of art was or was not influenced by another. I shall try to illustrate this use of the assumption of inferiority with a quotation from Walter Friedlaender's *Caravaggio Studies* as a point of departure. Friedlaender makes the following point:

It has been suggested that a direct connection exists between the art of Scipio Pulzone and that of Caravaggio, especially with respect to portraits. Such a connection is, in my opinion, difficult to substantiate. . . . Unlike many other North Italian painters, Caravaggio certainly did not have the ambition to become a great portraitist. The

few portraits which we have from his hand or which are attributed to him (and most of these are not undisputed) do not contribute very greatly to his fame. It is nevertheless quite possible that in some instances Caravaggio permitted himself to be influenced by the very respectable but rather dry manner of Pulzone's portraits. For example, there are certain general stylistic affinities between Pulzone's *Portrait of Cardinal Spada* and the *Portrait of Paul V* attributed to Caravaggio; and the portrait of Maffeo Barberini, which is now usually considered an early Caravaggio, was formerly even called a Pulzone.[99]

In the first sentence of this quotation Friedlaender refers to the hypothesis that some portraits by Caravaggio were influenced by Scipio Pulzone, and he argues that this hypothesis is difficult to substantiate.

It is interesting to observe Friedlaender's choice of words, when he acknowledges that the hypothesis about influence nevertheless is quite possible. Note, for example, the phrase "permitted himself to be influenced by." Here it seems that the author is implicitly using the assumption of inferiority. In that case I propose to reconstruct Friedlaender's main line of thought as follows:

(a) It is quite possible that some of Caravaggio's portraits were influenced by the art of Scipio Pulzone, in spite of (i) the assumption of inferiority and (ii) the fact that Caravaggio was a greater artist than Pulzone.

The fact that (i) and (ii) in the present case are disregarded is justified by Friedlaender in the following way:

(b) Caravaggio did not have the ambition to become a great portraitist;
(c) The few portraits which we have from his hand do not contribute very greatly to his fame.

[99] Walter Friedlaender, *Caravaggio Studies*, Princeton: Princeton University Press, 1955, pp. 71–72.

The last statement can be understood as saying or implying that (ii) is here provided with exceptions ("Caravaggio is a greater artist than Pulzone in every respect except portrait painting") in such a way that (i), the assumption of inferiority, cannot be applied, since the Caravaggio and Pulzone are on roughly the same artistic level as far as portrait painting is concerned.

The hypothesis that some of Caravaggio's portraits were as a matter of fact influenced by Pulzone can be supported by the following arguments, according to Friedlaender:

> (d) There are certain general stylistic affinities between Pulzone's *Portrait of Cardinal Spada* and the *Portrait of Paul V* attributed to Caravaggio;
>
> (e) The portrait of Maffeo Barberini, which is usually considered an early Caravaggio, was formerly called a Pulzone.

The force of these arguments is not quite clear, and one can discuss how much weight Friedlaender is willing to put on them. The force of the first argument, for example, obviously depends on whether the attribution of the *Portrait of Paul V* to Caravaggio is a questionable one or not. But even if it should turn out to be mistaken, it shows—like the mistake alluded to in (e)—that there are general stylistic affinities between the works of the two painters.

Other examples could also be given to illustrate how the idea about the supreme value of originality has influenced the judgment of art historians—and literary historians as well—in such cases: the scholars have been inclined to say that the evidence available does not prove that influence has taken place, because to accept the hypothesis of influence would be to them not merely to accept an empirical hypothesis but also to suggest or to challenge a value judgment. This does not mean, however, that the assumption of inferiority is unproblematical or that it is generally accepted by art historians or literary historians. It is not; and, as I shall try to show now, there are good reasons for this.

In this context it is necessary to discuss briefly how the assumption of inferiority is or could be understood, and what kinds of reasons could be used to support it. It can be interpreted as a statement about frequencies. To be somewhat more specific, it can be understood as a statement about the ratio of the number of favorable and possible cases, as follows. As a point of departure, we use the total number of influence relations between artists. Then we find out the number of cases where bad artists have influenced good ones and discover that this number, relatively speaking, is a small or insignificant part of the total number of influence relations. Since no investigations, to the best of my knowledge, have ever been made to determine these numbers in an empirical way, the assumption of inferiority would probably have to be construed as a hypothesis or conjecture about the relations between these numbers.

However, I would like to call attention to the following problem. Influences from good works of art are usually much easier to trace than influences from bad works of art, for the simple reason that it is usually much more difficult for us to find out what bad works of art an artist long ago saw or read. When art historians and literary historians make comparative investigations, they often consider only a small section of what I previously have called the artistic field: first or second rate works of art, but not third or fourth rate works of art, let alone works which are considered to be totally without artistic merit. Though these works were well-known (widely read, etc.) long ago, they may be forgotten today. This makes it very difficult to estimate the frequencies mentioned above in a precise and nonarbitrary way.

But the assumption of inferiority can also be understood as a methodological norm, according to which scholars are entitled, on the basis of the frequencies mentioned above —or rather, on the basis of a conjecture about these frequencies—to draw conclusions from aesthetic judgments about the qualities of the relevant works of art to the prob-

153

ability for the statement that one of these works of art influenced the other. I shall not here take a definite stand as to whether this assumption of inferiority is reasonable or as to how far it can be pushed or stretched, though I am inclined to be sceptical of this assumption. It is tempting to understand it as a crude rule of thumb, to which there are a great number of exceptions. But an empirical study would, I believe, show that these exceptions are so many and so important that it is probably a mistake to regard the assumption of inferiority as even a crude rule of thumb.

1.7 CONCLUDING REMARKS

In this chapter I have tried to distinguish between a number of different concepts of influence. The term "artistic influence" refers to a causal relation which is here defined in the following way: if X influenced the creation of Y with respect to a, and if Y was created by B, then B's contact with X was a necessary condition, and also a part of a sufficient condition, for the creation of Y. In this respect the concept of artistic influence probably resembles many other causal relations. But in a number of respects there are interesting differences between the concept of artistic influence and other causal relations, and I have tried to indicate these differences in the present chapter.

I have stated thirteen requirements, (R 1) through (R 13), in order to single out a concept I proposed to call "genuine artistic influence." Further distinctions can, of course, be made within the thus delimited notion of genuine artistic influence. For instance, one might want to distinguish between the influence a dominant person in an artistic movement or tradition has on his followers, and the influence this person may have on other artists who do not follow him, but who find an artistic mode of expression of their own with the help of his influence.

The notion of artistic influence is, to be sure, not a clear and well-defined concept. Discovering that a concept is

vague, one might try to do two things: change it into a more precise concept, or leave it as it is and try to say precisely in what respects this concept is not precise. Here I have tried to do a combination of the two. I have tried to make the concept more precise by introducing a number of distinctions; and I have tried to indicate in what respects it is not precise by suggesting the requirements (R 1) through (R 13) and by calling attention to obscurities in these requirements.

2.

Conditions for Influence

IN THIS chapter I shall make an attempt to indicate and clarify the conditions that have to be satisfied, if a hypothesis about artistic influence in the narrow or wide sense is to be regarded as true or at least well corroborated. Thus, the point of departure for the discussion in the present chapter will be a sentence like "If X influenced Y with respect to a, then p"; and the objective of the investigation is to replace p in this sentence with specific and fairly precise statements.

To clarify the status of the results in this chapter, I must be somewhat more specific about the requirements that the statements replacing p are supposed to satisfy. These statements describe:

> (a) factors which in combination with each other are explicitly or implicitly supposed in writings on the history of art and literature to be positively relevant for the hypothesis that X influenced the creation of Y with respect to a.
> (b) factors the absence of which are explicitly or implicitly supposed in writings on the history of art and literature to be positively relevant for the hypothesis that X did *not* influence the creation of Y with respect to a.

156

Each of these factors is thus a necessary condition, and also part of a sufficient condition, for influence to take place. In case (a), p is used as evidence for hypotheses of the form "X influenced Y with respect to a." But in case (b), p is used to reject such hypotheses.

The conditions to be discussed in the first three sections below could be called "external conditions"; if they are satisfied or not in a particular case will have to be decided by historical and biographical investigations. These conditions form a group that should be distinguished from the two remaining conditions, both of which could be called "internal conditions"; if they are satisfied or not in a particular case will have to be decided primarily by analysis of and comparisons between different works of art.

At this point the following comment may be clarifying. In section 1.5 above I defined "necessary condition" and "sufficient condition" as causal relations between events (actions, etc.), but in this chapter I am going to use these expressions to refer to logical relations between sentences or statements. These definitions are related to each other in the way suggested in section 1.5 Since the context will make clear in what sense these expressions are used, I do not think that this will cause any difficulties. Obviously, similarity between X and Y in a particular respect a is not a causally necessary condition for X to have influenced Y positively with respect to a.

2.2 THE TEMPORAL REQUIREMENT A

A necessary condition for artistic influence to have taken place can be stated schematically as follows:

(C 1) If X influenced the creation of Y with respect to a, then Y was made after X with respect to a.

I shall use this schematic formula as a point of departure for the discussion in the present chapter. It can, as will soon

be evident, be made precise in a number of ways, and I shall also consider some alternatives to it.

2.2.1 *Some Comments on (C 1)*

The importance of making explicit in what respect the influence took place can be brought out by the following considerations, which show that the expression "with respect to *a*" has an essential function both in the if clause and in the then clause of (C 1).

Suppose that two artists share a studio and usually work together. They specialize in painting still lifes, and one day one of them invents a new technique (such as, for example, mixing sand in the color and applying this color to canvases that have been prepared with tar or asphalt). The other artist becomes excited about the possibilities of this new technique and starts to use it before the painting of the first artist is completed. Moreover, another artist can pay a visit to them and be inspired by half-finished paintings he sees in their studio, and so forth. Thus, X can influence Y, even though X was not completed before Y. It would accordingly be a mistake to require that X as a whole should have been created before Y; it is sufficient if Y in the relevant respect *a* was created after X was created in this respect.

I would like to make two more comments on (C 1). In the first place, the temporal connection between the creation of X and of Y can be made more precise in a number of ways. For example, it is possible to say that the creator of X shall have begun to create X with respect to *a* before the creator of Y has begun to create Y with respect to *a*, or that the creator of X shall have completed X with respect to *a* before the creator of Y has completed Y with respect to *a*, or that the creator of X shall have completed X with respect to *a* before the creator of Y has begun to create Y with respect to *a*. The first alternative can be applicable in some special cases, but I shall here regard the last alternative as the standard version of (C 1).

In that case (C 1) can be replaced by the following somewhat more exact sentence:

(C 1.1) If X influenced the creation of Y with respect to a, and if A created X and B created Y, then A shall have completed X with respect to a before B began to create Y with respect to a.

If nothing is said explicitly in what follows as to how the temporal connection is to be understood, I shall always have the standard version of (C 1) in mind.

In the second place, it is possible to make (C 1.1) more precise by asking and answering the following questions: what exactly is it that A is supposed to have completed and B is supposed to have begun? Or, to put the questions differently: at exactly which moment has a painting or a poem been completed or been created? When the artist has a first vague and dim idea of what he wants to do? When the first sketch or draft is finished? When the last sketch or draft has been made? When the painting is completed and the artist has put his signature on it? When the writer has checked the proofs of his novel and made his last corrections?

It is clear that it is possible to obtain a number of variations of the standard version of (C 1) by introducing these alternatives explicitly in (C 1.1) as follows:

(C 1.2) If X influenced the creation of Y with respect to a, and if A created X and B created Y, then A shall have completed

$$\left\{ \begin{array}{l} \text{the first sketch of} \\ \text{the last sketch of} \\ \text{the final version of} \\ \text{etc.} \end{array} \right\} \quad X \text{ with}$$

respect to a before B began to create

$$\left\{ \begin{array}{l} \text{the first sketch of} \\ \text{the last sketch of} \\ \text{the final version of} \\ \text{etc.} \end{array} \right\} \quad Y \text{ with}$$

respect to a.

The variations suggested by this formula can be applied both to artistic and literary influence with very small and quite insignificant changes of terminology (replacing "sketch" by "draft," etc.).

The temporal requirement A is not always used or mentioned explicitly in reasonings for and against hypotheses about influence. In many cases the chronology is quite obvious and familiar to the readers, and it is then a waste of time to discuss whether this or that version of (C 1) is satisfied or not. Should the scholars discussing whether influence took place or not in a particular case have reason to doubt that their readers are familiar with the time of creation of the relevant works, they may mention the relevant dates in passing. But the chronology is not always obvious. There are, of course, cases when the chronology is unknown, uncertain, or has been a matter of dispute. This is, for instance, true about the date of creation of several of Stagnelius' poems.

In these cases the temporal requirement occupies a central position in discussions about whether influence has taken place or not, and versions of the then clause of (C 1) can be used both to support hypotheses about influence and to reject such hypotheses. That the poem *Nattvardsbarnen* had been written and published only within a month after the publication of *Platons dröm* was used as an important argument by Albert Nilsson in his book *Tre fornnordiska gestalter* to support the claim that Tegnér was influenced by Grafström. Versions of the then clause of (C 1) are also above all, used to reject hypotheses about influence; if the then clause is false, then influence cannot have taken place.

2.2.2 *Some Examples*

I shall now illustrate these two uses of the temporal requirement with some examples taken from two Swedish scholars.

In his book *Inbillningens värld*, Olle Holmberg points out that there are striking resemblances between the mood,

motif, and phrases of Tegnér's *Återkomsten till hembygden* and Runeberg's *Den gamles hemkomst*:

> The poems are similar to each other both with respect to mood, motif, and particular expressions, though the poem by Runeberg does not have the natural and moving tone of the poem of the older poet.[1]

Holmberg then goes on to ask whether the similarities between the poems

> depend upon the fact that they have been created in a similar way under similar circumstances, or if the similarities are due to the fact that one of these poets was "influenced" by the other.[2]

However, a few pages later Holmberg rejects the possibility of influence between the two writers, and then he uses the following argument:

> There can be similarities without imitation or suggestion. The poems by Tegnér and Runeberg cannot possibly have influenced each other, since one of them was written before the other, and the other was published before the first.[3]

This argument clearly shows the relevance of some of the distinctions made in (C 1.2). We must distinguish between

[1] Olle Holmberg, *Inbillningens värld*, vol. II:1, Stockholm: Bonniers, 1929, p. 77. My translation. The original Swedish text reads as follows: Dikterna äro varandra lika både i stämning, motiv och enstaka uttryck, ehuru Runebergs poem icke har de naturliga och bevekande tonfall som den äldre skaldens äger.

[2] *Ibid.* My translation. The original Swedish text reads as follows: bero på att de ha uppstått på samma sätt ur samma omständigheter, eller om den [likheten] har sin orsak däri att den ene skalden "påverkat" den andre.

[3] *Ibid.*, p. 80. My translation. The original Swedish text reads as follows: Likheter kunna finnas utan att imitation eller suggestion förelegat. Tegnérsdikten och Runebergsdikten kunna icke ha påverkat varandra, ty den ena skrevs före den andra, och den andra publicerades före den ena.

the first (or last?) hand-written version of a poem and the published version of it; a poem may be in manuscript several years before it is published.

Aron Borelius uses the temporal requirement in his book on Johan Fredrik Höckert in the following way, when he compares the art of Tidemand and Höckert and tries to show that the Swedish artist was influenced by the Norwegian artist:

> already a quick comparison between the titles of some of their works indicates to some extent a connection between them: "Gudstjenste i en norsk landskirke"— "Gudstjänst i ett kapell i svenska lappmarken," "Brudefaerd i Hardanger"—"Brudfärd på Hornavan," "Ligefaerd paa Sognefjord"—"Begravning i Lappland," "Bjørnjaegerens Hjemkomst"—"Hemkomsten från jakten," "Kvinner i Vaabenhuset ved Mora Kirke"—"I vapenhuset" (Mora). And for every one of these parallels it holds that the painting by Tidemand has been created before the corresponding one by Höckert.[4]

The fact that titles of the paintings by two different artists resemble each other does of course not in itself prove anything. But Borelius calls attention to a large number of parallels, and he stresses that in all these cases the painting by Tidemand precedes the corresponding one by Höckert. Obviously the author here uses these facts to support the hypothesis that Höckert was influenced by Tidemand.

2.2.3 *A Complication*

So far I have presupposed the object-focussed conception of art, and the values of the variables X and Y in the various

[4] Aron Borelius, *Johan Fredrik Höckert*, Stockholm: Norstedts, 1927, p. 206. My translation. The original Swedish text reads as follows: redan en flyktig jämförelse mellan titlarna på några av de bägge artisternas verk skvallrar i sin mån om ett samband dem emellan: [titles as in text]. Och om var och en av dessa paralleller gäller, att Tidemands bild tillkommit före den motsvarande av Höckert.

162

versions of (C 1) have accordingly been names or descriptions of works of art. The examples in the previous subsection also illustrate this conception.

In concluding I would, however, like to consider some of the complications that are likely to arise if the object-focussed conception of art is replaced by the action-focussed conception. In that case (C 1) would have to be replaced by something like

(C 1)* If A_x influenced A_y with respect to a, then A_x was performed before A_y with respect to a.

In this schema, a can be replaced by names or descriptions of various aspects of the actions A_x and A_y. But what precisely are these actions?

They can be of different kinds. A_x can, for instance, be replaced by names or descriptions of one or more of the following actions: the creation of the work of art X, the exhibition of the work of art X, and the destruction of the work of art X; and the same holds, mutatis mutandis, for A_y. A good example of a combination of these actions would probably be Tinguely's creating and exhibiting of self-destructing sculptures. Here the action is more important than the shape, color, and structure of the physical objects he produced. For this reason, a formulation like (C 1)* will be more adequate in discussing whether or not some other contemporary artist was influenced by Tinguely.

Now each of the possible values of A_x can, of course, be combined with any of the possible values of A_y in the way that is made explicit by the following expanded version of (C 1)*:

(C 1.1)*

$$\text{If the action } A_x \text{ of } \left\{ \begin{array}{l} \text{creating} \\ \text{exhibiting} \\ \text{destructing} \\ \text{etc.} \end{array} \right\} X$$

influenced the action A_y of

$$\left\{ \begin{array}{l} \text{creating} \\ \text{exhibiting} \\ \text{destructing} \\ \text{etc.} \end{array} \right\} Y \text{ with respect to } a, \text{ then } A_x \text{ was} \left\{ \begin{array}{l} \text{planned} \\ \\ \text{performed} \end{array} \right\}$$

$$\text{before } A_y \text{ was} \left\{ \begin{array}{l} \text{planned} \\ \\ \text{performed} \end{array} \right\} \text{ with respect to } a.$$

The relevance of the distinctions between planning and performing an action should be obvious and could be illustrated with examples analogous to the ones mentioned by Holmberg in the previous subsection. Clearly a person can plan to do something without ever performing it, and he may also perform an action without having planned it in advance.

2.3 THE REQUIREMENT OF CONTACT

If the artist who created the work of art Y was not familiar with (had never had any contact with) the work of art X, then X cannot have influenced the creation of Y in any respect. The same holds, of course, for writers and poets. A necessary condition for artistic influence to have taken place can therefore be stated as follows:

(C 2) If X influenced the creation of Y with respect to a, then the person who created Y was familiar with X, at least in the respect a.

This is only a preliminary formulation, which has to be qualified and made more precise by introducing a number of distinctions.

2.3.1 *Four Versions of (C 2)*

The key term in (C 2) is "was familiar with." Unfortunately, this expression is not very clear and therefore requires a few comments. There are many different kinds of contacts, and their intensity and frequency can vary considerably.

To begin with, I would like to make a rough distinction between direct and indirect contacts:

The creator of Y was familiar with X

The creator of Y had a direct contact with X.

The creator of Y had an indirect contact with X.

Accordingly, it is possible to make a rough distinction between the following two versions of (C 2):

(C 2.1) If X influenced the creation of Y with respect to a, then the person who created Y had at some time a direct contact with X with respect to a.

(C 2.2) If X influenced the creation of Y with respect to a, then the person who created Y had at some time an indirect contact with X with respect to a.

Moreover, the direct and indirect contacts can be combined with each other in the following ways:

(C 2.3) If X influenced the creation of Y with respect to a, then the person who created Y had at some time both a direct and an indirect contact with X with respect to a.

(C 2.4) If X influenced the creation of Y with respect to a, then the person who created Y had at some time a direct or an indirect contact with X with respect to a.

In what follows I shall refer to (C 2.4) as the standard version of (C 2).

There is a point in distinguishing between these four versions of (C 2) only to the extent that the distinction between direct and indirect contacts can be made clear and intelligible, and I shall now turn to that problem.

As a point of departure for my discussion I propose to use the following quotation from Haskell Block's book on Mallarmé:

It is not easy to determine from the *"Rêverie"* alone precisely how well Mallarmé knew Wagner's work. In his letter to Dujardin in which he promises his manuscript for the August 8, 1885 number of the *Revue Wagnérienne* he declares, "Je n'ai jamais rien vu de Wagner"; nevertheless, he had heard or read innumerable descriptions of Wagner's operas, and he displays some familiarity with them in his essay. His knowledge of Wagner's theories was certainly not first hand to any significant extent, but was probably derived mainly from Wyzewa, Dujardin, and others of the circle of the *Revue Wagnérienne*. It is, of course, possible that Mallarmé might have acquired a more thorough and earlier knowledge of Wagner, principally through Baudelaire's essay, and even in early numbers of the *Revue Wagnérienne* there are a number of important citations from Wagner's *"Lettre sur la Musique."*[5]

This quotation is interesting, because it illustrates well the kind of methodological problem that is likely to arise in discussing contacts, and it also indicates what kind of evidence is used to solve these problems.

However, the quotation is particularly interesting in this context, because the author hints at a distinction between direct and indirect contacts which I will now try to make explicit. To say that a person had a *direct* contact with a work of art *X* is to say—and this is a stipulative definition on my part—that this person has at least once contemplated or regarded *X*; and to say that a person has had direct contact with a poem or a novel is analogously to say that he has at least once read the poem or the novel in question.

However, the term "direct contact" does not refer to a clear concept with sharp boundaries. It is possible to distinguish between a series of experiences of art and literature, all of which may be classified as "direct contacts" in the loose sense indicated above, where the intensity and

[5] Haskell M. Block, *Mallarmé and the Symbolist Drama*, Detroit: Wayne State University Press, 1963, p. 62.

depth of the experience depends on the following factors, among others:

(a) the attention and concentration of this person at the moment of the contact (when he reads or looks at X);

(b) the external conditions—lighting conditions, freedom from disturbing noises, etc.—under which the contact takes place;

(c) the number of times and the total time the person devotes to contemplation of (reading, etc.) X;

(d) the background, needs, expectations, and knowledge of this person, including his knowledge of art and literature;

(e) the aesthetic sensitivity, analytical powers, and ability to experience art and literature; and

(f) the extent to which he has used and relied upon the analyses and interpretations of X by other scholars or critics.

If this is so, then there can obviously be important differences between two persons' contacts with a work of art, even if both of them have had direct contact with the same work of art.

I hope this is enough to indicate the most important sources of vagueness of the concept of direct contact, and I shall now turn to the concept of indirect contact. To say that a person P has had an *indirect* contact with a work of art X is to say—and this is again a stipulation on my part—that there is another person A who has had direct contact with X and who then has described X or his experiences of X to P, or that there is a whole series of persons A, B, C, . . . , where the only one who has had a direct contact with X is A and A has described X and his experiences of X to B, and B has reported to C what A has said about X, and C in his turn has reported to P what B has said, and so forth. It seems reasonable to suppose that the indirect contact becomes weaker and more dim, the longer the series of persons involved.

Thus the term "indirect contact" also does not refer to a

concept with sharp boundaries. In the first place, "indirect contact" is defined in terms of "direct contact," which is itself a vague concept. But there are many other sources of vagueness. A description of a work of art can be done in many ways, and one might ask if there are any minimum requirements that a description has to satisfy in order for it to be a description of a certain particular picture. At what point does the description cease to be a description of this picture? When does it become a pure construction of the imagination of the critic or scholar? Analogous questions can be asked about summaries of novels and poems.

These questions raise intriguing problems, to which I think it is difficult to find any general, true, precise, and nontrivial answers. But it is not necessary to solve these problems for my present purposes. Nor is it necessary to have an exact definition of the concept of indirect contact in this investigation; it suffices to call attention to some of the ways in which the boundaries of this concept are unclear. But the fact that there is no sharp distinction between direct and indirect contacts does not, of course, imply that there is no distinction at all to be made here.

2.3.2 Some Examples

I shall now try to illustrate some of these versions of (C 2) by examples from writings on the history of art and literature.

In his book on the Swedish poet Fröding, Henry Olsson uses the following spatial metaphor to state that Fröding's early poem *Claverhouse* was influenced by Strindberg:

> Behind [this poem by Fröding] there is also Strindberg's well-known ballad about "herr Beaujolais de Beaune," about which Fröding himself says that "I recall from my youth how the striking tune was in my ears all the time."[6]

[6] Henry Olsson, *Fröding. Ett diktarporträtt*, Stockholm: Norstedts, 1950, p. 212. My translation. The original Swedish text reads as follows: Bakom ligger också Strindbergs bekanta Ballad om "herr Beaujolais de Beaune," varom Fröding själv säger att "jag minns från min ungdom hur den smittsamma melodin beständigt sjöng i mina öron."

Here the author tries to show that the requirement of contact in the strict version (C 2.1) is satisfied by referring to an autobiographical statement by Fröding ("about which Fröding himself says that").

In her article on the relations between Cézanne and Delacroix, Sara Lichtenstein compares some paintings by these two artists. In the following quotation she tries to show that, as far as one pair of pictures is concerned, both the temporal requirement A and the requirement of contact is satisfied:

> Another probable connection exists between the early *Orgy* by Cézanne and *Héliodore chassé du temple* by Delacroix. The fresco at Saint-Sulpice was unveiled to the public in the summer of 1861 during Cézanne's first stay in Paris, and was reproduced in several magazines. An etching apparently from that year is still in Cézanne's studio. Cézanne was moved by what was one of Delacroix's best and most personal mural decorations, one of the few executed almost entirely by him.[7]

Here it seems fairly clear that the requirement of contact is satisfied, though Lichtenstein does not prove that Cézanne has had a direct contact with the work by Cézanne; she shows only that the requirement of contact in the weaker version (C 2.2) is satisfied, but that is quite sufficient for her purposes. It can, of course, sometimes be very difficult to show that any of the four versions of (C 2) is satisfied, because the evidence available is too fragmentary; and in those cases scholars will have to try to estimate the probability or plausibility of the statement that some of these versions of (C 2) are satisfied.

The strength of the evidence can in such cases vary considerably, and it is possible to distinguish between at least the following situations:

(a) the scholar does not manage to prove that the requirement of contact is satisfied;

[7] Sara Lichtenstein, "Cézanne and Delacroix," *AB*, XLVI, 1964, p. 58.

(b) (a), but the scholar manages to show that the available evidence does not prove that this requirement was not satisfied;

(c) (b), and the scholar manages to show that the assumption that this requirement was satisfied is probable or plausible in view of all known facts.

In the last case, we have a sliding scale from fairly probable to very probable to extremely probable.

The following quotation illustrates how scholars may argue to show that the requirement (C 2) probably is satisfied. The quotation is taken from R. W. Lee's study of Castiglione's influence on Spenser's early hymns.

> the *Courtier* is the most likely source for Spenser's Renaissance Platonism. From the date of its publication at Venice in 1528, it was enormously popular in western Europe, and must have been readily accessible to Spenser, if not in one of the numerous Italian editions, at least in the English translation of Sir Thomas Hoby, which appeared in 1561. Twice, in his letters to Spenser, Harvey mentions "Castilio" as an author much read at Cambridge, where Spenser had been a student only a few years before. And for the Englishman of the sixteenth century, when Italian influences counted for so much, the book was not only the clearest mirror of the Renaissance ideal of the gentleman—and we may recall that Spenser and Castiglione alike aimed "to fashion a gentleman or noble person in virtuous and gentle discipline"—but it also contained the most eloquent utterance in Renaissance literature of the Platonic creed of love and beauty that so fascinated the mind of the age.[8]

A number of known facts make it probable that the requirement of (direct) contact is satisfied: the popularity of

[8] Rensselaer W. Lee, "Castiglione's Influence on Spenser's Early Hymns," *Philological Quarterly*, VII, 1928, pp. 65–66.

the *Courtier* at the time, the fact that it was widely read at Cambridge, that Spenser was interested in books of this type, and so forth. These circumstances do not, of course, *prove* that the requirement of contact is satisfied; and Lee is also careful to write only that this "is the most likely source."

2.3.3 *The object-focussed vs. the action-focussed conception of art*

So far I have presupposed the object-focussed conception of art, and the values of the variables X and Y have accordingly been names or descriptions of works of art. It might be interesting to see what complications arise if the object-focussed conception of art is replaced by the action-focussed conception of art.

In this case (C 2) would have to be replaced by something like:

(C 2)* If A_x influenced A_y with respect to a, and if A_y was performed by P, then P was familiar with A_x with respect to a.

By distinguishing between direct and indirect contacts, we can get four versions of (C 2)* which correspond exactly to the four versions of (C 2):

(C 2.1)* If A_x influenced A_y with respect to a, and if A_y was performed by P, then P had at some time a direct contact with A_x with respect to a.

(C 2.2)* If A_x influenced A_y with respect to a, and if A_y was performed by P, then P had at some time an indirect contact with A_x with respect to a.

(C. 2.3)* If A_x influenced A_y with respect to a, and if A_y was performed by P, then P had at some time a direct and an indirect contact with A_x with respect to a.

(C 2.4)* If A_x influenced A_y with respect to a, and if A_y was performed by P, then P had at some time a direct or an indirect contact with A_x with respect to a.

Thus the distinctions between direct and indirect contacts are relevant in the present context also, and the problems to which these distinctions give rise will reappear here too.

Moreover, the values of the variables A_x, A_y, and a are, of course, identical with the values of these variables in (C 1)*. By combining each of the possible values of the variable A_x with every possible value of the variable A_y it is easy to obtain further variations of each of the four versions of (C 2)* along the lines indicated by the following expanded statement of what I would like to call the standard version of (C 2)*:

$$(C\ 2.4)^*\ \text{If the action } A_x \text{ of} \begin{cases} \text{creating} \\ \text{exhibiting} \\ \text{destructing} \\ \text{etc.} \end{cases} X \text{ influenced}$$

$$\text{the action } A_y \text{ of} \begin{cases} \text{creating} \\ \text{exhibiting} \\ \text{destructing} \\ \text{etc.} \end{cases} Y \text{ with respect to } a,$$

and if A_y was performed by the person P, then P had at some time a direct or an indirect contact with A_x.

2.4 THE TEMPORAL REQUIREMENT B

Picasso may very well have been familiar with the art of Cézanne without being influenced by it, but he cannot have been influenced by the art of Cézanne without being familiar with it. Analogously, Tennessee Williams may very well have been familiar with the writings and theories of D. H. Lawrence without having been influenced by them. But if he was influenced by them, he must have been familiar with them.

Generally speaking it is true that the artist or writer B who created (wrote) Y can very well have had both direct

and indirect contacts with X without necessarily being influenced by X. Moreover, if the first contact between B and X took place only after Y was already completed, then it is out of the question that X could have influenced the creation of Y in any respect. The requirements discussed in the two previous sections are comparatively weak and I shall now state a stronger requirement:

(C 3) If X influenced the creation of Y with respect to a, then Y with respect to a was made after C,

where C is the first contact between X and the creator of Y. I shall now make a few comments on this requirement and then illustrate it with a few examples.

2.4.1 *Comments on (C 3)*

I would like to make two comments on (C 3). In the first place, this requirement is stronger than the two previous ones in the sense that it implies, but is not implied by, them. That this is so is fairly obvious; it can be shown in the following informal way.

Let B be the creator of Y. If B's first contact with X took place before B had created Y, then it obviously follows that X was created before Y. But the converse does not hold. Even if X was created before Y it need not be the case that B's first contact with X took place before he created Y, assuming that B had a contact with X (which, of course, need not at all be the case). Moreover, if Y was created after B's first contact with X, then it is trivially true that B at some moment in his life had contact with X. But again, the converse does not hold. It can obviously be true that B at some moment in his life had contact with X but false that Y was created after this moment.

In the second place, it is possible to obtain some variations of (C 3) by explicitly introducing some of the distinctions that were made in the previous two sections. Thus,

requirement (C 3) can be replaced by the following some-what more complex statement:

(C 3.1) If X influenced the creation of Y with respect to a, then $\begin{cases} \text{the first sketch} \\ \text{the last sketch} \\ \text{the final version} \end{cases}$ of Y was made after B's first $\begin{cases} \text{direct} \\ \text{indirect} \end{cases}$ contact with X.

In what I propose to call the standard version of (C 3) it is required that only the final version of Y—the differences between the first sketches and the final versions can some-times be of great importance—was created after B's first direct *or* indirect contact with X.

The distinctions between the different versions of (C 3) may occasionally be important. This can be shown in the following way. Let us suppose that the standard version of this requirement is satisfied in a particular case, that is, that the final version of Y was made after B's first contact with X. Thus a necessary condition for influence is satisfied. But if (i) there are no significant differences between the first sketch and the final version in the relevant respect a, and if (ii) it can be shown that the first sketch was made before B's first contact with X, then influence is out of the question.

Thus the two first requirements (C 1) and (C 2) are corol-laries to (C 3). There are two reasons why, in spite of this fact, I have chosen to discuss these requirements in sep-arate sections. The first reason is that this strategy made it possible to analyze the vagueness in the concept of contact and to clarify the temporal connection between the creation of X and Y in a way that was easier to follow. The second and more important reason, however, is that writers on the history of art and literature—as I think the examples in the previous sections show—sometimes appeal only to the fac-

tors mentioned in the then clauses of (C 1) and (C 2) when they try to support or reject statements about influence. Thus it is an advantage for reasons other than pedagogical to discuss (C 1) and (C 2) separately.

2.4.2 *Some Examples*

In his book *The Influence of Ezra Pound*, K. L. Goodwin writes as follows:

> If one accepts Edmund Wilson's theory that the change manifests itself in the poems of *The Green Helmet and Other Poems* it becomes important to establish whether, as a matter of chronology, it was possible for Yeats to have been influenced in the writing of the poems by Pound.[9]

The problem hinted at in this quotation can—with (C 3) in mind—be stated as follows: it is of decisive importance to investigate if *C*, that is, Yeats' first contact with the poetry of Pound, took place before Yeats had written the poems in *The Green Helmet and Other Poems*.

I shall now call attention to a somewhat different example. In his previously quoted book on Manet, Nils Gösta Sandblad makes the following point in discussing the possible influence of Goya on Manet:

> Moreover in all such questions he had access to a guiding pattern which had been known to him ever since his Spanish Journey in 1865, namely Goya's execution scene in the Prado in Madrid.[10]

Sandblad does not *prove* here that Manet had had a direct contact with Goya's famous execution scene before he created *L'Exécution de Maximilien*. But it is reasonable to sup-

[9] K. L. Goodwin, *The Influence of Ezra Pound*, London: Oxford University Press, 1966, p. 76.
[10] Nils Gösta Sandblad, *Manet. Three Studies in Artistic Conception*, Lund: Gleerups, 1954, p. 122.

pose that if a painter like Manet goes to Madrid, then he will visit the Prado museum; and if he visits the Prado museum, then he will notice Goya's paintings.

It would, of course, be possible to support the claim that Manet had a direct contact with the art of Goya during his visit to Spain in 1865 in many ways; for example, by showing that Manet had described his reactions to Goya's paintings in letters to his friends or in his diary. Analogously, it would be possible to refute the claim that Manet had a direct contact with Goya's execution painting during his visit to Spain in 1865, if it could be shown that this painting was out of the museum at the time of Manet's visit to Madrid for restoration, exhibition elsewhere, or some such reason.[11]

In general it may, of course, be difficult to show that (C 3) is satisfied. But scholars sometimes manage to do this by working in essentially the same way as a detective. This work includes studies of the artist's travels, visits to museums, collections of art, letters, notebooks, sketches, diaries, libraries, friends (and their collections of art), and so forth. (As a curiosity I might mention that someone has taken the trouble to check not only the private library of the Swedish poet Esaias Tegnér but also what books he has borrowed from the University Library at Lund; all this information is now printed and easily available.)[12]

It would not be difficult to find other examples of discussions as to whether (C 3) is satisfied in a particular case or not,[13] but it does not seem necessary to analyze more examples in order to see the theoretical problems involved; they are clear enough.

2.4.3 An Alternative to (C 3)

If we presuppose the action-focussed conception of art rather than—as I have done in this section—the object-

[11] For Manet's relations to Spain and to Spanish painters, see E. Lambert, "Manet et l'Espagne," GBA, IX, 1933, pp. 368–82.

[12] See A. Silow, Tegnérs boklån i Lunds universitetsbibliotek, Uppsala, 1913 (Uppsala universitets årsskrift, 1913:1).

[13] See, for instance, Borelius, Höckert, p. 154.

focussed one, then I think it is obvious from the two pre-
ceding sections that the alternative to (C 3) would have to
be something like:

(C 3)* If A_x influenced A_y with respect to a, then A_y
was $\left\{ \begin{array}{l} \text{planned} \\ \text{performed} \end{array} \right\}$ after B's first direct or indirect contact
with A_x.

As in the previous cases, it is possible to obtain a number
of variations of (C 3)* by combining the possible values of
A_x (the creation, exhibition, and destruction of X) with each
of the possible values of A_y (the creation, exhibition, and
destruction of Y).

2.5 THE REQUIREMENT OF SIMILARITY

I shall begin by discussing some problems raised by posi-
tive artistic influence. Later in this section I shall consider
some of the complications which are introduced by the no-
tion of negative influence. If a work of art X influenced the
creation of another work of art Y positively with respect
to, say, the technique of composition, then X and Y are simi-
lar in this particular respect. But they need not, of course,
resemble each other in other respects.

The requirement of similarity can be stated in the follow-
ing schematic and preliminary way:

(C 4) If X influenced Y with respect to a, then X and Y
are (noticeably) similar with respect to a.

This requirement raises a number of intriguing methodo-
logical and theoretical problems, some of which will be dis-
cussed in detail in the present section: How does one de-
cide whether X and Y are similar in a particular respect?
What conclusions can be drawn from the fact that X and
Y are similar in a particular respect? and so forth.

The reason why scholars pay so much attention to simi-
larities between works of art when they discuss whether
one work of art influenced another is probably the fact that

a is a property or quality of the relevant works of art, and that this property can be perceived and described. Moreover, comparisons between *X* and *Y* help to direct the attention of the beholders to features of these works which they might otherwise have missed. The discussion of particular hypotheses about influence can then be combined with what many writers on the history of art and literature would consider to be their main task: description, analysis, and interpretation of works of art. If the three previous requirements are called "external" conditions, then (C 4) should obviously be called an "internal" requirement; "internal" methods are used to decide whether the then clause of (C 4) is true or not in a particular case.

In what follows I shall first illustrate how (C 4) is used in writings on the history of art and literature to decide whether or not hypotheses about artistic influence are true. To that end I shall quote from such writings and comment upon the quotations. Then I shall discuss some important theoretical and methodological problems in a somewhat more systematic fashion.

2.5.1 *Some Examples*

In his 1964 book on Poussin, Walter Friedlaender makes the following comparison between a number of paintings by Poussin and Raphael:

> In these groups of paintings . . . the influence of Raphael's tapestries is plain to see. Raphael's *Blinding of Elymas* shows the same immediate consequences and the *peripeteia* of the *Judgment of Solomon*; Poussin's *Death of Sapphira* is an intentional continuation, in content and in form, of Raphael's *Death of Ananias* in the tapestry series. The affinity with Raphael's grandiose constructions give spatial freedom and grandeur to Poussin's paintings, to which he adds landscape backgrounds expanded and deepened into panoramic *vedute*.[14]

[14] Walter Friedlaender, *Nicolas Poussin. A New Approach*, New York, 1964, p. 74.

This quotation is interesting for several reasons.

First, the phrase "is plain to see" clearly indicates that according to Friedlaender the traces of the influence are visible. Second, the phrase "the same immediate consequences" specifies these traces: they are striking similarities between the relevant paintings in a number of respects. Third, the phrase "is an intentional continuation" implies that according to Friedlaender, Poussin was well aware of the influence from Raphael's tapestries. Moreover, the words "in content and in form" suggest that the influence was effective on several different levels, and on content as well as form. Again, the word "affinity" stresses the fact that the visible traces of the influence in this case are similarities between the works of Raphael and those of Poussin.

The next example is taken from Sir Kenneth Clark's book on Piero della Francesca. In discussing the relations between Piero and Masaccio, the author makes the following point:

> But although Piero may have been introduced to Masaccio through those more comprehensible artists who had already undergone his influence, in the end it was the prolonged contemplation of the Carmine frescoes themselves which moulded his style. From them he learnt the majestic tempo, the grave gestures, the vision of an ennobled humanity, which characterize all his works. And on the technical side he learnt the architecture of drapery and the grouping of figures in space.[15]

I shall use a simple diagram to illustrate what I take to be the main line of thought in this quotation.

The author here discusses influence relations between three artists or groups of artists: Piero della Francesca, Masaccio, and the successors of Masaccio (or the school of Masaccio). For the sake of brevity I shall refer to them respectively as "P," "M," and "Ms." In order to facilitate a

[15] Kenneth Clark, *Piero della Francesca*, London: Phaidon, 1951, pp. 5–6.

179

discussion of the possible relations between P, M, and Ms
I shall now place them at the angles of a triangle:

Ms
·

M · · P

In the first sentence of the quotation Clark mentions the
hypothesis that Piero della Francesca was influenced in-
directly by Masaccio, through some artists "who had al-
ready undergone his influence"; Masaccio has influenced
these artists directly, and in their turn they have influenced
the art of Piero della Francesca directly. According to
Clark, this hypothesis cannot be refuted. But it is supple-
mented with another one: there is also direct influence
from the Carmine frescoes by Masaccio on the art of Piero.

These relations can be illustrated by the following dia-
gram, where (as in the previous chapter) I use arrows to
symbolize direct artistic influence:

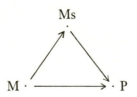

In the two subsequent sentences of the quotation the author
specifies in what respects Piero was influenced by Masaccio;
Clark calls attention to a number of similarities between
the works by Masaccio and those by Piero della Francesca.
It should be noted that the similarities are of several dif-

ferent kinds: technical, compositional, psychological, and so forth.

The requirement of similarity is also used in the following line of argument, quoted from Erwin Panofsky's *Early Netherlandish Painting*. At one point Panofsky discusses some artists or schools of artists which have influenced the art of the Master of Flémalle:

> The influence [on the Master of Flémalle] of Franco-Flemish miniatures, especially of the Italianizing kind, cannot be denied and is extremely important. The general composition of the Dijon panel with its obliquely placed shed, the triad of angels on the left and the single angel on the right has justly been derived from the "Nativity" in the "Tres Riches Heures" and here we also find the adoring shepherds—a motif newly assimilated from Italian sources (though, we remember, not foreign to the provincial tradition either). Furthermore, a close similarity has been observed between the Dijon "Nativity" and the miniatures in the "Brussels Hours" by Jacquemart de Hesdin. With them it shares a taste for cool, pearly colors (purplish brown, white shaded with blue or mauve, and a neutral gray) which merge into an admirable, silvery tone by virtue of the Master's command of the *nouvelle pratique*.[16]

In this quotation Panofsky specifies (as Clark did in the previous quotation) a number of similarities between the works of art he compares. But his argument differs from that of Kenneth Clark's in the following three respects.

In the first place, the similarities specified by Panofsky are of a different kind than those mentioned by Clark. Secondly, the similarities specified by Panofsky belong on the whole to the same category—the colors and composition of the relevant works—in contrast with those mentioned by Clark. In the third place, the similarities specified by Panof-

[16] Erwin Panofsky, *Early Netherlandish Painting*, Cambridge, Mass.: Harvard University Press, 1953, pp. 158–59.

sky are relatively uncomplicated and simple, in the sense that it is rather easy to test the statement that there are similarities between the relevant works of art in the respects specified by Panofsky. (I am here for a moment disregarding the value-loaded term "admirable" in the quotation from Panofsky.) Such a test need not presuppose any specific aesthetic sensitivity in Panofsky or his readers.

In discussions as to whether influence took place or not it is of course important to consider the *differences* between the works of art compared as well. It is, as one might expect, far from uncommon that art historians point out both similarities and differences when they compare works of art with each other. For instance, Karl Schefold writes as follows in an article on the origins of Roman landscape painting:

> Roman landscapes repeat again and again the elements of this composition. . . . But in style the relief is quite different from all Roman art.[17]

Here Schefold calls attention to similarities in the elements of composition between a relief and a number of Roman landscapes. But he also points out the differences in style between this relief and the landscapes.

There is a somewhat more detailed comparison in the following quotation, taken from Frederick Antal's book *Hogarth and his Place in European Art*:

> A certain connection does however exist between Hogarth and Zoffany—especially the early Zoffany of the 'sixties and early seventies'. . . . Among Zoffany's early pictures of the stage, *The Famous Return* (1762, Earl of Durham), is astonishingly close to Hogarth's representation of the same play in the same year: the identical incident is chosen and identical too is the arrangement of the figures. But in Zoffany the psychological conception

17 Karl Schefold, "Origins of Roman Landscape Painting," *AB*, XLII, 1960, p. 89.

is less intense, the composition is more loosely knit, the figures have less *élan* and accessories abound.[18]

Here Antal compares similarities on several levels (composition, choice of motifs) with differences on several other levels (psychological characterization, etc).

These two quotations raise a number of intriguing theoretical and methodological problems. What methods or principles are used—or could be used—in weighing similarities against differences in such situations? The problem is indeed an important one, since art historians frequently point to differences between works of art, when they try to refute statements about influence, as I shall try to show now. So: if there are both similarities and differences between two works of art—and this is almost always the case —what conclusion is one entitled to draw as to the possibility of influence?

A few pages ago I quoted Walter Friedlaender's statement that "Poussin's *Death of Sapphira* is an intentional continuation, in content and in form, of Raphael's *Death of Ananias.*" In his recent discussion of these paintings, Kurt Badt—in his monumental book *Die Kunst des Nicolas Poussin*—does not mention Friedlaender's name explicitly, but the following passage is probably intended as a criticism of Friedlaender's hypothesis about influence:

> Künstlerisch aber ist Poussin's Bild von dem Fresko Raffaels grundsätzlich dadurch verschieden, dass der Bezug zur Transzendenz auf entgegengesetzte Weise behandelt ist. Ananias blickt verzweifelt zum Himmel auf, Sapphira aber sinkt blicklos zur Erde.[19]

[18] Frederick Antal, *Hogarth and his Place in European Art*, London: Routledge & Kegan Paul, Ltd., 1962, p. 178.

[19] Kurt Badt, *Die Kunst des Nicolas Poussin*, Köln: DuMont Schauberg, 1969, p. 569; freely translated into English: But artistically Poussin's picture is fundamentally different from the fresco by Raphael in the respect that the relation to transcendence is treated in opposite ways. Ananias is looking desperately to heaven, but Sapphira is sinking to earth with empty eyes.

In this quotation Badt calls attention to a number of important artistic differences between these paintings, and the context suggests that these differences make the hypothesis about influence between the works by Raphael and Poussin very implausible.

There is a similar—and perhaps somewhat clearer—line of argument in Luis Cardoza y Aragón's book on Orozco:

> Al hablar de influencias en sus primeros años, se ha recordado a Toulouse-Lautrec y a Goya. . . . Con Toulouse-Lautrec hay afinidades exteriores que no son propriamente influencias, como en la serie *Casa de lágrimas.* Toulouse-Lautrec no dispone una burla como la de Orozco. La temperatura es otra: los contrastes que ofrece la realidad, los conflictos vitales, no presentan en Europa la agudeza que presentan en México, por las tradiciones de la sátira, aquí y allá, y, sobre todo, porque Toulouse-Lautrec los ve, dada la época en que vivió—*la belle epoque*—sin la grave resonancia político-social que hay en el mexicano.
>
> Algo parecido ocurre con la influencia de Goya: son dos mundos y dos épocas y dos espíritus muy distintos.[20]

It is instructive to compare this quotation with the previous one.

[20] Louis Cardoza y Aragón, *Orozco*, [Mexico City]: Instituto de Investigaciones Esteticas, Universidad Nacional Autónoma de Mexico, 1959, p. 157, freely translated into English: Speaking about influences in his early years, one has pointed to Toulouse-Lautrec and to Goya. . . . There are superficial similarities between Orozco and Toulouse-Lautrec, which are not influences, properly speaking, as in the series *Casa de lágrimas.* Toulouse-Lautrec does not have a sense of humour like Orozco. The temper is different: the contrasts which reality offers, the vital conflicts, are not as sharp in Europe as they are in Mexico, because of the traditions of satire here and there, and, above all, because Toulouse-Lautrec sees them, according to the epoque in which he lived—*la belle epoque*—without the serious political and social resonance which there is in the work of the Mexican artist.

Something similar is true about the influence from Goya: they are two very different worlds, epochs, and spirits.

The first quotation can also be understood as saying that the differences between the two works by Raphael and Poussin are so fundamental that they make the possibility of influence quite uninteresting, though they do not reject or exclude this possibility. This interpretation is somewhat weaker than the one suggested above, and it would seem to fit in well with the general approach followed by Badt.[21] The second quotation can perhaps also be interpreted in this way. But here it is much clearer than in the first quotation that the author takes the differences between the works of Toulouse-Lautrec and Orozco to refute the hypothesis about influence; the author stresses that the external similarities or affinities between the works of the two artists "no son propriamente influencias," and then he goes on to call attention to a number of important differences between the works of these two artists.

In concluding this survey of examples, I would like to discuss some quotations from literary historians. In his dissertation on the style of Stagnelius' poetry, which I have quoted earlier, Sten Malmström makes the following comparison between the works of Propertius and those of Stagnelius:

> The idea of the composition is quite similar to, for instance, Propertius' fourth elegy in the first book, where he addresses Cynthia, who is critical towards Bassus, with the following words. . . . But all this is a superficial similarity. It is more essential that Stagnelius got the

21 Cf. the following declaration in the introduction to the book by Kurt Badt, referred to in note 19: "Das Anliegen dieses Buches ist es, die Kunst Poussins aus ihren Ursprüngen und in ihrer Originalität zu verstehen. Es geht davon aus, dass es ein Irrtum sei, das historische Bild eines Künstlers auf Abhängigkeiten, Entlehnungen, Uebernahmen, kurz auf Verbindungen mit der Vergangenheit zu gründen" (p. 15), freely translated into English: "The purpose of this book is to understand the art of Poussin from its origins and in its originality. The book is based on the assumption that it would be a mistake to base a historical exposition of an artist on influences, borrowings, and so forth, in short, on relations with the past."

courage from Propertius to absolutely frank erotic self-confessions. In Propertius Stagnelius has found a description that roughly covered his own experiences, even so far that his poem in the passage quoted above comes close to an imitation in a modern setting; the inspiration from antiquity is also noticeable in the syntax: Stagnelius' changes of images with "or" recall the "sive-sive" formulations which are so common in Propertius and Horace. But Stagnelius has also in the lover Propertius found a c o n t r a s t to the adorer Erik Johan Stagnelius.[22]

Here the author points out a number of more or less precise similarities and differences between Stagnelius' and Propertius' poems. It is clear that the contrast he calls attention to in the last line does not reject the hypothesis of influence or make it implausible.

Here is another and somewhat more complicated example. In his book *Shakespeare's Debt to Montaigne*, G. C. Taylor tries to show that Shakespeare was influenced by Montaigne. In the following quotation, Taylor uses both the requirement of similarity and the temporal requirement A. It should also be noted that the similarities are carefully specified:

[22] Sten Malmström, *Studier över stilen i Stagnelius lyrik*, Stockholm: Svenska Bokförlaget/Bonniers, 1961, pp. 281–82. My translation. The original Swedish text reads as follows: Den kompositionella idén är helt likartad med t.ex. Propertius' fjärde elegi i första boken, där han till den mot Cynthia kritiske Bassus riktar orden. . . . Men allt detta är dock endast utanverk. Väsentligare är att Stagnelius av Propertius' elegidiktning hämtat mod till absolut uppriktiga erotiska självbekännelser. Hos Propertius har Stagnelius funnit en skildring som ungefärligen täckte hans egna erfarenheter, så långt t.o.m. att hans dikt i det citerade partiet närmar sig en imitation i modern miljö; den antika inspirationen sträcker sig in i det syntaktiska: bakom Stagnelius' bildväxlingar med "eller" anar man de hos Propertius och Horatius vanliga "sive-sive"-formuleringarna. Men Stagnelius har också i älskaren Propertius funnit en k o n t r a s t till adoratören Erik Johan Stagnelius.

By the contribution of about a hundred close phrasal cor-
respondences and of about a hundred additional paral-
lels deserving of notice, and by the compilation of a glos-
sary of about seven hundred and fifty words, selected
from Florio's Montaigne, which were used by Shake-
speare during and after, but not before 1603 (the date
of Florio's first publication of the Essays), it proposes to
demonstrate that Shakespeare was, beyond any doubt,
profoundly and extensively influenced by Montaigne;
definitely influenced in regard to vocabulary, phrases,
short and long passages, and, after a fashion, influenced
also in thought. At the outset, however, it may be well to
forestall objections by stating that the writer by no means
contends that Shakespeare was in thought a follower or
a disciple of Montaigne, as will be more fully indicated
in the course of the discussion.[23]

The evidence collected by Taylor may seem overwhelming.
But his theses have provoked a rather lively discussion, and
this discussion is interesting in the present context.

Alice Harmon is one of Taylor's critics. In her article
"How Great Was Shakespeare's Debt to Montaigne?" she
criticizes some of the arguments put forward by Taylor:

Those who have attempted to show that Shakespeare's
borrowing from Montaigne was extensive have failed to
take sufficient account of the wide currency in the Renais-
sance of ideas common to the two writers.[24]

The basic idea in Harmon's article is thus that the similari-
ties to which Taylor and others have called attention are
not specific enough; the similarities consist to a large extent
of ideas which were common during this period of time.

[23] G. C. Taylor, *Shakespeare's Debt to Montaigne*, Cambridge, Mass.:
Harvard University Press, 1925, pp. 4–5.
[24] Alice Harmon, "How Great Was Shakespeare's Debt to Mon-
taigne?" *PMLA*, LVII, 1942, p. 989.

To demonstrate this she makes a critical examination of some of the parallels Taylor used to support his thesis. Taylor has, among other things, pointed out that both Florio and Shakespeare compare an "idle mind" to an "unweeded garden." The force of this argument is criticized by Alice Harmon as follows:

> Shakespeare need not have gone to Florio for this similitude. It was one of the familiar commonplaces on Education, and it is to be found in the works of those great favorites, Cicero, Seneca, and Plutarch.[25]

If this is true, then the similarity referred to by Taylor is not specific; the relevant simile is to be found in a great number of writings which there is good reason to believe that Shakespeare was acquainted with. Accordingly, the probability that Shakespeare was influenced by Montaigne in particular rather than by anyone else decreases.

However, Taylor has replied to Harmon's criticisms in a theoretically very interesting article, entitled "Montaigne-Shakespeare and the Deadly Parallel." He points out that Alice Harmon has only examined five out of the hundred parallels that he discussed in his book.[26] Moreover, he argues that the main idea in Harmon's article is not new but comes close to ideas expressed in his own book; and to support this claim, he quotes the following passage from his own earlier book:

> If Shakespeare had never read a line of Montaigne, he would inevitably have employed many of the same wise saws and modern instances, the stock phrases and literary commonplaces of their age, and likewise many of the same brilliant detached thoughts and fragments of thoughts in which the literature of the age of Elizabeth and James abound.[27]

[25] *Ibid.*, p. 992.
[26] G. C. Taylor, "Montaigne-Shakespeare and the Deadly Parallel," *Philological Quarterly*, XXII, 1943, p. 333.
[27] Taylor, *Shakespeare's Debt*, pp. 5–6.

Thus, Taylor seems to be well aware of the fact that many similarities between two authors do not necessarily mean that one of them was influenced by the other; the occurrence of these similarities can be explained in other ways.

Moreover, Taylor criticizes Harmon's criticisms of his use of parallels between texts written by Shakespeare and Montaigne to support the hypothesis that Shakespeare was influenced by Montaigne. According to Taylor, the similarities between Shakespeare and Montaigne are more specific than the similarities between Shakespeare and the various other possible sources mentioned and quoted by Alice Harmon. Among other things, Taylor makes the following point:

> It is well to illustrate the inadequacy of the commonplaces cited by Miss Harmon by way of explaining away a borrowing by Shakespeare from Montaigne. . . . *Note* in the following passages as many as six separate and distinct resemblances which no accident or commonplace can explain.[28]

In other words, Taylor does not deny that many similarities between Shakespeare and Montaigne are of a fairly general sort and that they can be explained as reflections of ideas common at the time of Montaigne and Shakespeare. But he does not want to admit that this is true of all similarities between Montaigne and Shakespeare; some of these similarities are so specific that the only possible or reasonable explanation, according to Taylor, is that Montaigne influenced Shakespeare.

A somewhat less complicated example than the previous one is the following brief quotation from K. L. Goodwin's study of the influence of Ezra Pound:

> 'These are the Clouds' looks as if Pound had little influence on its composition, for its first few lines are full of abstractions and vague, unidentified generalizations. . . .

[28] Taylor, "Montaigne-Shakespeare," p. 335.

'Brown Penny' is so full of Yeats' earlier romanticism that there can be no question of possible influence from Pound. . . .[29]

It seems reasonable to interpret this quotation as saying that there are no similarities between Pound's poems and the poems by Yeats mentioned above, and that Yeats therefore cannot have been influenced by Pound. The connection between this argument and (C 4) should be obvious; it is easy to derive (C 4) from "if X and Y are not similar with respect to a, then X did not influence Y with respect to a."

2.5.2 Distinctions and Problems

In this section I shall discuss some general methodological and theoretical problems raised by (C 4) and by the examples above in a somewhat more systematic fashion. I shall also introduce a number of distinctions and suggest some more precise formulations of (C 4).

(A) *Irrelevant similarities and differences.* When students of the history of art and literature are about to decide whether the requirement of similarity in a particular case is satisfied or not, then they systematically disregard certain similarities and differences.

There are, to take a simple example, a number of important and obvious differences between a drawing and a marble sculpture of Julius Caesar: the drawing is light, the sculpture is heavy; the drawing can be torn into pieces, but the sculpture cannot; the drawing will burn if put in a fire, but the sculpture will not; the drawing is two-dimensional, whereas the sculpture is three-dimensional; and so forth. These differences, however, are quite irrelevant, since they are due to the fact that the two artists have been working with different materials and media. Similarly, there are a number of obvious similarities between a marble sculpture of Julius Caesar and a marble sculpture of Winston Churchill; both sculptures are heavy, three-dimensional,

[29] Goodwin, *Ezra Pound*, p. 85.

and so forth. Again, these similarities are irrelevant; they are due to the fact that the two artists have worked in the same material and medium.

At this point I would like to refer to the distinction between standard properties and variable properties of works of art which I have discussed elsewhere.[30] That a piece of marble sculpture is three-dimensional, heavy, immovable, and so forth, is not sensational; these properties belong to the standard properties of sculptures, whereas the particular form, shape, size, and color (if any) are variable properties of sculptures. Similarly, the properties of being two-dimensional, colorless, and so forth, are standard properties of drawings, whereas the size, form, and the distribution of black and white on the surface are variable properties.

When new genres are created, like collages in the beginning of this century and moving sculptures in the 1960s, then some of the standard properties of paintings and sculptures are replaced by new ones, or some of the previous standard properties are made into variable properties. Moreover, one and the same property, like being colorless or moving, can be a standard property of works of art belonging to one genre and a variable property of works of art belonging to a different genre. Now if X is a work of art which can be classified in different ways, as belonging to different genres, a number of interesting problems arise as to this distinction.[31] But there is no need to go into details here; I hope the distinction is clear enough for my limited purposes from the examples given above.

I suggest that the distinction between standard and variable properties—though this distinction in itself is perhaps not entirely clear—can be used to clarify the distinction between relevant and irrelevant similarities (or differences): when scholars decide whether or not the require-

[30] Göran Hermerén, *Representation and Meaning in the Visual Arts,* Lund: Läromedelsförlagen, 1969, chapter 2.
[31] Cf. Kendall L. Walton, "Categories of Art," *Philosophical Review,* LXXXIX, 1970, pp. 334–67.

191

ment of similarity in a particular case is satisfied, they will disregard similarities between the standard properties of the works of art, if these works belong to the same genre; and if they do not belong to the same genre, then differences between the standard properties of the works of art under comparison will be disregarded as irrelevant.

(B) *The role of knowledge and expectations.* Classifications of works of art into different categories and genres are, of course, based on knowledge and hypotheses of various kinds. Thus hypotheses and knowledge also play an important role for how the distinction between standard and variable properties are drawn, and hence indirectly for the decision as to what similarities and differences are to be regarded as irrelevant in a particular case. But knowledge and expectations, as I have already emphasized in section 1.4.2, can also be of importance in another way.

Let us suppose that X and Y are two works of art, which are fairly similar to each other. I have tried to show that what we know about X and Y will determine our expectations of the similarities between these works of art. If, for instance, we know that X and Y are made by the same artist, then we will expect them to be similar. And if we expect them to be similar we tend to focus our attention on the differences between them; it is the differences rather than the similarities that will be interesting, when one has these expectations.

Analogously, if we know that X and Y are made by different artists, then we will expect them to be very different in a number of respects, even in cases when X and Y represent the same motif. If we expect X and Y to be different and yet find that they are similar, we are likely to be somewhat surprised and then we tend to focus our attention on the similarities; it is the similarities rather than the differences that will be interesting, when one has these expectations.

However, one could object that what I have called "sketches$_D$" provide an exception to these general observations, since they are usually very similar to the original and yet made by an artist other than the one who created the original. But this is no objection to what I have said above. If we know that X is a sketch$_D$ of Y and not a copy of Y, then we will not expect it to be as similar to Y as if X had been a copy of Y, even though X and Y are made by different artists. Thus our knowledge about whether the pictures were made by the same artists or not is not the only thing that determines our expectations; they are also determined by our knowledge of the relations between X and Y.

These observations are important, because hypotheses and classifications can be revised as a result of new discoveries. At first it may be supposed that X is a free copy of Y, but then it may be discovered that X and Y were in fact made by different artists. Hitherto unknown documents perhaps also show that X was created before Y, or that the persons who created these works of art did not know about the existence of each other. In that situation we are likely to reappraise our judgment about the similarities between X and Y. If there is no causal connection at all between these works, the similarities between them are remarkable; but if X is a free copy of Y, they are not.

The situation may, of course, also be reversed. Let us suppose that X is a painting made in Argentina and that Y is a painting made in Russia. The paintings are made by different artists at roughly the same time. There is no evidence of any connection between them at all, and accordingly we do not expect them to be very similar. If they are independent works of art, the similarities are striking, and accordingly we focus on them; it is the similarities rather than the differences that seem to need an explanation. But it is, of course, also possible that it is later found out that the Argentinian painter paid a visit to Moscow before he created his work of art X, that the Russian painter had an

exhibition in Moscow at that time, and that the Argentinian painter visited the exhibition. Then we are likely to re-appraise our judgment of the similarities.

Now suppose that the only way to decide whether X is a copy of Y, or a paraphrase of Y, or is influenced by Y, and so forth, is to look at the similarities between X and Y. Then we would be in danger of moving in a circle: on the basis of what we judge as significant and striking similarities, we decide, say, that X is a free copy of Y; and on the basis of our hypothesis that X is a free copy of Y, we decide whether the similarities between X and Y are significant and strik-ing. But, needless to say, this is not so. As I have tried to show in this book, many kinds of evidence are used to de-cide whether X is a copy, paraphrase, model, and so forth, of Y.

(C) *Positive and negative influence.* The examples dis-cussed in the previous section are all instances of positive influence. However, as I tried to show in chapter 1, scholars in art history and literary history also discuss negative in-fluence; and in these cases (C 4) cannot be applied, for ob-vious reasons. Accordingly, (C 4) should be replaced by the following two requirements:

(C 4.1) If X influenced the creation of Y positively with respect to a, then X and Y are similar in this respect.

(C 4.2) If X influenced the creation of Y negatively with respect to a, then X and Y are systematically different with respect to a.

These new requirements, and particularly (C 4.2), raise a number of intriguing problems, and I shall here comment on some of them; but first I would like to discuss an example.

In his book on Velázquez, Aron Borelius discusses the relations between Rubens and Velázquez, and at one place he makes the following remark about the latter's *Los Bor-rachos* (Prado, Madrid):

We understand this picture as Velázquez' nationally self-confident declaration of independence against the mythologizing baroque style of Rubens and its claim to sovereignty, which at this time was accepted all over the world.[32]

The left part of this work of art is painted in mythologizing style, and the right part is painted in realistic, Spanish style. Borelius points to a number of circumstances which according to him indicate that the right part of the picture should be understood as a perhaps unconscious protest against the baroque style, as represented by Rubens in the first place. If this is true, then we have here an example of negative influence; and then (C 4.2) should be applicable: if what Borelius suggests is true, then there should be a number of systematic differences between the art of Rubens and the choice of motifs, style, and so forth, in the right part of *Los Borrachos*.

In this context I would like to stress that the distinction between positive and negative influence can be drawn in different ways. For example, it could be argued that the causal connection between X and Y is different, depending on whether X influenced the creation of Y positively or negatively. But it is also possible to suppose that the causal connection is of the same kind in these two cases, and to understand "X influenced the creation of Y positively with respect to a" as an abbreviation of "X influenced the creation of Y with respect to a, and X and Y are similar with respect to a." Analogously, "X influenced the creation of Y negatively with respect to a" would in the latter case be understood as an abbreviation of "X influenced the creation

[32] Aron Borelius, *Velazquez*, Stockholm: Norstedts, 1951, p. 53. My translation. The original Swedish text reads as follows: För vår del uppfatta vi den [tavlan] som Velazquez' nationellt självsäkra suveränitetsförklaring gentemot den mytologiserande rubenska salongsbarocken och dess vid ifrågavarande tid världen över accepterade anspråk på allenavälde.

of Y with respect to a, and X and Y are systematically different with respect to a."

If the concepts of positive and negative influence are defined in the latter of the two ways suggested above, then clearly (C 4.1) and (C 4.2) will turn out to be analytically true. But it is not at all obvious that they will be analytically true, if these concepts are defined in the first of the two ways suggested above. The main difficulty with this type of definition is the difficulty of identifying the two kinds of causal connections which are presupposed, and to describe these two causal relations in a clear way.

It is not easy to see what factors decide—or should decide—the choice between these two ways of defining the concepts of positive and negative influence. In view of the difficulties mentioned above I am at present inclined to favor the second alternative. I shall therefore assume to begin with that the concepts of positive and negative influence are defined in such a way as to make (C 4.1) and (C 4.2) analytically true.

(D) *Criteria of similarity.* Especially in literary studies, the use of comparative methods often gives an impression of exactness. The situation is not much different in studies of the history of art. In particular, this is true when fragments of a poem or novel by one author are printed next to fragments of a poem or a novel by another author in order to show the similarities, or when a detail in one painting is reproduced, blown up, and published next to a blow-up of a detail of another painting in order to demonstrate the similarities between the two artists.[33] However, this impression of exactness can sometimes be very deceptive.

On this and the following pages I propose to discuss a number of problems raised by (C 4.1) and (C 4.2). I shall begin with the following general question: What criteria are used—or could be used—by scholars in order to decide

[33] Cf. Sven Linnér, "The Structure and Functions of Literary Comparisons," *JAAC*, XXVI, 1967, pp. 169–79.

whether two works of art X and Y are similar in a particular respect a? As it is stated here, this question concerns positive influence only. But there is, of course, a corresponding problem concerning negative influence: What criteria are used—or could be used—by art and literary historians in order to decide whether X and Y are systematically different with respect to a? I shall here concentrate on the first problem, and I shall assume that the answer to that question, *mutatis mutandis*, also can be applied to the second question.

In general, statements about similarity between two or more works of art are considered to be verified, if readers or beholders notice or experience similarities between these works of art. Thus, experience of similarity is the first candidate for a criterion of similarity, and this criterion can schematically be stated as follows:

(K 1) X and Y are similar with respect to a, if and only if readers and beholders notice that X and Y are similar with respect to a.

However, (K 1) is far from clear as it stands, and it raises more problems than it answers.

In the first place, several objections may be made to the proposed criterion (K 1). Thus it may be objected that (K 1) is circular or leads to an infinite regress. But this is so only if (a) the criterion (K 1) is taken as a definition, and (b) both occurrences in (K 1) of "X and Y are similar with respect to a" have the same meaning. However, both (a) and (b) are false; the last ten words in (K 1) might be paraphrased by: "react by exclaiming 'How similar with respect to a! How striking!' when X and Y are presented to them under certain specifiable standard conditions." Thus this difficulty can be disregarded, but (K 1) is still unclear on a number of important points.

For example, who are the "readers and beholders?" All those who look at X and Y under normal circumstances? The majority of those who look at X and Y under normal

circumstances? All qualified or informed persons who look at X and Y under normal conditions? and so forth. It is not difficult to imagine that some readers or beholders will notice that X and Y are similar in a certain respect, whereas other readers or beholders will not notice this. How are such situations to be handled? If (K 1) is to be applied, we have to disregard the experiences of some readers or beholders. Which ones? And why?

Thus the application of the apparently innocent and trivial criterion (K 1) raises many problems; and these problems are not at all farfetched. It is, for instance, obvious that the expectations, knowledge, attitudes, background, etc. of the observers play an important role in this context. With our special frame of reference, we may notice similarities between works of art which the artist and his contemporaries—with their particular frame of reference—did not notice, and vice versa. Those who interpret Kant or Plato in a scholarly way may not be able to see any interesting similarities between the doctrines of these philosophers and the contents of certain poems by Tegnér. Tegnér, or any other poet, may of course also have misunderstood Plato and Kant.

There is no need to multiply examples. At first sight (K 1) is appealing because it suggests that statements about similarity can be tested experimentally, and it indicates how this should be done, at least in principle. But the considerations in the preceding paragraphs call attention to the danger of anachronisms. It will not do to give equal weight to the reactions and experiences of every reader or beholder. Perhaps we should only take into account the reactions of those who have the same cultural frame of reference as the author or artist? If, however, this proposal is accepted (K 1) loses the appeal it had from the start; it becomes extremely difficult, if not impossible, to test statements about similarity experimentally.

Anyway, the difficulties with (K 1) are obvious enough,

and they suggest that (K 1) should be replaced by the following criterion:

> (K 2) X and Y are similar with respect to a, if and only if every person with the property or system of properties P who looks at (reads, contemplates) X and Y under normal circumstances will notice that X and Y are similar with respect to a.

To avoid certain obvious objections, the property P must not be the property of noticing that X and Y are similar with respect to a under normal circumstances; in that case, the last part of (K 2) is turned into a tautology.

Moreover, it could perhaps be argued that X and Y can be similar even if nobody is looking at them, and that (K 2) accordingly should be replaced by something like

> (K 3) X and Y are similar with respect to a, if and only if it holds for every person with the property or system of properties P that if such a person were to look at (read, contemplate) X and Y under normal circumstances, then this person would notice that X and Y are similar with respect to a.

This formula indicates more clearly than the previous ones what problems are involved in showing that two works of art are similar in a particular respect.

For instance, exactly what properties does P refer to? The outcome of applying the criterion to specific problems may, as I suggested above, vary with the qualifications, expectations and frames of reference of the readers. Moreover, what is to be counted as "normal circumstances?" On what grounds are counterfactual conditionals of the type in the last part of (K 3) defended? What methods can be used to measure subjective similarity and to decide whether a person notices that X and Y are similar with respect to a?

The problems raised by the criteria of similarity proposed here are very intriguing, and it may appear difficult

to arrive at a satisfactory solution. At any rate, there does not seem to be a simple, clear, obvious, nontrivial and true answer to these questions. But the problems are not insoluable. Gösta Ekman and other psychologists have studied estimations of similarity experimentally and found that the intersubjective agreement is surprisingly large at apparently arbitrary estimations of similarity. It turned out, Ekman writes in his discussion of additive similarities, that the similarity "is directly proportional to the ratio between the lower pitch and the arithmetical mean value of the two compared pitches."[34]

Moreover, if one person notices that X and Y are similar in a particular respect, but another fails to notice this similarity, the first person can use several methods to make the other see the similarity. He can point out the similarities between X and Y as clearly as possible, using the technique available to art and literary critics: comparisons, analogies, similes, metaphors, and so forth.[35] It is also a characteristic feature of the reasoning in scholarly books on the history of art and literature that the author frequently refers to quotations and reproductions. If these reproductions and quotations are studied along with the main text, the reader can check for himself the claims about similarity made by the author.

(E) *A conceptual framework for discussing similarities.* It is, as I have argued above, obviously important to specify

[34] My translation. The original Swedish text reads as follows: är direkt proportionell mot kvoten mellan den lägre tonhöjden och medelvärdet av de två jämförda tonhöjderna. The quotation is taken from G. Ekman, "Några tendenser i experimentell psykologi," *Svensk Naturvetenskap 1957–1958,* p. 246. The experiment is described in H. Eisler and G. Ekman, "A Mechanism of Subjective Similarity," *Report from the Psych. Laboratory, Stockholm University,* Nr. 56, 1958. See also G. Ekman, G. Goude and Y. Waern, "Subjective Similarity in Two Perceptual Continua," *Report from the Psych. Laboratory, Stockholm University,* Nr. 60, 1958.

[35] Cf. Frank Sibley, "Aesthetic Concepts," reprinted in W. E. Kennick, ed., *Art and Philosophy,* New York: St. Martin's Press, 1964, pp. 351–73.

in what respect X and Y in a particular case are supposed to be similar, if one wants to avoid pseudoagreement or pseudodisagreement. Moreover, the examples discussed in this chapter have indicated that the respects in which two works of art (or poems, novels, etc.) can be similar may be of different kinds or types.

It is important to be explicit on this point for several reasons. First, the problem of verification may be slightly different in different cases. It is easier to show that the size or color of a figure in two paintings are similar to each other than it is to show that the expression or methods of composition of these paintings are similar to each other. Moreover, similarities of different kinds do not have the same weight; the fact that X and Y both depict a carnation in roughly the same size and color does not, of course, prove that one of these paintings influenced the other; such similarities have less weight in this context than structural similarities of various kinds.

However, to be able to talk about similarities and estimations of similarities in a more clear way, I shall need a somewhat more precise conceptual framework than the one I have been using so far. We need to distinguish not only between the respects and levels of similarity, but also between the extensiveness, precision, and exclusiveness of the similarity. As a point of departure for my attempt to introduce and clarify these concepts, I intend to use a number of quotations where an art historian analyzes similarities between paintings.

In his book *The Assisi Problem and the Art of Giotto*, Alastair Smart devotes chapter 16 to a discussion of the painters of the legend of St. Francis in the upper church of San Francesco and their influence. In this chapter he makes a number of detailed observations on the similarities and differences between paintings, among others the following ones:

> The closeness of the connections between Pacino di Bonaguida and the authors of the Legend is perhaps summed

up in the remarkable resemblance of the figure of Moses
in the *Tree of Life* to one of the seated attendants
in Scene XXV of the Assisi cycle; and in the formalized
treatment of the garments of the attendant immediately
to the left the resemblances to the *Moses* are equally
strong.[36]

We may note in particular the similarities in the draw-
ing of the horses' heads, with their great eyes and flared
nostrils, and the distinctive treatment of the striated
manes.[37]

Comparing once more the scene of the Blessed Gher-
ardo's charity with *The Gift of the Mantle* in the Upper
Church, we may note the similarity of the uses to which
landscape is put in the structure of the two compositions.
The smooth plateau of rock upon which the figure stands
ends, in each case, in a miniature precipice at the lower
edge of the picture-area, the figures being separated from
this mysterious opening in the earth by only a few
inches.[38]

Like the St. Cecilia Master, Pacino habitually breaks up
the surfaces of his landscapes into a multiplicity of shapes
giving an effect of variegated pattern.[39]

No less interesting is the resemblance of the two chil-
dren who stand on the left side of Scene V at Assisi to the
types consistently repeated by Pacino in representations
of the Christ-Child and other youthful figures. The child
represented in profile in the fresco, with his short,
turned-up nose, long upper lip, and small chin, corre-
sponds closely in feature with the Christ-Child of Pa-
cino's Madonna in the Accademia.[40]

[36] Alastair Smart, *The Assisi Problem and the Art of Giotto*, Oxford:
Oxford University Press, 1971, p. 238; this and the following extracts
are printed by permission of The Clarendon Press, Oxford.

[37] *Ibid.*, p. 239. [38] *Ibid.* [39] *Ibid.*, pp. 239–40.
[40] *Ibid.*, p. 240.

Several of his interiors have certain features in common with those of the St. Francis Master and his associates in the Upper Church, both in their particularization of detail and in their spatial organization; and the treatment of perspective in such compositions as the Morgan Prayer of the Blessed Gherardo and the Vatican Miniature illustrating the story of the miraculous crucifix at S. Miniato recalls the pictorial conventions accepted in Scene IV of the *Legend*.[41]

A particular close analogy with the 'abstract imagery' underlying the central passage of the Morgan *Christ before Pilate* and Scene VII at Assisi is to be found in the representations of *The Adoration of the Kings* on *The Tree of Life* and in the Morgan series—where the rhythmic pattern of forms that knit together the figures of the Virgin and the kneeling king is interrupted at its centre by the figure of the Christ-Child, the symmetrical regularity of the total 'image' being toned down, as before, by a secondary stress, which in each variant of the design is provided by the king's proffered gift.[42]

Yet it is at the lower end of the nave that the affinities between Pacino and the style of the *Legend* seem to be most marked. In *The Miracle of the Spring* the principles of composition, the figure-style and the simple, decorative use of colour all find their echoes in *The Blessed Gherardo Soliciting Alms* and here, as we have seen the conventions employed for the treatment of landscape are repeated exactly in the Morgan illumination and in others in the series.[43]

So exact a repetition of the Assisian iconography is in itself striking.[44]

These quotations give a number of examples of different kinds: from similarities between figures, methods of com-

[41] *Ibid.*, p. 241. [42] *Ibid.*, pp. 242–43.
[43] *Ibid.*, p. 243. [44] *Ibid.*, p. 251.

position, uses of colors, and so forth, to similarity in iconography.

In passing, I would like to comment on the use of "effect" and "recalls" in the fourth and the sixth quotation. It may be suggested that these terms indicate that Smart's statements could or should be taken as autobiographical reports about the effects of the painting on him and about what he recalls when he is looking at the relevant works. However, this does not seem to be a very plausible interpretation; Smart surely wants to say more than that the Vatican Miniature he discusses "recalls" only to him "the pictorial conventions accepted in Scene IV of the *Legend*."

But even if these statements could and should be taken as autobiographical reports, this is no objection to the criterion (K 3) outlined above; it merely shows that the system of properties P must be so specified that there is only one person in the world, who has these properties—or, for those who prefer a more nominalistic language, that the system of labels P must be such that they only apply to one person—namely Alastair Smart.

In order to make any progress at all in this difficult area, we need a fairly well-defined conceptual framework by means of which we can describe, analyze and compare similarities between different works of art, and I shall now take a few steps in that direction by introducing such concepts as respect, level, extensiveness, and precision. I shall not attempt to draw the distinctions between these concepts in an exact way, only to indicate them roughly. I shall begin with "respect," and then take the others in the order mentioned above.

If X and Y are similar with *respect* to a, then a is a property or a quality. Moreover, X and Y sometimes both have (possess or exemplify) this property, for example, when X and Y are both red, that is, painted in the same color. But sometimes X and Y do not have the same properties, even though they are similar with respect to a, and that is probably the standard situation. In that case, X has a property

P and Y has a property Q, and P and Q can be grouped together into the same category a—for example, P can be the property of having a face painted in one way and Q the property of having it painted in a different way. Whether X and Y in this case are similar or not with respect to a depends, of course, on whether some beholders will or would under certain specifiable conditions notice any similarity between P and Q.

It may be tempting to replace this subjectivistic approach to judgments about similarity by criteria which at least prima facie do not presuppose a reference to some group of beholders. For example, at least in the simple cases where P and Q are colors, then it might be argued that P and Q are similar to each other if and only if P and Q are close to each other on the spectrum or on the Ostwald chart or on some other representation of the relations between colors. A similar criterion could be suggested for tones (pitches). However, such criteria raise a number of difficulties.

In the first place it may be asked: how "close" do P and Q have to be to each other in order to be similar? It seems to me that any answer to this question that does not appeal to the experiences of similarity by some persons is bound to be arbitrary—and we are back to the subjectivistic criteria. In the second place, it is important to remember that pitches and hues can be ordered in many different ways. If we presuppose one ordering system, P and Q may be similar; but if we presuppose a different system, they may not. And is there such a thing as *the* correct ordering system? The answer seems to be plainly no.

But even if these two difficulties could somehow be overcome, there remains a third one, which in this context is very serious. The criterion outlined above applies only to simple qualities like colors and tones. But judgments of similarity are by no means restricted to such qualities in writings on the history of art and literature. How is the criterion suggested above to be applied to comparisons be-

tween the symbolism of paintings by, say, Jan van Eyck and Broederlam, or the colorism of Rubens and Titian, or the method of composition of Picasso and Juan Gris?

Moreover, it seems to be important to realize that a, P, and Q can be described in several different ways. For example, comparing the two children to the left in Scene V at Assisi with some of Pacino's Christ-Childs, one might say "the children in these paintings resemble each other" or "these paintings resemble each other with respect to the drawing of the children." But it is also possible to be much more specific and (as Smart does) compare these children with respect to their profiles, turned-up noses, lips, and chins. In that case one might say that these children resemble each other with respect to their profiles, with respect to their noses, with respect to their lips and chins.

This fact has interesting consequences when one counts the number of respects and compares the similarities between two pairs of works of art, say X and Y and X and Z. It will clearly not do to say that X is twice as similar to Y as it is to Z, merely because X is similar to Y in four respects and only similar to Z in two respects; the argument turns on what respects X is similar to Y and Z, and on how these respects (or the relevant properties) are described. But these problems will be discussed much more fully in the next chapter, and I hope that what I have said so far will be sufficiently clear for my present purpose, which is to give some idea of the relations between the concepts of respect, level, extensiveness, etc.

Now, as to *levels* or types of similarities, the examples discussed earlier suggest that the respects in which two works of art are compared can be classified in different ways. For example, one might want to distinguish between the following levels: drawing, color, structure, choice of motifs, composition, expression, symbolism, and so forth. This classification can be made more systematic on the basis of more elaborate categories of analysis and interpretation than it is possible to work out in this investigation. But

whatever categories one is working with, it is clearly possible that X and Y can be similar in some respects and different in others, and that these respects can be on the same or on different levels.

These levels are general categories, in which works of art can be discussed, analyzed, and compared to each other. The categories are obviously different for Greek vases, Baroque paintings, and DADA poems. An attempt to develop such categories in some detail must therefore be done in close connection with analysis of empirical examples. There is in my view little hope that a specific set of categories will hold generally for all kinds of works of art.

The *extensiveness* of the similarities is decided by the number of respects and levels in which two works of art are similar to each other. Again, it is important to be aware of the danger of doing quasimathematics. The levels in which two works of art are compared can—in the same way as the respects—be described in many ways, and their criteria of identity are far from clear. The fact that two paintings are both made on canvas is obviously not as important as the fact that these paintings are very similar to each other in composition. There is, however, no need to repeat the points made above concerning *respects*. The total number of respects and levels in which X and Y are similar to each other could also be called the extension of the similarities between X and Y.

I shall say that the similarities between X and Y in a certain respect a are *exclusive* or specific, if and only if they hold only between X and Y, that is, if and only if there is no other work of art Z such that Z is similar to X and to Y with respect to a. Analogously, I shall say that the extension of the similarities between X and Y is exclusive, if and only if there is no other work of art Z such that the extension of the similarities between X and Y is identical with the extension of the similarities between X and Z or between Y and Z.

Clearly, the concept of exclusiveness is a comparative

concept; the similarities between X and Y can be more or less exclusive, according to the number of other works of art which also are similar to X and Y in the relevant respects. The concept of exclusiveness or specificity is defined in terms of extension, and extension is defined in terms of respects; accordingly, the points made about the quasi-quantitative character of the concept of respect are relevant here too.

Finally, I would like to introduce the notion of *precision* in this context. This is an elusive concept, but it is clear from the writings of art historians and literary scholars that they distinguish between degrees of similarity. In the first quotation above, for example, Smart calls attention to the "remarkable resemblance" between two figures, and later in the same quotation he says that the similarities between the treatment of the garments of two figures are "equally strong." The concept of precision presupposed here cannot be identified with any of the others so far discussed.

If X is a faithful copy of Y, then the similarities between X and Y are, by hypothesis, very precise in any arbitrarily chosen respect. But if X is not a faithful copy of Y, the similarity between X and Y in some respects can still be very precise. Moreover, it is possible to rank similarities between works of art in order of precision; X can be more or less similar to Y with respect to a. The similarities between X and Y with respect to a can accordingly be more precise than the similarities between Y and Z or between X and Z with respect to a; and such statements about the relative degree of similarity can be tested experimentally, at least in principle.

Now three works of art X, Y, and Z can all be similar to each other in a particular respect a, but the precision of the similarity need not be the same; the similarities between X and Y with respect to a may be more precise than the similarities between, say, X and Z in this respect. This suggests that the exclusiveness of the similarities between works of art could and should be made relative to the precision of

the similarities between these works of art in the relevant respects.

If that is true, the preliminary definitions of exclusiveness should be modified along the following lines: the similarities between X and Y in a certain respect a and with a particular precision p are exclusive, if and only if there is no other work of art Z such that Z is similar to X and to Y with respect to a and with the precision p. A similar modification could easily be made in the other definition of exclusiveness (with respect to extensiveness of the similarities) discussed above.

The concepts introduced above could be used to describe, analyze, and compare the similarities between different works of art; for example, between different representations of St. George and the Dragon as well as between any arbitrarily chosen works by one or two artists. My examples here have been drawn from art history writings, but the distinctions suggested above could also be applied to comparisons between literary works (poems, novels, and so forth).

(F) *Similarities as evidence of influence: examples.* Similarities are often regarded as evidence of influence. If X and Y are, as it is sometimes said, "strikingly similar" with respect to a, or if there is a "remarkable resemblance" between X and Y with respect to a, then this is frequently supposed to show that X and Y cannot be causally independent of each other with respect to a. I shall first quote some passages illustrating this kind of reasoning, and then I shall proceed to discuss some of the problems raised by these examples. As above, I intend to concentrate on positive influence, and I shall assume that the results of the investigation, mutatis mutandis, can be applied also to negative influence.

To begin with, I would like to quote the following general methodological declaration from the preface to Norman J. Fedder's study of the relations between D. H. Lawrence and Tennessee Williams:

The case for extensive and profound influence must rest, of necessity, on thematic and technical similarities which exist between respective works.[45]

I interpret this quotation as saying that the occurrence of thematic and technical similarities between the works of the two authors—in combination with evidence indicating that the temporal requirement B is satisfied—supports the hypothesis that one of them was influenced by the other.

A perhaps even clearer example of this kind of reasoning can be found in the following quotation, taken from K. L. Goodwin's book on the influence of Ezra Pound:

Occasional examples of single lines falling into this metre —lines such as 'Seven years and the summer is over,' or 'Does the watchman walk by the wall?'—could be discounted as being fortuitous. But where there are passages in which several lines fairly close together fall into the metre, the probability of influence is very strong.[46]

Thus Goodwin argues, if I understand him correctly, that occasional stylistic similarities do not prove that there is a causal connection between two authors. But if there are many stylistic and metric similarities, this can hardly be an accident; and these similarities make it probable that Eliot (the author compared to Pound in the quotation above) was influenced by Pound.

In his book on the philosophical and aesthetic studies of the Swedish poet Tegnér, Albert Nilsson argues as follows in order to show that Tegnér was influenced by Schiller's theory of semblance (*Schein*):[47]

The fact that Tegnér was also influenced by Schiller's theory in his characterization of the beautiful in his poem

[45] Norman J. Fedder, *The Influence of D. H. Lawrence on Tennessee Williams*, The Hague: Mouton, 1966, p. 5.

[46] Goodwin, *Ezra Pound*, p. 123.

[47] It is difficult to find an adequate English translation of the German term "Schein" (semblance, appearance, shine) in this context. Cf. Susanne Langer, *Feeling and Form*, New York: Scribner's, 1953, chapter 3, particularly pp. 49–50.

Det Eviga is, by the way, shown by the first two lines in the first version of the poem (later changed):

The beautiful things you create do not die with your body
their semblance ("sken") easily flies over the tomb.[48]

However, this argument does not seem to be particularly strong.

Sven Linnér has discussed this example in his book *Litteraturhistoriska argument,* and he points out that Nilsson's argument presupposes that "sken" in the poem is interpreted in a very specific way, and that it is quite possible that there are many other equally or even more reasonable interpretations of this term in ordinary language that makes it unnecessary to connect Tegnér's use of the term "sken" in this context with Schiller's theory of semblance.[49]

Another illustration of this argument can be found in the following quotation, taken from Rensselaer W. Lee's study of Castiglione's influence on Spenser's early hymns:

> These ideas [theories of beauty, going back to Plato and Plotinus] are common to all Renaissance Platonists whom Spenser knew. Yet here again, Spenser's exposition of them is closer in wording to Castiglione than to any of the others.[50]

To show that this is so, Lee makes a number of detailed comparisons between Castiglione's and Spenser's works. But what do these comparisons prove?

Strictly speaking, they prove only that Castiglione's way of expressing these ideas is very similar to Spenser's. To

[48] Albert Nilsson, "Tegnérs filosofiska och estetiska studier," in *Esaisas Tegnér,* Stockholm: Bonniers, 1913, p. 83. My translation. The original Swedish text reads as follows: Att Tegnér även vid karakteristiken av det sköna i poemet Det Eviga varit påverkad av skenteorin, visa ju för övrigt de två första raderna i deras första sedan ändrade ordalydelse: Det sköna, du bildar, dör ej med ditt stoft,/lätt flyger dess *sken* öfver grafven.

[49] Sven Linnér, *Litteraturhistoriska argument,* Stockholm: Svenska Bokförlaget/Bonniers, 1964, pp. 33–37.

[50] Lee, "Castiglione's Influence," p. 72.

show that the similarities between Spenser's and Casti-glione's works are exclusive in the sense defined earlier—and from the quotation above it seems that this is what Lee is claiming—Lee would have to compare Spenser's way of expressing these ideas to "all Renaissance Platonists whom Spenser knew." If this type of comparison had been carried out explicitly, it would have involved the works of a great number of artists or writers; and in this respect it would have differed from the other comparisons discussed so far. But still the underlying assumption or pattern of argument is the same: X is more similar to Y than to Z; thus X was influenced by Y rather than by Z.

The previous sentence, however, gives rise to a number of intriguing problems. Why "thus"? And what is meant by "thus"? I will now make a brief digression to comment on an assumption that is sometimes made quite explicitly by art historians and literary scholars. This assumption can be formulated in slightly different ways. But the basic idea is that there is some kind of causal or statistical connection between influence and similarities of a certain kind to be specified shortly: if X and Y are (strikingly) similar, then this is not a coincidence—it indicates that one of them was directly or indirectly influenced by the other. For the sake of brevity, I propose to refer to this assumption as "the assumption of noncoincidence."

I shall now illustrate this assumption with some examples. In his article on Titian's borrowings from ancient art, Otto J. Brendel compares the left half of Titian's *Education of Cupid* to Michelangelo's tondo in Florence and adds:

> The question is further complicated by the fact that in the version painted by Titian a memory of a Venetian monument, also, may be implied. The way Venus turns to the second Cupid, who leans against her shoulder, has its closest counterpart in the group of the seated Nymph conversing with the young Satyr behind her, in the al-

ready-mentioned *Ara Grimani*. I cannot regard *this similarity a mere coincidence*.[51]

If it is not a coincidence, then what is it? This is not made explicit by the author, but there can be no doubt that he means to suggest that Titian borrowed or was influenced by the group of seated nymphs on *Ara Grimani*.

Towards the end of his article on the relations between San Juan de la Cruz, Boscán, and Garcilaso de la Vega, E. Allison Peers makes the following point:

> It is, of course, true that if several apparent "coincidences" of the kind we have been describing occur in one passage, the more of them there are, or the more striking they are, *the less likely they are to be coincidences*.[52]

This quotation sheds interesting light on the assumption of noncoincidence and therefore deserves further comment.

Several words in this passage, notably "the more," "the less," and "likely" suggest that this assumption can be qualified and made more precise by introducing a number of rather elementary distinctions. In this way we can get a number of different versions of this assumption: (a) probabilistic and nonprobabilistic ones; (b) absolute and comparative ones; and (c) quantitative and qualitative ones. (I will return to some of these distinctions shortly.) By combining these distinctions with each other, we easily obtain eight different versions of the assumption of noncoincidence. But none of them can, it seems to me, for reasons already mentioned in section 2.5.2 (explanations of found or noticed similarities), be regarded as anything more than a crude rule of thumb.

In his introduction to comparative literature, Jan Brandt

[51] Otto J. Brendel, "Borrowings from Ancient Art in Titian," *AB*, 1955, p. 124; last italics mine.

[52] E. Allison Peers, "The Alleged Debts of San Juan de la Cruz to Boscán and Garcilaso de la Vega," *Hispanic Review*, XXI, 1953, pp. 105–106, my italics.

Corstius makes an instructive comparison between a sonnet entitled *Delfica* and Mignon's song in the third part of Goethe's *Wilhelm Meisters Lehrjahre*.[53] Commenting on this analysis in the subsequent chapter, the author writes as follows:

> The fact that the concept of influence may be clearly defined in the study of literature should have already become evident when the sonnet "Delfica" was being discussed. In that poem the influence of Mignon was not restricted to the first lines of the quatrains. The symbolic language, with respect to the images themselves as well as to their sequence, showed that, in that regard, the French poet had composed his sonnet after the scenic pattern of Mignon's song. We have seen how he did this and with what unique results. *Chance parallelisms in that instance were out of the question.*[54]

This example is somewhat more complex than the others; the author has carefully specified in what respects the two poems discussed by him are similar and in what respects they are different.

The most difficult and also most interesting theoretical problem in the present context seems to be this: What kinds of similarities do there have to be between any two works of art, if these similarities are to be regarded as evidence of positive influence and not merely as coincidences? There is an analogous problem concerning negative influence: What kinds of differences do there have to be between any two works of art, if these differences are to be regarded as evidence of negative influence and not merely as coincidences?

Of course, at this point it might be useful to refer to the distinctions between extensive, exclusive, and precise similarities discussed above. But that does not solve our problem. Instead of the old problems we would then have to

[53] Jan Brandt Corstius, *Introduction to the Comparative Study of Literature*, New York, Random House, 1968, pp. 152–61.
[54] *Ibid.*, p. 183. My italics.

face a set of new ones: In precisely how many respects should the two works of art in question be similar? How precise should the similarities be? How extensive? And what if the similarities are extensive but not precise? Or precise but not extensive? And so forth. There does not seem to be a general, precise, and true answer to these questions. This suggests that the scholar has to make a separate estimation of the probabilities in each individual case, considering the evidence and the possible alternative explanations in that particular case.

I shall now take some more examples from art history. In his book on Dutch still-life painting in the seventeenth century, Ingvar Bergström writes as follows:

> François Ykens seems to have been directly influenced by Heda's works. . . . The composition [in a still life by Ykens from 1636] closely resembles Heda's breakfast piece at Karlsruhe. In both pictures there are lingering traits of the additive conception. . . . It is possible that Ykens saw Heda's original in Rubens' or some other collection at Antwerp.[55]

The statement that a painting by Ykens "closely resembles" a painting by Heda is here used as an argument to support the claim that Ykens was influenced by Heda. In the last sentence of the quotation Bergström, by the way, suggests that the requirement of contact was satisfied in the present case.

Incidentally, it should be noted that Bergström is not here using the requirements of contact and similarity to refute hypotheses about influence according to the following pattern:

(I)

(a) If the requirements of contact and similarity are not satisfied, then X did not have any influence on the creation of Y.

55 Ingvar Bergström, *Dutch Still-Life Painting in the Seventeenth Century*, London: Faber & Faber, 1956, p. 143.

(b) The requirements of contact and similarity are not satisfied in this particular case.

(c) Hence: X did not have any influence on the creation of Y in this particular case.

As I have emphasized above, I am here confining myself to cases of positive influence, and I shall assume that what holds for positive influence will also hold for negative influence, mutatis mutandis.

Instead, it seems that Bergström's argument can be reconstructed along these lines:

(II)

(a') If the requirements of contact and similarity are satisfied, then (it is probable or plausible that) X influenced the creation of Y.

(b') The requirements of contact and similarity are satisfied in this particular case.

(c') Hence: (it is probable or plausible that) X influenced the creation of Y in this particular case.

This pattern is clearly a straightforward example of deductive reasoning according to the well-known rule of modus ponens.

However, it seems that Bergström's argument in the quotation above can also be interpreted roughly as follows:

(III)

(a'') If X influenced the creation of Y in some respect, then the requirements of contact and similarity are satisfied.

(b'') The requirements of contact and similarity are satisfied in this particular case.

(c'') Hence: in this particular case X influenced the creation of Y in some respect.

Obviously, the last pattern (III)—in contradistinction to (II)—is not deductively valid. But depending on the extensiveness, exclusiveness, and precision of the similarities, the premises in (III) can make the conclusion more or less probable (plausible).

The distinctions between the three patterns and also the points made above can be generalized. They do not only apply to the quotation from Bergström's book on Dutch still lifes, but they hold just as well for all the other examples discussed in subsection (F).

In concluding this survey of examples, I would like to make a few comments on a quotation of a somewhat different kind, taken from Jean Adhémar's monumental investigation of classic influences on mediaeval art in France:

> Malgré son originalité apparente, il a son prototype dans l'art gallo-romain; le rapprochement avec un tombeau antique retrouvé dans le cimetière de Saulieu le prouvera sans doute possible.[56]

Adhémar here compares two sarcophagi, one of which was made in Provence some time during the middle of the eleventh century. The line of argument in this quotation differs from the ones discussed above in the following respect.

In the last quotation the author does not say—as has been suggested in the other quotations—that one of the two works of art discussed influenced the other. The antique sarcophagus is considered as a representative of a large class of similar works of art, and what Adhémar is saying is not that the Saulieu sarcophagus influenced the particular sarcophagus he is discussing, but rather that the similarities between these sarcophagi are so striking that the sarcophagus from the middle of the eleventh century "sans doute possible" was influenced by some of the sarcophagi of which the Saulieu sarcophagus is a representative.

[56] Jean Adhémar, *Influences antiques dans l'art du moyen âge français*, London, 1939, p. 236.

(G) *Simi'arity as evidence against influence.* The absence
of similarity is sometimes cited as evidence against the pos-
sibility of influence; if X and Y are not similar with respect
to *a*, then X did not influence the creation of Y with respect
to *a*. The absence of exclusive similarities (in the sense de-
fined above) is often used analogously as evidence against
the necessity of influence; if X and Y are similar with re-
spect to *a* but these similarities are not exclusive, then X
need not have influenced the creation of Y with respect to
a; Y can just as well have been influenced by any of the
other works that are similar to it in this particular respect,
provided that they satisfy the requirement of contact and
the temporal requirements discussed above.

Now it follows from the definitions of the notion of ex-
clusive similarity in subsection (E) above that the absence
of exclusive similarities between two visual or literary
works of art X and Y presupposes the presence of nonex-
clusive similarities between these two works and at least
one other work Z. The presence of such nonexclusive sim-
ilarities can be used as evidence in discussions about in-
fluence. Accordingly, it is interesting to note that similari-
ties can be used as evidence not only of influence but also
against influence, and this clearly shows the importance
of distinguishing between similarities and influences.

Thus to point out that the similarities used as evi-
dence to support a hypothesis of influence are not exclusive
is one of the ways such a hypothesis can be criticized. This
can be illustrated by the following quotation from Hardin
Craig's article on the relations between Shakespeare and
Wilson's *Arte of Rhetorique*:

> But Shakespeare's ridicule of pedantry he need not have
> had suggested to him by Wilson, since it was common to
> Wilson, Cheke, Ascham, and perhaps a dozen other
> writers.[57]

[57] Hardin Craig, "Shakespeare and Wilson's *Arte of Rhetorique,*
An Inquiry into the Criteria for Determining Sources," *PMLA*, 1922,
p. 622.

Towards the end of his paper, Craig summarizes his main conclusion as follows: "In every case we have found that the thing supposed to have been borrowed was a thing which might just as well have come from some other quarter."[58] Of course, he has not in this way refuted the hypothesis about influence, but only pointed out that there are a number of other possible alternatives.

A similar strategy is adopted in E. Allison Peers' criticisms of the hypothesis that San Juan de la Cruz was strongly influenced by Boscán and Garcilaso de la Vega. Having cited two parallel passages, the author at one point continues by saying that one scholar

> entirely rejects this suggestion of influence, on the ground that the themes are common in the *Cancioneros* and in lyric poetry of the period generally. This is true: S. J. X. [San Juan de la Cruz] seems to be compressing a typical *Cancionero*-theme, of which the very basic words common to him and to both passages (*presencia* and *dolencia*) form an integral part.[59]

(H) *Explanations of found or noticed similarities.* Let us suppose that the problems discussed above in subsection (D) are solved, and that a scholar or critic has managed to demonstrate clear similarities between X and Y in one or more respects. Then the problem arises: how are these similarities to be explained?

Here I propose to distinguish between and to illustrate four main types of hypotheses which can be used to answer this question; the first of them is:

(H 1) There is a direct causal connection between X and Y.

This means that we have attempted to explain the similarities by conjecturing or assuming that there is a direct posi-

[58] *Ibid.*, p. 630.
[59] Peers, "The Alleged Debts of San Juan de la Cruz," p. 12.

tive influence between X and Y in the relevant respects; schematically:

(a)

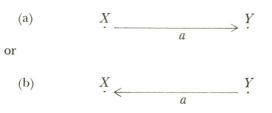

or

(b)

The influence can, of course, concern a great number of respects, but for the sake of simplicity I am here using only one variable a which—if necessary—could be replaced by a, b, c, etc.

The second main type of explanation is suggested by the following general hypothesis:

(H 2) There is an indirect causal connection between X and Y.

In this case, the similarities between X and Y are explained by conjecturing or assuming that there is an indirect positive influence between X and Y in the relevant respects; schematically:

(c)

or

(d)

These diagrams make it clear that when I am talking about "indirect influence" here, I am using the term in the sense indicated by the standard version of the first definition of indirect influence in section 1.3.2 above. But this type of explanation could also be used when "indirect influence" is used in the sense indicated by the second definition in 1.3.2.

The third main type of explanation is suggested by the following general hypothesis:

(H 3) X and Y have the same artistic source.

The basic idea is that the similarities are explained by assuming that there is a third factor Z (a work of art or a class of works of art) which directly or indirectly influenced the creation of both X and Y; schematically:

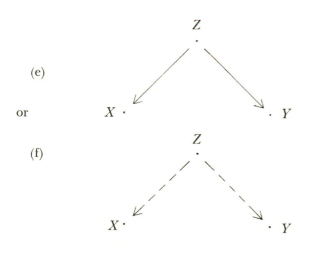

(e)

or

(f)

In diagram (f) I have used a broken arrow to stand for indirect influence. In that case we assume that the creation of X and Y was influenced by other works of art V and U which are not identical with each other and which in their turn were directly or indirectly influenced by a work of art or a class of works of art Z, schematically:

(g)

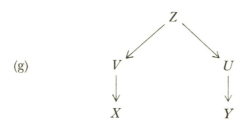

Finally, the last main type of explanation to be discussed here contains as a part the following general and negative hypothesis:

(H 4) X and Y are causally independent of each other.

In that case the similarities noticed between X and Y may depend on the fact that the two artists who created X and Y depict or describe similar objects or events; or that they illustrate the same story or text; or that they express similar feelings, emotions, or moods; or that they are working in the same genre or with the same material (clay, marble, and so forth); or that they have had similar experiences in the past; or that they have had the same or similar background (training, education, and so forth); or that they are living in the same political, social, or intellectual, milieu.

Thus, the general and negative hypothesis (H 4) can be supplemented by many other positive hypotheses, of which I have just given seven examples. The enumeration above does not, of course, make any claims of completeness. More-

over, some of these seven positive hypotheses might seem to be in need of further explanation. Why is it, for instance, that two poets in quite different places of the world so frequently have tried to describe similar objects or events, or to express similar feelings, moods, and emotions?

Some scholars might want to argue that at a certain moment the time is ripe for certain ideas, but this metaphorical statement does not provide much of an explanation. Others, like Maud Bodkin in her *Archetypical Patterns in Poetry*,[60] might want to seek an explanation along the lines envisaged by Carl Jung. Still others might want to say that poets and artists have a peculiar type of talent, and that this accounts for some of the striking similarities between works of art when influence seems to be out of the question. Finally, mere chance must also be taken into account. If a computer were fed with letters and programmed to combine them at random, it would sooner or later produce a poem very similar to—and perhaps identical with—Yeats' *Brown Penny*.

Now which of these four main types of explanation is the correct one? The answer to this question obviously varies from case to case. It is probably a sound methodological strategy to follow this piece of advice: if X and Y are strikingly similar to each other, then check whether the temporal requirements are satisfied. If it is found that Y in the relevant respect was created before X, or that the creator of Y did not have any contact with X, or that he became familiar with X only after he had already created Y, then explanations of the type (a) and (c) are obviously refuted. But there still remain at least five possibilities, the last of which can be combined with a variety of positive suggestions.

When hypotheses about influence are criticized, it sometimes happens that the critics point out that the author has

[60] Maud Bodkin, *Archetypical Patterns in Poetry*, London: Oxford University Press, 1948. Of course, the notions of archetype and collective unconsciousness are far from clear, but it would carry us too far from our topic to discuss them here.

not paid enough attention to other possible explanations of the similarities he has found. I shall here illustrate this point by citing some examples from writings on art history, of which the first two are of a slightly different kind from the others; they bring out that there is no necessary connection between similarities and influence, in the sense that similarities between *X* and *Y* do not imply that there is a causal connection between *X* and *Y*.

The first example is taken from Paul Lafond's book on the art and influence of Hieronymus Bosch, where he at one point makes the following statement about the relations between Bosch and Geertgen van Sint Jans:

> Malgré qu'on en ait dit, Jérôme Bosch ne semble guère avoir été influencé par Geertgen van Sint Jans, appelé encore Gerrit ou Gerhard van Haarlem, son compatriote, peut-être même son cadet. . . . Qu'il y ait eu des rapports entre leurs deux façons de peindre, d'interpréter le paysage surtout, c'est incontestable, mais il en est nécessairement ainsi entre artists de la même époque.[61]

The quotation shows clearly that some of those who used comparative methods even during the first decades of the century were aware of the fact that similarities between works of art can be explained in other ways than by assuming causal connections.

A similar point is made in a much more recent investigation by Jacob Rosenberg, Seymour Slive, and E. H. ter Kuile. In their book on Dutch art and architecture from 1600 to 1800, they discuss which artists were influenced by Rembrandt, and in that context they make the following point:

> The sobriety and dark tonality of Frans Hals' late portraits, the grandeur of the landscapes Jacob van Ruisdael

[61] Paul Lafond, *Hieronymus Bosch—son art, son influence, ses disciples,* Bruxelles & Paris: G. van Oest & Cie., 1914, pp. 31–32.

painted after the middle of the century, and the rich chiaroscuro of Willem Kalf's monumental still lifes suggest that Rembrandt's mature style made a profound impression upon some of Holland's most creative artists; but precisely how much of the similarity of mood and spirit of their works is a consequence of the influence of Holland's greatest artist and how much is the result of a shared national or period style is a question easier to pose than to answer.[62]

These authors are also clearly aware of the problem I have tried to call attention to above, and they stress the difficulties of choosing in this particular case between explanations of the first and fourth type.

I shall now discuss two examples, in which art historians criticize hypotheses about influence because the author they criticize has not considered other possible explanations of the similarities. In his book *The Illustrations of the Heavenly Ladder of John Climacus*, John Rupert Martin discusses the hypothesis that a miniature (Perpetua's ladder) was influenced by another; but he rejects this hypothesis with the following argument:

> There is no reason to think, however, that Perpetua's ladder reflects the influence of the Climax picture. The miniatures reveal no features that cannot be accounted for by the text of the vision.[63]

Thus, the hypothesis of influence is unnecessary, if Martin is right; the simplest explanation is that the artists in both cases followed the text. The similarities between the miniatures can then be accounted for by saying that the artist in both cases illustrated the text of the vision, which, incidentally, provides a good illustration of the last main type of explanation discussed above.

[62] J. Rosenberg, S. Slive, and E. H. ter Kuile, *Dutch Art and Architecture 1600–1800*, Harmondsworth: Pelican, 1966, p. 96.

[63] John R. Martin, *The Illustrations of the Heavenly Ladder of John Climacus*, Princeton: Princeton University Press, 1954, p. 19, n. 18.

E. von Ybl has tried to explain the asymmetric grouping of *The Three Graces* by L. Kern by assuming an influence from the early baroque style during the seventeenth century. In *Pagan Mysteries in the Renaissance,* Edgar Wind makes the following comment on this explanation:

> Unaware of its literary origins, the author [E. von Ybl] ascribes the asymmetrical grouping to 'Einfluss des Früh-barockstils des 17. Jahrhunderts.'[64]

According to Wind, there is thus a third factor that has influenced Kern's work of art.

In concluding this survey of possible explanations for similarities between works of art, I shall now try to illustrate some of the problems art historians have to face when they explain similarities, and I think that what I am going to say can be generalized to literary history as well. As a point of departure I propose to use the following quotation from Nils Gösta Sandblad's book on Manet, which I have cited several times before:

> It is, at any rate, important to establish the fact that this connection [between Goya's execution scene in the Prado and Manet's *L'Exécution de Maximilien*] is already to be seen in the Boston painting and that the artist at this stage was attracted by Goya. We see here one instance of how Manet needed a well-established point of departure for his work, and how, when this was not supplied by the newspaper articles, he went further afield, to other sources of inspiration. In the general conception—the placing of the groups, the distance between them, and their positioning on a gentle diagonal he could find his surest support in Goya.[65]

In the last sentence the author specifies the similarities between the two paintings. The problem is: how are these similarities to be explained?

[64] Edgar Wind, *Pagan Mysteries in the Renaissance,* London: Faber & Faber, 1958, p. 51.
[65] Sandblad, *Manet,* p. 122.

To get a clear picture of the problems confronting art historians in such a situation I would like to propose the following experiment. Let us suppose that Manet was not familiar with Goya's works, and both Goya and Manet—without knowing anything about the existence of each other—are to paint an execution scene. Both Goya and Manet will then, we can safely assume, depict two groups of people in their paintings: those who are to be executed, and those who are to perform the execution. Let us go on and ask: from what angle is it reasonable to suppose that the two painters will represent the execution?

Knowing the artistic ideals of the time, the earlier works of the two artists, and so forth, it is possible to exclude at once several possible alternatives as extremely unlikely; for example, that the painters would represent the execution from behind those who are to be executed or from behind those who are to perform the execution. It is reasonable to suppose that the psychological interest of the artists (and of the future beholders) will be concentrated on the faces, expressions, and gestures of the persons depicted, and on the differences there may be in this respect between those who are to be executed and those who are to perform the execution. Thus, there seems to be only one plausible answer to the question of a reasonable angle from which to paint the scene: from the side.

If this is true, then the situation can be represented by the following diagram, where A are those who are to be executed, B is the execution patrol, and P is the painter:

In my view it is likely that P will stand below B (as indicated in the drawing above), and hence that the angle *a* will be sharp and considerably less than 90°—for the simple reason that the expression, gestures, and faces of those who are to be executed are much more interesting than the expression, etc., of the soldiers.

Finally, I would like to ask: which moment is it reasonable to suppose that the two painters will choose to represent? The answer will in both cases be the same: they will represent the moment when the soldiers fire and perform the execution, because that is the most dramatic moment of the execution. In this way it is possible to reduce the importance of the perhaps otherwise striking similarities between the two paintings. Even if Manet had not been familiar with Goya's execution scene in the Prado, there is bound to be some similarity between their paintings. We have good reason to suppose that they would represent two groups of people from roughly the same angle and at the same moment, and that one of these groups would be soldiers firing at the other.

It should perhaps also be mentioned in this context that there are other pictures with similar motifs which Goya and perhaps also Manet might have been familiar with. E. H. Gombrich has called attention in his *Meditations on a Hobby Horse* to Porter's representations of Napoleon's massacres in Spain.[66] The fact that the two artists represent a similar motif will explain many similarities between their paintings, and these similarities do not indicate that one of the artists influenced the other.

This fact raises the following methodological problem in this particular case: which of the similarities discussed by Sandblad in the quotation above can be explained by saying that the artists have represented the same motif, and which similarities (if any) indicate that Manet was influenced by Goya? It should be clear from what I have said

[66] E. H. Gombrich, *Meditations on a Hobby Horse and Other Essays on the Theory of Art*, London: Phaidon, 1963, pp. 124–26.

above that this is a difficult question to answer in a clear, nontrivial, and convincing way. Accordingly, it is difficult to settle disagreement between art historians as to how this question should be answered.

For example, it could be argued that the fact that Goya and Manet both represent the same or a similar motif (an execution scene) explain not only the general similarities discussed above (such as, what groups of people are represented? from what angle are they represented? at what moment are they represented?). It could also be argued that the distance between the two groups would, within certain limits, be given by the practice followed at executions. Moreover, it is reasonable to suppose that in both cases the artists would want to paint the execution from up close in order to be able to give a clear picture of what is happening. Finally, the perspective and the angle of depiction in combination create the diagonal which is clearly visible in the composition of the two paintings.

So far, I have not said anything about the many and important differences between these paintings. Anyone who has seen the originals in Boston and Madrid will notice that the colors and the dramatic tempo of the two paintings are quite different. But I hope that what I have said is sufficient to illustrate some of the methodological problems art historians have to face in this context. In the next subsection I shall call attention to some other methodological problems raised by this example.

(I) *Weighing of similarities.* When art historians choose between possible explanations of the similarities they have found between any two works of art, they will have to weigh the similarities against the other available evidence, and this weighing raises a number of interesting questions.

Consider again the execution scenes by Goya and Manet. As I mentioned above, there are not only similarities between these paintings; there are also a number of striking differences between the pictures. These differences belong

to the available evidence just as much as the similarities do. And what principles are used, or could be used, when similarities of the sort to which Sandblad has called attention are weighed against differences of colors, technique, and dramatic tempo? It is extremely difficult to find a clear and noncontroversial answer to this question.

It is, of course, possible to say that if the similarities are aesthetically more important than the differences, than the similarities will outweigh the differences. But this answer is unsatisfactory as long as there are no reliable methods of deciding questions about the relative aesthetic importance of features of works of art. It might instead be suggested that if the similarities are more numerous than the differences, then they will outweigh the differences. But this will not do, for the reasons I have already mentioned when I called attention to the difficulties involved in counting similarities. It would seem to be more promising to look at the exclusiveness and the precision of the similarities and say that if the similarities are more exclusive, or more precise, or both more exclusive and more precise, than the differences, then the similarities outweigh the differences. But in what sense can differences be exclusive and precise? I shall return to these questions in the final section of this chapter.

However, similarities and differences between works of art are not the only kind of evidence available to art historians. Sometimes they have access to statements or notes by the artists involved, and these notes will have to be examined critically by historical methods before they can be used as evidence. Here we can distinguish between two cases: (a) in spite of obvious similarities between X and Y, the artist who created Y denies that he was influenced by X, and (b) in spite of obvious differences between X and Y, the artist who created Y acknowledges that he was influenced by X. In this case the scholar has to weigh similarities (and differences) against what the artist has said, and this weighing involves other problems than those of the first weighing process.

230

Suppose, for example, that we found a note in Manet's diary of the following kind: "Yesterday I had dinner with Mr. and Mrs. X. He had just been to Spain and seen the works by Goya and was struck by what he called the 're-markable resemblances' between my execution scene and Goya's execution scene in the Prado. He wondered whether I had been influenced by Goya, which I vehemently denied. And it is true: I did not have Goya's painting in mind when I depicted the execution of Maximilian. But Mr. X persisted, and a long discussion followed which was very unpleasant for Mrs. X." Does this show that Sandblad is wrong? Not necessarily, since the artist does not have to be aware of the fact that he got the idea from Goya. Besides, even if he was aware of this fact, he can make rationalizations after-wards or put a note like this in his diary just to deceive fu-ture art historians.

This imagined example illustrates case (a) above. I shall now illustrate case (b) with a quotation from Michel Seuphor's book on the life and work of Piet Mondrian. Here the author writes as follows about the relations between Bart van der Leck and Piet Mondrian:

> He often went to the home of Van der Leck—"every evening," the latter told me—to talk about painting.
>
> I have never understood how Van der Leck could have had any influence whatever on Mondrian at that particu-lar moment. Van der Leck's paintings are cold and super-ficial; their style suggests chromos. There is something pitilessly hard in the works of Van der Leck of this pe-riod. Mondrian was, on the contrary, all warmth and in-wardness. He had long sought inwardness in his art. Extremely sensitive, he strove to reconcile opposites. His vision of the world was entirely spiritual. That of Van der Leck was rather anecdotic and trivial. But the facts are there. Mondrian tells in a little piece, written in 1931, how he met Van der Leck, "who, even though his works were still representational, painted in flat areas of pure

color." And he adds: "My technique, which was more or less Cubist, hence still more or less pictorial in nature, was influenced by his exact technique."

So it was Van der Leck who influenced Mondrian to paint in flat surfaces, and to use rectangular planes of pure color.[67]

This quotation is interesting, since it suggests that after all similarity need not be a necessary condition for positive artistic influence.

However, even if Seuphor is right, this does not follow. In the first place it can be argued that here we are not confronted with a genuine example of positive influence (in the sense defined in chapter 1 above), and that this alleged counterexample therefore does not force us to give up or modify the requirement of similarity in a drastic way. In the second place, "X is similar to Y" does not mean "any person who looks at X and Y under normal conditions will notice the similarities between X and Y." Accordingly, from the statement that Michel Seuphor does not notice any similarities between the works of Van der Leck and Mondrian at this particular time, it does not follow that there are no similarities between these works; there can very well be similarities, even though Seuphor does not notice them.

But suppose that nobody can notice any similarities between the works by Mondrian and Van der Leck—at least not in any of those respects in which Mondrian says he was influenced by Van der Leck. Suppose, moreover, that Van der Leck influenced Mondrian not by talking about art and the philosophy of painting, but by his own works of art, as Seuphor seems to presuppose. Then we have to face a problem. Shall we trust Mondrian's words more than his works, or his works more than his words? As in the previous case, the artist may of course have put this note in his diary just to confuse or deceive future art historians, but let us for a moment disregard that possibility.

[67] Michel Seuphor, *Piet Mondrian. Life and Work*, New York: Abrams, n.d., pp. 129–30.

I would like to stress that the testimony of Mondrian's works need not be incompatible with the testimony of his words. It could be true that Mondrian was influenced by Van der Leck, though his works are not particularly similar to those of Van der Leck. For example, it can be argued that Mondrian's artistic imagination transformed the impulses he got from van der Leck, and that the differences between his paintings and those by Van der Leck at this time indicate the originality of Mondrian's artistic talents. In that case one is using the following rough rule of thumb: the more probable it is that the creator of Y was familiar with X, the less extensive, exclusive, and precise need the similarities between X and Y be.

(J) *Normative conclusions.* Finally, what normative conclusions can be drawn from this discussion about the problems involved in showing that two visual or literary works of art are similar to each other? Here are a few normative suggestions.

To begin with, it should perhaps be stressed that the respects in which two works of art X and Y may be compared can be arranged in a sliding scale from fairly simple and easily measurable features of these works to more complex features, which are very difficult to describe and interpret in an intersubjectively satisfactory way. For example, if X and Y are paintings, we have material, size, and technique at the one end of this scale. At the other we have style, expression, theme, and world view. Somewhere in between these two extremes we have the motifs, the composition, and the way various details like hands, noses, garments, and so forth, are rendered. If, however, X and Y are poems or vases or palaces, the scale will, of course, be at least partly different.

When a scholar has good reason to think that a statement to the effect that one work of art is similar to another might be controversial, he should be as careful as possible. This means that he ought to be specific about the similarities between these works of art. In other words, he should investi-

gate (a) if there are similarities on several levels between the works he is discussing; (b) if there are similarities in different respects on the same level; and, above all, (c) if the similarities he has noticed are extensive, exclusive, and precise.

Furthermore, he should (d) try to point out or describe the similarities he has noticed as clearly as possible, and (e) to weigh these similarities against the differences between the works and against other available evidence, including statements made by the artist or poet himself. The last point is essential, and it is obvious that this weighing is a very complex operation and not at all a simple addition and subtraction, where the numerical number of similarities and differences is decisive.

Apart from the difficulties in counting similarities—which I have already mentioned several times—simple addition and subtraction will not do in this context for the following reason. It is easy to conceive that in a particular case there may be a few, exclusive similarities in aesthetically significant respects between two works of art, and that these few similarities are much more important than a large number of differences in aesthetically nonsignificant respects.

Moreover, the similarities noticed by a scholar should not only be weighed against differences and other evidence available; (f) their relevance should also be carefully considered. This relevance is a matter of degree, and I have suggested above that the extent to which a particular similarity is relevant depends on a number of different circumstances: the particular type of hypothesis about influence, the medium and genre of the works, and the historical situation.

In other words, let us suppose that X and Y are similar in a particular respect a: a rose is depicted on both of them. Does this indicate that one of these works was influenced by the other? Whether it does or not depends on what sense of "influence" is being used, whether X and Y are paintings or vases, what genre they belong to (whether they are paint-

ings of, say, still lifes or battle scenes), and finally when and where they were created.

The importance of considering the historical situation carefully in this context can be illustrated by two simple and schematic examples. If two contemporary painters use the same kind of oil colors, this similarity between their works has, of course, very little relevance for the hypothesis that one of them influenced the other. But if we go back a few hundred years, when the technique and colors used today were invented, the situation might well be quite different. Similarly, let us suppose that X and Y depict objects and events which were extremely rare during the seventeenth century but are quite common today. If these works were created during the seventeenth century, then this similarity would be a stronger support for the hypothesis about influence than if they had been created last year. Thus familiarity with the historical situation in which the works were created is indispensable to those who want to make a sound judgment on the relevance of the similarities between these works for hypotheses about influence.

Finally, if the extensiveness, exclusiveness, and precision of the similarities have been determined in the ways suggested above, the scholar has to provide an explanation of these similarities; and in that case he should (g) systematically test as many possible alternative explanations as he can conceive of.

2.5.3 Concluding Remarks

In concluding this chapter I would like to call attention to two complications, the first of which has already been alluded to several times.

Even if it is fairly clear that the creator of one work of art was influenced by another, there may still be a number of important differences between these works of art. This point is well illustrated by the following quotation from Anthony Blunt's recent book on Poussin, where he writes as follows on the relations between Poussin and Titian:

235

On the other hand, if Poussin borrows freely from Titian, he puts his own interpretation on what he borrows. His compositions are simpler than Titian's and have a sharpness and a clarity derived from classical bas-reliefs which contrast with the richness of the Venetian painter's works. His color derives from Titian's but is purer and less broken, sacrificing richness and subtlety to simplicity. In his paintings there is more intellect and less poetry than in Titian's, and this difference is in conformity with the attitudes of the two artists toward their subjects. Titian is more influenced by Neo-Platonism than Poussin, who never paints a pure paean in praise of love as does Titian in the *Feast of Venus*. His themes are more closely related to the idea of nature, her harmony and fertility. With Poussin, the presiding deities are Priapus, Flora, and Apollo, but Apollo as the source of life in nature, not the symbol of beauty and truth.[68]

The author here describes a great number of important differences between the works of these two painters. Let us concentrate on one of these differences and ask the following questions.

Suppose that X and Y are not similar in a particular respect a. What does this show? Does it, for example, show

(a) that X did not at all influence Y with respect to a, or

(b) that X did not influence Y positively with respect to a, or

(c) that X rather influenced Y negatively with respect to a?

This question is difficult to answer on this general level; one has to consider each particular case separately. However, the following general remarks can be made.

Lack of similarity in a particular respect does not refute the hypothesis that X influenced Y in this respect; X can

[68] Anthony Blunt, *Nicolas Poussin*, London & New York: Pantheon Books, 1967, p. 124.

very well have influenced the creation of Y with respect to a, even if X and Y are not similar to each other in this respect. But if X and Y are not similar with respect to a, then obviously the hypothesis that X influenced Y positively with respect to a is refuted. Whether or not X influenced Y negatively in this case depends, among other things, on the kind of differences involved.

The fact that the narrative technique in *Tom Jones* is different from that in *The Old Man and the Sea* does not show that Hemingway was negatively influenced by Fielding. Their novels can be extremely different in form as well as in content, and yet Fielding's novel need not have played any role whatsoever in the creative work of Hemingway. But let us suppose that the following conditions are satisfied: (a) these novels are in some striking way systematically different, (b) we know or have good reason to believe that the author of one of them was familiar with the other (by letters, memoirs, diary notes by himself or his friends), and (c) we have good reason to believe that the former author strongly disliked the works of the other. Then it is very likely that we have an example of negative influence.

Let us now proceed to the other and perhaps more interesting complications. So far I have assumed that X and Y are works of art, and have discussed the problems involved in showing that works of art are similar to each other, thus working within the framework of the object-focussed conception of art. Now what happens if this conception is replaced by the action-focussed conception of art? In that case (C 4.1), for instance, would have to be replaced by something like:

(C 4.1)* If A_x influenced A_y positively with respect to a, then A_x and A_y are similar in this respect.

In this case, it will be remembered, A_x is the action of creating, exhibiting, or destroying X, and A_y is analogously the action of creating, exhibiting, or destroying Y. This formulation raises the following problem: does it make sense

to talk about similarities between actions? In what sense can these actions be similar? And in what respects can they be different?

The following points of comparisons suggest themselves:

(a) the intentions with which the actions in question are performed;
(b) the physical movements which constitute part of the actions;
(c) the objects X and Y mentioned in the description of the actions;
(d) the effects of the actions on some group of people.

I shall now make a few brief comments on this list.

As far as I can see, (b) is in this context irrelevant and can be left aside. Moreover, if (c) is chosen, then everything I have said in this section can also be applied when the action-focussed conception of art is presupposed. So the interesting cases seem to be (a) and (d). Thus we can obtain a number of variations of (C 4.1)* by replacing the then clause with statements like the following ones, assuming that X was created by A and Y by B:

(a) then what A intended to achieve by performing A_x resembles what B intended to achieve by performing A_y;
(b) then the actual effects of performing A_x resemble the actual effects of performing A_y;
(c) then the intended effects of performing A_x resemble the intended effects of performing A_y.

It is clear that here the criteria of similarity will be quite different from those suggested previously. If two intentions are similar in the sense that they have a property in common, then this property is—to say the least—very likely to be different from any of the properties two works of art might have in common. The problems of verification and testing will also be quite different when you focus on the actions of the artist rather than on the works he has created.

238

However, it would carry us too far to consider these problems in detail.

2.6 THE REQUIREMENT OF CHANGE

All the requirements for artistic influence I have discussed so far can be satisfied in a particular case, and yet there need not be any causal connection—direct or indirect—between the works compared to each other. The decisive question is whether the contact between X and the creator of Y in some way changed Y's artistic or literary creations. But exactly what is meant by "changed" here? How is one to decide whether such a change has taken place? And what arguments could be used to support the claim that a change has taken place?

In this section I shall make an attempt to answer these questions. First I propose to discuss a number of examples from writings on the history of art and literature, where a requirement of change in one form or another is hinted at or seems to be presupposed. Then I shall make an attempt to state the requirement of change in a somewhat more precise way. In doing so I shall distinguish between two versions of this requirement with a somewhat different range of application. Finally, I intend to discuss and analyze some of the arguments that could be used to support the claim that a change has taken place.

2.6.1 *Some Examples*

I shall begin by discussing some quotations from writings in art history. The first example is taken from the book by Michel Seuphor on Piet Mondrian to which I referred towards the end of the previous section. Seuphor continues his analysis of the relationships between Van der Leck and Mondrian as follows:

> On the other hand, it seems that it was Mondrian's example which led Van der Leck to abandon naturalism. Van

239

der Leck's transformation was abrupt; it was not the result of a slow development, as in Mondrian, and it proved ephemeral.[69]

Seuphor here suggests that Mondrian influenced the art of Van der Leck, and that this influence led to a radical and sudden change in Van der Leck's painting—or rather, this radical and sudden change is an empirical fact, and it is explained by the conjecture that Van der Leck was influenced by Mondrian.

In the quotation above two contemporary abstract painters are compared with each other. But the requirement of change is, of course, also relevant when paintings of other periods and in other styles are considered. In his book on Dutch still-life painting, Ingvar Bergström makes the following point:

Presumably under the influence of Kalf, his great contemporary at Amsterdam, his color gained in warmth, depth, and glow.[70]

As in the quotation from Seuphor, the author here compares the artistic achievements of two different artists— that is, two series of paintings—and not two specific works of art with each other. If I understand Bergström correctly, he means that the influence from Kalf explains the changes in the paintings of the other artist; and these changes are carefully specified: they concern certain aspects of the color (its warmth, depth, and glow).

The following quotation is taken from an investigation by Raymond Klibansky, Fritz Saxl, and Erwin Panofsky:

In portraits of Luna, the oriental influence became so strong that while she is still represented as Diana in Paris Bibl. Nat., MS lat. 7330, . . . she appears as a man, like the ancient oriental Sin, in Brit. Mus., Sloane MS 3983 and its derivatives.[71]

[69] Seuphor, *Piet Mondrian*, p. 130.

[70] Bergström, *Dutch Still-Life Painting*, p. 144.

[71] R. Klibansky, E. Panofsky, and F. Saxl, *Saturn and Melancholy*, London, 1964, p. 203.

In this quotation it is said explicitly that the oriental influence has changed some representations of Luna; due to the oriental influence Luna, usually represented as a woman, is in the Sloane manuscript represented as a man, "like the ancient oriental Sin."

In his book on Manet, Nils Gösta Sandblad writes as follows:

> It was also in these two paintings [*Le Déjeuner sur l'herbe* and *Olympia*] that, under the immediate stimulus of the Japanese woodcut, he carried through the reorganisation of form which he had so seriously introduced into *La Chanteuse des rues*.[72]

It is here argued that the influence in this case resulted in changes in artistic form. Changes can obviously occur on different levels, and they can be of different kinds and concern different respects; it is therefore important to specify in what respect or respects the change has taken place if the readers are to be able to check and test what is said. The problems and distinctions made in section 2.5.2 above can—*mutatis mutandis*—be applied here too.

The Japanese influence on the paintings by Manet is specified clearly in the following statements, which also are taken from Sandblad's book:

> During the first stage, chiefly represented by *La Chanteuse des rues*, the artist had cautiously attempted the exercise of the Japanese conception of form in the portrayal of active subjects from contemporary life. After this had followed the short, heroic epoch during which he exploited his new, linear style with its concentration on surfaces and its absence of shadows, in daring rivalry with Raphael and Titian. During the years after 1865, on the other hand, he allowed the Japanese element to appear with special clarity in the engravings, because there the technique itself was a stimulus to a pure linear style.[73]

[72] Sandblad, *Manet*, p. 87. [73] *Ibid.*, p. 103.

Sandblad here tries to show how successive changes took place in the art of Manet. During a certain period the Japanese elements in his art increased in number and became more and more obvious; at this time the art of Manet was more similar to Japanese art than it was previously.

In the last quotation, an artistic tradition was compared to part of an artist's production. In the following quotation, only two individual works of art seem at first sight to be involved:

> Like the *Demoiselles* it [the *Baigneuse* or *Nu* by Braque] is a milestone in the history of Cubism. The debt to Picasso is immediately obvious; the large canvas, the scale of the figure itself and the distortions within it, the muted pinks, buffs and greys (which, despite the brighter touches, are the predominant colours in the *Demoiselles*), the treatment of the background in terms of large angular planes—all these features are new in the work of Braque.[74]

But, of course, the final words "all these features are new in the work of Braque" presuppose a comparison between the *Baigneuse* and Braque's earlier works in the respects mentioned in the quotation.

I will now turn to some quotations from writings on the history of literature. In his paper on the relations between Thomas Carlyle and Jean Paul Richter, J.W.S. Smeed writes as follows:

> Before the extent of Jean Paul's influence can be assessed, Carlyle's style before *Sartor* must be discussed briefly. The letters up to 1822 are plain and straightforward, with none of the peculiarities of his later style. . . . At any rate, these early works lack virtually all the familiar jeanpaulian features of his later style. The emergence of these characteristics in the late 1820s must be the direct out-

[74] John Golding, *Cubism: A History and an Analysis 1907–1914*, London: Faber & Faber, 1959, p. 62.

come of Carlyle's study of Jean Paul, not merely a demonstration of temperamental affinities.[75]

Here the author is saying or implying that Carlyle's style changed not only *after* his contact with Richter, but *because of* this contact; and he supports this claim by trying to show that the style of Carlyle's works in the late 1820s is more similar to the style of Richter's works than is the style of his earlier works (or, alternatively, more similar in the relevant respects to the style of Richter's works than to the style of his own earlier works).

The next example to be discussed here differs in several important ways from the previous one. At one place Staffan Björck makes the following point in his book on Heidenstam and Sweden at the turn of this century:

> It is out of question to insist on any "influence" from Kjellén's journalism on the poetry of Heidenstam. The complex of thought in *Åkallan och löfte* has deeper roots, which should be obvious from what has been said above.[76]

At least prima facie, Björck only compares Kjellén's writings to one work of art, *Åkallan och löfte*. Moreover, Kjellén's journalistic writings are not works of art, and Björck wants—in contradistinction to the authors quoted above—to *refute* a hypothesis about influence. Björck tries to show that Heidenstam's poetry has not been changed by (the contact with) Kjellén's journalistic writings; "the complex of thought in *Åkallan och löfte* has deeper roots." The similarities which can be found between the contents of Kjel-

[75] J.W.S. Smeed, "Thomas Carlyle and Jean Paul Richter," *CL*, XVI, 1964, p. 239.

[76] Staffan Björck *Heidenstam och sekelskiftets Sverige*, Stockholm: Natur & Kultur, 1946, p. 123. My translation. The original Swedish text reads as follows: Att insistera på någon "påverkan" från Kjelléns journalistik på Heidenstams diktning, kan inte komma ifråga. Tankekomplexet i Åkallan och löfte har djupare rötter, vilket redan bör ha framgått.

lén's political journalism and Heidenstam's poem do not show, therefore, that the latter has been influenced by the former.

In K. L. Goodwin's *The Influence of Ezra Pound* there is the following interesting passage:

> Now *The Tower* was published in 1928, by which time Pound and Yeats had been separated for many years and had little contact with each other, and, although it is true that Yeats developed new ideas and interests very slowly, there is little evidence that the changes apparent in the poems of *The Tower* represent the belated effects of Pound's influence.[77]

The quotation is interesting because the author suggests that changes can occur even though no influence took place. The fact that Yeats' later poetry is more like Pound's poetry than Yeats' earlier poems are does not necessarily mean that Yeats' later poetry was influenced by Pound.

Elsewhere in the same book Goodwin rejects the hypothesis that Yeats' poem *Brown Penny* was influenced by Pound with the following argument:

> 'Brown Penny' is so full of Yeats's earlier romanticism that there can be no question of possible influence from Pound: Yeats had been using material like
> > For he would be thinking of love
> > Till the stars had run away,
> > And the shadows had eaten the moon
> long before he had heard of Pound.[78]

The gist of this argument is that the contact with Pound has not meant any change in this particular case; *Brown Penny* is in the relevant respects too similar to the poems written by Yeats before he had come into contact with Pound and his poems.

[77] Goodwin, *Ezra Pound*, pp. 75–76.
[78] *Ibid.*, p. 85.

2.6.2 *Formulations of the Requirement of Change*

It would not be difficult to find more examples, but what I have said above will be sufficient as a starting point for the discussion in the following subsections.

To begin with, the requirement of change could be stated in the following rough and preliminary way:

(C 5.1) If X influenced the creation of Y with respect to a, then the contact with X changed the artistic and literary production of the person who created Y with respect to a.

To clarify what is meant by "changed" here I shall consider a possible objection to (C 5.1).

Suppose that an artist has a long and homogeneous production behind him. At a certain time he becomes involved in a series of tragic accidents which result in a crisis of personality. This crisis would have brought about a radical change in his painting, if he had not come into contact with the paintings of his colleague A at this very moment. This contact gives him inspiration and strength to continue to paint in roughly the same way as before. In this case there appears to be a clear example of artistic influence but no change.

The situation can be visualized by the following diagram, where "t" is the moment when the crisis of personality takes place and B comes into contact with the paintings of A:

Time t

B's production

The contact with A's paintings gets B to continue to paint in roughly the same style as before instead of changing his style in the direction indicated by the broken arrow.

In this case, the situation is as follows. By hypothesis (the contact with) A's work X influenced (the creation) of B's work Y in some respect or respects, but the contact with X did not change the artistic or literary production of B in the sense that the works produced by B after the moment he had come into contact with the works of A are in any significant respect different from the works B had produced before this moment. In that case it would seem that changes of the kind mentioned here are not necessary conditions for influence to have taken place, and this suggests that (C 5.1) should be modified or abandoned.

To meet this objection I suggest that (C 5.1) be replaced by the following requirement:

> (C 5.2) If X influenced the creation of Y with respect to a, then Y is with respect to a different from what it would otherwise have been.

Leaving everything else aside for a moment, there seems to be at least prima facie a slight difference between (C 5.1) and (C 5.2) in their range of application. The first formulation can only be applied to cases where we compare series of paintings and poems (the production of B before and after the contact with A) with the works by A, whereas the second can be applied also to comparisons of singular works of art with each other. To see this, (5.2) has to be clarified.

The last four words in (C 5.2), "would otherwise have been" could be expanded to—and replaced with—"would have been, if the person who created Y had not come into contact with X." The idea behind this replacement is obviously that if the contact referred to had not taken place, then Y would not have been created as it is with respect to a. In this way it is possible to meet objections of the kind mentioned above, but (C 5.2) raises a number of other dif-

ficult problems connected with the well-known difficulties of defining truth-conditions for counterfactual conditionals, to which Roderick Chisholm and Nelson Goodman have called attention.

Before I enter into a discussion of some of the problems in showing that (C 5.2) is satisfied in a particular case, I would like to call attention once more to what was said in chapter 1 about the value of *a* and the distinction between normative and nonnormative concepts of influence. In the first case—where statements about influence have normative implications—it is necessary that the changes be aesthetically significant or important.

2.6.3 *Arguments Supporting the Claim That Changes Have Taken Place*

If changes of the kind indicated above are necessary conditions for influence, then it is obviously important (a) to clarify and specify the nature of these changes, and (b) to indicate what methods are or could be used to decide whether a change of the requisite sort has taken place, and, finally (c) to study what arguments are or could be used to support (or refute) the claim that changes of the relevant kind have taken place.

In the previous subsection I have outlined a partial answer to (a), and in this subsection I propose to concentrate on (c). It will be clear from this discussion of the arguments that the methods used in this context are comparative methods, and that the theoretical problems they raise are all connected with criteria of similarity and judgments of similarity. These problems have already been dealt with at some length in subsection 2.5.2, and there is no need at this point to repeat what was said there.

A close reading of the examples in the beginning of this chapter suggests some ideas about what arguments could be used to support statements to the effect that a change of the relevant kind has taken place. I shall here try to develop and systematize these ideas. To begin with I shall discuss

the arguments in a fairly abstract manner in order to be able to state them as clearly as possible and to trace the logical relations between them. After that I shall add a few more examples to illustrate some of the distinctions I have proposed.

It appears reasonable to think that the arguments will be of different kinds, depending on the kind and extensiveness of the change. The following argument could be used to support the claim that the work of art Y with respect to a is different from what it would have been, if the person who created Y had not come into contact with X:

ARGUMENT (A 1): Y is with respect to a more similar to X than it is to any of the earlier works by the person who created Y.

If B is the person who created Y, then the last eight words in (A 1)—"earlier works by the person who created Y"— could be replaced by "works which with respect to a were completed before B had come into contact with X." This somewhat longer formulation makes clear what is meant by "earlier works."

In several of the examples discussed above the claim that influence took place seems to be explicitly or implicitly supported by arguments resembling (A 1). For example, Sandblad argues that Manet's paintings during a certain period were influenced by Japanese art, and he supports this claim by showing that the Japanese elements in the works by Manet after a certain point increase in number and become more and more obvious. In short, this amounts to saying that the works created by Manet after this point are more similar to Japanese art than to his earlier works. Moreover, Björck refutes the hypothesis that *Åkallan och löfte* was influenced by Kjellén by saying that the thoughts expressed in *Åkallan och löfte* are *not* more similar to the thoughts expressed by Kjellén than to some of the thoughts expressed earlier by Heidenstam.

Several objections may be raised against this argument,

however. I shall here discuss one of them in order to clarify the argument and eliminate possible sources of misunderstanding. Suppose someone were to say: *Ulysses* by James Joyce is obviously more similar to the earlier works by Joyce than it is to *The Odyssey* by Homer, and yet the latter clearly influenced the creation of Joyce's *Ulysses*; the work by Homer was a source of inspiration to Joyce. Thus it is not true that Y in this case is more similar to X than Y is similar to the earlier works by the person who created Y —and yet X influenced the creation of Y. How is this objection to be answered?

I do not think this objection is fatal. The objection can, it seems to me, be met by specifying clearly in what respect or respects the work by Homer has influenced the work by Joyce, in what respect or respects *Ulysses* by Joyce is similar to Homer's *Odyssey*, and in what respects it is similar to the earlier works by Joyce. It seems prima facie very plausible that the works by Homer and Joyce are similar in some respects, and that the works by Joyce are similar to each other in other respects. Thus, the objection does not show that there is anything wrong with (A 1). But it shows how important it is to make explicit in what respects X and Y are similar and in what respects X is supposed to have influenced Y.

The argument I have discussed above should be distinguished from the following one:

ARGUMENT (A 2): Y is more similar to X with respect to a than X is similar to any of the earlier works by the creator of Y.

This formulation is equivalent to:

ARGUMENT (A 2)': X is more similar to Y with respect to a than X is similar to any of the earlier works by the person who created Y.

However, (A 1) and (A 2) are not equivalent, and it is important not to confuse them with each other, even though

the difference between them may appear to be rather subtle. The relations between these two arguments can be illustrated in the following way.

Let Z be a variable ranging over the works of art created by B—the person who created Y—before he came into contact with X. Thus, if this contact took place at the time t, then Z can be replaced by names and descriptions of works of art created by B before t. I shall now place X, Y, and Z on a vertical line, where the distance between the letters is a function of the similarity between the relevant works of art; the closer to each other X and Y are on this scale, the more similar to each other (in the relevant respects) are the works of art that X and Y stand for, and conversely. Now the members of Z may not, of course, be equally similar to, say, X, so the distance between X and Z is a function of the similarity between X and the member of Z which is most similar to X in the relevant respects.

After these preliminaries, the first argument (A 1) can be illustrated by the following diagram:

In this diagram the distance between X and Y is shorter than the distance between Y and Z; thus Y is more similar to X in the relevant respects than Y is similar to any member of Z. (For the sake of simplicity I shall here and in the following two diagrams suppose that the similarity between X, Y, and Z concerns a particular respect a without always mentioning a.)

The two versions—(A 2) and (A 2)′—of the second argu-

ment can correspondingly be illustrated by the following diagram:

X

Y

Z

Here the distance between X and Y is shorter than the distance between X and Z; thus Y is in the relevant respects more similar to X than X is to Z (and X is more similar to Y than X is similar to Z).

Now it is important to notice that argument (A 1) does not follow logically from (A 2); (A 2) can very well be true, even though (A 1) is false. The statement that the distance between X and Z is longer than the distance between X and Y is obviously compatible with the statement that the distance between Y and Z is shorter than the distance between X and Y, as the following figure shows:

X

Y

Z

This diagram illustrates the case when (A 1) is false but (A 2) is true.

Nor does (A 2) follow from (A 1); (A 1) can very well be true, even though (A 2) is false. The statement that the distance between X and Y is shorter than the distance between

251

Y and Z is obviously compatible with the statement that the distance between X and Y is longer than the distance between X and Z, as the following figure shows:

If the last two paragraphs are correct, then (A 1) and (A 2) are logically independent of each other.

I hope that these diagrams will help to bring out the difference between these two arguments. Let us now for a moment return to some of the examples discussed above, for instance, to the quotations from Sandblad in which it is argued that the paintings by Manet were influenced by Japanese art. Is Sandblad here tacitly or explicitly supporting these claims by (A 2) or by (A 1)? Or consider Goodwin's criticism of the hypothesis that *Brown Penny* was influenced by Pound. Is Goodwin here explicitly or implicitly appealing to the negation of (A 2) or to the negation of (A 1)? How should the quotations from Smeed and Golding be interpreted? The fact that it may be difficult to answer these questions in an unambiguous way does not, of course, show that the distinction between (A 1) and (A 2) is untenable.

By replacing the expression "any of the earlier works by the person who created Y" in (A 1) and (A 2) with "any other work that the person who created Y had come into contact with before he created Y," it is possible to obtain the following two new arguments:

ARGUMENT (A 3): Y is with respect to a more similar to X than Y is similar to any other work that the person

who created Y had come into contact with before he created Y.

ARGUMENT (A 4): Y is with respect to a more similar to X than X is similar to any other work that the person who created Y had come into contact with before he created Y.

Before I illustrate these new arguments I would like to make a brief comment on the logical relations between the four arguments I have so far distinguished.

If one explicitly makes the trivial assumption that the set of works of art created by an artist is a proper subset of the set of works of art this artist has come into contact with, then it is obviously true that (A 3) implies (A 1) and that (A 4) implies (A 2), but not conversely. What I have said above about the logical relations between (A 1) and (A 2) holds also, *mutatis mutandis*, for the relations between (A 3) and (A 4). Hence, (A 4) is logically independent of (A 3).

Instead of working with four different arguments supporting the claim that (C 5.2) is satisfied, it may be tempting to make these arguments into necessary conditions for artistic and literary influence, and thus to replace (C 5.2) with the following four requirements:

(C 5.3) If X influenced the creation of Y with respect to a, then (A 1) is satisfied;

(C 5.4) If X influenced the creation of Y with respect to a, then (A 2) is satisfied;

(C 5.5) If X influenced the creation of Y with respect to a, then (A 3) is satisfied;

(C 5.6) If X influenced the creation of Y with respect to a, then (A 4) is satisfied.

These four requirements are logically related to each other in the way indicated by the comments on the four arguments above.

However, the proposal to replace (C 5.2) with these four requirements raises a number of problems, even if the complications concerning negative influence are disregarded. The most important problem in this context is the following one. It seems to be possible to raise exactly the same type of criticism against every one of these four new requirements as was put forth earlier against (C 5.1), which then suggested that (C 5.1) should be replaced by (C 5.2). To meet these objections it is necessary to add to each of the four requirements above a clause of the type: "unless there is any relevant counterevidence of the type that was discussed when (C 5.1) was introduced."

At this point, however, one must take into account that it can be very difficult in practice (1) to decide exactly what circumstances are to be counted as "relevant counterevidence," and (2) to show that these circumstances in a particular case exist or have occurred or taken place. As far as I can see it is possible to avoid all these problems if (C 5.2) is used as the starting point and (A 1) through (A 4) are regarded as arguments or reasons—but not as necessary conditions—for the statement that the contact with X changed in the relevant respects the artistic production of the person who created Y.

In concluding this subsection I would like to return to a quotation from Albert Nilsson's *Tre fornnordiska gestalter*, on which I have commented once before in a different context:

> As far as I can see, we must exclude the possibility that Tegnér's poem is independent of that by Grafström. The part of Lessing's treatise to which Grafström refers does not contain the idea that Love and Death are two bewilderingly similar twin brothers. Tegnér is not similar to Lessing but to Grafström, who on the basis of the brief passage about the much debated classic figure creates a new myth. It is quite inconceivable that two *Swedish* poets independently of each other and *almost at the same*

time would create the same myth, using Lessing's treatise as a point of departure.[79]

The main argument for the hypothesis that Tegnér was influenced by Grafström in the relevant respect could be interpreted in two ways, and I shall here use this quotation to illustrate the two arguments (A 3) and (A 4).

The relevant passage in Lessing's treatise did not belong to either Tegnér's or Grafström's earlier literary production; it is part of a work both these authors had come into contact with before they created their own poems about Love and Death. For this reason, we can apply neither argument (A 1) nor argument (A 2); instead we have to choose between (A 3) and (A 4). If the main argument for Nilsson's thesis is that the poem by Tegnér is more similar to the poem by Grafström with respect to the mythological contents than to Lessing's treatise, then we have an instance of (A 3). But if the main argument is that the poem by Grafström is more similar to the poem by Tegnér than it is similar to Lessing's treatise as far as the mythological contents are concerned, then we are confronted with an instance of (A 4). Both interpretations seem possible, but again this is no objection to the distinction between the arguments.

Albert Nilsson attaches a great deal of importance to the fact that both these poets (Tegnér and Grafström) are Swedes, and that their poems were published so close in time to each other. These facts, in combination with the similarities between the two poems, make it extremely unlikely, according to Nilsson, that Tegnér was not influenced by Grafström; the probability that Tegnér would have written his poem in the way he did without being familiar with the poem by Grafström is, according to Nilsson, close to zero. However, several points in Nilsson's reasoning have later been challenged. Carl Fehrman has in *Liemannen, Thanatos och Dödens ängel* argued that the similarities be-

[79] Albert Nilsson, *Tre fornnordiska gestalter*, Lund: Gleerups, 1928, p. 394. My translation. For the original Swedish text see chapter 1, note 65.

tween the poems by Tegnér and Grafström are not particularly specific, and that accordingly it could very well be the case that Tegnér was not influenced by Grafström.[80]

It may appear to be very difficult to show that the requirement of change—as it has been stated here in (C 5.1) and (C 5.2)—is ever satisfied. It *is* difficult, but the difficulties should not be exaggerated. Here, as in so many other cases we have to deal with probabilities, and in the reasoning pro and con the statement that a change of the requisite sort took place, the arguments (A 1) through (A 4) play, as I have tried to show, an important role. If the arguments are stated fairly precisely, they can in practice be used as partial criteria of whether changes have taken place or not.

I have throughout this section presupposed that the discussion concerned positive influence. But what I have said above also holds for negative influence, if "similar to" in the four arguments above is replaced by "systematically different from," or some related expression.

2.6.4 *Some Complications*

So far I have assumed that X and Y are works of art and have discussed the problems involved in showing that works of art are similar to each other or that one work of art is more similar to a second than to a third. Thus, I have taken the object-focussed conception of art for granted.

But what happens if this conception is replaced by the action-focussed conception of art? Then (C 5.2) would have to be replaced by something like

(C 5.2)* If A_x influenced A_y with respect to a, and if B was the person who created Y, then B would not have performed A_y in the way he did, unless he previously had come into contact with (seen, read about, etc.) A_y.

If someone wants to show that this requirement is satisfied in a particular case, he can, for instance, try to show that

[80] Carl Fehrman, *Liemannen, Thanatos och Dödens ängel*, Lund: Gleerups, 1957, pp. 86–91.

256

A_x is more similar to A_y than it is to any of the actions of creating, exhibiting, or destroying works of art performed by B before he became familiar with A_x, and thus the distinctions between the various kinds of argument that could be used to support claims of this kind would closely resemble the distinctions between the four arguments I tried to distinguish above, *mutatis mutandis*.

But (C 5.2)* also introduces a number of new complications. In what sense can two actions be similar, and what criteria can be used to settle the issue as to whether an action A_x is more similar to A_y than to A_z? These complications are identical with the ones discussed above in 2.5.3, and I shall not repeat here what I said there.

2.7 Concluding Remarks

An examination of scholarly discussions pro and con hypotheses about artistic or literary influence will show that the main reasons given *for* the statement that influence took place are statements to the effect that the then clauses in the five requirements distinguished above are satisfied. Analogously, such an examination will show that the main reasons given *against* the statement that influence took place are statements to the effect that one or more of the then clauses in these requirements is not satisfied.

Each of these reasons can then in its turn be the subject of a lengthy discussion with reasons pro and con. For instance, the discussion for and against the statement that the person who created Y did come into contact with X before he created Y can be very complex. The patterns of reasoning in debates as to whether the creation of Y in a particular case was influenced by X can therefore be very elusive and difficult to get hold of. But using the requirements discussed in this chapter as a point of departure, it is possible to classify the reasons pro and con and to make a survey of their logical relations in a fairly straightforward way.

To illustrate this point I would like to quote and comment on a passage in Dimitri Telos' article, "The Influence of the Utrecht Psalter in Carolingian Art." Telos writes in this article as follows:

> Even more extensive and varied seems to have been the influence of the Utrecht Psalter upon the School of St.-Denis. . . . The change of style in the works of St.-Denis in the late sixties coincides, as Friend pointed out, with the death in 867 of Louis, abbot of St.-Denis, and the retention of the abbacy of King Charles the Bald for himself. Whether or not the King brought his library to St.-Denis remains a question. But the eclectic nature of the works of the School implies the existence in one place of a number of manuscripts coming from different Carolingian centers, the style and iconography of which are reflected in the works of St.-Denis. A royal library such as Charles the Bald is known to have possessed would be the most logical source. His official relation to the monastery of St.-Denis, the liturgical connections . . . support such a view.[81]

In this quotation Telos seems tacitly to presuppose or refer to most of the requirements I have discussed in this chapter.

In the first sentence Telos is grading the extensiveness and the variety of the influence. That the requirement of change—and also the temporal requirement A—both are satisfied is indicated by the next sentence. The requirement of contact is discussed in the third sentence. The author cannot prove that this requirement is satisfied, but he tries to show that there is no evidence to the contrary and that the conjecture that it is satisfied is compatible with all known facts. He argues that these facts can be explained in a simple and elegant fashion if one assumes that the requirement of contact is satisfied. The requirement of simi-

[81] Dimitri Telos, "The Influence of the Utrecht Psalter in Carolingian Art," *AB*, XXXIX, 1957, p. 93.

larity seems to be hinted at in the next sentence: if X influenced Y, then X's "style and iconography" is similar to (is "reflected in") the style and iconography of Y.

As a whole, Telos' argument is an example of an addition proof.[82] He calls attention to a number of circumstances, all of which point in the same direction. Besides, he is assuming

(a) that all other known circumstances in the present context are of no importance, and

(b) that if the known circumstances all point in the same direction and support a particular hypothesis, then this hypothesis should be accepted as highly probable or well corroborated.

These assumptions, together with the then clauses in the requirements mentioned in the preceding paragraph, form the premises for Telos' conclusion.

Of course, it happens in many cases that a scholar or critic cannot prove that the temporal requirement B is satisfied. He may then try to show that the assumption that this requirement is satisfied is not incompatible with known facts. And in case there should be psychological, historical, geographical, or other circumstances which appear to be incompatible with this assumption, the critic or scholar may (a) try to eliminate these circumstances by showing that as a matter of fact they did not exist, happen, or take place, or (b) try to show that these circumstances—though they did exist, happen, or take place—are only apparently incompatible with the assumption that influence took place.[83]

[82] This term has been suggested by Sören Halldén. Cf. his *Logik och moraliskt ställningstagande*, Stockholm, 1962.

[83] For another example of an analysis of a discussion pro and con the statement that influence took place, see my article "Några problem i de estetiska vetenskapernas teori," *Litteraturvetenskap*, Stockholm: Natur och Kultur, 1966, particularly pp. 155–57. (A revised and enlarged version of this article has appeared in the mimeographed series, *Studies in the Theory and Philosophy of Science*, University of Umeå, 1973.)

As to the order of the requirements, I would like to stress the following point. I have distinguished in a crude way between "external" and "internal" requirements and dealt with the external ones first, mainly because the internal ones are more interesting and controversial; they require a rather extensive treatment. Thus I want to make clear that the order in which the requirements have been discussed here is due to systematic and pedagogical considerations; it is not intended to indicate the order in which these arguments are usually discussed in scholarly or critical writings. It seems to be very difficult to say something that is true and not trivial on this issue.

If, in spite of these difficulties, I can venture anything about the chronological problems, my impression is that the order is, as a rule, the following one:

(a) the requirement of similarity;
(b) the external requirements;
(c) the requirement of change.

I shall now outline very briefly what I take to be the standard line of argument.

Suppose that a scholar first finds similarities between two works of art or novels (poems, etc.). He may then make various hypotheses to explain these similarities; for example, that one of these works was directly and positively influenced by the other. This hypothesis is tested against the external requirements. If they are not satisfied in this particular case, the hypothesis is rejected. But if it turns out that this hypothesis is not incompatible with the statement that the external requirements are satisfied, then he can check whether the requirement of change is satisfied. However, a study of this process of conjecture and refutation falls outside the scope of the present investigation.[84]

[84] Among other things that also fall outside the scope of the present investigation, I would like to mention (a) studies of the frequency of discussions about influence in art and literature, and (b) analysis and classification of the different kinds of metaphors used

Finally, in discussing the meaning of and the necessary conditions for statements of the form "X influenced the creation of Y with respect to a," I have presupposed (a) that if X is replaced by a name or a description of a picture, then Y is also replaced by a name or a description of a picture (and vice versa), and (b) that if X is replaced by a name or a description of a literary work of art, then Y is also replaced by a name or a description of a literary work of art (and vice versa). However, artists can be influenced by poets and writers; and poets and writers can be influenced by artists.

Thus it seems that we should take into consideration the following four possible combinations:

(1) influence from picture to picture;
(2) influence from picture to text;
(3) influence from text to picture;
(4) influence from text to text.

What I have said above on the combinations (1) and (4) can also, *mutatis mutandis*, be applied to the two other combinations. However, in these new combinations additional problems arise. It may, for example, be more difficult to show in a convincing way that the requirements of similarity and change are satisfied.

Moreover, combination (3) raises an interesting demarcation problem. In this context it is important to distinguish between (a) the case where a literary work of art has influenced the creation of a picture, and (b) the case where a picture illustrates a literary work of art. In both cases it seems reasonable to say that the contact with the literary work in question was a necessary condition and also a part of a sufficient condition for the creation of the picture. Thus, the difference between the two cases does not seem to

by scholars and critics to suggest or assert that one work of art was influenced by another, or that one artist or group of artists was influenced by another.

have anything to do with the kind of causal connection involved; it lies on a different level.

It seems to be quite clear that a literary work of art can influence the creation of a picture, even if the artist is not aware of this. In fact, this may happen quite frequently. But if an artist has illustrated a literary work he is always aware of this fact. Perhaps he has worked with the literary text next to him or after just having read the text. The fact that an artist intended to illustrate a literary work of art can be evident from the title given by the artist to his work, or from the fact that the work is printed along with the literary text in question.

If a picture illustrates a text, then there is as a rule a great number of obvious, extensive, precise, and exclusive similarities between what is represented in the picture and the story told in the text. But if a literary text has influenced the creation of a picture, there need not be any obvious, extensive, precise, or exclusive similarities between the picture and the story. The imagination of the artist can transform what is being said in the text, and in some cases (negative influence) there may not be any similarities at all between the picture and the (story in the) text.[85]

[85] For further discussion of the concept of illustration and for distinctions between different kinds of illustrations, see my book *Representation and Meaning in the Visual Arts*, chapter 3.

3.

Measurement of Influence

3.1 INTRODUCTION

IN THE first chapter of this book I tried to analyze the meaning of statements saying or implying that one work of art was influenced by another. Here the concept of artistic and literary influence was the focus of interest, and I made an attempt to distinguish between different kinds of artistic and literary interest. In the second chapter I discussed the different kinds of reasons that are used by writers on the history of art and literature to support or refute such statements about influence.

As the examples in these two chapters have shown, scholars and critics sometimes discuss influence relations between more than two visual or literary works of art. These discussions do not always concern which of two or more works of art have influenced the creation of a third. Scholars and critics sometimes take into account that the creation of a work of art can be influenced by several others, and they can try to show this without taking a stand on the question as to which of these works of art have had the strongest influence.

But it also happens that writers on the history of art and literature explicitly argue or maintain that one work of art had a stronger influence on the creation of another than a third one had. In these cases the scholars or critics explicitly

grade the strength of the influence; they discuss what might be called relative influence, where the different hypotheses are expressed by sentences of the following type:

(a) X influenced the creation of Y more than Z did;
(b) X influenced the creation of Y more than X influenced the creation of Z.

By specifying the respect or respects in which the influence took place in different ways, it is possible to obtain a number of variations on (a) and (b):

(a) X influenced the creation of Y with respect to a more than Z did with respect to a.
(b) X influenced the creation of Y with respect to a more than Z did with respect to b.
(c) X influenced the creation of Y with respect to a more than X influenced the creation of Z with respect to a.
(d) X influenced the creation of Y with respect to a more than X influenced the creation of Z with respect to b.

It is hypotheses of this kind I propose to discuss in the present chapter.

Discussions pro and con such hypotheses are often very unclear. There may be several reasons for this. The two most important ones can probably be stated as follows:

(1) the methods used to grade the strength of the influence are rarely, if ever, made explicit;
(2) different scholars and critics may very well use different methods to grade the strength of the influence.

This easily leads to fruitless arguments, to pseudoagreement as well as pseudodisagreement, where scholars and critics talk at cross purpose.

Using the results in the previous two chapters as a point of departure, I shall in this chapter try to state and illustrate some methods that are or could be used to grade the strength of the artistic influence. I shall also try to call attention to difficulties in some of these methods and to make

explicit some of the assumptions that are made when these methods of measuring artistic and literary influence are used.

It can be argued, of course, that the notion of relative influence, and that discussions of the strength of artistic and literary influences, are not interesting. But it is a fact, as I shall show in the next section, that writers on the history of art and literature grade the relative influence of works of art, and this fact makes it worthwhile to study different possible ways of measuring influence.

3.2 Some Examples

In this section I shall comment on some examples taken from writings on the history of art and literature, where scholars have compared the relative influence of different works of art or artists on the creation of a particular work of art. I have chosen examples of somewhat different kinds on purpose.

The following quotation from a paper by Hugh Holman is an example of a fairly explicit and unqualified comparison of the kind I intend to discuss in this chapter:

> I am trying to suggest that the influences on the work of modern Southern writers have been cosmopolitan and that the traditional stream of American writing has affected them less than it has affected equivalent groups of writers from other sections of the nation.[1]

Holman does not say in what respects Southern writers have been influenced by other writers, and he uses "affect" rather than "influence." But I suppose that "affected" is here used as a synonym of "influenced," and that Holman is say-

[1] Hugh Holman, "European Influences on Southern American Literature: A Preliminary Survey," in Werner P. Friedrich, ed., *Comparative Literature. Proceedings of the International Comparative Literature Association*, II, Chapel Hill: University of North Carolina Press, 1959, p. 447.

ing that "the traditional stream of American writing" has had less influence on modern Southern writers than it has on other groups of writers in America.

In his study of the influence that the Platonic Fourth book of Baldessare Castiglione's *Il Cortegiano* had on Spenser's *Fowre Hymnes*, Rensselaer W. Lee mentions that several scholars have pointed out other Platonic writings of the Renaissance as sources of the hymns, and he continues:

> but neither of these scholars has so much as mentioned Castiglione to whom Spenser owes a larger debt, line for line, than to either Ficino, Bruno, or Benivieni.[2]

Here Lee is obviously arguing that Spenser was more influenced by Castiglione than by any of the other authors mentioned above, and this point is repeated several times with slightly varying formulations in his article.

The two quotations so far discussed are both fairly obvious and straightforward examples of grading of influence, and I will now discuss a quotation of a somewhat different kind. Discussing the influence of Cubism in France from 1910 to 1914, John Golding makes the following point concerning the importance of Derain, which according to him has been overstressed by Apollinaire:

> Nevertheless, during the years immediately following 1907 Derain continued to be a strong influence on many of the young painters who were turning away from Impressionism and Fauvism towards a solider, more austere, form of expression.[3]

Here Golding is not explicitly comparing and grading the relative influence of two painters on a third. But his use of the term "strong influence" suggests that a comparison is

[2] Rensselaer W. Lee, "Castiglione's Influence on Spenser's Early Hymns," *Philological Quarterly*, VII, 1928, p. 65.

[3] John Golding, *Cubism: A History and an Analysis 1907–1914*, London: Faber & Faber, 1959, p. 141.

being made. Moreover, if it is said that X has a strong influence on Y, and that Z has a weak influence on Y, then it follows that X has a stronger influence on Y than Z has.

A few pages later in the book Golding makes another grading of the relative strength of influences, which this time results in a statement of the form "X and Z influenced Y equally":

Indeed, the colour, the smoothness of the modelling and the simple, rounded forms suggest that Léger had been influenced as much by the art of the Douanier Rousseau as by that of Cézanne.[4]

Statements of this type raise the same theoretical and methodological problems as the more common ones of the type "Y was more influenced by X than by Z."

Comparisons of the latter sort are made also in Golding's book, as the following quotation shows:

In a discussion of the general composition and appearance of the *Demoiselles* [by Picasso] another possible influence should be mentioned: that of El Greco. . . . The angular, and in the case of the three women at the extreme left and right of the *Demoiselles*, rather 'faceted' appearance of the figures, and the heavy, chalky highlights found in certain parts of the drapery could well have come from a study of El Greco's work.

But on a more concrete level the *Demoiselles* owes most to Picasso's use of 'primitive' sources.[5]

The hypothesis of influence from El Greco is here only pointed out as a possibility; Golding does not assert that Picasso was in fact influenced by El Greco. But in addition to the similarities noted in the quotation, he points out on the same page that Picasso's walls at this time "were decorated with reproductions of El Greco."

[4] *Ibid.*, p. 145. [5] *Ibid.*, p. 51.

In his extensive investigation of Caravaggio's followers in Italy, Alfred Moir points out that comparatively few works of the Italian painter Manfredi have been traced, but that there is a small number of works by his hand from the second decade of the seventeenth century. Moir continues:

> They are not many; but they make clear that among the original quartet of Caravaggio followers, Manfredi was closest to the master.[6]

What Moir is saying is thus that Caravaggio had a stronger influence on Manfredi than he had on any of the other of his first four followers. Since Moir makes this claim on the basis of a comparison between the works of the artists involved, this is a clear case of grading the strength of artistic influence.

On the subsequent pages Moir specifies in what respects Manfredi was influenced by Caravaggio. Here Moir writes as follows:

> Manfredi followed the lead of the young Caravaggio both in painting pure genre subjects and in treating nominally religious or classical subjects as though they were pure genre; but his manner of painting these subjects was derived from that of the mature Roman Caravaggio.[7]

Thus, according to Moir, Manfredi was influenced by Caravaggio both with respect to his choice of motifs and with respect to the way in which he rendered these motifs.

It is, of course, far from unusual that art historians compare the influence of two artists on a third without explicitly grading the strength of the influence. Sometimes they confine themselves to asserting that in this particular case two artists have influenced, or been influenced by, a third. There are also examples of this kind in Moir's book:

[6] Alfred Moir, *The Italian Followers of Caravaggio*, Cambridge: Harvard University Press, 1967, p. 85.
[7] *Ibid.*, pp. 86–87.

The inspiration of the Bassano family, modified by the influence of Caravaggism, is evident in the Homer subjects.[8]

Here Moir discusses a group of paintings by the Italian artist Mola which represent different episodes in the life of Homer. There are a number of interesting differences between this quotation and the previous ones.

In the first place Moir discusses not individual artists but groups of works of art: paintings by the Bassano family, by the Caravaggio school, and Mola's Homer paintings. Moreover, Moir does not grade the strength of the artistic influence; he does not say explicitly which of the two mentioned groups of artists had the stronger influence on Mola. Nor does Moir specify in what respect or respects Mola was influenced by these artists. Finally, these two causal relations do not seem to be quite independent of each other.

The last point can be made more explicit as follows. A close reading of the quotation above suggests that Moir maintains the following three theses:

(a) The Bassano family has influenced the creation of Mola's Homer paintings.

(b) The Caravaggio school has also influenced the creation of Mola's Homer paintings.

(c) The influence from the Caravaggio school has modified the influence from the Bassano family.

In the last sentence "modifies" refers to a causal relation; thus three different relations of influence seem to be involved in this example.

It seems reasonable to interpret (c) as saying or implying that if the influence from the Caravaggio school had not taken place, then the influence from the Bassano family would have had the effect that Mola would have created his paintings in a somewhat different way than he as a matter of fact did; and in that case his paintings would look

[8] *Ibid.*, p. 149.

269

different than they do. In this sense the two causal relations in (a) and (b) above are causally related to each other.

I shall now discuss some literary examples. In his book on Kurt Schwitters, Werner Schmalenbach makes the following point in his discussion of Schwitters' poetry:

> Among the German Expressionists composing poems in this vein was August Stramm, who was killed in the war; he exercized the greatest influence on the younger generation and became Schwitters' exemplar too. . . . In his theoretical reflections on pure word-poetry Schwitters was mainly influenced by the Sturm poet and *diseur* Rudolf Bluemner, with whom he became friends.[9]

The expressions "greatest influence" and "mainly influenced by" in this quotation suggest that the author here is grading the strength of literary influence twice, though it can be argued that only in the first case do we have a genuine example of *literary* influence (but whether metapoetry of this kind—"reflections on pure word-poetry"—is or is not itself a kind of poetry is of little importance here).

In his book *The Influence of D. H. Lawrence on Tennessee Williams*, which I have quoted several times in the previous chapters, Norman J. Fedder at one place makes the following point:

> Tennessee Williams' poetry, however, evidences the profound influence of the symbolists—particularly that of Hart Crane.[10]

This quotation can be interpreted as saying or implying that Hart Crane had a stronger influence on Tennessee Williams than any other symbolist had. Obviously the author is here grading literary influence, though he does not specify in what respects Williams was influenced by the

[9] Werner Schmalenbach, *Kurt Schwitters*, New York: Abrams, 1967, p. 194.

[10] Norman J. Fedder, *The Influence of D. H. Lawrence on Tennessee Williams*, The Hague: Mouton, 1966, pp. 25–26.

symbolists and by Crane (but he does this in other places of his book).

At this point I would like to call attention once more to the following passage in an article by Örjan Lindberger, which I discussed in chapter 1:

> There is only one point on which it is possible to assume a positive influence from Renan. . . . But even on this point one has to realize that the influence from Renan is of limited importance. Lagerkvist's confession and allegiance to rational thought is in the first place a reaction to the antiintellectualism of Nazism.[11]

This quotation is somewhat more complicated than the previous one. Three texts are compared to each other, and the author takes a clear stand on the question as to which of these texts had the strongest influence on Lagerkvist. On the one hand we have here an hypothesis about positive artistic influence; on the other hand we have an hypothesis about negative nonartistic influence.

Lindberger tries to show that the positive artistic influence from Renan has had a "limited importance." This expression can be interpreted in several ways. It can be understood as saying or implying that the influence from Renan has only concerned a few specific respects, or that it has been less strong than the negative influence from the Nazis, or that it has been artistically and aesthetically less significant than this negative influence. It seems reasonable in this particular case to suggest a combination of the two first possible interpretations.

Finally, in his book *David to Delacroix*, Walter Friedlaender discusses the influence of Bonington on Delacroix:

> In 1832, seven years after his trip to England, Delacroix undertook an expedition to Morocco which had much

[11] Örjan Lindberger, "Pär Lagerkvists bön på Akropolis," *Samlaren*, LXXXI, 1960, p. 28. My translation. For the original Swedish text see note 34 to chapter one.

stronger influence on him and on his art [than Bonington had].[12]

As in the previous quotation, the author here contrasts artistic with nonartistic influence. However, he does not say if the influence concerns the same or different respects. It is, for example, quite possible that the trip to Morocco influenced the choice of subject matter and that the contact with the art of Bonington influenced the style—that is, the way in which the motifs were rendered—of Delacroix.

3.3 MEASURES I–III: THE SIZE OF THE SIMILARITIES

In his study of the Italian followers of Caravaggio, Alfred Moir points out that Mao was one of Baglione's pupils, and that both these painters were inspired by Caravaggio. Moir continues:

> This evidence makes it appear that Mao was almost as reliant on Caravaggio as Baglione was during the early 1600s. Unlike his master, he remained constant to Caravaggio and increased his dependence on him throughout his life.[13]

Moir presented the evidence to support his claims in the pages preceding this quotation. As far as I can see, the evidence consists on the whole of similarities and lack of similarities between the works of the three artists. The occurrence of these similarities is used, it seems, as a measure of the size of the influence.

For example, Moir makes the following point concerning the relations between Caravaggio and Baglione:

> Thus only a handful of Baglione's paintings, most of them done during a period of about three years, are derivative from Caravaggio. . . . Even at his best, Baglione did lit-

[12] Walter Friedlaender, *David to Delacroix*, Cambridge: Harvard University Press, 1964, p. 116.

[13] Moir, *Italian Followers of Caravaggio*, p. 35.

tle more than cast light and shadow over otherwise academic late Mannerist compositions.[14]

Moir seems to be saying two things here: first, that the similarities are limited to a few of Baglione's works; and second, that even in these works, the similarities are neither particularly precise nor exclusive.

Baglione wrote a biography of Mao, and of the paintings by Mao which are mentioned in this biography only one has been identified with certainty. Concerning this painting Moir makes the following point:

> Together with the evident derivation from Baglione, it shows a few signs of Caravaggio's influence, specifically in the undistorted poses of all the figures, in the handling of light and shadow on the two foreground figures, and in the careful, objective presentation of the female figure.[15]

Here Moir specifies a number of respects in which there are similarities between the works by the two artists.

In literary criticism, too, scholars sometimes rate the importance of influences. As the next two quotations will show, these ratings are sometimes far from clear. In his book on the foreign influences on French literature, to which I have already referred several times, Philippe van Tieghem makes the following point in discussing the influence of Ariosto:

> Après celle de Pétrarque et de ses émules, l'influence italienne la plus importante en France est celle de l'Arioste, en particulier celle du *Roland furieux*.[16]

In this brief sentence there are a number of comparisons of several different types: between individual authors (Petrarca and Ariosto), between an author and a class of

[14] *Ibid.*, p. 32. [15] *Ibid.*, p. 34.

[16] Philippe van Tieghem, *Les Influences étrangères sur la littérature française 1550–1880*, Paris: Presses Universitaires de France, 1961, p. 19.

literary works (Ariosto and French literature) and between the various works of an individual author (*Roland furieux* in comparison to the other works of Ariosto).

Moreover, the statement that the most important Italian influence on French literature (next to Petrarca) is that of Ariosto can be interpreted in several ways, some of which will be dealt with at length in this chapter. For instance:

(a) Ariosto influenced more French literary works of art than any other Italian writer;

(b) Ariosto influenced French literary works of art in more respects than any other Italian writer;

(c) the influence from Ariosto lasted longer on French literature than the influence from any other Italian writer;

(d) Ariosto influenced French literary works of art more profoundly than any other Italian writer;

(e) the influence from Ariosto on French literature has been aesthetically more significant than the influence of any other Italian writer.

These interpretations are not equivalent, as will become clear from the subsequent discussion in this chapter, but they do not exclude each other. Two or more of them can easily be combined, and perhaps van Tieghem meant to say that all of them are true.

A similar example can be found in Norman Fedder's study of the influence of D. H. Lawrence on Tennessee Williams, where the author at one place argues as follows:

The role of these other writers [Faulkner, Saroyan, etc.] in shaping Williams' literary development will be delineated in the following chapters; but it will be seen that —in comparison with the influence of D. H. Lawrence— their impact on Williams has been of only subsidiary importance.[17]

[17] Fedder, *The Influence of D. H. Lawrence*, p. 15.

In this quotation it is unambiguously said that Tennessee Williams was more influenced by D. H. Lawrence than by any of the other authors mentioned.

However, the expression "importance" in the last line of the quotation is not quite clear, and it may be noted that the two last lines in the quotation can be interpreted in several different ways, among others the following ones:

(a) D. H. Lawrence influenced more works by Williams than any other author did;

(b) D. H. Lawrence influenced works by Williams in more respects than any other author did;

(c) the influence of D. H. Lawrence on Williams lasted longer than the influence of any other author;

(d) D. H. Lawrence influenced Williams more profoundly than any other author did;

(e) the influence of D. H. Lawrence has been aesthetically more significant than the influence of any other author.

Which of these interpretations is correct?

This question seems to imply that the interpretations are mutually exclusive, but this need not be so. The interpretations can also in this case be very well combined with each other, and by combining them with each other systematically it is possible to obtain a great number of different theses.

In this context it is particularly interesting to see what methods Fedder uses to support his claims about Lawrence's influence on Williams: he points to parallel formulations in the works written by these two authors. This method is described already in the preface of the book, where Fedder programmatically asserts that

the case for extensive and profound influence must rest, of necessity, on thematic and technical similarities which exist between respective works.[18]

[18] *Ibid.*, p. 18.

If I understand him correctly, Fedder here seems to suggest that the similarities between the works of two authors can be used as a measure of the size or strength of the influence between them.

In view of the important role that analyses of similarities obviously play in discussions pro and con statements about influence, it might be suggested that one should take seriously what is hinted at in some of these quotations and suppose that the size of the similarities somehow indicates the size or the strength of the influence. The comments to some of the examples above suggest, however, that the size of the influence can be measured in several ways, and here the previously introduced distinctions between extensive, precise, and exclusive similarities are helpful.[19]

Thus we can and should distinguish between the following three different measures:

MEASURE I: If X and Z both influenced the creation of Y, and if the similarities between X and Y are more extensive than the similarities between Y and Z, then Y was more influenced by X than by Z.

MEASURE II: If X and Z both influenced the creation of Y with respect to a, and if the similarities between X and Y with respect to a are more precise than the similarities between Y and Z with respect to a, then Y was more influenced by X than by Z with respect to a.

MEASURE III: If X and Z both influenced the creation of Y with respect to a, and if the similarities between X and Y with respect to a are more exclusive than the similarities between Y and Z with respect to a, then Y was more influenced by X than by Z with respect to a.

But these measures raise a number of problems, some of which have been discussed in connection with the notion of similarity in section 2.5 and also in section 2.6 (for example, the difficulties in counting similarities) and I shall not re-

19 For the distinction between extensive, precise, and exclusive similarities see section 2.5.2 (E) above.

peat these points here. Instead I shall mention two general objections that can be made against all these measures; these objections are based on the simple fact that there can be influence without similarity and similarity without influence.

In the first place none of these three measures can be used to grade the strength of negative influence. In that case one would have to replace the expression "similarities" with "systematic differences" or some of its cognates. In the second place the similarities between two works of art can be explained in many ways, as I have pointed out several times. They may, for example, be due to the fact that the artists have had similar experiences or are depicting the same kind of motifs. Thus it is by no means certain that the extensiveness, precision, and exclusiveness of the similarities is a reliable indication of the size or strength of the artistic (or literary) influence. Besides, these three measures may in a particular case give quite different results.

3.4 Measure IV: The Size of the Change

In view of the difficulties mentioned in the preceding section it may be tempting to abandon the measures discussed above and instead suggest that the size of the changes indicates the size of the influence; the more changes the contact with the actual work brought about, the greater is the influence. This measure could be stated as follows:

> MEASURE IV: If X and Z both influenced the creation of Y with respect to a, and if the contact with X changed Y more with respect to a than the contact with Z did, then Y was more influenced by X than by Z with respect to a.

I shall now comment on some of the problems raised by this method of grading the size or strength of artistic (or literary) influence.

If a measure of this kind is to be of any practical use at all, it is necessary to supplement it with methods by means

277

of which it is possible (a) to decide if changes of the relevant kind have taken place, and (b) to determine the extent of these changes. I shall not repeat here the points I made in the discussion of the requirement of change (section 2.6), but I would like to state and examine critically some of the assumptions upon which the use of this measure is based. These assumptions are not unproblematic; to the extent that they are controversial, they indicate theoretical and methodological problems in using this method to measure artistic and literary influence.

If it is going to be possible to apply this method to particular cases, it is necessary to be familiar with the situation (point of departure) of the three works X, Y, and Z which are compared to each other before the contacts. Otherwise it is clearly impossible to determine if and to what extent a change has taken place. However, it is not always the case that we have this knowledge about X, Y, and Z.

Nevertheless, the difficulties should perhaps not be exaggerated. The situation, moreover, is somewhat different depending on the exact range of significance of the variable Y. If Y stands for the artistic or literary production of a person *after* a certain period of time (when the contacts took place), then it is, to be sure, possible to compare these works of art with his production *before* that time and see if there are any conspicuous differences between the works he made before and after the contact.[20]

But if Y stands for a singular work of art, the situation is quite different. To say that the contact with X changed the creation of Y is in this case to say or imply that if the con-

[20] Of course, the changes can be used to determine the time of contact. If B's style or painting changed fundamentally in, say, 1888 and became much more like the style of van Gogh than it used to be, then this can be taken to indicate that B came into contact with van Gogh's paintings in 1888. (Obviously, the changes do not *prove* that the contact took place in 1888. As was the case with Ernst Josephson, the changes in style may be accounted for in other ways; they may be due to a personality crisis, a mental disease, etc.)

tact with X had not taken place, then Y would not have been created in the way it was. And how do we know anything about that? To be able to determine if and to what extent this contact changed the creation of Y in a precise way, we must know with some exactness how Y would have been created, if the artist who created Y had *not* come into contact with X. The difficulties in knowing anything about this with certainty are only too obvious.

But even if we succeed in solving this problem, it can be very difficult to estimate the extent of the change; and that brings me to the second main difficulty. What methods could be used to measure how much Y was changed by the contacts with X and Z? Let us assume

(a) that we have access to all sketches and drafts the artist made for Y,

(b) that we know exactly when the creator of Y came into contact with X,

(c) and that we know when all these sketches and drafts for Y were made.

Let us also assume that the person who created Y came into contact with X when he was working on some of the sketches for Y.

In this case, it might be suggested that the following method could be used: we should compare the sketches produced before the moment when the contact took place to the sketches produced after the contact, and study the differences. These differences would then somehow indicate the size of the change. But artistic creativity is an elusive process, and the differences between some of the sketches may be explained in many ways; they need not have anything at all to do with the fact that the person who created Y at a certain moment read or saw X or Z or any other works of art. Besides, it is rarely the case that the three assumptions (a), (b), and (c) above are true.

But let us for a moment disregard all these difficulties

and assume that they have been overcome in a particular case. Thus we know the situation or the starting point before the contacts, and we have reliable methods by means of which we can decide how much the creation of Y was changed by the contacts with X and Z. But then we have to face the following problem. The use of measure IV will not give reliable results, unless we know something about what might be called the "initial resistance to changes in various directions" in the person who created Y before the contacts with X and Z took place. And are there any reliable methods for estimating this resistance?

It would be very unrealistic to assume that this initial resistance to changes is equal in all artists and authors, or that it is equal in the same artist to changes in all directions. If the creator of Y is inclined to change his style, choice of motifs, etc., in a certain direction—the initial resistance to changes in this direction is low—then it does not take much influence to make him change his style or choice of motifs in that direction. If, however, the creator of Y is not inclined to change his style, etc., in a certain direction—the initial resistance is high—then a very strong influence is needed to bring about such a change.

It would therefore be a mistake to assume without any qualifications that two changes, which "objectively speaking" are equal, represent influence of equal size or strength. On the contrary, if one of the artists is self-sufficient and independent and goes his own way, whereas the other is easily impressed by the works of others, these changes may represent influences of very different size and strength. Many critics and scholars seem to be aware of this fact and try to make clear the size of the initial resistance to changes, before they draw any conclusions as to the size and strength of the influence.

It need hardly be stressed that the difficulties in determining the exact size of this initial resistance may be enormous and in many cases perhaps impossible to overcome. Scholars and critics will have to confine themselves to mak-

ing rough estimates of a probabilistic kind, given known facts about the independence of the artists involved, their relations to each other, and so forth. Moreover, it seems reasonable to assume that in times—such as ours—when originality is highly praised, the initial resistance to changes will tend to increase. But in times—such as the sixteenth and seventeenth centuries—when it was considered to be an artistic achievement of the first rank to be able to imitate the ancients, the initial resistance to changes might be much lower.

Now it is, of course, important to distinguish between the influence of a work of art on a person and the influence of one work of art on another. This has been stressed above in section 1.2.2, and what I am saying here is not meant to contradict the points made there. It is indeed possible that a work of art can have a strong influence on an artist in the sense that it affects his way of thinking and living, even if it does not have any visible influence on his works of art; it may also in some cases make him stop creating works of art. Thus psychologic influence of this kind does not imply that artistic or literary influence has taken place. But artistic influence obviously implies that some kind of psychologic influence has occurred; if Y was created by B, and if the creation of Y was influenced by X, then B's contact with X influenced his way of thinking and acting.

Thus what I am saying in the preceding paragraphs does not mean that I want to give up this distinction between on the one hand psychologic influence and on the other artistic and literary influence. On the contrary, I want to call attention to the fact that even though the former of these concepts is implied by the others, they are not correlated with each other in the sense that if the visible signs of influence from X in the works Y and Z are equal (however that is to be determined), then it is also true that the psychologic influence of X on the creators of Y and Z is equally strong, and conversely. This has to be taken into account in grading the strength of the influence and in

evaluating the evidence offered for or against a hypothesis
about the relative strength of influences.

In this context I would like to call attention to the follow-
ing interesting remark in K. L. Goodwin's *The Influence
of Ezra Pound*:

> There is a difference between the amount of evidence
> needed to make a theory of influence by Pound on Yeats
> plausible, and the amount needed for a theory of influ-
> ence by Pound on Eliot. Yeats was an older man than
> Pound, and he treated Pound as a subordinate. Eliot was
> a slightly younger man, owing his reputation largely to
> Pound, and treating him with deference. The relationship
> between Pound and Eliot was, therefore, far more con-
> ducive to influence.[21]

If I understand him correctly, Goodwin is here arguing that
known facts about the relations between the three artists to
each other make it reasonable to suppose that the initial
resistance to influence from Pound is greater in Yeats than
in Eliot, and that it accordingly requires more evidence to
show that Pound influenced Yeats than it requires to show
that Pound influenced Eliot.

Concerning the influence from Pound on Eliot, Goodwin
writes that Eliot himself has admitted that he was influ-
enced by Pound. But Goodwin argues that this influence is
less than Eliot's words indicate, and he continues:

> There are, I suggest, two reasons for this. The first is that
> Eliot deliberately avoided putting into print work that
> showed traces of Pound's influence: this was partly be-
> cause he was an intelligent man, and partly because
> Pound disapproved of the practice. The result has been
> that there is little tangible evidence of Pound's in-
> fluence.[22]

[21] K. L. Goodwin, *The Influence of Ezra Pound*, London: Oxford
University Press, 1966, pp. 141–42.
[22] *Ibid.*, p. 142.

Here Goodwin describes a number of circumstances that must be taken into account by those who try to determine the extent of Pound's influence on Eliot on the basis of a comparison between the published poems by the two authors. Due to known facts about Pound and Eliot, it is reasonable to assume that Eliot did not print poems which were influenced by Pound in too obvious a way.

In John R. Martin's analysis of the influence of the Farnese gallery on various artists, we have another example of a discussion where hypotheses about resistance to changes seem to be presupposed or at least hinted at. In his book *The Farnese Gallery*, Martin makes the following point:

> Now it is significant that those artists, classic and baroque alike, on whom the Gallery produced the greatest effect were also those who were most concerned to recapture in their work the spirit of antiquity. To a large degree the Farnese frescoes owed their unique power to the fact that in them Annibale had opened up a new approach to the antique.[23]

In this quotation the author discusses the reasons why the Farnese gallery had such a "unique power" on some artists.

It seems reasonable to interpret the quotations as saying or implying that those artists who "were most concerned to recapture the spirit of antiquity" had the lowest initial resistance to changing their style of painting in the direction of the kind of art that is represented by the Farnese gallery, and that this fact—the low initial resistance of these artists—explains the strong influence of the paintings in the Farnese gallery on these artists. To avoid circularity, it is of course necessary to determine the actual initial resistance to changes and the extent to which influence has taken place independently of each other.

[23] John R. Martin, *The Farnese Gallery*, Princeton: Princeton University Press, 1965, p. 148.

3.5 MEASURES V–VI: THE PROBABILITY OF THE CHANGE

Another way of measuring the strength of artistic influence is suggested by some ideas developed by Patrick Suppes in *Set-Theoretical Structures in Science*.[24] Let (in this and the following paragraphs only) *a* and *b* be events. Suppose that the event *a* (that the person who created the work of art *Y* came into contact with another work of art *X*) influenced the event *b* (that *Y* was created in the way it was). Let us finally suppose that *a* took place at time *t* and *b* at *t'*. Then it holds—among other things—that *t* precedes *t'* in time, and that the probability of *b* to taking place at *t'* given that *a* took place at *t* is greater than the probability of *b* to taking place at *t'* given that *a* did not take place at *t*. These ideas can be made more precise in a number of ways that I do not have to discuss here; the reader who is interested in the technical details is referred to the book by Suppes.

What is more important here than the technical details is to discuss, illustrate, and clarify the idea that the probability for the occurrence of *b* given that *a* occurs (or occurred) minus the probability for the occurrence of *b* given that *a* does not occur (alternatively: did not occur) could be used as a measure of the strength of the artistic or literary influence. To begin with, I would like to discuss a quotation, taken from *The Influence of Ezra Pound* by K. L. Goodwin. In this book Goodwin compares, as I have mentioned earlier, different versions of some of Yeats' poems. Most of these changes concern details, but in some cases the revisions are more extensive.

Concerning the changes in the poem *The Folly of Being Comforted*, Goodwin makes the following interesting remark:

It will readily be seen that even these changes are of little importance. They certainly seem to bear no marks of

[24] Patrick Suppes, *Set-Theoretical Structures in Science*, Stanford: Institute for Mathematical Studies in the Social Sciences, 1967, chapter 5.

Pound's tuition, for Yeats was quite capable of making such changes by himself, and in any case Pound was not present when the changes were made.[25]

The last phrase in the quotation ("and in any case Pound was not present . . .") is relevant only if Goodwin is here talking about nonartistic rather than artistic influence. But it does not matter very much in this context whether Goodwin is talking about artistic or nonartistic influence. The probability for the hypothesis that Yeats would have made these changes in *The Folly of Being Comforted*, given that he had had contact with Pound, must be considered to be fairly high in view of the evidence available. Goodwin would certainly admit that.

This is not sufficient to show, however, that influence took place. The point of Goodwin's remark that "Yeats was quite capable of making such changes by himself" is that the probability for the hypothesis that Yeats would have made these changes given that he had not had any contact with Pound must also be considered to be fairly high in view of the evidence available. If the probability for the second hypothesis (that Yeats would have made these changes, given that he had not had contact with Pound) is subtracted from the probability for the first hypothesis (that Yeats would have made these changes, given that he had had contact with Pound), the result would, according to Goodwin, be close to zero. But if Pound had exercised any influence on these changes, then the result of this subtraction would not have been zero; and the stronger Pound's influence was, the closer the result of the subtraction would be to 1.

I shall now try to state a measure of the size of the artistic and literary influence along the lines suggested above. However, it may not be out of place to make the following comment. The technicalities to be introduced and discussed below are not very complex, but it may nevertheless seem strange to apply concepts and formulas of probability cal-

[25] Goodwin, *The Influence of Ezra Pound*, p. 87.

culus to the vague and imprecise language of art history and art criticism. There is obviously a danger of making artificial distinctions and carrying the search for precise formulations too far here, but it may nevertheless be interesting to try to develop the vague ideas above in a somewhat more rigorous way and see how far they are useful. For one thing, it will then be easier to see the difficulties with this kind of measure.

In order to be able to state the measure briefly, I shall introduce some abbreviations. Let $P =$ the probability for the hypotheses that:

(1) fy $= Y$ was created at the time t with the properties it has with respect to a;

(2) kxy $=$ the creator of Y came into contact with X before t;

(3) kzy $=$ the creator of Y came into contact with Z before t; and let a slash (/) mean "given that."

Moreover, let a line above an expression mean that this expression is negated. Thus "$P(fy/\overline{kxy})$" is to be read as "the probability for the hypothesis that Y was created at t with the properties it has with respect to a, given that the creator of Y did not come into contact with X before t."

With the help of these abbreviations, it is now possible to state a new measure of the size of the artistic influence:

MEASURE V: If X and Z both influenced the creation of Y with respect to a, and if $P(fy/kxy) - P(fy/\overline{kxy}) = m$, and if $P(fy/kzy) - P(fy/\overline{kzy}) = n$, and if $m > n$, then Y was more influenced by X than by Z with respect to a.

However, it is possible to raise a number of objections against this measure. Even if it should be acceptable from a theoretical point of view, the application of this measure to particular cases raises a number of practical problems.

One of these problems is obvious enough, and that concerns the determination of the values for m and n. What methods could be used to estimate the probabilities? Are

there any nonarbitrary methods that can be applied to the situations art historians are dealing with? Critics and scholars will here have to make conjectures, and the grounds for these conjectures are usually rather loose. This obviously makes the subtraction more complicated; it shows that m and n should be replaced by $m + r$ and $n + s$, where r and s, which indicate the range of error, may or may not be identical.

But if this is so, then the difficulties of applying this measure to practical cases may be enormous. It is, of course, possible to take some of the complications mentioned earlier into account in determining the probabilities. For example, it is possible to consider the initial resistance to changes in various directions and other circumstances when one is trying to estimate the probabilities for the four alternatives (that is, for $P(fy/kxy)$, $P(fy/k\overline{x}y)$, etc.), but that does not change the point made above. Besides, in estimating these probabilities one does not take into account the size of the change, only that the change took place. And this seems to be a serious limitation.

In my view it is quite conceivable that in a particular case the value of m could turn out to be greater than the value for n, even if it is true that:

(a) if the creator of Y had not come into contact with X before Y was created, then the result would have been a work of art somewhat different from Y (in its present shape);
(b) and if the creator of Y had not come into contact with Z before Y was created, then the result would have been a work of art very different from Y (in its present shape).

It does not seem too farfetched, therefore, to assume that measures IV and V may give different results, at least sometimes. This shows the importance of combining the different measures and, above all, of indicating clearly which measure one is using.

If there is a causal connection between the contacts and the way the works of art are created, then it might be argued that the above measure, using subtraction, should be replaced by a measure that uses division, perhaps along the following lines:

MEASURE VI: If X and Z both influenced the creation of Y with respect to a, and if $\dfrac{P(fy/kxy)}{P(fy/\overline{kxy})} = m$, and if $\dfrac{P(fy/kzy)}{P(fy/\overline{kzy})} = n$, and if $m > n$, then Y was more influenced by X than by Z with respect to a.

However, it seems to me that exactly the same problems that were raised by measure V will reappear here; it may well be just as difficult to apply this measure to practical cases as it is to apply the previous one.

3.6 Measures VII–IX: The Extensiveness of the Change

In the previous sections of this chapter, I have discussed some methods by means of which it would be possible to measure and grade artistic or literary influence in a particular respect a. (The first measure is an exception.) With the help of these methods it would be possible to answer questions such as "How much was the imagery of Yeats influenced by the poems by Pound?" and "Did Pound's poetic technique have a greater influence on Eliot than on Yeats?"

However, critics and scholars sometimes discuss who had most influence on a poem or a painting without specifying the respect in which the influence is supposed to have taken place. Consider the following quotation, taken from Walter Friedlaender's 1964 book on Poussin:

> The schema and the treatment of Titian's landscapes impressed the youthful Poussin deeply, whereas the influence of Bolognese landscapes or of Raphael's art is prominent only in a few special paintings. . . . Already in the

late 1620s, paintings such as *Narcissus and Echo* show a loose, almost impressionistic treatment of large trees that form a background extremely close to Titian's style.[26]

Here there is a loose reference to the respects in which the influence took place. But the quotation is also interesting in this context, since it suggests two different ways of measuring the extent of the influence, both of which can be treated under the heading "the extensiveness of the change."

In the first place, one might simply try to count the number of respects in which Titian and Raphael influenced Poussin. Alternatively, given that they both influenced Poussin in the same respects, one might count the number of works of art by Poussin which were influenced by these artists in these particular respects. Thus we can get the following two measures:

MEASURE VII: If X and Z both influenced the creation of Y with respect to a, and if Y was created by B, and if X influenced more works by B with respect to a than Z did, then X had more influence on B than Z had.

MEASURE VIII: If X and Z both influenced the creation of Y, and if the contact between X and the creator of Y changed Y in more respects than did the contact between Z and the creator of Y, then Y was more influenced by X than by Z.

I shall now make a few comments on these two measures.

The first thing to be noted is that they do not measure the same thing: VII measures the extent of the influence of certain works on a particular *artist*, whereas VIII measures the extent of the influence on a certain *work* (or series of works). Moreover, variations of the two measures can easily be obtained by replacing X and Z with names or descriptions of series of works of art $X_1, X_2, \ldots X_n$, and $Z_1, Z_2, \ldots Z_n$, respectively.

26 Walter Friedlaender, *Nicolas Poussin. A New Approach*, New York: Abrams, 1964, p. 76.

I would also like to point out that measure VII easily lends itself to generalization along the following lines:

MEASURE IX: If X and Z both influenced the creation of Y with respect to a, and if X influenced more works of art with respect to a than Z did, then X had, on the whole, more (artistic) influence than Z with respect to a.

Still other variations of measure VII can easily be obtained by dropping first the clause "with respect to a" in the first if clause, then dropping the whole first if clause, and finally by dropping the last occurrence of "with respect to a" in the formulation above.

However, before I go into further details, I would like to illustrate these new measures with some more examples. In his book on the foreign influences on French literature, to which I have already referred to several times, Philippe van Tieghem writes as follows on the influence of Ariosto's *Roland furieux*:

Aussi l'influence du *Roland furieux* fut-elle infiniment plus grande sur le théâtre et la poésie lyrique que sur l'épopée ou le roman.[27]

One might ask what kind of measure the author has used in comparing the strength of the influence of *Roland furieux* in different genres, and there can probably be some disagreement as to how the quoted sentence is to be interpreted. But it does not seem too far-fetched to assume that van Tieghem is using extensiveness to grade influence, perhaps one of the variations of measure IX.

There are numerous other examples of grading of influence in van Tieghem's book, and in this context I will only comment on one more. Discussing the influence of Byron on French literature, van Tieghem writes:

L'influence de Byron fut, sur le romantisme français, de 1820 à 1840, la plus générale, sinon la plus profonde.[28]

[27] van Tieghem, *Les Influences étrangères*, p. 19.
[28] *Ibid.*, p. 181.

Here I think it is fairly clear that "la plus générale" can be interpreted as "the most extensive," and that, again, something like measure IX is presupposed.

It is interesting to compare the previous two quotations to the following one, taken from Albert Friedman's book on the ballad revival:

> With other poets, with Hardy, Kipling, Yeats, or Frost, only a portion of their works can be construed as influenced by folksong; with Housman, the ballad note is the tonic of virtually everything he composed.[29]

I take this statement to mean that the extensiveness of the influence of folksong is greater on Housman than on any of the other poets mentioned above. But which measure has been used in grading the influence? It seems that none of those above, but something like the following variation on measure VII:

> MEASURE VII': If the creation of Y and Z were both influenced by X with respect to a, and if Y was created by B and Z was created by C, and if X influenced more works by B than by C with respect to a, then X had a stronger influence on B than it had on C.

Variations on this measure can be obtained by replacing "with respect to a" with "in some respect."

Measure VIII also raises a number of intriguing problems, some of which I shall call attention to in the following paragraphs.

The key sentence in measure VIII ("the contact between X and the creator of Y changed Y in more respects than the contact between Z and the creator of Y did") should here be understood as follows: "if this contact with X had not taken place, then the artist in question would have created

[29] Albert Friedman, *The Ballad Revival*, Chicago & London: University of Chicago Press, 1961, p. 336.

291

a work of art Y' which would have been different from Y in more respects than the work this artist would have created if the contact with Z had not taken place." Such counterfactual conditionals may seem to be very dubious; and it is, of course, possible to ask on what grounds claims of this kind could be justified.

I have here presupposed that Y in the key sentence—and accordingly also in VIII as a whole—is replaced by names and descriptions of one particular artistic or literary work. But if X is replaced by names and descriptions of a series of works of art, then the key sentence might be interpreted as expressing a perhaps less controversial type of statement. In that case, this sentence could be understood as saying or implying that the artistic production of this artist after his contact with X differs in more respects from his production before this contact than did his production after and before his contact with Z.

However, the interpretation of the key sentence and the problems connected with it are not the only problems that are raised by measure VIII. An important point is that it is far from clear what is to count as *one* respect. What criteria could be used to decide whether X and Z influence Y in the *same* respect or not? If "style," "expression," "symbolic contents," etc., are regarded as different respects, then it is clear that these categories are not separated from each other by anything like sharp and precise boundaries.

Moreover, concepts such as style and expression are very complex, and they can be divided into many components. This is particularly true of style, as the quotation from Goodwin in section 1.2.1 brings out clearly. ("The more superficial tricks of style—the startling new image . . . the omission of articles, the insertion of letters into narrative—. . . . The less superficial aspects of style, such as the handling of colloquial rhythms and the use of brief anecdotes to illustrate a point. . . .") If it is not specified in a fairly precise way what is to count as *one* respect, then there is

likely to be a great deal of confusion, pseudoagreement and pseudodisagreement when measure VIII is applied to particular cases in order to estimate the size of the influence.

But there are further problems. Let K_x be the class of respects in which the contact with X changed Y, and let K_z be the class of the respects in which the contact with Z changed Y. These two classes can be related to each other in several ways. For example, K_x can be a proper subset of K_z, or K_z can be a proper subset of K_x. But they can also be related to each other as indicated by the following diagram:

If one of these classes is a proper subset of the other, then it makes sense to compare them. But what method could be used in the case illustrated above?[30]

In that case, it seems possible to use measure VIII only if it is taken for granted that a change in one respect is not only comparable to a change in a different respect, but is equal to a change in another respect in the sense that both of them carry the same weight; and that, accordingly, it is possible to add the number of different respects (changes in style, expression, choice of motifs, and so forth) to a sum which represents the size of the influence of a particular

[30] An x in an area of the diagram indicates that this area is not empty.

work of art. This sum can then be compared to other sums representing the size of the influence of other works of art.

However, this assumption is very controversial, to say the least. Simple additions and subtractions are here out of place. Scholars and critics can only in a very vague and rough way make estimations, and in these estimations it is also necessary to consider the "weight" of the different respects. At any rate, it seems hardly self-evident that a change in one respect without any qualifications could be equated with changes in other respects. For these reasons, it seems extremely difficult, therefore, to suggest any simple mechanical rules of addition that could be used in the cases illustrated by the diagram above.

Thus, if X influenced the creation of Y with respect to a (but not with respect to b), and if Z influenced the creation of Y with respect to b (but not with respect to a), it seems to be very difficult to decide in a nonarbitrary fashion whether X influenced the creation of Y more than Z did. But how about cases when X and Z have influenced the creation of Y in precisely the same respect (that is, K_x is identical with K_z)? Or the two possibilities mentioned earlier, that one of these classes is a proper subset of the other (K_x is included in K_z, or K_z is included in K_x)? Prima facie, they might appear to be quite unproblematic.

But to think that they are unproblematic would be a mistake. Suppose, for example, that X and Z both have influenced the creation of Y in the two respects a and b and in no other respects. Does it follow that X and Z influenced the creation of Y equally? Not necessarily, if it is granted X can influence the creation of Y more or less strongly in a particular respect. Besides, it is then possible to get into situations where X influenced the creation of Y more with respect to a and less with respect to b, whereas Z influenced the creation of Y more with respect to b and less with respect to a; and then it seems difficult to decide in a nonarbitrary fashion whether X influenced the creation of Y more than Z did.

3.7 MEASURES X-XI: THE IMPORTANCE OF THE CHANGE

In view of the difficulties mentioned above, it may be tempting to try the following measure, which is suggested by the last interpretations of the literary examples discussed on pages 274-275:

> MEASURE X: If X and Z both influenced the creation of Y, and if the changes in Y due to the influence of X are aesthetically more important than the changes due to the influence of Z, then Y was more influenced by X than by Z.

I shall now make a few comments on this measure.

The basic idea in measure X is thus that we should limit our attention to significant or important changes in order to avoid the difficulties in counting the changes, which I have pointed out above; if we cannot count *all* the changes, because they are too many or too difficult to identify, we can at least try to count all the significant changes. But significant in relation to what? Clearly, this measure presupposes an aesthetic standard, a set of norms and values, or at least a vague idea about what is valuable in art and what makes it worthwhile to study the history of art and literature.

Obviously, some of the difficulties mentioned in the previous section will reappear in connection with this measure. For instance, the use of measure X presupposes that it is possible, at least roughly, to state what the changes are and to distinguish between the changes due to the influence of X and those due to the influence of Z. Moreover, it is easily possible to get variations of this measure depending on exactly what the value of the variable Y is taken to be. But the most conspicuous difficulty is, of course, to decide whether one set of changes is aesthetically more important than another. Are there any reliable methods of deciding questions of this kind?

Naturally, it may be both interesting and rewarding to

try to investigate (in whatever way possible) whose influence had the greatest aesthetic significance for the creation of Y or for the artistic development of Y's creator. But then one has ceased to make empirical judgments about the relations between X, Y, and Z and begun to make value judgments. Moreover, it should be noted that X can very well influence the creation of Y in one single respect only, but this influence can be aesthetically much more important than the influence from Z, in spite of the fact that Z has influenced the creation of Y in more respects than X has. It is therefore far from clear that the same answer will be given to the questions "Did X influence Y in more respects than Z did?" and "Was the influence of X on Y aesthetically more important than the influence of Z on Y?"

Now, whether these difficulties are fatal or not, depends on one's views on what the purpose of investigations of the history of art and literature is or should be. Is it purely theoretical? Or should scholars in disciplines like history of art and comparative literature also, or mainly, try to enhance their readers' experiences of works of art by calling attention to aesthetically or humanly significant features of the works they discuss? This, incidentally, is one example of the important role of such normative considerations about the purpose of humanistic studies, and it would be well if these views on the purpose of humanistic scholarship were made explicit and discussed seriously.

However, those who feel that historic scholarship even in disciplines like history of art and comparative literature should be purely theoretical, and still want to retain something of the basic idea behind the introduction of measure X, may want to replace this measure by:

MEASURE XI: If X and Z both influenced the creation of Y, and if the changes in Y due to the influence of X according to the system S of norms and values are aesthetically more important than the changes due to the influence of Z, then Y was more influenced by X than by Z.

The basic idea in this measure is thus to relativize the measurement of influence to a particular set of values and norms, which may be postulated explicitly or implicitly taken for granted. The scholar can—if he uses this measure—either postulate his own normative views or describe normative views commonly held at the time and place where he lives. Anyway, it may be argued that in this case the scholar does not advocate these values and norms; he is merely saying, "If these values and norms are accepted, then"

However, there seems to be a rather thin line between using value premises in this way and advocating them. Is it likely that a scholar would use such a set of premises unless he thought they were reasonable? It is, of course, theoretically possible that a scholar would use value premises without supporting them himself. But is this much more than a theoretical possibility? Moreover, if a distinguished scholar uses a particular set of value premises as a basis when he compares the influence of two works of art on a third, then this will easily impress his readers and have various intended or unintended normative effects on them. Anyway, different scholars and critics will probably not use quite the same set of values and norms, so if anything like measure XI is going to be used, it is imperative that the premises be made explicit.

But if one wants to stick to the idea that studies in the history or art and literature are or should be strictly theoretical, and if one does not want to give up the attempt to grade the relative size of artistic and literary influence, then there are other empirical measures that could be used instead of the ones discussed in this section; and I shall now turn to some of them.

3.8 Measures XII–XIII: The Duration of the Influence

Philippe van Tieghem's investigation of foreign influences on French literature from 1550 to 1880 contains numerous examples in which the author compares the relative

strength of various literary sources. For instance, van Tieghem writes in his preface as follows:

> Parmi les influences subies par la littérature française, la plus constante, la plus profonde, reste celle des Anciens, grecs et surtout latins.[31]

Here it seems that van Tieghem is combining two measures, and in this section I will concentrate on the one hinted at with the words "la plus constante"; they suggest that the duration of the influence is used as a measure.

To begin with, I propose to distinguish between the following two preliminary formulations of these measures:

MEASURE XII: If X and Z both influenced Y in a particular respect a, and if the influence of X on Y with respect to a lasted longer than the influence of Z on Y in this respect, then X had more influence on Y than Z had.

MEASURE XIII: If X and Z both influenced Y in some respect (not necessarily the same), and if the influence of X on Y lasted longer than the influence of Z on Y, then X had more influence on Y than Z had.

Both these formulations need some clarification, and I will now comment briefly on these two measures.

First, both of them should obviously be distinguished from measure VII, and the generalized version of this measure, that is, measure IX. It is, of course, possible for an artist or a work of art to have an influence on many other works during a short period of time. But it is also possible for an artist or a work of art to have an influence on few works of art during a long period of time, if these works are created on different occasions and the length of time between the creation of each of them is considerable. Thus these measures, VII and IX on the one hand, and XII and XIII on the other, need not give the same result.

[31] van Tieghem, *Les Influences étrangères*, p. 4.

It is also clear that the two measures above should be distinguished from each other. They can very well yield different results, when applied to the same situation: X can have more influence on Y than Z has according to measure XII, and at the same time Z can have more influence on Y according to measure XIII. Moreover, measure XI will, of course, give different results depending on what is counted as *one* respect; if a is a general category like form or content or structure, then a may be defined as a disjunction of other respects b, c, d, \ldots and so forth, where b, c, d are various subcategories. If measure XI is not to give arbitrary results, and create pseudoagreement or pseudodisagreement, it is necessary to insist on intrapersonal and interpersonal consistency in defining what is to be meant by "in a particular respect a."

Needless to say, in order to make sense the variable Y in the last two measures must be replaced by names or descriptions not of individual works of art but of a series of works of art or a class of works of art. To make this explicit, the measures might be reformulated as follows:

MEASURE XII': If X and Z both influenced members of the class of works Y in a particular respect a, and if the influence of X with respect to a on members of Y lasted longer than the influence of Z on members of this class in this particular respect, then X had more influence on Y than Z had.

MEASURE XIII': If X and Z both influenced members of the class of works Y in some respect (not necessarily the same), and if the influence of X on members of Y lasted longer than the influence of Z on members of this class, then X had more influence on Y than Z had.

Again, if the measures are not to give arbitrary results, then two scholars arguing whether X had more influence on Y than Z had, must, of course, define the class Y in equivalent ways. If, for example, they disagree as to whether Goya had

more influence on modern painting than Delacroix, and if they use the measures above, then they should make sure that they have the same thing in mind when they talk about "modern painting."

Since it is possible to influence many works in few respects as well as few works in many respects, the measures in this section should be clearly distinguished from measure I. They need not give the same result; a simple exercise in logic shows that the following four combinations are possible:

 (a) many works in many respects;
 (b) many works in few respects;
 (c) few works in many respects;
 (d) few works in few respects.

It is, of course, not easy to say what is to be counted as many and few (many and few in relation to what?), but I shall disregard these problems here.

In concluding this section, I would like to make explicit that the measures discussed in this section can be combined with many of the others. If, for example, we return for a moment to van Tieghem's statement about the constancy of the influence from classic writers, one may ask: what has been constant? The number of works influenced each year? The number of respects influenced? The aesthetic importance of the influence? Or all of these together?

3.9 CONCLUDING REMARKS

In this final section I shall try to draw some practical conclusions from the discussions in this chapter. I have tried to show how difficult it is to grade and measure artistic and literary influence in a clear and yet nonarbitrary way. There may, of course, be other methods of measuring influence than the ones I have considered, and some of the difficulties to which I have called attention could perhaps be overcome.

But even so, some people might want to argue that the result of the investigations in this chapter shows that it might be interesting to distinguish in a rough way between strong and weak influences, but that it is futile to try to measure the influence in a more precise way. Of course, this does not mean that comparisons between the relative influence of two works of art are bound to be arbitrary or that it should be practically impossible to achieve reliable results as to whether X influenced the creation of Y more than Z did. But what practical conclusions could be drawn from the difficulties I have called attention to above?

If one wants to find out whether X had more influence on Y than Z had, then it is a good strategy to start by analyzing the works of art and their background from many different points of view. In particular, it is important to try to discover material that sheds a light (a) on the initial resistance to changes in various directions of the artists involved, and (b) on the size of the changes that the contacts with X and Z have brought about. To avoid too crude statements about the relations between X, Y, and Z, it is wise to use many different measures and to relate the conclusions to the various measures used; when the conclusions are stated, it is important to indicate what information the comparisons are based on and what methods of measurement have been used.

Obviously, different scholars can use different methods and have different information about the works of art and their background. Besides, it is always possible that someone will find a letter or a diary in an archive that will shed new light on some circumstance of importance in this context. By making explicit what information and what methods one is using, it is therefore possible to eliminate the dangers of fruitless verbal disputes, pseudoagreements and pseudodisagreements. This means that the three-place relation "X influenced the creation of Y with respect to a" in discussions of relative influence should be replaced by the five-place relation "X influenced the creation of Y more

than Z with respect to a according to the method of measurement M."

Finally, in this chapter I have mostly discussed sentences of the form "X influenced the creation of Y more than Z did." But what I have said about these sentences and statements in the form of these sentences also applies—*mutatis mutandis*—to sentences of the following kind:

(a) X influenced the creation of Y more than X influenced the creation of Z;

(b) The creation of X was more influenced by Y than by Z;

(c) X influenced the creation of Y more with respect to a than with respect to b.

In these cases analogous problems arise concerning how to measure and grade the strength and size of the influence.

4.

Consequences and Conclusions

4.1 INTRODUCTION

LIKE Haskell Block, at least in his earlier paper on this subject,[1] Claudio Guillén seems to think that studies of influences are "indispensable to the understanding of literature itself."[2] Guillén calls attention to the differences between influence and "recurrent techniques and conventions, or of noninfluential echoes and parallelisms."[3] And he adds: "what is needed today, . . . is not just an empirical, haphazard approach to these differences, but a series of concepts and terms which will account for them."[4] To achieve this has been part of my objective.

This book is divided into three main parts. In the first chapter I try to clarify the notion of artistic and literary influence by introducing a number of distinctions between different kinds of influence. The most important are the distinctions between positive and negative influence, direct

[1] Haskell M. Block, "The Concept of Influence in Comparative Literature," *YCGL*, VII, 1958, pp. 30–37, particularly p. 37.

[2] Claudio Guillén, "The Aesthetics of Influence Studies in Comparative Literature," in Werner P. Friedrich, ed., *Comparative Literature: Proceedings of the Second Congress of the International Comparative Literature Association*, I, Chapel Hill: University of North Carolina Press, 1959, p. 183, n. 18.

[3] *Ibid.*

[4] *Ibid.*

and indirect influence, and influence in the narrow and wide sense. These distinctions are logically independent of each other; by combining them systematically it is possible to distinguish between many kinds of influences. Besides, each of these distinctions can be drawn in several ways. Thus there is not one concept or a family of concepts but several related families of concepts of artistic and literary influence.

In the second chapter I introduce and discuss a number of necessary (or apparently necessary) conditions for artistic and literary influence. In these conditions I describe and analyze evidence of the kind scholars generally use to support or criticize hypotheses of influence; for instance, statements to the effect that the work supposed to have been influenced was created after the influencing one; that the person who is supposed to have been influenced was familiar with the other work of art; and that the two works are similar to each other in relevant respects. I distinguish between six conditions of this kind, and in discussing them I introduce distinctions and point out problems of verification.

In the third chapter I analyze some of the methods used by art historians and literary historians to grade the relative strength and size of the influence. The point of departure for the discussion in that chapter is a number of quotations from writings on art history and literary criticism, where the authors say or imply that one artist or work of art had more influence on another than a third had. To clarify these statements, I introduce and distinguish between a number of methods of measuring influence which are or could be used in this context, and I call attention to various difficulties in the application of these methods or measures to empirical problems.

In this final part of the book I will not give a summary in the usual sense by repeating the distinctions, requirements, and measures discussed in the previous chapters. Instead I will outline briefly what I take to be the significance of

some of the results from the present investigation. I propose to do that by relating some of the things I have said, or the consequences of what I have said, to some of the things said or suggested by other scholars. This may serve the double purpose of clarifying my own views on some specific points and of suggesting further references to those who want to read about other approaches to the problems of artistic and literary influence.

4.2 INFLUENCE, TRADITION, AND DEVELOPMENT

The notion of tradition is of considerable importance to scholars in comparative literature and art history. It is sometimes thought that there is some kind of incompatibility between the notions of influence and tradition in the sense that one would either have to study influences or traditions; and since traditions are more interesting than influences, studies of influence ought to be abandoned.

But this is a mistake. For what is meant by "tradition" in this context? I suggest that the notion of tradition should be analyzed along the following lines: X and Y belong to the same literary tradition, if and only if the following requirements are satisfied:

(a) X and Y are both literary works;
(b) there is some kind of similarity between X and Y;
(c) there is a direct or indirect influence relation between X and Y.

An analogous analysis can, of course, be suggested for the notion of artistic tradition.

I do not have to point out that these three requirements are far from clear; it has been part of the objective in the present book to clarify statements of this kind. But here the notion of tradition is defined partly in terms of the notion of influence; hence these notions are not incompatible with each other. And it is possible to define the notion of tradition in this way, as soon as an explicit distinction is made

305

between direct and indirect influence and between different kinds of indirect influence.

To be somewhat more specific, I will comment briefly on a paper by Ihab H. Hassan.[5] If I understand him correctly, he tries to define the notion of influence as some kind of noncausal relation. He summarizes his attempt at a redefinition as follows:

> So conceived, the idea of influence becomes tantamount, not to causality and similarity operating in time, but to multiple correlations and multiple similarities functioning in a historical sequence, functioning, that is, within the framework of assumptions which each individual case will dictate.[6]

The main problem here is to understand what is meant by "functioning in a historical sequence." Is not some kind of causal relation involved in this notion?

Clearly, it is possible to be influenced both by a particular work of art and by a tradition originating from this work. If Hassan has the latter in mind, he has merely replaced one problem with another. In that case, he discusses influence as a relation between an individual work and a class of works, whereas I have discussed influence as a relation between individual or singular works. But one of these approaches does not exclude the other.

It is not clear to me if and to what extent Hassan would disagree with anything I have written so far in this book. But the basic idea in his paper is that the notion of influence is superfluous in many contexts, and that it should be discarded in favor of notions like tradition and development. The former of these he conceives of as a "structural pattern, as a set of norms, norms of language and of attitudes."[7]

Criticizing the traditional notion of influence, Hassan writes as follows:

[5] Ihab H. Hassan, "The Problem of Influence in Literary History: Notes Toward a Definition," *JAAC*, XIV, 1955, pp. 66–76.

[6] *Ibid.*, p. 73. [7] *Ibid.*, p. 74.

Similarity is taken with reference to a developed system of norms, a *tradition*; causality is discarded in favor, not of correlation, but of the more flexible and significant notion of *development,* the modification of one tradition into another.[8]

Again, one must ask for clarification of what appears to be the key term in this quotation, namely "modification." What is meant by "modification" here? Is not the notion of direct or indirect influence involved in some way or other in this notion?

Of course, it is possible to *describe* the development of a literary tradition in the sense that one notes and compares, say, literary conventions at different times and places. But if we want to *explain* why a tradition spread from one place to another (and, for instance, make a more thorough study of the contacts between persons, groups, traditions, and cultures), it seems very difficult indeed to avoid the notions of direct and indirect influence. Thus if we merely want to describe literary and artistic traditions, we can do without the notion of influence. But if we want to achieve anything more than that, we need it; and, I might add, we also need a psychological theory of what is involved in creating works of art.

However, it seems that what really interests Hassan is to characterize or evaluate a poet's work. For instance, at one place in his paper he writes:

Such insights are the fruit of the comparative method which, to call upon Eliot once more, does not involve the vain study of sources and influences, but rather the definition of the poet's type through comparisons with other manifestations of the same type in other languages and other traditions.[9]

This quotation raises many questions. For instance, how do we decide whether two works of art are manifestations *of*

[8] *Ibid.,* p. 75. [9] *Ibid.,* p. 76.

the same type? But my main objection is that the opposition suggested here between studies of "sources and influences" and studies of traditions seems to be a pseudoopposition; I fail to see that one of these tasks has to exclude the other.

In other words, to "define" a poet's type, or to "value a poet" (as Eliot says in a passage quoted approvingly by Hassan), are important tasks which require comparisons of the kind mentioned above; we must, as Eliot says, set the poet, "for contrast and comparison, among the dead." But this is, as I understand it, something quite different from the historical task of studying the influences on and of his works. To characterize a poet's work one can compare it to writings which he may never have heard of, let alone read or become influenced by; and these comparisons can be suggestive and illuminating. But they are out of place in a historical study.

However, perhaps all Hassan wants to say is that what he calls "definitions of a poet's type" in his view are more interesting than searches for influences of or on his works. If this is so, then many scholars would no doubt be inclined to agree with him. But in that case he addresses himself to other problems than the ones discussed in this book.

4.3 INFLUENCE AND INTERPRETATION

If one poet is influenced by another, he always to some extent transforms the work of the other poet. This is also true when an artist borrows a detail, a figure, or a pose from another: he puts it into a new context, and he changes it in a variety of ways, as is shown by a comparison between *Dead Christ with Two Angels* by Paris Bordone (c. 1550–60, Palazzo Ducale, Venice) and *Narcissus* by Nicolas Poussin (c. 1623–26, Louvre, Paris).[10] Thus the history of the influ-

[10] This connection between Poussin and Venice has been pointed out by Erwin Panofsky, "Imago Pietatis," *Festschrift für Max J. Friedlaender*, Leipzig: E. A. Seemann, 1927, pp. 267–96; and by Denis Mahon,

ence of a work can be said to be the history of creative comments on this work. In this sense, poetic influence is, as Harold Bloom has pointed out, "part of the larger phenomenon of intellectual revisionism."[11]

These creative comments, whether conscious or subconscious, presuppose the use of imagination, and I shall therefore assume that the following statement is true:

(a) If X was influenced by Y, and if X was created by A, then A has interpreted Y and used his imagination in this interpretation.

In my view there are very good arguments supporting this thesis, both conceptual and empirical, though one may argue a great deal about how "interpreted" in (a) should be interpreted. But at any rate (a) does not mean that a poet always misinterprets the works that influence him, as Harold Bloom seems to suggest in a recent paper.[12] Thus, I would deny that the following statement is true:

(b) If X was influenced by Y, and if X was created by A, then A has always misinterpreted Y,

at least if "misinterpret" is used in anything like its ordinary sense.

However, I hasten to add that Bloom does not say that (b) holds generally. It is true when (and only when?) the poets involved are what he calls "strong poets." Thus (b) should be replaced by

(c) If X was influenced by Y, and if X was created by A, and if A is a strong poet, then A has misinterpreted Y,

or by

"Nicolas Poussin and Venetian Painting: A New Connexion, I–II," *BM*, LXXXVIII, 1946, pp. 15–20; 37–42.

[11] Harold Bloom, "*Clinamen* or Poetic Misprision," *New Literary History*, III, 2, 1972, p. 379.

[12] *Ibid.*

(d) If X was influenced by Y, and if X was created by A, then: A has misinterpreted Y, only if A is a strong poet,

or by

(e) If X was influenced by Y, and if X was created by A, then: A has misinterpreted Y, if and only if A is a strong poet.

I suppose that these theses according to Bloom can be generalized to cover other arts as well by replacing "strong poet" with "strong painter," "strong sculptor," and so forth.

Which of these three theses above does Bloom hold? This is not easy to tell from his paper. But he is at least committed to (c), since he makes the following point in italics:

> *Poetic Influence—when it involves two strong, authentic poets—always proceeds by a misreading of the prior poet, an act of creative correction that is actually and necessarily a misinterpretation.*[13]

The word "misinterpretation" implies that the influenced poet has tried to interpret his predecessors but failed, that there is something wrong with his poem. According to the *Oxford English Dictionary*, "misinterpretation" is synonymous with "erroneous interpretation," and "misinterpret" is synonymous with "to interpret erroneously or in an incorrect sense; to give a wrong interpretation to." But if one poem X was influenced by another poem Y, it surely seems odd to say that there is—necessarily—something wrong with X.

The crucial questions here are: is any of the three theses (c), (d), and (e) true? If so, which one? And what kind of evidence can be used to support these theses? The answer to these questions, of course, depends on how the distinction between strong and weak poets is drawn. But this dis-

13 *Ibid.*, p. 381.

tinction is nowhere explained clearly by Bloom in his paper.[14] To be sure, he makes a number of statements about strong and weak poets, and also about what strong and weak poets would say and do in various situations. For example, he writes that "really strong poets can read only themselves,"[15] "Even the strongest poets were at first weak,"[16] and "the strong poet fails to beget himself."[17] He also makes obscure claims like: "To be pure spirit, yet to know in oneself the limit of opacity; to assert that one goes back before the Creation-Fall, yet to be forced to yield to number, weight and measure; this is the situation of the strong poet."[18]

But these similes and metaphorical statements do not help very much; they badly need clarification. Are they analytic or synthetic? If the latter is the case, how could they be tested? Under what conditions would Bloom regard them as falsified? Clearly, there is a danger here of drawing the distinction between strong and weak poets in such a way that the theses (c), (d), and (e) become trivially true. Let us, for instance, suppose that "A is a strong poet" is defined in terms of "If A's poems have been influenced by any literary works, then A has always misinterpreted these works." Then all the three theses above are saved but only at a very high price; they have been turned into analytical truths; hence they are trivial. But, apparently, Bloom does not want to say anything that is trivially true; he presents his main idea as "outrageous."[19]

The point I want to make is simply this: to be able to decide whether his ideas are "outrageous," one must know more precisely which thesis he is arguing for and how this thesis should be understood; and in order to know this, fur-

[14] Perhaps this distinction is explained in Bloom's recent book *Influence and Imagination*, New Haven: Yale University Press, 1972, but I have not yet been able to find a copy of this book.

[15] Bloom, *"Clinamen,"* p. 373.

[16] *Ibid.*, p. 376. [17] *Ibid.*, p. 385.

[18] *Ibid.*, p. 382. [19] *Ibid.*, p. 380, last line.

ther clarification of the key concepts of Bloom's article is needed.

4.4 INFLUENCES, VALUE JUDGMENTS, AND NORMATIVE IMPLICATIONS

Several scholars have suggested that causal statements are somehow connected with value judgments or normative judgments. For instance, William Dray has argued that there is an "intrinsic" or "essential" connection between causal analyses in history and decisions about who is to be blamed; and Claudio Guillén seems to deny that statements about influence are empirical statements; according to him, they are value judgments. I will now comment on these two views and try to show that neither of them should be confused with what I have written in section 1.6 about the normative implications of influence statements.

4.4.1 *Dray on Causality*

If I understand him correctly, Dray wants to maintain that it is often impossible to draw a sharp line between causal analyses and moral decisions. At least, this is what he seems to be saying in this passage:

> A causal explanation is often, for instance, designed to show what went wrong; it focuses attention not just on what was done or could have been done, but on what *should* or *should not* have been done by certain historical agents. Thus, selecting the causal condition sometimes cannot be divorced from assigning blame.[20]

To illustrate his point, Dray discusses the following example.

Let us suppose that two historians argue whether it was Hitler's invasion of Poland or Chamberlain's promise to de-

[20] William Dray, *Law and Explanation in History*, Oxford: Oxford University Press, 1957, p. 99, my italics.

fend Poland that caused the outbreak of the Second World War. According to Dray, these historians are "not just arguing about whether these were the necessary conditions of what happened."[21] But what are they arguing about then? He continues:

> They are trying, rather, to settle the question of who was to blame. In such cases, it should be noticed, there is an *essential* connexion between assigning responsibility and attributing causal status. The point is not that we cannot hold an agent responsible for a certain happening unless his action can be said to have caused it. It is rather that, unless we are prepared to hold the agent responsible for what happened, we cannot say that his action was the cause.[22]

This quotation contains many unclear and problematic expressions. For instance, in what sense does Dray use "cannot"? What does he mean by the key expression "essential connexion"?

In a later book Dray has developed and clarified his position, using as a point of departure an instructive comparison between different explanations of the outbreak of the civil war in America:

> To southerners, the secession of the South (even the firing on Sumter) was simply a warranted response to a northern threat and was not a cause of the war, even though it was a necessary step in bringing it about and may even have initiated it. To northerners, denying the constitutional right of secession and claiming legal possession of federal property in the states, the cause was southern resistance to rightful occupation—the last act in a series expressing resistance to the idea of the Union. The concept of causation employed by such conspiracy theorists on either side is thus *logically tied* to the evaluation of those actions which are candidates for causal status. That the

<hr/>

[21] *Ibid.*, p. 100. [22] *Ibid.*, my italics.

actions of either Black Republicans or the slaveholders and their allies were the cause of the war is a judgment *requiring* the prior judgment that these same actions were reprehensible.[23]

But this quotation also contains many unclear expressions. What is meant, for example, by "logically tied" and by "requiring"?

I have elsewhere discussed Dray's views in some detail and distinguished between a number of possible interpretations of what he wants to say.[24] I will not repeat all of this here. Instead, I will limit myself to mentioning what I take to be some of the main arguments against the position outlined by Dray; and I am then interpreting him as saying that there is a logical connection between the following two statements:

(a) A's action X caused the outbreak of Y (the war);
(b) A is responsible for the outbreak of Y (the war);

in the sense that (b) follows from (a). Further distinctions can then be introduced by distinguishing between different kinds of implications (what is meant by "follows from"?) and by distinguishing between different kinds of causes, but let us for a moment disregard these complications.

Now, several objections can be made to this thesis, or rather to this family of theses. First, I would like to point out that the evidence presented by Dray does not suffice to prove his claims. Clearly, the fact that some historians have failed to distinguish between causal analyses and value judgments does not prove that there is no distinction to be made between causal analyses and moral judgments.

Second, one must ask: why is A's action X reprehensible or to be blamed? If the answer is: because this action

23 William Dray, *Philosophy of History*, Englewood Cliffs: Prentice-Hall, 1964, p. 49, my italics.
24 Göran Hermerén, *Värdering och objektivitet*, Lund: Studentlitteratur, 1972, pp. 43–53.

caused the outbreak of the war, then one must know wheth-
er (a) is true before one takes a stand as to whether A ought
to be blamed. But then (a) cannot possibly be "a judgment
requiring the prior judgment that these same actions were
reprehensible," as Dray writes in one of the quotations
above.

If, however, the answer is: because A's action is incom-
patible with certain moral norms, the following two com-
ments suggest themselves. The question then boils down to
whether and how these more fundamental moral norms can
be justified, and that is not a logical issue. Besides, it is easy
to imagine that many actions conforming to moral norms
can cause a war. Thus it is difficult to see that there is a log-
ical connection between (a) and (b) even in this case.

4.4.2 *Guillén on Influence and Evaluation*

In a paper published two years after Dray's first book on
this subject, Claudio Guillén writes as follows:

> To ascertain an influence is to make a value-judgment,
> not to measure a fact. The critic is obliged to evaluate the
> function or the scope of the effect of A on the making of
> B, for he is not listing the total amount of these effects,
> which are legion, but ordering them. Thus "influence"
> and "significant influence" are practically synonymous.[25]

I will now comment on the view expressed in this quotation
and relate it to mine.

Taken at face value, it seems that the first sentence flatly
contradicts what I have been arguing; I surely want to say
that statements of influence are statements of facts, though
they have normative implications of the kind described in
section 1.6. However, whether Guillén's view contradicts
mine depends on what he means by the expression "make a
value-judgment." Some light on this is shed by the next sen-
tence, where "evaluate" is the key word. However, it seems

[25] Guillén, "The Aesthetics of Influence Studies," pp. 186–87.

315

that "evaluate" in this context can be interpreted in two quite different ways: (a) to pass an aesthetic judgment on, and (b) to estimate.

If interpreted in the first way, then what Guillén says may seem to come fairly close to what I am saying. Nevertheless there are several important differences between our positions. According to Guillén, the critic *"is obliged to* evaluate." In other words, Guillén formulates a norm, addressed to critics, telling them to make evaluations of certain kinds on certain occasions. But this is entirely different from what I have tried to do. I have asked: what are the normative effects of these statements? What is the author saying, or intending to say, when he argues that one artist was influenced by another? By exploring what Austin might call the illocutionary and perlocutionary dimensions of such utterances,[26] I have tried to explain in what sense statements of influence, as a matter of fact, have normative implications.

If, however, "evaluate" in the quotation above is interpreted in the second way, the differences between our positions are still more obvious. For to evaluate in that sense is not to make a value-judgment at all; and it might be noted that on this interpretation, the first and the second sentence in the quotation from Guillén would contradict each other. In that case, "evaluate" is roughly synonymous with "estimate" in phrases such as "to estimate the probability that the cause of the death of a white, married businessman in Los Angeles, who died of lung cancer at the age of 65, was air pollution rather than smoking." Clearly, no value-judgment is involved here.

Thus the two interpretations between which I want to distinguish are "to evaluate aesthetically the function of the influence" and "to estimate what function the influence has had." These two interpretations do not exclude each other. On the contrary, the first presupposes the second. Even

26 See chapter 1, note 84.

though the context seems to favor the first interpretation, Guillén might very well have had only the second or perhaps both of them in mind. Anyway, in neither case is his position identical with mine.

4.5 INFLUENCE, ORIGINALITY, AND NORMATIVE IMPLICATIONS

Some scholars, interested in studying influences but aware of the normative implications of statements of influence and anxious to avoid the resentment these implications sometimes have caused, have tried several ways out of this dilemma. One way is simply to give up research in influences. Another way is to reinterpret the notion of originality.

In fact, the latter strategy has been proposed in an article by J. T. Shaw:

> Some scholars and critics, including many who have studied literary indebtedness, seem to feel that to suggest an author's literary debts diminishes his originality. But originality should not be understood in terms of innovation. . . . The innovation which does not move aesthetically is of interest only to the formalist. What genuinely moves the reader aesthetically and produces an independent artistic effect has artistic originality, whatever its debts.[27]

Several objections can be made to this proposal, however.

In the first place, the reinterpretation suggested by Shaw is clearly at variance with the dictionary meaning of "originality"; this word is defined in terms of innovation in several standard dictionaries I have consulted. For example, the *Oxford English Dictionary* defines "originality" as "the quality of being independent of and different from anything that has appeared before; novelty or freshness of style or

[27] J. T. Shaw, "Literary Indebtedness and Comparative Literary Studies," in N. P. Stallknecht and H. Franz, eds., *Comparative Literature. Method and Perspective*, Carbondale: Southern Illinois University Press, 1961, p. 60.

character."[28] Similar definitions are given in *The Concise Oxford Dictionary* and *The Oxford Dictionary of English Etymology*.

In the second place, one must ask: who is the reader Shaw refers to in the last sentence? If X is an original work of art, and if Y is an imitation of X, then a reader may very well be "moved aesthetically" by Y, particularly if he is not familiar with X. But surely it would be absurd to claim that this makes Y into an original work of art. To avoid this, it is tempting to disqualify some readers and only count the reactions of those who satisfy certain requirements of the following type: they have some familiarity with works of art; they can discriminate between and appreciate aesthetic qualities; and they know whether the work of art in question is an imitation of another. But then the problem is only moved to a new level and not solved; it reappears when we have to explain the meaning of "imitation."

Finally, the quotation is unclear on another important point. One may ask what is meant by the term "independent" in the last sentence. If "independent" is defined in terms of "original," then the last sentence is turned into a tautology; and in that case the problem is again left unsolved. A possible way out of this difficulty, however, is to say that "original" is used in different senses in the expressions "original work of art" and "original artistic effect." But if this strategy is adopted, one must, of course, explain this distinction in some detail.

Now it might be said that Shaw is here concerned more with originality as a characteristic of the work of art than as a characteristic of the artist, and that accordingly he is not addressing himself to the same problem as I did in sec-

28 *OED* also gives, among others, the following synonyms of "original": "that is the origin or source of something; from which something arises, proceeds, or is derived," "produced by or proceeding from some thing or person directly; not derivative or dependent," "made, composed, or done by the person himself (not imitated from another)."

tion 1.6. Nevertheless, there is a much simpler solution to the dilemma. What I want to argue is merely that it is unnecessary to make the reinterpretation of "originality" proposed by Shaw, if one distinguishes, as I have suggested earlier, between:

(a) if X influenced the creation of Y with respect to a, then the praise for the invention of a goes to the creator of X rather than to the creator of Y,

on the one hand, and

(b) if X influenced the creation of Y with respect to a, then X is a better work of art than Y is

on the other hand. The distinction between a work of art as a whole and its composition or a detail like a borrowed figure is obvious enough, and I do not need to work out this distinction precisely for my present purpose.

It suffices to point out that if what I am saying is correct, and the distinction between (a) and (b) is maintained, then it need not be a fault or indicate an artistic weakness to be influenced. The decisive thing is how these influences are used. A painting by Rembrandt, such as *The Storm on the Sea of Galilee* (figure 32) may be a masterpiece, even though he has used a drawing by Martin de Vos (figure 33) as a model for the composition, and the painting is not original in that respect. Thus there is no need for artists and writers to deny familiarity with works of art they have read or seen and been influenced by; and there is no need on this account for art historians and literary scholars to give up research of influences.

4.6 PRACTICAL CONCLUSIONS

This is mainly an analytical study. But conceptual clarification is not an end in itself, and the *raison d'être* of such investigations is that by sharpening and improving the intellectual tools of the scholar, they are useful to those who are interested in the empirical problem of determining if

and to what extent one writer or artist was influenced by another. In this final section I will therefore briefly outline what I take to be the practical conclusions of this investigation.

First of all, I will begin by raising a very general issue. In view of the difficulties I have pointed to in determining whether the requirements of similarity and change are satisfied, it may be argued that the most important practical conclusion of this study is that it shows the futility of search for influences, and hence that this kind of research ought to be given up and should be replaced by studies of traditions, analogies, parallelisms, and so forth, whether or not influence is involved.

However, this may be going too far, even if the difficulties I have pointed to are genuine. The crucial question here is this: Are these difficulties so severe in comparison with the difficulties that confront scholars who suggest and test other kinds of hypotheses about works of art that they should be considered to suggest that research about influences ought to be abandoned? A rational answer to this question should be based not only on considerations of the difficulties in testing various kinds of hypotheses but also on considerations of the payoffs of different approaches to the study of art.

In my view, questions of this kind should not be decided by philosophers, at least not by them alone. Therefore I am not making any large-scale recommendations about the research policy in art history and comparative literature in this book. My personal view, however, is that hypotheses of influence can be corroborated just as well as most other empirical hypotheses. I also think that investigations of this kind can sometimes lead to interesting results, vital to the understanding of works of art, even though the rather meager findings of many studies of influences are striking and have often been pointed out.[29]

29 Haskell M. Block, *Nouvelles tendences en littérature comparée*, Paris: Editions A.-G. Nizet, 1970, pp. 14–19, and the literature he

To be somewhat more specific, it seems to me that studies of influences can be worthwhile for the following reasons: (a) if these studies are not confined to superficial source hunting but are combined with analyses of the genesis of the works of art involved, they may give valuable insights into creative processes and show how artistic imagination works; (b) if they are combined with psychological and sociological investigations, studies of this kind may also teach us a great deal about how cultural contacts are made and how new ideas are spread from person to person or tradition to tradition: (c) they can show in what respects an artist is original, if attention is focussed not only on in what respects he was influenced by others but also on how he uses these influences and in what respects he was *not* influenced by works of art known to have been familiar to him; and (d) if the history of the influence of a work of art can be said to be the history of creative comments on this work, then histories of the influence of great works over the centuries will shed interesting light both on the artists involved and on the taste of these periods.[30]

What I hope to achieve with this book, however, is not to show that research about influences should, or should not, be abandoned; rather, I hope to generate discussions about these and a series of related methodological problems, and to stimulate cooperation across the traditional borders between academic disciplines.

So far I have discussed general issues. But the analyses in the present book also indicate a number of practical conclusions concerning minor points for those who work

refers to, particularly René Wellek, "The Crisis of Comparative Literature," *Concepts of Criticism*, New Haven & London: Yale University Press, 1963, pp. 282–95.

[30] For other proposals about fruitful and important topics of comparative literature, see Henri Peyre, "Comparative Literature in America," in his *Observations on Life, Literature, and Learning in America*, Carbondale: Southern Illinois University Press, 1961, pp. 165–66.

with problems of artistic and literary influence, and I shall now turn to them.

The analyses suggest the following strategy for those who want to criticize a proposed hypothesis of influence: try to find out if and to what extent the requirements discussed in chapter two are satisfied in this particular case. Analogously, the analyses suggest the following strategy for those who want to *prove* or show that a hypothesis of influence is correct: try to show that all the requirements discussed in chapter two are satisfied in this particular case. If some of them are not, then make this clear to the readers. Concerning the requirements that are not satisfied, the following strategy suggests itself: try to show that, in view of the available evidence, it is likely that they are.

In this book I have also stressed the importance of working with a wide perspective; it does not suffice merely to pay attention to two or three particular authors or artists when one discusses problems of influence. It is necessary to study the whole intellectual and artistic setting, and to include examinations of the relations between individuals, groups, movements, and traditions. Moreover, in the sections on similarity and change, and also in chapter three, I have suggested a number of practical conclusions concerning minor points (for example, I stressed the importance of systematically testing the many possible explanations of similarities between works of art), but I will not repeat them here.

This study can be developed further in many directions. There is an obvious connection between many issues discussed in this book and problems in the philosophy of history in general and, in particular, the philosophy of art history, aesthetics, and theory of value. On some occasions I have pointed out these connections and discussed them briefly. But I have not explored them at any length, because they are so complex that they have to be dealt with separately. Above all, the groundwork has to be prepared first, and I have tried to do that in the present book.

Bibliography

This bibliography does not aim at completeness; with a few exceptions, only works which are quoted or referred to in this book are listed below. Long subtitles have sometimes been shortened or omitted in well-known works.

Adhémar, Jean, *Influences antiques dans l'art du moyen age français*, London, 1939 (Studies of the Warburg Institute, VII).

Alciati, Andrea, *Emblemata*, Augsburg, 1531 (and many subsequent editions).

Alston, William P., *Philosophy of Language*, Englewood Cliffs: Prentice-Hall, 1964.

Andersson, Aron, *English Influence in Norwegian and Swedish Figure Sculpture in Wood, 1220–1270*, Stockholm, n.p., 1949; dissertation at the University of Stockholm.

Antal, Frederick, *Hogarth and his Place in European Art*, London: Routledge & Kegan Paul, Ltd., 1962.

Arnheim, Rudolf, *Picasso's Guernica. The Genesis of a Painting*, Berkeley & Los Angeles: University of California Press, 1962.

Aschenheim, C., *Der Italienische Einfluss in der Vlämischen Malerei der Frührenaissance*, Strassburg: Hertz 1910.

Austin, John, *How to do Things with Words*, London, Oxford & New York: Oxford University Press, Clarendon Press, 1962.

Avni, Abraham A., "The Influence of the Bible on European Literatures: A Review of Research from 1955 to 1965," *YCGL*, XIX, 1970, pp. 39–57.

Badt, Kurt, *Die Kunst des Nicolas Poussin*, Köln: DuMont Schauberg, 1969.

Balakian, Anna, "Influence and Literary Fortune: The Equivocal Junction of Two Methods," *YCGL*, XI, 1962, pp. 24–31.

Baldass, Ludwig, *Jan van Eyck*, London: Phaidon, 1952.

Baldensperger, Fernand and Friedrich, Werner P., *Bibliography of Comparative Literature*, Chapel Hill: University of North Carolina Press, 1950.

Beardsley, Monroe, *Aesthetics from Classical Greece to the Present*, New York: Macmillan, 1966.

———, and Schueller, Herbert, *Aesthetic Inquiry*, Belmont: Dickenson, 1967, pp. 241–52.

Bergström, Ingvar, *Dutch Still-Life Painting in the Seventeenth Century*, London: Faber & Faber, 1956.

Biederman, Charles, *Art as the Evolution of Visual Knowledge*, Red Wing, Minn.: Art History Publishers, 1948.

Björck, Staffan, *Heidenstam och sekelskiftets Sverige*, Stockholm: Natur & Kultur, 1946.

Blackmore, John T., *Ernst Mach. His Work, Life and Influence*. Berkeley & Los Angeles: University of California Press, 1972.

Block, Haskell M., "The Concept of Influence in Comparative Literature," *YCGL*, VII, 1958, pp. 30–37.

———, *Mallarmé and the Symbolist Drama*, Detroit: Wayne State University Press, 1963.

———, *Nouvelles tendances en littérature comparée*, Paris: Editions A.-G. Nizet, 1970.

Bloom, Harold, "*Clinamen* or Poetic Misprision," *New Literary History*, III, 2, 1972, pp. 373–91.

————, *Influence and Imagination*, New Haven: Yale University Press, 1972.

Blunt, Anthony, *Nicolas Poussin*, 2 vols., London & New York: Pantheon Books, 1967 (Bollingen Series, XXXV.7).

————, *The Paintings by Nicolas Poussin. A Critical Catalogue*, London: Phaidon, 1966.

Bodkin, Maud, *Archetypical Patterns in Poetry*, London: Oxford University Press, 1948.

Borelius, Aron, *Johan Fredrik Höckert*, Stockholm: Norstedts, 1927 (Sv. Allm. Konstförenings publikation XXXV).

————, *Velazquez*, Stockholm: Norstedts, 1951.

Bornäs, Göran, "Le Cocu battu et content. Étude sur un conte de La Fontaine," *Studia Neophilologica*, XLIV, 1972, pp. 37–61.

Bowra, C. M., *Heroic Poetry*, London: MacMillan, 1952.

Brandt-Corstius, Jan, *Introduction to the Comparative Study of Literature*, New York: Random House, 1968.

Brendel, Otto J., "Borrowings from Ancient Art in Titian," *AB*, 1955, pp. 113–25.

Cardoza y Aragon, Luis, *Orozco*, [Mexico City]: Instituto de Investigaciones Esteticas, Universidad Nacional Autónoma de Mexico, 1959.

Cazamian, L., "Goethe en Angleterre. Quelques réflexions sur les problèmes d'influence," *Revue Germanique*, XII, 1921, pp. 371–78.

Cederlöf, O., "Källorna till Las Lanzas," *Konsthistorisk Tidskrift*, XXVI, 1957, pp. 41–61.

Chadwick, H. M. and N. K., *The Growth of Literature*, 3 vols., Cambridge: Cambridge University Press, 1932–40.

Clark, Kenneth, *Piero della Francesca*, London: Phaidon, 1951.

Corstius, Jan Brandt, *Introduction to the Comparative Study of Literature*, New York: Random House, 1968.

Craig, Hardin, "Shakespeare and Wilson's *Arte of Rhetorique*, an Inquiry into the Criteria for Determining Sources," *PMLA*, 1922, pp. 86–98.

Dauchot, Fernand, "Le *Christ Jaune* de Gauguin," *GBA*, XLIV, 1954, pp. 65–68.

Davies, Martin, "Recent Manet Literature," *BM*, XCVIII, 1956, pp. 169–71.

De Tervarent, Guy, *see* Tervarent, Guy de.

De Tolnay, Charles, *see* Tolnay, Charles de.

Dray, William, *Law and Explanation in History*, Oxford, Oxford University Press, 1957.

————, *Philosophy of History*, Englewood Cliffs: Prentice-Hall, 1964.

Driscoll, Edward A., "The Influence of Gassendi on Locke's Hedonism," *International Philosophical Quarterly*, XII, 1, 1972, pp. 87–110.

Dupin, Jacques, *Joan Miró. Leben und Werk*, Köln: DuMont Schauberg, 1961.

Echeverria, Durand, "Rousseau's Pre-Revolutionary Influence," *Journal of the History of Ideas*, IV, 1972, pp. 543–60.

Eisler, H. and Ekman, G., "A Mechanism of Subjective Similarity," *Report from the Psych. Laboratory, Stockholm University*, Nr. 56, 1958.

Ekman, G., "Några tendenser i experimentell psykologi," *Svensk Naturvetenskap 1957-1958*, pp. 235-266.

————, Goude, G. and Waern, Y., "Subjective Similarity in Two Perceptual Continua," *Report from the Psych. Laboratory, Stockholm University*, Nr. 60, 1958.

Ellman, Richard, *Yeats: The Man and the Masks*, London: MacMillan, 1949.

Erben, Walter, *Joan Miró*, London: Lund Humphries, 1959.

Fedder, Norman J., *The Influence of D. H. Lawrence on Tennessee Williams*, The Hague: Mouton, 1966.

Fehrman, Carl, *Liemannen, Thanatos och Dödens ängel*, Lund: Gleerups, 1957 (Skrifter utg. av Vetenskaps-Societeten i Lund, 53).

Friedlaender, Walter, *Caravaggio Studies*, Princeton: Princeton University Press, 1955.

———, *David to Delacroix*, Cambridge, Mass.: Harvard University Press, 1964.

———, *Nicolas Poussin. A New Approach*, New York: Abrams, 1964.

Friedman, Albert B., *The Ballad Revival*, Chicago & London: University of Chicago Press, 1961.

Furberg, Mats, *Saying and Meaning*, Oxford: Basil Blackwell, 1971.

Gardner, Bellamy, "Children's Games on Chelsea Plates," *Apollo*, XXIX, 1939, pp. 60–62.

Gemzell, Carl Axel, *Raeder, Hitler und Skandinavien*, Lund: Gleerups, 1965.

Gillispie, Gerald, "Origins of Romance Lyrics: A Review of Research," *YCGL*, XVI, 1967, pp. 16–32.

Giraud, Victor, *Essai sur Taine. Son oeuvre et son influence,* Paris: Librairie Hachette, 1912.

Golding, John, *Cubism: A History and an Analysis 1907–1914*, London: Faber & Faber, 1959.

Gombrich, Ernst H., *Art and Illusion*, New York: Pantheon, 1960 (Bollingen series, XXXV.5).

———, *Meditations on a Hobby Horse, and Other Essays on the Theory of Art,* London: Phaidon, 1963.

Goodman, Nelson, "The Problem of Counterfactual Conditionals," *Journal of Philosophy*, XLIV, 1947, pp. 113–28; reprinted with minor changes in Nelson Goodman, *Fact, Fiction, and Forecast*, Indianapolis & New York: Bobbs-Merrill, 1965.

———, *Languages of Art*, Indianapolis and New York: Bobbs-Merrill, 1968.

Goodwin, K. L., *The Influence of Ezra Pound*, London: Oxford University Press, 1966.

Gowing, Lawrence, *Vermeer*, London: Faber & Faber, 1952; 2nd ed. 1970.

Guillén, Claudio, "The Aesthetics of Influence Studies in Comparative Literature," in Werner P. Friedrich, ed.,

Comparative Literature: Proceedings of the Second Congress of the International Comparative Literature Association, I, Chapel Hill: University of North Carolina Press, 1959.

———, "Literatura Como Sistema," *Filologia Romanza*, IV, 1957, pp. 1–29.

Gustafsson, Lars, *et al.*, *Forskningsfält och metoder inom litteraturvetenskapen*, Stockholm: Wahlström & Widstrand, 1970. (Almaserien, 24).

Halldén, Sören, *Logik och moraliskt ställningstagande*, Stockholm, 1962 (Filosofi- och psykologilärarnas förenings skriftserie, IV).

Harmon, Alice, "How Great Was Shakespeare's Debt to Montaigne?," *PMLA*, LVII, 1942, pp. 988–1088.

Hassan, Ihab H., "The Problem of Influence in Literary History: Notes Toward a Definition," *JAAC*, XIV, 1955, pp. 66–76.

Heckscher, William S. and Wirth, Karl-August, "Emblem, Emblembuch," in Ludwig H. Heydenreich and Karl-August Wirth, eds., *Reallexikon zur deutschen Kunstgeschichte,* V, Stuttgart, 1967, columns 85–228.

Held, J., *Dürers Wirkung auf die niederländische Kunst seiner Zeit*, Haag: Martinus Nijhoff, 1931.

Hermerén, Göran, "Aesthetic Qualities, Value, and Emotive Meaning," *Theoria*, XXXIX, 1973, pp. 71–100.

———, "The Existence of Aesthetic Qualities," in Bengt Hansson, *et al.*, eds., *Modality and Morality and other Problems of Sense and Nonsense* (Festskrift till Sören Halldén), Lund: Gleerups, 1973, pp. 64–76.

———, "Historiska förklaringar," *Historisk Tidskrift*, 1973, pp. 212–38.

———, "Några problem i de estetiska vetenskapernas teori," *Litteraturvetenskap*, Stockholm: Natur och Kultur, 1966; a revised and enlarged version is in the mimeographed series, *Studies in the Theory and Philosophy of Science*, University of Umeå, Nr. 6, 1973.

————, *Representation and Meaning in the Visual Arts*, Lund: Läromedelsförlagen, 1969.

————, *Värdering och objektivitet*, Lund: Studentlitteratur, 1972.

Holman, Hugh, "European Influences on Southern American Literature: A Preliminary Survey," in Werner Friedrich, ed., *Comparative Literature. Proceedings of the International Comparative Literature Association*, II, Chapel Hill: University of North Carolina Press, 1959, pp. 444–55.

Holmberg, Olle, *Inbillningens värld*, vols. 1, 2:1, 2:2, Stockholm: Bonniers, 1927–1930.

Huntley, Wiliam B., "David Hume and Charles Darwin," *Journal of the History of Ideas*, III, 1972, pp. 457–70.

Jairazbhoy, Rafique Ali, *Foreign Influence in Ancient India*, New York: Asia Publishing House, 1963.

————, *Oriental Influences in Western Art*, London: Asia Publishing House, 1965.

Jonsson, Inge, *Swedenborgs skapelsedrama De cultu et Amore Dei*, Stockholm: Natur & Kultur, 1961.

Josephson, Ragnar, *Konstverkets födelse*, Stockholm: Natur & Kultur, 1955.

Klibansky, R., Panofsky, E., and Saxl, F., *Saturn and Melancholy. Studies in the History of Natural Philosophy, Religion and Art*, London: Thomas Nelson & Sons, 1964.

Lafond, Paul, *Hieronymus Bosch—son art, son influence, ses disciples*, Bruxelles & Paris: G. van Oest & Cie., 1914.

Lambert, E., "Manet et l'Espagne," *GBA*, IX, 1933, pp. 368–82.

Langer, Susanne, *Feeling and Form*, New York: Scribner's, 1953.

Lauriol, C., *Les Influences reciproques du paysage flammande et du paysage italien pendant la renaissance*, Bruxelles, 1951.

Lee, Rensselaer W., "Castiglione's Influence on Spenser's Early Hymns," *Philological Quarterly*, VII, 1928, pp. 65–77.

Leiris, Alain de, "Manet: Sur la plage de Bologne," *GBA*, LVII, 1961, pp. 53–62.

Lessing, Alfred, "What is Wrong with a Forgery?" *JAAC*, XXIII, 1965, pp. 460–71. Reprinted in Monroe Beardsley and Herbert Schueller, *Aesthetic Inquiry*, Belmont: Dickenson, 1967, pp. 241–52.

Levin, Harry, "La littérature comparée: point de vue d'outre atlantique," *Revue de littérature comparée*, XXVII, 1953.

Lichtenstein, Sara, "Cézanne and Delacroix," *AB*, XLVI, 1964, pp. 55–67.

——, "Delacroix's Copies after Raphael I-II," *BM*, CIII, 1971, pp. 525–33, 593–603.

Lindberger, Örjan, "Pär Lagerkvists bön på Akropolis," *Samlaren*, LXXXI, 1960, pp. 25–35.

Linnér, Sven, *Litteraturhistoriska argument*, Stockholm: Svenska Bokförlaget/Bonniers, 1964.

——, "The Structure and Functions of Literary Comparisons," *JAAC*, XXVI, 1967, pp. 169–79.

Lowes, John Livingstone, *The Road to Xanadu. A Study in the Ways of the Imagination*, New York: Vintage Books, 1959.

Lugt, Frits, "Rembrandt: follower and innovator," *Art News*, 1952, pp. 38–51.

Macklin, Ruth, "Explanation and Action: Recent Issues and Controversies," *Synthese*, XX, 1969, pp. 388–415.

Mahon, Denis, "Nicolas Poussin and Venetian Painting: A New Connexion I-II," *BM*, LXXXVIII, 1946, pp. 15–20, 37–42.

Maison, K. E., *Bild und Abbild*, München & Zürich: Droemersche Verlagsanstalt, 1960. (Originally published in English under the title *Themes and Variations*.)

Malmström, Sten, *Studier över stilen i Stagnelius lyrik*, Stockholm: Svenska Bokförlaget/Bonniers, 1961.

Mandowsky, E., *Untersuchungen zur Iconologie des Cesare Ripa*, Hamburg: Proctor, 1934.

Martin, John R., *The Farnese Gallery*, Princeton: Princeton University Press, 1965.

————, *The Illustrations of the Heavenly Ladder of John Climacus*, Princeton: Princeton University Press, 1954 (Studies in Manuscript Illumination, V).

Meiss, Millard, *Painting in Florence and Siena after the Black Death*, Princeton: Princeton University Press, 1951; also in Harper Torchbook edition, New York: Harper & Row, 1964.

Moir, Alfred, *The Italian Followers of Caravaggio*, Cambridge, Mass.: Harvard University Press, 1967.

Moritz, Manfred, "On Super-Norms," *Ratio*, X, 1968, pp. 101–15.

Nilsson, Albert, "Tegnérs filosofiska och estetiska studier," in *Esaisas Tegnér. Filosofiska och estetiska skrifter*, Stockholm: Bonniers, 1913.

————, *Tre fornnordiska gestalter,* Lund: Gleerups, 1928.

Olsson, Henry, *Fröding. Ett diktarporträtt*, Stockholm: Norstedts, 1950.

Panday, K. C., *Contemporary Aesthetics*, 2 vols., Varanasi: n.p., 1959.

Panofsky, Erwin, *Early Netherlandish Painting*, Cambridge, Mass.: Harvard University Press, 1953.

————, " 'Imago Pietatis'; Ein Beitrag zur Typengeschichte des 'Schmerzensmanns' und der 'Maria Mediatrix,' " *Festschrift Für Max J. Friedlaender*, Leipzig: E. A. Seemann, 1927, pp. 261–308.

————, *Problems in Titian; Mostly Iconographic*, London: Phaidon, 1969.

Paz, Octavio, *Marcell Duchamp or the Castle of Purity*, London: Cape Goliard Press, 1970.

Peers, E. Allison, "The Alleged Debts of San Juan de la Cruz to Boscán and Garcilaso de la Vega," *Hispanic Review*, XXI, 1953, pp. 1–19, 93–106.

Penrose, Roland, *Picasso. His Life and Work*, Harmonds-worth: Penguin, 1971.

Perloff, Marjorie, "Yeats and Goethe," *CL*, XXIII, 1971, pp. 125–40.

Peyre, Henri, *Observations on Life, Literature, and Learning in America*, Carbondale: Southern Illinois University Press, 1961.

Platen, Magnus von, *Tvistefrågor i svensk litteraturforskning*, Stockholm: Aldus/Bonniers, 1966.

———, "Piraten och Johannes V. Jensen," *Svensk Litteraturtidskrift*, XXXVI, 1972, no. 3, pp. 23–24.

Poglayen-Neuwall, Stephan, "Titian's Pictures of the Toilet of Venus and Their Copies," *AB*, 1934, pp. 358–84.

———, "Eine tizianeske 'Toilette der Venus' aus dem Cranach-Kreis," *Münchener Jahrbuch der bildenden Kunst*, N.F., VI, 1929, pp. 167–99.

Praz, Mario, *Studies in Seventeenth-Century Imagery*, 2nd ed., Rome: Edizioni di Storia e Letteratura, 1964 (Sussidi Eruditi, 16).

Rewald, John, *The History of Impressionism*, rev. ed., New York: Museum of Modern Art, 1961. (Distributed by Doubleday & Co.)

Ripa, Cesare, *Iconologia*, Rome, 1593 (and many subsequent editions).

Rosenberg, J., Slive, S., and Ter Kuile, E. H., *Dutch Art and Architecture, 1600–1800*, Harmondsworth: Pelican, 1966.

Rosenblum, Robert, *Cubism and 20th Century Art*, New, York: Abrams, 1961.

Rothman, Nathan L., "Thomas Wolfe and James Joyce: A Study in Literary Influence," in Richard Walser, ed., *The Enigma of Thomas Wolfe*, Cambridge, Mass.: Harvard University Press, 1953, pp. 263–89.

Rudner, Richard, "On Seeing What We Shall See," in Richard Rudner and Israel Scheffler, eds., *Logic and Art. Essays in Honor of Nelson Goodman*, Indianapolis & New York: Bobbs-Merrill, 1972, pp. 163–94.

Saksena, Usha, "Western Influence on Premchand," *YCGL*, XI, 1962, pp. 129–32.

Sandblad, Nils Gösta, *Manet. Three Studies in Artistic Conception*, Lund: Gleerups, 1954 (Skrifter utg. av Vetenskaps-Societeten i Lund, 46).

Schefold, Karl, "Origins of Roman Landscape Painting," *AB*, XLII, 1960, pp. 87–96.

Schmalenbach, Werner, *Kurt Schwitters*, New York: Abrams, 1967.

Schrade, Leo, *Monteverdi. Creator of Modern Music*, London: Gollancz, 1951.

Searle, John, *Speech Acts*, New York: Cambridge University Press, 1969.

Seuphor, Michel, *Piet Mondrian. Life and Work*, New York: Abrams, n.d.

Shaw, J. T., "Byron, the Byronic Tradition of the Romantic Verse Tale in Russian, and Lermontov's *Mtsyri*," *Indiana Slavic Studies*, I, 1956, pp. 165–90.

————, "Lermontov's *Demon* and the Byronic Verse Tale," *Indiana Slavic Studies*, II, 1958, pp. 163–80.

————, "Literary Indebtedness and Comparative Literary Studies," in N. P. Stallknecht and H. Franz, eds., *Comparative Literature. Method and Perspective*, Carbondale: Southern Illinois University Press, 1961, pp. 58–71.

Sibley, F. N., "Aesthetic Concepts," in W. E. Kennick, ed., *Art and Philosophy*, New York: St. Martin's Press, 1964, pp. 351–73.

Silow, A., *Tegnérs boklån i Lunds universitetsbibliotek*, Uppsala, 1913 (Uppsala Universitets Årsskrift, 1913:1).

Sjöberg, Leif, "Biederman's Structurism: Its Influences," *Art International*, 1966, no. 10, pp. 33–35.

Sloane, Joseph C., "Manet and History," *Art Quarterly*, XIV, 1951, pp. 92–106.

Smart, Alastair, *The Assisi Problem and The Art of Giotto. A Study of the Legend of St. Francis in the Upper Church of San Francesco, Assisi*, Oxford: Oxford University Press, 1971.

Smeed, J.W.S., "Thomas Carlyle and Jean Paul Richter," *CL*, XVI, 1964, pp. 226–53.

Spear, Richard E., "The Literary Source of Poussin's Realm of Flora," *BM*, 1965.

Stallknecht, Newton, P. and Franz, Horst (eds.), *Comparative Literature: Method and Perspective*, Carbondale: Southern Illinois University Press, 1961.

Stallman, R. W., "The Scholar's Net: Literary Sources," *College English*, XVII, 1955, pp. 20–27.

Suppes, Patrick, *Set-Theoretical Structures in Science*, Stanford: Institute for Mathematical Studies in the Social Sciences, 1967.

Tägil, Sven, "Wegener, Raeder, and the German Naval Strategy. Some Viewpoints on the Conditions for Influence of Ideas," *Cooperation and Conflict*, II, 1967, pp. 101–12.

Taylor, G. C., "Montaigne-Shakespeare and the Deadly Parallel," *Philological Quarterly*, XXII, 1943, pp. 330–37.

———, *Shakespeare's Debt to Montaigne*, Cambridge, Mass.: Harvard University Press, 1925.

Telos, Dimitri, "The Influence of the Utrecht Psalter in Carolingian Art," *AB*, XXXIX, 1957, pp. 87–96.

Tervarent, Guy de, "Instances of Flemish Influence in Italian Art," *BM*, LXXXIV, 1944, pp. 290–94.

Thomas, J. Wesley, "The German Sources of William Gilmore Simms," in P. A. Shelly *et al.*, ed., *Anglo-German and American-German Crosscurrents*, I, Chapel Hill: University of North Carolina Press, 1957, pp. 127–53.

Tideström, Gunnar, "[Analys av] Lagerkvist *I själens gränder*," *Lyrisk Tidsspegel. Diktanalyser*, Lund: Gleerups, 1947; 5th ed., 1960.

Tieghem, Philippe van, *Les Influences étrangères sur la littérature française (1550–1880)*, Paris: Presses Universitaires de France, 1961.

Tolnay, Charles de, *Hieronymus Bosch*, London: Methuen, 1966.

Valeriano, P., *Hieroglyphica*, Basel, 1556 (and several subsequent editions).

Van Tieghem, Philippe, *see* Tieghem, Philippe van.

Vinge, Louise, *The Narcissus Theme in Western European Literature up to the Early 19th Century*, Lund: Gleerups, 1967.

————, Review of Lars Gustafsson, ed., *Forskningsfält och metoder inom litteraturvetenskapen* (Stockholm, 1970), in *Samlaren*, 1971, pp. 274–77.

Walton, Kendall, "Categories of Art," *Philosophical Review*, LXXIX, 1970, pp. 334–67.

Weisgerber, Jean, *Faulkner et Dostoievsky: confluences et influences*, Bruxelles: Presses Universitaires de France & Presses Universitaires de Bruxelles, 1968 (Université libre de Bruxelles. Travaux de la Faculté de Philosophie et Lettres, XXXIX).

Wellek, René, *Concepts of Criticism*, New Haven & London: Yale University Press, 1963.

Werner, John M., "David Hume and America," *Journal of the History of Ideas*, III, 1972, pp. 439–56.

Wesley, Thomas J., "The German Sources of William Gilmore Simms," in P. A. Shelley *et al.*, eds. *Anglo-German and American-German Crosscurrents*, I, Chapel Hill: University of North Carolina Press, 1957, pp. 127–53.

Williams, Stanley T., *The Spanish Background of American Literature*, New Haven: Yale University Press, 1955.

————, "Spanish Influences on the Fiction of William Gilmore Simms," *Hispanic Review*, XXI, 1953, pp. 221–28.

Wind, Edgar, *Pagan Mysteries in the Renaissance*, London: Faber & Faber, 1958.

Wittkower, Rudolf, *Gianlorenzo Bernini*, London: Phaidon, 1966.

Young, Edward, *Conjectures on Original Composition*, 1759; facsimile edition, Leeds: The Scholar Press, 1966.

Zhirmunsky, V. M., "On the Study of Comparative Literature," *Oxford Slavonic Papers*, XIII, 1967, pp. 1–13.

335

Index *

action, causal, and non-causal analyses of human actions, 104-5
action-dominated (or action-focussed) conception of art, 20-24, 26-28, 162-63, 171-72, 176-77, 237-38
acts, locutionary, illocutionary, and perlocutionary, 135n
additive similarities, 200
Adhémar, Jean, 27, 217
aesthetic significance, 247, 271, 274, 275, 296
aesthetic value, 129
Alicati, Andrea, 80, 82; *Concordia*, 82
allusions, 75-77, 89-91; conditions of, 77; Hermerén's earlier treatment of, 76-77; relation to genuine influence, 89-91
Almangien, Jacob van, 138
Alston, William, 135
Altamira, 35

Andersson, Aron, 9, 120
Antal, Frederick, 27, 182-83
antithetical similarities, 46, 48. *See also* systematic differences and negative influence
Apollinaire, 266
Ara Grimani, 213
Ariosto, 273-74, 290
Arnheim, Rudolf, 56
art, action-focussed vs. object-focussed conception of, 20, 22-24, 26-28, 171-72, 237-38; concept of, 19; representative and nonrepresentative, 21
art and originality, 141-44. *See also* artistic value and originality
artistic and nonartistic influence, 28-31
artistic creation, 4, 6, 31, 279
artistic field, 3, 153
artistic value and originality, 129-33

* A page number followed by n indicates a note for that page. Titles of novels, poems, and works of art are in *italics*. The index does not include the bibliography and the preface.

assumption of comparability, 293-94
assumption of inferiority, 149-54
assumption of noncoincidence, 212-13
Austin, John, 134, 135n
Austråt Madonna, 120
Avni, Abraham A., 9n

Bacon, Francis, paraphrase of Velázquez' portrait of Pope Innocent X, 69-70
Badt, Kurt, 183-84, 185, 185n
Baertling, Olle, 48, 99
Baglione, 272-73
Balakian, Anna, 43
Baldass, Ludwig, 121
Baldensperger, Fernand, 9n
Bassano, 269
Baudelaire, 139
Beardsley, Monroe, 128n, 143
"because," the meaning of, 110-11
Bellini's *Feast of the Gods*, 64-65
Bergström, Ingvar, 215-17, 240
Bernini's *Truth Unveiled*, 81-82
Biederman, Charles, 30
billiard ball model of artistic creation, 4, 6
Björck, Staffan, 243, 248
Blackmore, John, 8n
Block, Haskell, 10, 27, 94, 165-66, 303, 320n
Bloom, Harold, 309-12
Blunt, Anthony, 235-36
Bodkin, Maud, 223
Bonington, R. P., 28, 271-72
Bordone, Paris, 308; *Dead Christ with Two Angels*, 308
Borelius, Aron, 162, 176n, 194-95
Bornäs, Göran, 41n
borrowings, 144; and genuine influence, 89-91; and models, 77-78; necessary conditions of, 77-78; two subclasses of, 148-49

Boscán, 213, 219
Bosch, Hieronymus, 124-25, 138, 224
Bowra, C. M., 54n
Braque, George, 89, 242; *Baigneuse*, 89
Brendel, Otto J., 212-13
Briganti, 36
Bruegel, Pieter, 21
Byron, 290

Caravaggio, 32, 36, 150-52, 268-69, 272-73; *Portrait of Paul V*, 150-52
Cardoza y Aragón, Luis, 184
Carlyle, Thomas, 31, 89, 114, 242-43; *Sartor*, 89, 114
Caroselli, 32
Castiglione, Baldessare, 170-71, 211-12, 266
causal analyses and moral decisions, 312-15
causal concepts with and without normative implications, 145
causal connection implied in hypotheses about influence, 119-23
causal relations, combinations of, 112
causal requirement, 93-94
Cavarozzi, 121-22
Cecco, 121-22
Celle, Giovanni dalle, 29
Cézanne, 169, 172, 267
Chadwick, N. K. and H. M., 54n
changes, initial resistance to, 280-83; methods used to measure changes, 279-83
Chisholm, Roderick, 247
Chrétien de Troyes, 54
Clark, Kenneth, 27, 179-80, 181
Climacus, John, 225
Colombini, 29

comparative literature, 320, 321n
comparative methods, 4, 6, 247.
 See also similarity *and*
 systematic differences and
 negative influence
conditions, external and internal,
 157, 178
consistency, interpersonal and
 intrapersonal, 299
Constable, John, 56, 58; *Valley
 farm*, 56-58
copies, 62-67; examples of, 63-65;
 necessary conditions of, 63;
 symmetry and transitivity of,
 66-67
Corstius, Jan Brandt, 95, 213-14
counterfactual conditional, 107,
 126-27, 247, 292; basis of, 116,
 126-27, 199
Courbet, 20
Craig, Hardin, 218-19
Crane, Hart, 270-71
criteria of similarity, 196-200
Cruz, San Juan de la, 213, 219

Dauchot, Fernand, 82
Delacroix, Eugène, 28, 55n,
 68, 169, 271-72, 300; *Les Femmes
 d'Alger*, 28-68
Delauny, 37
Derain, 266
description vs. explanation of
 the development of literary
 traditions, 307
direct and indirect contacts,
 165-68
direct artistic influence, 32-41
direct contact, definition of,
 166-67
direct influence, concept of,
 41-42
Dossi brothers, 124-25
Dray, William, 312-14
Driscoll, Edward A., 8n

Duchamp, Marcel, 19-20, 21, 23-
 24, 145-46; *The Bottle Dryer*,
 23-24; *Mona Lisa*, 145-46
Dupin, Jacques, 72n

Echeverria, Durand, 8n
Eisler, H., 200n
Ekman, Gösta, 200
El Greco, 267
Eliot, T. S., 210, 282-83, 308
Ellman, Richard, 17, 27
Erben, Walter, 72n
"evaluate," two interpretations
 of, 316
exclusive similarities, 207-8;
 absence of, 218-19
experience of similarity, 197
experimental research, 5
explanation and description of
 the development of literary
 traditions, 304
explanations of found or noticed
 similarities, 219-29
explanations of influences, 123-25
explanations, requests for, 120
expression, 292
external conditions, 157, 178
Eyck, Jan van, 121

Farnese gallery, influence of,
 283
Fedder, Norman J., 9, 27, 38-39,
 140-41, 209-10, 270, 274-76
Fehrman, Carl, 255, 256n
Fielding, 237
Flémalle, Master of, 181
Florio, 187-88
forgery, 100-103; difference
 between forgeries and copies,
 102
Fraenger, W., 138
Franz, H., 94n, 317n
Friedlaender, Walter, 27, 28, 150,
 178-79, 183, 271, 288-89

Friedman, Albert, 10, 291
Friedrich, Werner P., 9n, 95n,
 265n, 303n
Fröding, Gustaf, 168-69; *Claver-
 house*, 168
Frost, 291
Furberg, Mats, 135n

Gardner, Bellamy, 85-86
Gauguin, Paul, 82; *Green Christ*,
 82
Geertgen van Sint Jans, 224
Gemzell, Carl Axel, 8
Gentileschi, Artemisia, 121-22
genuine influence, 89-100
Gericault, Theodore, 58-62;
 The Raft of Medusa, 58-61
Gillispie, Gerald, 9
Giotto, 201-4
Goethe, 214
Gogh, Vincent van, 278n
Golding, John, 10, 13, 27, 37,
 89, 242, 252, 266-67
Gombrich, Ernst H., 79n, 228
Goodman, Nelson, 127n, 129n,
 247
Goodwin, K. L., 9, 11, 27, 36,
 116-17, 175, 189-90, 210, 244,
 252, 282-83, 284-85
Goude, G., 200n
Gowing, Lawrence, 139-40
Goya, Francisco, 9n, 46, 73, 118n,
 175-76, 226-29, 299; *La Maja
 Desnuda*, 73
Grafström, 114-16, 160, 254-56
Guillén, Claudio, 95, 303, 312,
 315-17
Gustafson, Lars, 131n

Halldén, Sören, 259n
Hals, Frans, 224-25
Hampshire, Stuart, 104n
Hardy, 291

Harmon, Alice, 187-89
Hassan, Ihab H., 306-8
Heckscher, William S., 81n
Heda, 215
Heidenstam, Verner von, 117,
 243-44, 248
Hemingway, Ernest, 237
Hermerén, Göran, 13n, 55n, 76-
 77, 191n, 259n, 262n, 311n
Heydenreich, Ludwig H., 81n
Hill, C. F., 9n
Höckert, Johan Fredrik, 123,
 162
Hogarth, 182-83
Holman, Hugh, 265
Holmberg, Olle, 160, 164
Homer, 249
Honthorst, 121-22
Housman, 291
Huet, Jean Baptiste, 86
Huntley, William B., 8n

illocutionary act, 135n
illocutionary and perlocutionary
 dimensions, 135, 313. *Cf.* 135n
importance of art and literary
 history, 22, 235
importance of combining the
 different measures, 287
importance of indicating clearly
 which measure one is using,
 287
indirect contact, definition of,
 167-68
indirect influence, definitions
 of, 32; nonstandard version of
 the first definition, 36; stand-
 ard version of the first defini-
 tion, 35; weak version of the
 first definition, 36
influence and forgery, 100-103.
 See also 127-54
influence and interpretation,
 308-12

influence hypotheses and explanations, 123-25
influence, imitation, and plagiarism, 127-29
influence, kinds of: artistic and nonartistic, 28-32; direct and indirect, 32-42; positive and negative, 42-50. *See also* 50-104, esp. 97-100
influence, originality and artistic value, 129-37, 317-19
influence, reasons for studying, 321; three fundamental questions, 93
influence research, bad connotation of, 8
influence statements as explanations, 119-23
influence, tradition, and development, 305-7
influence vs. traces of influence, 95
initial resistance to changes, 280-83, 287
intentional requirement, 96-97
internal conditions, 157, 178
internal methods, 178. *Cf.* 157
intrapersonal and interpersonal consistency, 299
irrelevant similarities and differences, 190-92

Jairazbhoy, Rafique Ali, 9
Japanese influence on Manet, 241-42, 248, 252
John Climacus, 225
Jones, Arne, 24
Jonsson, Inge, 39-40
Josephson, Ernst, 9n, 278n
Josephson, Ragnar, 6n, 56
Joyce, 249
Jung, Carl Gustav, 223

Kalf, Willem, 225, 240

Kern, L., 226
Kipling, 291
Kivy, Peter, 143n
Kjellén, 243-44, 248
Klein, Yves, 21
Klibansky, Raymond, 240
knowledge and expectations, role of, 62, 192-94
Kuile, E. H. ter, 224-25

Lafond, Paul, 224
Lagerkvist, Pär, 43-44, 271
Lambert, E., 176n
Lamm, Martin, 39-40
Langer, Susanne, 210n
Lawrence, D. H., 15, 38, 140-41, 172, 209-10, 274-75
Leck, Bart van der, 231-33, 239-40
Léger, 267
Lee, R. W., 170-71, 211-12, 266
Leonardo da Vinci, 55n, 145-46
Lessing, Alfred, 128n
Lessing, G. E., 114-15, 254-55
Lichtenstein, Sara, 169
Lindberger, Örjan, 43-44, 271
Linnér, Sven, 7, 196n, 211
literary influence and reception, 43
locutionary act, 135n
Lowes, John Livingstone, 6n
Lugt, Frits, 79-80, 137-38
Luna, 240-41

Macklin, Ruth, 105n
Mahon, Denis, 305n
Maison, K. E., 65, 79n, 82n
Mallarmé, 10, 15, 165-66
Malmström, Sten, 45, 118-19, 185-86
Mandowsky, E., 81n
Manet, Edoard, 46, 55, 78-79, 118n, 138-39, 175-76, 226-29, 241-42, 248, 252; *Le Déjeuner*

Manet, Edoard (*cont.*)
 sur l'herbe, 78-79, 241; *The Death of Maximilian*, 46, 118n, 175-76, 226-29
Manfredi, 268
Mao (Salini, Tommaso), 272-73
Marcantonio Raimondi, 78-79, 124-25; *The Judgment of Paris*, 78-79
Martin, John Rupert, 225, 283
Masaccio, 179-80
Master of Flémalle, 181
measurement of influence, 263-300; importance of combining the different measures, 287; practical conclusions, 300-302
measure I, 276; II, 276; III, 276; IV, 277; V, 286; VI, 288; VII, 289; VII', 291; VIII, 289; IX, 290; X, 295; XI, 296; XII, 298; XII', 299; XIII, 298; XIII', 299
Meegeren, van, 100
Meiss, Millard, 27, 28-29
Melden, A. I., 104n
methods, used to estimate probabilities, 286-87; used to measure changes, 279-83
Michelangelo, 55, 212-13
Milton, 39-41
Miro, Joan, 70-72; *Dutch Interior*, 70-72
misinterpretation, OED definition of, 307
models, 77-88; difference from borrowings and copies, 77-78, 86-87; necessary conditions of, 78
Moir, Alfred, 9, 27, 32, 36, 121-22, 268-69, 272-73
Mola, 269
Molière, 113
Mondrian, Piet, 35, 231-33, 239-40

Monet, Claude, 15
Montaigne, 186-89
Moritz, Manfred, 133

Narcissus myth, 39
necessary and sufficient conditions, examples of, 108-9; as three-place relations, 110-12
necessary condition, 106-13; definition of, 108; part of, 111-12
negative influence, 42-49, 194-96
negro sculpture and Picasso, 10
Nilsson, Albert, 114-16, 160, 210-11, 254-55
Nizami, 54
nonartistic vs. artistic influence, 28-31
normative action and intention, 134-36
normative and nonnormative concepts, 144-49
normative conclusions, 233-35
normative effects, 136-37
normative implications, 102, 127-29, 130, 133, 247
normative requirement, 96
norms for praise and blame, 133
Novalis, 143

object-dominated (object-focussed) conception of art, 20-24, 26-28, 162-63, 171-72, 176-77, 237-38
objet trouvé, 20
Odyssey, 249
Oldenburg, Claes, 55
Olsson, Henry, 168
ontological requirements, 14, 18, 26-27, 93
order of requirements, logical and chronological problems, 260
originality, definition of, 317-

18; importance in art, 128-33, 141-44; Romantic conception of, 131; Shaw's interpretation of, 314

Orozco, 184-85

Ovid, 39-41

Panday, K. C., 143

Panofsky, Erwin, 27, 181-82, 240, 308n

parallels, examples, 51-52; necessary conditions of, 51

paraphrase, 68-75; examples of, 68-72; necessary conditions of, 68

parody, 92

Passavanti, 29

pastiche, 92

Patinir, 21

Paz, Octavio, 19

Peers, E. Allison, 213, 219

Penrose, Roland, 10, 129

perlocutionary act, 135n

Petrarca, 273-74

Peyre, Henri, 321n

Picasso, Pablo, 10, 13, 15, 19, 68, 75-76, 89, 99, 129, 172, 242, 267; *Demoiselles d'Avignon*, 89, 242, 267; paraphrase of *Las Meninas* by Velázquez, 68-69, 75; *The Studio*, 75

Piero della Francesca, 179-80

plagiarism, moral blame and artistic blame, 127-29; standard definitions of, 128

Platen, Magnus von, 46n

Porter, R. K., 228

positive and negative influence, 28, 42-49, 194-96

Pound, Ezra, 11-12, 17, 36, 116-17, 175, 189-90, 210, 244, 252, 282-83, 284-85

Poussin, Nicolas, 64, 178-79, 183, 185, 235-36, 288-89, 305;

copy of Bellini's *Feast of the Gods*, 64; *Death of Sapphira*, 178, 183; *Narcissus*, 289, 308

practical conclusions of this investigation, 319-22

Praz, Mario, 8on, 81n

probabilities, 169-70, 188, 210, 215, 216-17, 233, 256, 284; methods used to estimate, 286-87

probability calculus, 285-86

Propertius, 185-86

Pulzone, Scipio, 150-52; *Portrait of Cardinal Spada*, 151-52

quotations, verbal and nonverbal, 144, 148-49

Raeder, 8

Raimondi, Marcantonio, 78-79, 124-25

Raphael, 70, 178-79, 183; and Poussin, 288-89; *Death of Ananias*, 178, 183; drawing of Pope Julius II, 70; portrait of Pope Julius II, 70

reasons, for studying influences, 318; for studying discussions about artistic and literary influence, 7

Rembrandt, 20, 79-80, 137-38, 224-25, 319; *The Storm on the Sea of Galilee*, 79-80, 316

Renan, 43-44, 271

requirement of assimilation, 98-99

requirement of change, 239-57, esp. 245-47; arguments supporting the claim that changes have taken place, 247-56

requirement of contact, 164-72

requirement of continuity, 98-99

requirement of different creators, 104

requirement of long-lasting
effect, 98-99
requirement of similarity, 99-
100, 177-239
requirement of totality, 98
respects, criteria of identity,
292
Rewald, John, 118n
Richter, Jean Paul, 31, 89,
114, 242-43
Ripa, Cesare, 30, 80-82;
influence of, 81n; *Truth*, 81-82
Rosenberg, Jacob, 224-25
Rosenblum, Robert, 10, 75
Rousseau, H., 267
Rubens, Paul Peter, 55n, 62-65,
194-95; copy of Titian's
*Bachanal with the Sleeping
Ariadne*, 63-64; copy of Titian's
Painting of a Bride, 65
Rudner, Richard, 129n
Ruisdael, Jacob van, 224-25
Runeberg, F., 161

Salini, Tommaso (called Mao),
272-73
Sandblad, Nils Gösta, 46, 118n,
138-39, 175, 226, 228, 230-31,
241-42, 248, 252
Saulieu sarcophagus, 217
Saxl, Fritz, 240
Scheffler, Israel, 129n
Schefold, Karl, 182
Schelling, 143
Schiller, 210-11
Schlegel, 143
Schmalenbach, Werner, 270
Schrade, Leo, 143n
Schueller, Herbert, 128n
Schwitters, Kurt, 270
Searle, John, 135
Seuphor, Michel, 231-32, 239-40
Shakespeare, W., 130, 186-89,
218-19

Shaw, J. T., 41n, 94, 314-16
Sibley, Frank, 13n, 200n
Silow, A., 176n
similarity, additive, 200; anti-
thetical, 256; conceptual
framework of, 200-209; criteria
of, 196-200; distinction be-
tween extensive, precise, and
exclusive similarities, 204-9;
evidence against influence, 218-
19; evidence of influence,
27, 209-17; examples of, 209-
17; explanations of, 219-29;
subjective, 197, 199-200, 205;
verification of statements
about similarities between
individual works of art and
groups of works of art, 16;
weighing of similarities, 229-
33
similarity requirement, 96
Simms, William Gilmore, 15n
Sjöberg, Leif, 30n
sketch, necessary conditions of,
55; two senses of, 55
Slive, Seymour, 224-25
Sloane manuscript, 241
Smart, Alastair, 201, 204
Smeed, J.W.S., 31, 114, 242-
43, 252
source, necessary conditions of, 78
Spanish influence on American
literature, 15
speech acts, 134, 135n
Spenser, Edmund, 170-71, 211-
12, 266
St. Catherine, 29
Stagnelius, 45, 118-19, 160,
185-86
Stallknecht, N. P., 94n, 314n
standard properties, 191
Steen, Jan, 70-72; *Tanzstunde
des Kätzchens*, 70-72
Stella, Jacques, 85-86

344

Strindberg, A., 168
strong and weak poets, Bloom's distinction between, 310-11
style, 292
subjective similarity, 197; measurement of, 199-200
sufficient condition, 106-13; as three-place relation, 110-12; part of, 111-12; definition of, 108; examples of, 108-9
supernorms, 132-33
Suppes, Patrick, 284
Swedenborg, E., 39-41
systematic differences and negative influence, 48, 237, 256, 277. *See also* antithetical similarities

Tägil, Sven, 8n
Taylor, G. C., 186-89
Tegnér, E., 114-16, 160-61, 198, 210-11, 254-56; *Återkomsten till hembygden*, 161
Telos, Dimitri, 258-59
temporal requirement A, 157-64; B, 172-74
Tervarent, Guy de, 124-25
Tidemand, Adolph, 123, 162
Tideström, Gunnar, 117
Tieghem, Philippe van, 9, 10, 27, 37, 113, 273-74, 290, 298, 300
Tinguely, 163
Titian, 20, 55, 62, 63-64, 65, 212-13; and Poussin, 235-36, 288-89; copy of Raphael's portrait of Pope Julius II, 70; *Bachanal with the Sleeping Ariadne*, 63-64; *Education of Cupid*, 212-13; *Painting of a Bride* or *Lavinia in Bride Dress*, 65
Tolnay, Charles de, 138
Toulouse-Lautrec, 184-85

tradition, analysis of, 305
transference of evaluations, 135, 137
translation, 92
Troyes, Chrétien de, 54
typological analogies, 51

Ulysses, 249
Utrecht Psalter, 258

Valeriano, Piero, 80
value of a method, 4
variable properties, 191
Vega, Garcilaso de la, 213, 219
Velázquez, 9n, 68-70, 75-76, 82, 194-95; *Los Borrachos*, 194-95; *The Surrender at Breda*, 82; *Las Meninas*, 75; *Portrait of Pope Innocent X*, 69-70
Vermeer, 30, 139-40
Vinci, Leonardo da, 55n, 145-46
Vinge, Louise, 39-40, 131n
visibility requirement, 93-95
Vos, Martin de, 79-80, 319

Waern, Y., 200n
Wagner, 10, 15, 166
Walton, Kendall L., 191n
Warhol, Andy, 23-24
Wegener, 8
weighing of similarities, 229-33
Weisgerber, Jean, 9
Wellek, René, 321n
Werner, John M., 8n
Wesley, Thomas J., 15n
Williams, Stanley T., 15
Williams, Tennessee, 15, 38-39, 140-41, 172, 209-10, 270, 274-75
Wind, Edgar, 226
Wirth, Karl-August, 81n
Wright, G. H. von, 104n

Ybl, E. von, 226
Yeats, 12, 116-17, 175, 189-90, 244, 282, 284, 285, 291; *The Folly of Being Comforted*, 116-17, 284-85

Ykens, François, 215
Young, Edward, 141-43

Zhirmunsky, V. M., 51, 54
Zoffany, 182-83

Library of Congress Cataloging in Publication Data

Hermerén, Göran, 1938-
 Influence in art and literature.

 Bibliography: p.
 1. Influence. 2. Judgment (Aesthetics) 3. Art—
Themes, motives, etc. 4. Literature—Philosophy.
I. Title.
BH301.J8H47 1975 700'.1 73-2466
 ISBN 0-691-07194-2